Paintings and Drawings

at the

Shelburne Museum

NANCY C. MULLER

The Shelburne Museum
Shelburne, Vermont

MCMLXXVI

*Shelburne Museum, Inc., organized in 1947
under the laws of the State of Vermont, is an exclusively
charitable, educational and
non-profit membership corporation.*

*This book is one of a series on early American arts and antiques
published by the museum. For a list of these publications,
write directly to Shelburne Museum,
Shelburne, Vermont 05482.*

TABLE OF CONTENTS

FOREWARD

The paintings and drawings in the Shelburne Museum collection can be separated into three categories — European, including both old masters and the Impressionists; American, consisting of folk and academic works; and outdoor paintings of hunting scenes, wildlife or wilderness landscapes. Each of these categories reflects a particular interest and enthusiasm of the Museum's co-founder, Mrs. J. Watson Webb.

Growing up in a household filled with treasures from Europe and the Far East, Electra Havemeyer Webb from an early age acquired a strong visual literacy which was to be sustained and nourished throughout her life. Her mother, Louisine Waldron Elder, had been introduced to French Impressionist paintings in Paris by her close friend, the American painter Mary Cassatt. With marriage to the New York sugar refiner Henry O. Havemeyer, Louisine Elder established a partnership with an equally enthusiastic collector. With Miss Cassatt's advice, the Havemeyers' interests and collections expanded tremendously. First acquiring recognized European masters such as Rembrandt and Goya, they were soon embellishing their Tiffany designed home with the paintings of Corot, Courbet and the then avant-garde Manet, Monet, and Degas. Their collections ultimately consisted of an astonishing array of art, including Oriental pottery, porcelain, rugs, textiles, paintings and bronzes; Greek and Roman pottery, bronzes, figurines and coins; and Syrian and Persian pottery. While most of this extraordinary collection is now in the Metropolitan Museum of Art, many of the paintings inherited by Electra Havemeyer Webb are now at the Shelburne Museum housed in a Greek revival building whose interiors were taken from the apartment of Mrs. Webb and her husband, J. Watson Webb, on Park Avenue in New York City.

The American painting collection has largely been accumulated since the formation of the Shelburne Museum in 1947. Having married Mr. Webb in 1910, Electra Havemeyer Webb began furnishing their summer home in Shelburne with New England country furnishings. As her appreciation and knowledge of American antiques grew, so did her collections — dolls, quilts, pewter, china, glass, furniture, weathervanes, cigar store Indians — all of which are now on exhibit in the Shelburne Museum's thirty-five buildings. One of the first collectors to appreciate the aesthetic strength of folk art, Mrs. Webb's early interest in folk sculpture soon expanded to include folk painting. Today these paintings along with those of their academically trained brethren are exhibited in several of the Museum's houses and in its Webb Gallery of American Art.

Both excellent riders, Mr. and Mrs. Webb enjoyed fox hunting, an interest which led to their hunting quail, grouse and pheasant. Shortly after World War I they began hunting large game animals in Alaska and Canada. Their interest in big game was shared by their Long Island neighbors, Mr. and Mrs. William N. Beach of Great Neck, who gave the Museum their personal collection of western scenes and wild animal and bird paintings. These paintings are now exhibited in the Beach Gallery, a cedar log structure nestled in the woods next to the Beach Lodge in which the Beachs' hunting trophies are displayed.

Within these three categories the visitor to the Shelburne Museum can see a wide range of artistic achievement covering over three centuries of endeavor. Other forms of art which can also be seen; prints, sculpture, silhouettes, theorems, calligraphic drawings and Pennsylvania German frakturs have had to be omitted from this catalogue because of its length. The paintings and drawings listed have been separated into European, American and Anonymous sections. The European and American works have been arranged alphabetically by artist, while the Anonymous works have been ordered by subject — portraits, landscapes, still-lifes, and other cohesive groups having been organized together.

Publication of the Catalogue has been supported by a grant from the National Endowment for the Arts in Washington, D. C., a Federal agency. Special thanks are due to Gladys Floyd for typing the manuscript and to John M. Miller III for photographing or printing most of the visual material in the book. I very much appreciate the suggestions of J. Watson Webb, Jr., President of the Museum, who read the manuscript, and the help of Kenneth E. Wheeling who assisted with the layout and organization of the book. Most credit, however, must go to H. R. Bradley Smith who originated this project. Many years of his work and research are reflected in these pages, and without his great effort, this Catalogue would not be ready today. To him in particular, I extend my warmest thanks and appreciation.

<div style="text-align: right">Nancy C. Muller</div>

Shelburne, Vermont
December, 1975

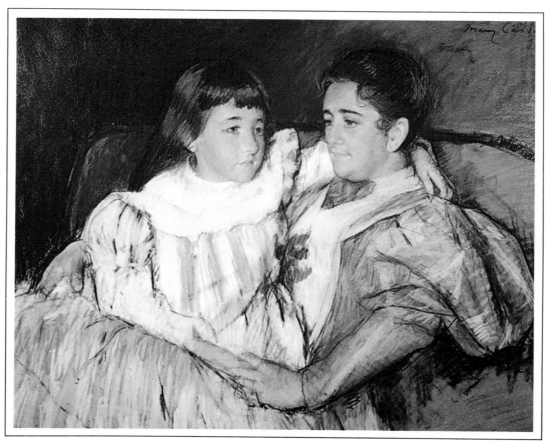

1. Mary Cassatt, PORTRAIT OF MRS. HAVEMEYER AND HER DAUGHTER ELECTRA, 1895. Collection of Electra B. McDowell

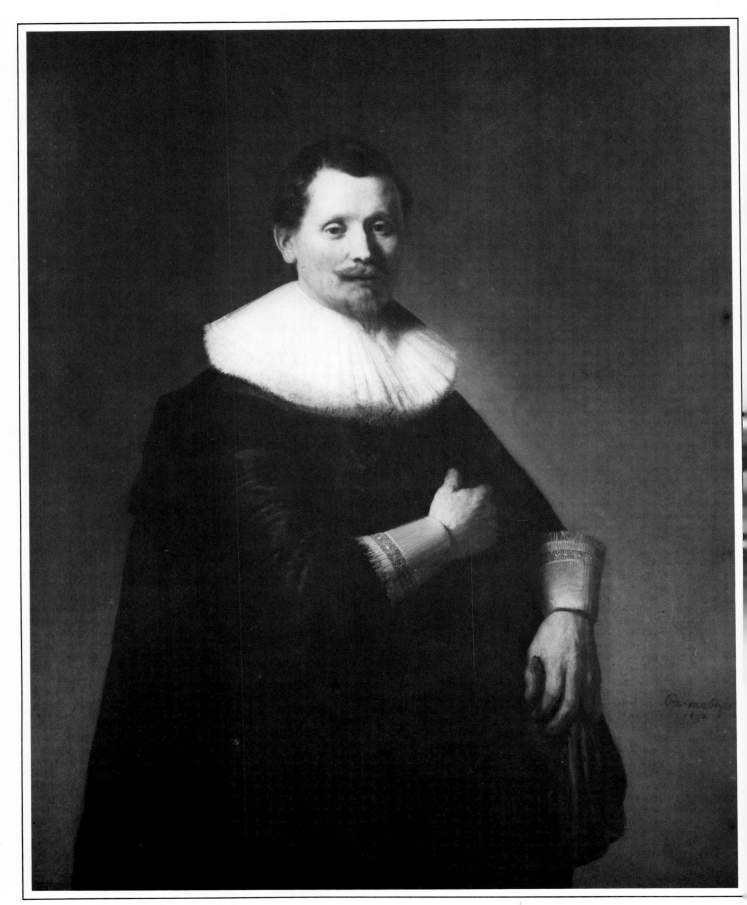

2.　Rembrandt, PORTRAIT OF A MAN — THE TREASURER

EUROPEAN ART

Bonheur, Rosa (1822 – 1899)

FORAGING PARTY:
WILD BOARS IN THE FONTAINEBLEAU FOREST

Figs. 3, 4

H 96½"; w. 69¼" 1876
oil on canvas
signed, l.l.: "Rosa Bonheur/1876"
Gift of: Mr. J. Watson Webb, Jr., 1962
Exhibited: Royal Academy, Antwerp, Belgium, 1876
(cat. #27.1.5-38)

Trained by her father, a French landscapist, Rosa Bonheur
at an early age became a successful animal painter. One

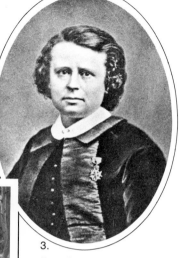

3.

Rosa Bonheur

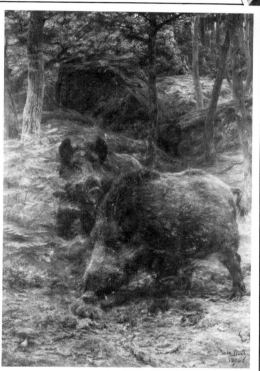

4.

of her favorite pastimes was to wander through Fontaine-
bleau Forest sketching and painting. The Fontainebleau,
the scene for this painting, covered some 40,000 acres
filled with huge elms, oaks, beeches, and pines. Once con-
taining thousands of stags, roes, roebucks, wild boars,
hares, pheasants, and partridge, the forest is now almost
devoid of wildlife. She painted THE FORAGING PARTY
for Ernest Gambart, the Spanish Consul General at Nice,
as a pendant to her portrait of a stag entitled KING OF
THE FOREST.[1] These two paintings she considered her
masterpieces. The boar depicted in the center of Shel-
burne's painting was a pet named Kiki whom Miss Bon-
heur kept until he became too savage and had to be
destroyed.

[1] Henri Cain, *Reminiscences of Rosa Bonheur,* edited by Theodore Stan-
ton (London and New York, 1910), p. 302.

Breyer,

HACKNEY CAB

Fig. 5

H. 7⅜"; 13½" 1903
watercolor, oil, and pencil on composition board
signed, l.r.: "Breyer/1903"
signed, on verso: "#453 painted by Breyer 1903, 21, October
 1862"
Inscribed on mat: "21, October, 1862"
(cat. #27.2.5-5)

The hackney cab was actually a brougham, im-
ported to England from France about 1838 by Lord
Brougham. He had his coachman redesign the vehi-
cle into this small gentleman's private carriage,
which soon found wide use as a taxi. The word
hackney comes from the French *haquenée,*
referring to the horse pulling a carriage for hire.

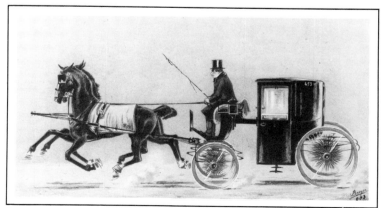

5.

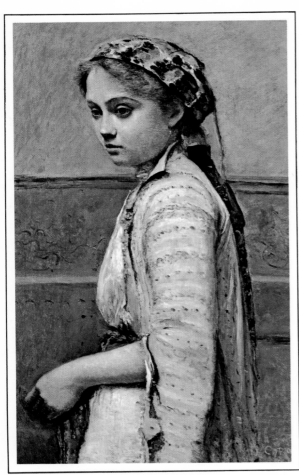

6.

Corot, Jean Baptiste Camille (1796 – 1875)

GREEK GIRL — MLLE. DOBIGNY Fig. 6

H. 32¾"; w. 21½" 1868-1870
signed, l.r.: "COROT"
Exhibited: Exposition, Maitres du Siecle, Paris, 1886, no. 48
 M. Knoedler and Co., New York, 1934
 Art Institute of Chicago, 1934
 Louvre, 1934
 New York World's Fair, May to October, 1940
 Wildenstein Gallery, New York, 1942
 Philadelphia, 1946
 Yale University Art Gallery, spring, 1950
 The Art Institute of Chicago, 1960
 Metropolitan Museum of Art, summer, 1961
 Knoedler Galleries, March 29-April 23, 1967
(cat. #27.1.1-149)

PORTRAIT OF MLLE. DOBIGNY — THE RED DRESS Fig. 7

H. 30¾"; w. 18½" 1865-1870
oil on panel
signed, l.r.: "COROT"
Exhibited: Exposition Centennale, Paris, 1900
 Art Institute of Chicago, 1934
 Philadelphia, 1946
 The Art Institute of Chicago, 1960
 Metropolitan Museum of Art, summer, 1961
 Knoedler Galleries, March 29-April 23, 1967
(cat. #27.1.1-154)

Among the first of the French artists to paint landscapes entirely out-of-doors was Jean Baptiste Corot. A serious artist by the age of twenty-six, Corot studied with Michallon and Jean-Victor Bertin, both neo-classicists. During a long trip to Italy between 1825 and 1828, Corot frequently worked outdoors, attracted to scenes of rustic intimacy which he attempted to capture in a transitory state. His taste in this respect was like that of the Impressionists although he relied primary on nuances grey and tan to give both volume and expression to his work.

After returning to France in 1828, Corot continued to paint landscapes, working for the most part in Provence, Normandy and Brittany. He was to make two other trips Italy — in 1834 and 1843, and visited both Switzerland and Holland. After 1857 Cor exhibited regularly at the French Salon where, while classified as a neo-classicist, was criticized for his lack of finish. Most of these figure paintings, few of which he ever exhibited, date between 1865 and 1874 when poor health forced Corot to giv up living in the country. Both of Shelburne's portraits depict one of his favorite mo els, Emma Dobigny. While wearing a Greek costume, Mlle. Dobigny does not appe exotic; the weight and gravity of her solid figure are what compel one's attention.

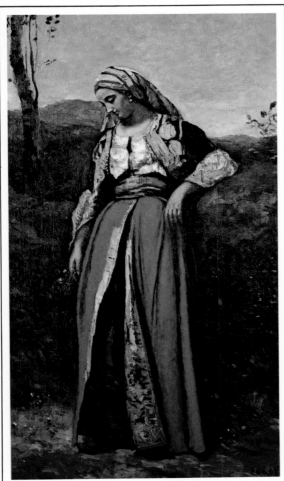

7.

Courbet, Gustave (1819 – 1877)

STILL LIFE — FRUIT Fig. 8

H. 22"; w. 28½"
oil on canvas
signed, l.l.: "71 Ste. Pelagie, G. Courbet"
Exhibited: New York, Harriman Gallery, November 7-25, 1933
 Art Institute of Chicago, "A Century of Progress", 1933
 New Haven, Yale University Art Gallery, 1956
 Philadelphia Museum of Art, 1960
 Museum of Fine Arts, Boston, 1960
 Metropolitan Museum of Art, summer, 1961
 Knoedler Galleries, March 29-April 23, 1967
(cat. #27.1.3-23)

Born in 1819 the son of a rich landowner in Ornan, France, Gustave Courbet was seriously concerned with painting by 1840. In Paris he first exhibited at the Salon 1844. Five years later he was awarded the Salon's gold medal for a painting entitle L'APRÈS DINÈE A'ORNANS. Thereafter Courbet became increasingly concerne with painting reality, giving a new dignity to what he observed around him. Attack by both Classicists and Romanticists as well as the critics in 1855, he erected a pavilion facing the Palais de l'Exposition where he exhibited over forty of his pair ings and printed a catalogue in which his manifesto on REALISM was published. Gradually his views gained acceptance, particularly from younger students to wh he preached on the supremacy of nature. The critics, too, were soon persuaded his genius; in 1872 he was offered the Legion d'Honneur (which he refused) and w nominated Prèsident des Artistes. As the Franco-Prussian war began, Courbet's socialist leanings caused him to join the Commune. Charged along with other Socialists with the destruction of the Column Vendôme, Courbet was imprisoned from September 22 to December 18, 1871 at Saint-Pelagie in Paris.

This painting and many other still-lifes were done while he was serving this se tence. In 1873 when his case was reopened, Courbet's goods were confiscated, a he escaped to La Tour de Peitz on Lake Geneva, Switzerland. After being fined 1877 823,000 francs for destroying the Column, Courbet's paintings were auc tioned off by the French government to repay his debts. Grief-stricken and de pressed, Courbet died in Switzerland on the last day of that year.

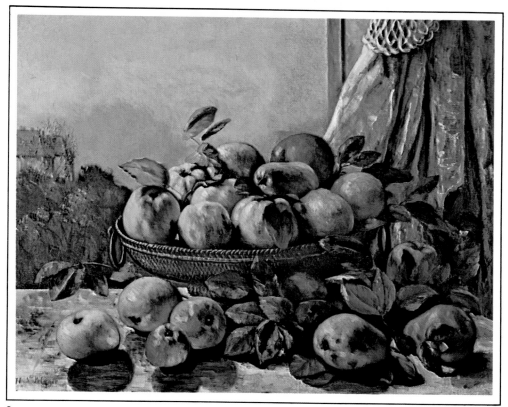

8. Courbet, STILL LIFE — FRUIT

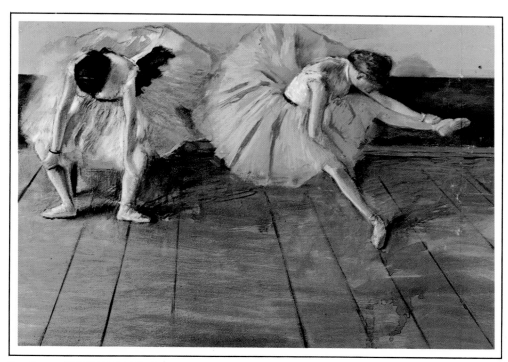

9. Degas, TWO BALLET GIRLS

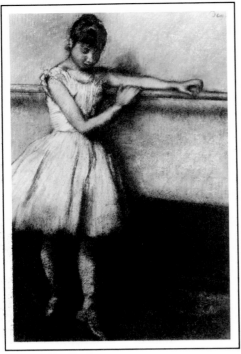

10.

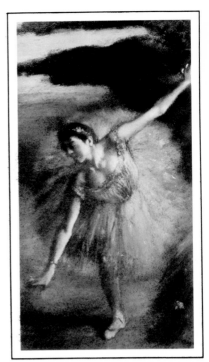

11.

Degas, Edgar Hilaire Germaine (1834 – 1917)

DANCER IN GREEN

Fig. 11

H. 28"; w. 15"
pastel on paper
signed, l.r.: "Degas"
Exhibited: "Masterpieces of Old and Modern Masters, Knoedler Galleries, 1915
 Metropolitan Museum of Art, summer, 1961
 Knoedler Galleries, March 29-April 23, 1967
(cat. #27.3.1-33)

DANCER IN YELLOW

H. 28"; w. 15"
pastel on paper
signed, l.r.: "Degas"
Exhibited: Metropolitan Museum of Art, summer, 1961
 Knoedler Galleries, March 29-April 23, 1967
(cat. # 27.3.1-32)

DANSEUSE À LA BARRE

Fig. 10

H. 26¼"; w. 18½"
pastel on paper
signed, l.r.: "Degas"
Exhibited: Metropolitan Museum of Art, summer, 1961
 Knoedler Galleries, March 29-April 23, 1967
(cat. #27.3.1-34)

TWO BALLET GIRLS

Fig. 9

H. 18⅛"; w. 26¼"
pastel on paper
signed, l.r.: "Degas"
Exhibited: "French Masterpieces of the Late XIX Century," Durand-Ruel
 Galleries, 1929, no. 5
 Metropolitan Museum of Art, summer, 1961
 Knoedler Galleries, March 29-April 23, 1967
(cat. #27.3.1-31)

12. Card announcing Degas sale, 1919.

At the age of sixteen Louisine Waldron Elder was to purchase her first Degas — a pastel entitled REPETITION DE BALLET for $100.00. Introduced to Degas' work by her close friend Mary Cassatt, Miss Elder (ultimately to become Mrs. Henry O. Havemeyer) maintained a strong partially for his work and was to eventually buy over 100 of his paintings.

Although resembling the Impressionists in his concentration on the transitory, Degas, moody and arrogant, remained on the periphery of this art movement. Never did he give up his primary concern with line, nor did *plein* air painting appeal to his sophisticated nature. Even his paintings of jockeys on horseback have an urbane air and are constructed in a formal, almost classical manner. He painted people rather than landscapes, catching their movements in unexpected, even awkward poses. While a superb draftsman, Degas was as concerned with space as with line, an interest sharpened by his appreciation of Japanese prints. Increasingly Degas concentrated on two themes — nudes and ballet dancers. These four pastels, all of ballerinas, exhibit the rich variations which a single theme could invoke in a fertile mind. Whether catching a dancer at rest or whirling across the dance floor, Degas managed to capture the essence of the ballet.

Attributed to

Goya, Francisco Jose (1746 – 1828)

PORTRAIT OF THE PRINCESA DE LA PAZ

Fig. 13

H. 40″; w. 31″
oil on canvas
Exhibited: Knoedler Galleries, Exhibition of El Greco and Goya, 1912
Knoedler Galleries, April 9-April 21, 1934
Yale University, Exhibition of Pictures Collected by Alumni, 1957
Brooklyn Museum, October, 1935
Metropolitan Museum of Art, Summer, 1961
Knoedler Galleries, March 29-April 23, 1966
(cat. #27.1.1-153)

This portrait of the young Dòna Maria Teresa de Borbón y Vallabriga, Condesa de Chinchón, wife of the Prince of Peace, is nearly identical to a painting in a collection belonging to the Dukes of Sueca at Boadilla del Monte, Spain. In this version, done for the Princess' husband, she wears a green bow on her bonnet while in the other painting it is blue. Goya, painter to the court of Charles IV, depicted the Royal family, as here, in an elegant, brightly colored, but delicate style. In his later portraits Goya's searching eye became more bitter and pitiless, mocking the pretentious vanity and ugliness of his sitters. The portrait may have been painted by Augustín Esteve, a pupil of Goya's who became painter to the Court in 1800. There are other duplicates of Goya's portraits which may well have been done by Esteve.[1]

[1] Martin S. Soria notes that "exact copying was foreign to Goya's temperament but suited Esteve's talents perfectly." See Martin S. Soria, "Augustin Esteve and Goya", *The Art Bulletin* (September, 1943, V. XXV, No. 3).

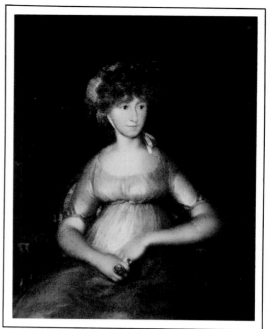

13.

Copied after

Henderson, Charles Cooper (1803 – 1877)

PULLING UP TO UN-SKID Fig. 14

H. 49″; w. 85½″
oil on canvas
signed, on baggage cover, u.r.: "CHС"
Gift of: Mr. Stewart Huston, 1961
(cat. #27.1.5-43)

This huge painting of an English mail coach is a duplicate of an original work of Charles Cooper Henderson's by an unknown artist — possibly Henderson himself. The painting was also the source of a print illustrated as Plate III in *Fore's Coaching Recollection*, engraved by J. Harris, London, in 1843 by "Messrs, Fores at their sporting and fine print repository and Frame Manufactory, 41 Piccadilly corner of Sackville Street."[1]

Henderson was born in Surrey, England, the son of John Henderson, an amateur painter. All of the Henderson children were given art lessons by Samuel Prout. Although Charles read for the bar, he continued to paint during his period of study. While on a tour of France and Spain with his father, Henderson showed a keen interest in French horse harnesses, trappings, and coaching accessories. Having been disinherited because of this "unsuitable" marriage in 1829, Henderson lived in Berkshire and London where he painted for a living, specializing in coaching scenes. Many of his works were engraved, and he exhibited at the Royal Academy twice, in 1840 and 1848. Inheriting money after his mother's death in 1850, Henderson gave up painting for several years, living in high style. He was well remembered for driving a yellow mail Phaeton around London. In his later years he continued to paint for amusement until his death in 1877.[2]

[1] Information from the engraving in the Shelburne Museum Collection (cat. #27.6.9-1).
[2] Sir Walter Gilbey, Bar., *Animal Painters of England* (London: Vinton & Co., 1900), V. II, pp. 15-21.

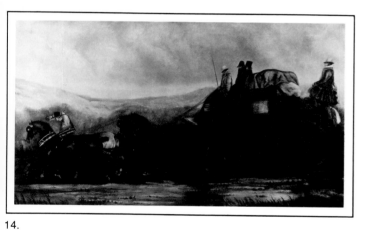

14.

Laporte, G. H. (c. 1800 – 1873)

WILLIAM SMITH AND HIS HOUNDS OF FOXHUNT MANOR, MAYFIELD, SUSSEX

Fig. 15

H. 28″; w. 35¾″ 1825
oil on canvas
signed:
(cat. #27.1.5-83)

A popular painter of animals, figures and hunting subjects, George H. Laporte, the son of the landscape painter John Laporte, was trained in Germany and had settled in London by 1821. Equally deft in watercolor and oil, Laporte began exhibiting at the Royal Academy by the age of twenty-two. Between 1834 and 1873 he contributed 136 paintings to the New Watercolour Society in London and forty-two of his paintings were copied as prints for *Old Sporting Magazine.* Especially noted for his paintings of horse and sporting dogs, Laporte painted a number of animal portraits for the Duke of Cumberland. He died October 23, 1873, at his home in Norfolk Square, London.

15.

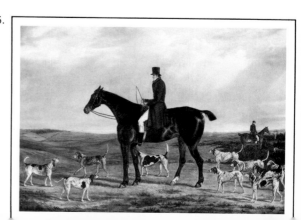

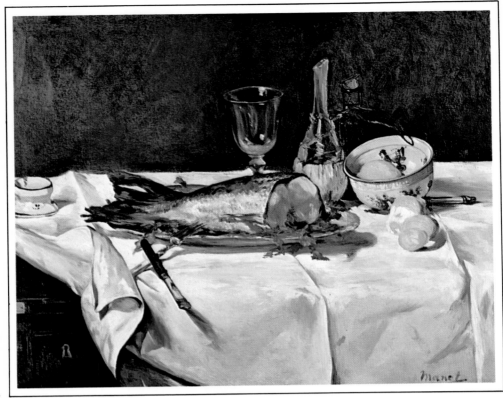

16.

Manet, Edouard (1832 – 1883)

LE SAUMON

Fig. 16

H. 29″; w. 37″ 1869
oil on canvas
signed, l.r.: "Manet"
Exhibited: Exposition posthume, 1884, no. 50
 Durand-Ruel Galleries, loan exhibition, Manet, 1913
 Durand-Ruel Galleries, "French Masterpieces of the
 Late XIX Century", 1928
 Palais du Louvre, Manet Exhibition, May-October
 1932
 Pennsylvania Museum of Art, Manet-Renoir Exhibit,
 November 11-December 11, 1933
 Metropolitan Museum of Art, summer, 1961
 Knoedler Galleries, March 29-April 23, 1967
 Metropolitan Museum of Art, December 13,
 1974-February 13, 1975.
(cat. #27.1.3-24)

Born in 1832, Edouard Manet was the son of Au-
guste Manet, chief of personnel in the French Minis-
try of Justice, and Eugénie Désiree Fournier. After
serving an apprenticeship aboard a transport ship
for two years beginning in 1848, Manet entered the
studio of Thomas Couture where he was to remain
for six years. Several of his early paintings were
accepted by the Salon, and he received an honora-
ble mention in 1861, however in 1863 three of his
paintings were rejected. One, DEJEUNER SUR
L'HERBE (today recognized as one of the turning
points in the history of modern art) was, while on
display at the Salon des Refusés, the object of con-
siderable derision and harsh criticism for its stark
realism. That autumn he painted OLYMPIA which
became the object of even greater scorn. In 1867
Manet erected his own pavilion at the Paris World
Fair in which he exhibited many of his paintings.
Two years later he painted this still-life, the same
year in which both DEJEUNER SUR L'HERBE
and THE BALCONY were finally accepted at the
Salon.

BLUE VENICE

Fig. 18

H. 23⅛″; w. 28⅛″ 1874 – 1875
oil on canvas
signed, right, on post: "Manet"
Exhibited: Exposition posthume, 1884, no. 79
 Durand-Ruel Galleries, loan exhibition, Manet, 1913,
 no. 15
 Palais du Louvre, Manet Exhibition, May to October,
 1932
 Metropolitan Museum of Art, summer, 1961
 Knoedler Galleries, March 29-April 23, 1967
(cat. #27.1.5-30)

Mary Cassatt said of Manet that "he had been a long
time in Venice. I believe he spent the winter there,
and he was thoroughly discouraged and depressed
at his inability to paint anything to his satisfaction.
He had just decided to give it up and return home to
Paris. On his last afternoon in Venice he took a fairly
small canvas and went out on the Grand Canal just
to make a sketch to recall his visit; he told me he
was so pleased with the results of his afternoon's
work that he decided to remain over a day and finish
it."[1] This painting is the result.

[1] Quoted in Louisine W. Havemeyer, *Sixteen to Sixty, Memoirs of
A Collector* (Privately printed for the family of Mrs. H. O. Have-
meyer and the Metropolitan Museum of Art, 1961), p. 226.

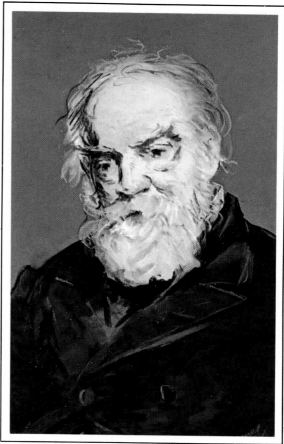

Manet

PORTRAIT OF CONSTANTIN GUYS

Fig. 17

H. 21¼″; w. 13⅜″ 1877 – 79
pastel on paper
signed, l.r.: "Manet 187 ?"
Exhibited: Exposition, Vie Moderne, 1880, no. 14
Exposition posthume, 1884, no. 159
Exposition universalle, 1889
Metropolitan Museum of Art, summer, 1961
Knoedler Galleries, March 29-April 23, 1967
(cat. #27.3.1-35)

This bust portrait is of the caricaturist Constantin Guys, a man who produced many drawings in pen, pencil, and brush during his life time. Manet, a close friend, owned a number of his works. About the time he did this pastel, Manet began suffering from ataxic paralysis which was to cripple and ultimately kill him. In 1881 he received the Chevalier de la Légion d'Honneur and died on April 30, 1883, ten days after the amputation of his left leg.

17.

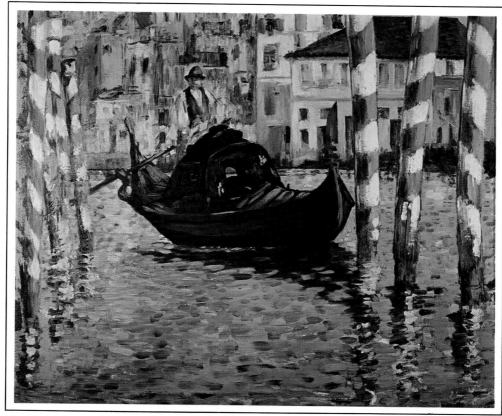

18.

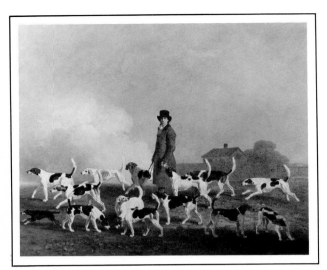

19.

Martin, Anson A. (active 1840 – 1861)

CHRISTOPHER HALTON ON "BLACK DIAMOND"

Fig. 20

H. 26¼"; w. 36¾" 1840
oil on canvas
signed, l.r.: "A. A. Martin"
Gift of: The Webb Estate, 1961
(cat. #27.1.5-41)

A painter of coaching and hunting scenes, Anson Martin was well known in mid-nineteenth century England. One coaching piece bearing the signatures of both Martin and Charles Cooper Henderson (p. 11) gives evidence of collaboration between the two artists. Several engravings of Martin's paintings are known, including THE BEDAH HUNT published by W. H. Simmons in 1842 and JOCKEYS IN THE NORTH AND SOUTH OF ENGLAND, a pair of colored lithographs by G. Black.

Marshall, Ben (1767 – 1835)

HUNTSMAN ON FOOT AND HOUNDS

Fig. 19

H. 42"; w. 51" 1802
oil on canvas
signed, l.l.: "B. Marshall £ ² ⁺ 1802"
Exhibited: Metropolitan Museum of Art, summer, 1961
 Knoedler Galleries, March 29-April 23, 1967
(cat. #27.1.5-29)

Born in Leicester, England, Ben Marshall was first trained as a portraitist by F. L. Abbott. After viewing a painting entitled THE DEATH OF A FOX by Saurey Gilpin at the Royal Academy in 1793, Marshall became interested in painting animals, particularly horses and dogs. While living in Marylebone, he developed his skill to the point that his animal portraits were soon much in demand. He became a close friend of the engraver John Scott who transposed Marshall's paintings into prints for *Sporting Magazine* between 1796 and 1822. Moving to London, Marshall occasionally exhibited at the Royal Academy. Later he moved to Newcastle where he received commissions from such prominent clients as George III, George IV, and various Earls and Lords. Eight engravings of his paintings appeared in *Sportsman's Repository,* published in 1820, and sixty of them appeared in *Sporting Magazine.* In 1825 Marshall retired to London where he died ten years later. One son, Lambert, also became a painter.

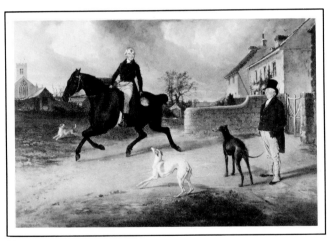

20.

Monet, Claude (1840 – 1926)

THE DRAWBRIDGE

Fig. 21

H. 21"; w. 25"
oil on canvas
signed, l.r.: "Claude Monet"
Exhibited: Metropolitan Museum of Art, summer, 1961
 Knoedler Galleries, March 29-April 23, 1967
 Metropolitan Museum of Art, December 13, 1974-February 16, 1975.
(cat. #27.1.2-109)

Born in 1840 in Paris, Claude Monet had moved with his family to Le Havre by 1845. As a child he loved the out-of-doors and was constantly drawing, particularly doing caricatures. In 1858 he was to meet Eugene Boudin, an artist who first introduced him to landscape painting and stressed the importance of painting out-of-doors. The following year Monet went to Paris where he entered the Académie Suisse. Serving in the Chasseurs d'Afrique in Algeria for two years between 1860 and 1862, Monet returned to Paris because of illness and shortly thereafter entered Gleyre's studio. There he was to meet Bazille, Renoir and Sisley. From this time on Monet was to spend the rest of his life painting landscapes, continually studying the effects of light on color. Spending summers in Saint-Michel, Le Havre, and Argenteuil and winters in Paris, Monet also travelled — to England in 1870 and Holland in 1871. This painting of a drawbridge was done in Amsterdam. (It is believed to have been the first Monet painting to have come to America).

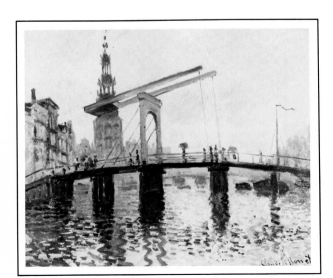

21.

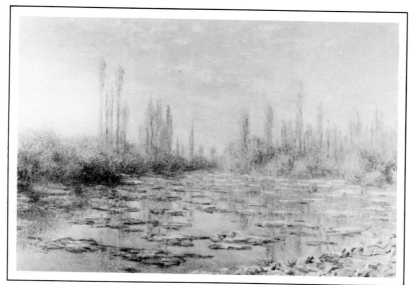

22.

Monet

THE FLOATING ICE

Fig. 22

H. 38¼"; w. 58¼" 1880
oil on canvas
signed, l.r.: "Claude Monet 1880"
Exhibited: Metropolitan Museum of Art, summer, 1961
 Knoedler Galleries, March 29-April 23, 1967
(cat. #27.1.2-108)

Impoverished but eager for recognition, Monet and his confrères Pissaro, Cezanne, Renoir, Sisley, Guillaumin, Degas, and Morisot set up on exhibition in April of 1874 in Nadar's photography studio on the rue des Capucines where Monet was to exhibit a painting entitled "Impression, Sunrise". The journalist Leroy wrote of this painting in *Le Charivari* on April 25, "Impression, I might have guessed as much. I was thinking that since I am so impressed, there must have been some impression in that picture."[1] The word "impressionist" stuck, although it soon lost its derisive connotation. Struggling against poverty, Monet continued painting, primarily in or near Paris. This painting and several others of ice breaking up on the Seine were painted during the winter of 1879 and 1880. It was refused by the Salon in 1880. Monet's brushwork shows an increasing tendency to break into dots of color.

[1] Jean Leymarie, *Impressionism* (New York: Skira, n.d.), p. 26.

LANDSCAPE — HAYSTACKS IN THE SNOW

Fig. 23

H. 23"; w. 39" early 1891
oil on canvas
signed, l.l.: "Claude Monet 91"
Exhibited: Metropolitan Museum of Art, summer, 1961
 Knoedler Galleries, March 29-April 23, 1967
(cat. #27.1.2-106)

Between 1890 and 1891 Monet began two series of paintings of poplars and haystacks. Going out each day with an armload of canvases, he would work on each one successively as the light changed. On October 7, 1890 he wrote to Gustave Geffroy:

I'm plugging away, toiling doggedly at a series of different effects (on haystacks) but at this time of year the sun goes down so fast that I can't keep up with it. I'm becoming so slow in my ways it's maddening. But the further I go, the more I realize the amount of work involved in rendering what I'm after: the 'instantaneousness', the envelope of things, with the same light pouring in everywhere. More than ever, easy canvases tossed off at one go get my back up.[1]

[1] Denis Rouart, *Claude Monet* (Skira, 1958), p. 86. Some thirty of these paintings, done at different times of day, exist. Fifteen of the haystack series were exhibited at Durand-Ruel's gallery in May of 1891 and were an instantaneous success.

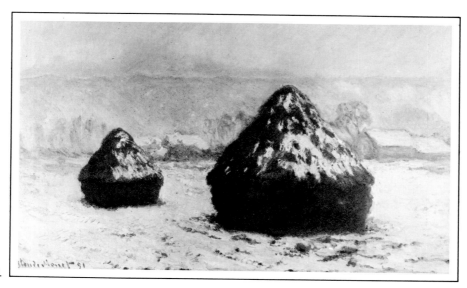

23.

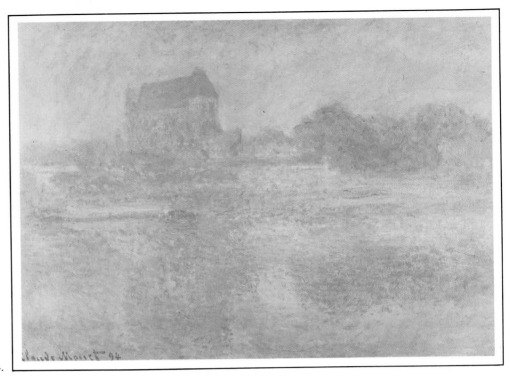

24.

Monet

OLD CHURCH AT VERNON

Fig. 24

H. 25½"; w. 35½" 1894
oil on canvas
signed, l.l.: "Claude Monet 94"
Exhibited: Metropolitan Museum of Art, summer, 1961
 Knoedler Galleries, March 29-April 23, 1967
(cat. #27.1.2-107)

THE THAMES AT CHARING CROSS BRIDGE

Fig. 25

H. 25"; w. 35⅜" 1899
oil on canvas
signed, l.l.: "Claude Monet 99"
Exhibited: Metropolitan Museum of Art, summer, 1961
 Knoedler Gallery, March 29-April 23, 1967
(cat. #27.1.4-70)

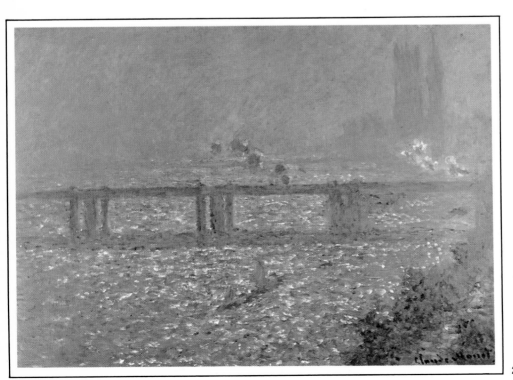

25.

Monet continued to paint and travel, visiting Norway in 1895, London in 1901, Madrid in 1904, and Venice in 1909. In the late 1890's, despite failing eyesight, Monet began work on the water lily series in which light itself became the real subject, anticipating abstract expressionism by about thirty years. Following a double cataract operation in 1922, Monet continued painting until his death in 1926.

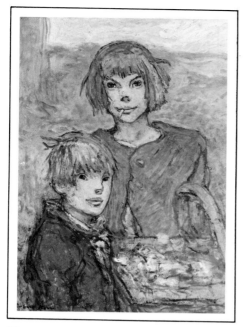

26.

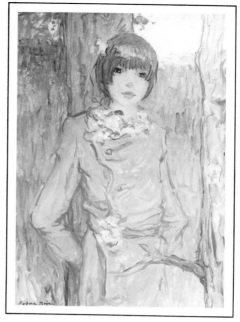

27.

Noir, Robert

PORTRAIT OF TWO CHILDREN

Fig. 26

H. 25″; w. 19″
signed, l.l.: "Robert Noir"
Exhibited: Metropolitan Museum of Art, summer, 1961
 Knoedler Galleries, March 29-April 23, 1966
(cat. #27.1.1-155)

PORTRAIT OF A GIRL

Fig. 27

H. 25″; w. 19″
signed, l.l.: "Robert Noir"
Exhibited: Metropolitan Museum of Art, summer, 1961
 Knoedler Galleries, March 29-April 23, 1966
(cat. #27.1.1-156)

The melancholy painter Robert Noir was a nephew of the journalist Victor Noir who was killed in a duel with Prince Pierre Bonaparte in 1870. Robert was made custodian of his uncle's skull in a bizarre request in Victor's will. Noir, a struggling painter, attained some recognition, including an honorable mention in 1903 from the Salon des Artistes Français. Chronically depressed, a month before his own death, Robert asked friends to help him put the skull with his uncle's body in a vault at Père la Chaise. Shortly thereafter he committed suicide in the Bois de Boulonge.

Reinagle, Philip (1749 – 1833)

COURSING THE FOX

Fig. 28

H. 27″; w. 35″
oil on canvas
signed, "P. Reinagle, R.A."
Gift of: The Webb Estate, 1961
(cat. # 27.1.5-40)

A pupil of the English court painter, Allan Ramsey, Philip Reinagle later became Ramsey's assistant. A portraitist, Reinagle painted King George III and Queen Charlotte many times. After the age of thirty-four, Reinagle turned to landscape and sporting scenes, strongly influenced by the Dutch animal painters. Some of his dog paintings appeared in *The Sportsman's Cabinet* in 1803. He also did hunting and hawking scenes, bird paintings, copied old masters, and painted landscapes of England, Italy and Spain. Elected an associate of the British Royal Academy in 1787, Reinagle became an Academician in 1812. He died in Chelsea in 1833 at the age of eighty-four. His son, Richard Ramsey Reinagle, was also a painter.

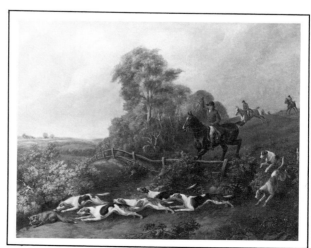

28.

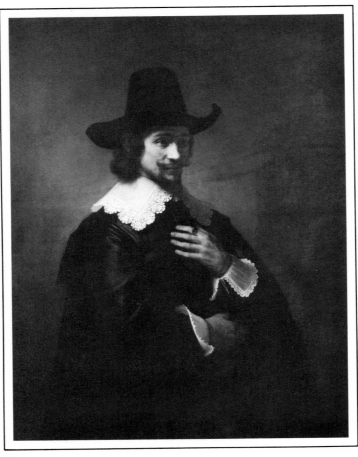

29.

Rembrandt Harmensz. van Rijn (1606 – 1669)

PORTRAIT OF A MAN — THE TREASURER

PORTRAIT OF A YOUNG MAN IN A BROAD-BRIMMED HAT

Fig. 2

H. 44"; w. 36" 1632
oil on canvas
signed, l.r.: "H. Van Ryn 1632"
Exhibited: Metropolitan Museum of Art, summer, 1961
 Knoedler Galleries, March 29-April 23, 1967
(cat. #27.1.1-151)

Painted in 1634, this portrait called THE TREASURER was done while Rembrandt was attaining a peak of success. His move from Leyden to Amsterdam in 1631 had proved profitable in every respect — he had married Saskia Van Uylenburgh in June of 1634 and was the most sought-after artist in the city. Amsterdam's citizens placed a high value on portraiture and wished to be portrayed as worthy and respectable. Invariably dressed in black and grey with white ruffs or collars, these people were not painted in an idealized manner but as the sober and hard-working men and women they were. Rembrandt accepted this tradition and in this portrait has focused attention on details of the Treasurer's clothing while painting his features in a smooth and straightforward manner. Already, however, Rembrandt has moved beyond traditional portraiture in his handling of light. "Just black, grey, and white, neither more nor less, but the tonality is peerless. The atmosphere is invisible, yet one can feel the air."[1]

Fig. 29

H. 45⅞"; w. 36" 1643
oil on canvas
signed, l.r.: "Rembrandt F. 1643"
Exhibited: Corps legislatif, Paris, 1874
 University Tsrensntsnary of Amsterdam, April-November, 1932
 Metropolitan Museum of Art, summer, 1961
 Knoedler Galleries, March 29-April 23, 1967
(cat. #27.1.1-150)

Nine years after painting THE TREASURER, Rembrandt did this portrait of a MAN IN A BROAD-BRIMMED HAT. With Saskia's illness and death in June of 1642 and dwindling commissions, his life in these years had become increasingly difficult. THE NIGHT WATCH, completed the previous year had met a somewhat disappointing reception. Increasingly sensitive to the psychology of the inner man, Rembrandt's later portraits assume an air of solemn detachment. Unlike Frans Hals who characterized his sitters in momentary gestures and expressions, Rembrandt painted his clients in attitudes of solemn contemplation. As his tonality had gradually become warmer and softer, his handling of space assumed greater importance, surrounding the sitter in an envelope of brooding silence.

[1] Joseph Emile Muller, *Rembrandt* (New York: Harry N. Abrams, Inc., n.d.), p. 59.

Sartorius, John F. (c. 1775 – c. 1831)

FEMALE GROUSE

H. 14¼"; w. 17½"
oil on canvas
signed, l.r.: "J. F. Sartorius, ???9"
Gift of: Mr. and Mrs. William N. Beach
(cat. # 27.1.5-74)

MALE GROUSE

Fig. 30

H. 14"; w. 17½"
oil on canvas
signed, l.r.: "J. F. Sartorius 1811 (?)
Gift of: Mr. & Mrs. William N. Beach
(cat. #27.1.5-73)

John F. Sartorius, the elder son of John Nost, while not as talented as his father, painted spirited hunting pieces which exhibited a thorough knowledge of country life and its pursuits. His horse portraits and race paintings were occasionally shown at the Royal Academy and between 1805 and 1827 he contributed to *Sporting Magazine*.

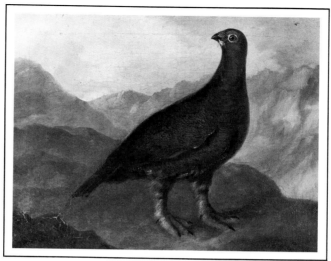

30.

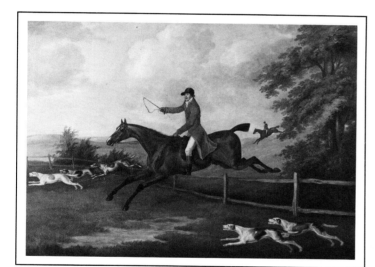

31.

Sartorius, John Nost (1755 or 1759 – 1828)

FOX HUNTING SCENE

Fig. 31

H. 29½"; w. 41" 1814
oil on canvas
signed, l.l.: "J N Sartorius pint 1814"
Gift of: The Webb Estate, 1961
(cat. # 27.1.5-42)

Four generations of the Sartorius family became noted painters of sporting themes. John, Sr., (c. 1700-1780), born in Nuremberg, Germany, was painting horse portraits in England by 1722. His son, Francis (1734-1804), especially recognized for his horse portraits, depicted more winners at the turf than anyone of his time. Francis' son, John Nost, painter of this hunting scene, trained either at the Royal Academy or at Joshua Brookes' Museum and Anatomical School on Blenheim Street in London. A frequent contributor to the Royal Academy, he painted hunting, shooting, and coursing scenes in addition to individual portraits of horses, copies of which often appeared in *Sporting Magazine* between 1795 and 1827.

Stevens, G. (active 1810 – 1865)

SEVEN GROUSE

Fig. 32

H. 27¾"; w. 36"
oil on canvas
on verso (label): "From /ROWLAND WARD
 LTD./NATURALISTS &
 TAXIDERMISTS/166.
 Piccadilly/LONDON, w. 1"
and in pen: "Title: Grouse/Artist: G. Stevens"
Gift of: Mr. and Mrs. William N. Beach
(cat. #27.1.5-76)

This artist is undoubtedly George Stevens, a British still life and animal painter. He exhibited at the Royal Academy between 1810 and 1861, and exhibited 246 works at the Society of British Artists, Suffolk Street. He specialized in paintings of horses and cats.

32.

33.

34.

Thorburn, Archibald (1860 – 1935)

BLACK GAME

Fig. 33

H. 14"; w. 21½" 1928
watercolor on paper
signed, l.l.: "A. Thorburn 1928"
Gift of: Mr. and Mrs. William N. Beach
(cat. #27.2.5-16)

EIGHT SCOTCH GROUSE

H. 21½"; w. 29½" 1911
watercolor on paper
signed, l.l.: "Archibald Thorburn/1911
Gift of: Mr. and Mrs. William N. Beach
(cat. #27.2.5-15)

GROUSE IN FLIGHT

Fig. 34

H. 22"; w. 30¼" 1911
watercolor on paper
signed, l.l.: "A. Thorburn 1911"
(cat. #27.2.5-17)

PAIR OF SCOTCH GROUSE

H. 10¼"; w. 14¼" 1933
watercolor on paper
signed, l.l.: "A. Thorburn/1933
Gift of: Mr. and Mrs. William N. Beach
(cat. #27.2.5-14)

The son of the miniature painter Robert Thorburn, Archibald Thorburn was born in Scotland in 1860. An animal painter and illustrator, Thorburn specialized in the study of game birds, concentrating on their habits, coloration, and structure. Minutely detailed, his paintings reveal his intimate knowledge of bird life. He exhibited at the Royal Academy after 1880 and also at the Society of British Artists, Suffolk Street.

35.

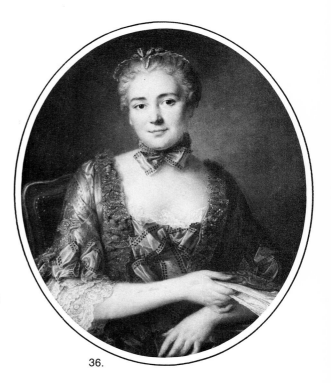

36.

Van Loo, Carle Charles Andre (1705 – 1765)

MADAME LOUISE MIGNOT DENIS (1712 – 1790)

Fig. 36

H. 28⅝"; w. 23¼" c. 1745
oil on canvas
on verso (stretcher): No. 1216, Van Loo/Madame Denis, niece
 de Voltaire, Lateau Dompierre
 d'Horonoy/M.C.K.''
Gift of: The Clara Blum Estate, in memory of Electra Havemeyer
 Webb
(cat. #27.1.1-167)

Married in 1738, Madame Louise Mignon Denis be-
came a widow six years later and went to live with
her uncle, the noted historian, poet, and dramatist,
Voltaire. Plump, lively and intelligent, Madame
Denis was a delightful hostess and companion. An
actress, she also wrote and produced a comedy en-
titled *The Punished Coquette.* Undoubtedly she was
living with Voltaire when Van Loo painted this por-
trait. Two years after Voltaire's death in 1778, she
married a man ten years her junior, a union reported
to have brought her great unhappiness.

Carle Van Loo, a French painter and engraver,
came from a long line of artists originally from Flan-
ders. His father, Louis, his older brother, Jean Bap-
tiste, and his own son, Jules Cesar Denis Van Loo
were all painters. A pupil of his brother, Carle par-
ticipated in many decorative projects, the most im-
portant probably being the restoration of Fontaine-
bleau.

Wardle, Arthur (1864 – 1949)

ON THE MOORS

Fig. 35

H. 19⅜"; w. 30½"
oil on canvas
on verso (tag): "Artist — Arthur Wardle (Exh. R. A. — S. S. 1880-1893)
 Title: "On the Moors"
 Registered Number 24217/20 x 30/-----Fd.''
Gift of: Harry H. Webb, 1964
(cat. #27.1.5-35)

Born in London in 1864, Arthur Wardle painted domestic and wild
animals and sporting subjects in oil, pastel, and watercolor. He
exhibited at the Royal Academy between 1880 and 1935, and
also at the Society of British Artists and the New Watercolor So-
ciety.

37. Johannes Adam Simon Oertel. COUNTRY CONNOISSEURS

AMERICAN ART

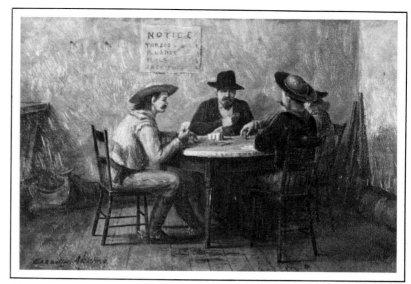

38.

Adams, Cassilly (1843 – 1921)

FIVE CARD STUD

Fig. 38

H. 7½"; w. 11½"
oil on canvas
signed, l.l.: "Cassilly Adams"
Gift of: Mrs. George B. Kolk, 1965
(cat. #27.1.7-27)

The painter is undoubtedly the son of William Althorp
Adams (1797-1878) and Mary Biddle Cassily, who married
in 1842 and moved to Cincinnati. A lawyer, his father even-
tually became a painter and a taxidermist. Cassilly Adams
is known to have painted CUSTER'S LAST STAND[1] and a
small canvas similar to this one entitled PLAYING
CARDS.[2]

[1] *M. and M. Karolik Collection of American Watercolors and Drawings,
1800-1875* (Boston: Museum of Fine Arts, 1962), I, p. 74.
[2] PLAYING CARDS (oil on canvas, 12 × 17¾, collection of Carl Schaefer
Dentzel, Los Angeles) described in Patricia Hills, "The American Frontier —
Images and Myths," Whitney Museum of American Art, June 26-September
16, 1973.

Addison, W. C.

TWIN BAYS — LAKE CHAMPLAIN

H. 12"; w. 23"
oil on canvas
signed, l.l.: "W. C. Addison"
on verso: "Twin Bays on Lake Champlain #11"
(cat. #27.1.4-43)

Found in a home on Loomis Street, Burlington, Vermont,
this painting depicts a scene identical to that in an
anonymous painting, illustrated on p. 172. The location of
Twin Bays is as yet undiscovered.

Attributed to

Akin, Edward (active 1875)

TWO ARCTIC BIRDS ON ICE

Fig. 39

H. 14"; w. 23½" c. 1875
oil on canvas
(cat. #27.1.5-3)

Found in New York state, this small, engaging painting of
two birds floating on a piece of ice, is almost certainly by
the same artist as a painting entitled ARCTIC BIRDS, done
by Edward Akin of New Bedford, Massachusetts in 1875.[1]

[1] Advertisement for Vose Galleries, *Art Gallery,* October, 1968.

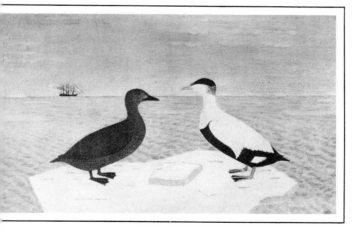

Attributed to

Allen, Sophia Jane

FIRST CATHOLIC CHURCH IN GLOUCESTER,
MASSACHUSETTS

Fig. 40

H. 18¾"; w. 24"
pastel on paper
on verso, tag on stretcher: "Attributed to Sophia Jane Allen, age 11 yrs.
 Gloucester Mass. First Catholic Church in
 Town."

(cat. #27.3.2-7)

This large church, high on a hillside, is, according to the
description on the reverse, located in Gloucester, Mas-
sachusetts; however inquiries in Gloucester have revealed
no information as to its name or location.

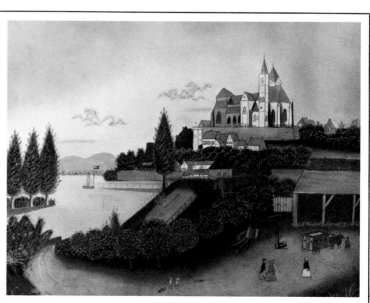

40.

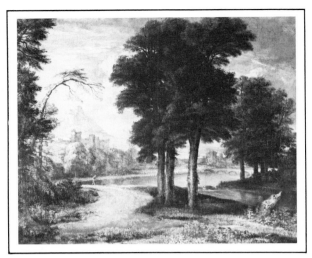

41.

Ames, Ezra (1768 – 1836)

SARAH ANN TOMPKINS (1805 – 1845)

Fig. 42

H. 31½″; w. 25″ 1809
oil on canvas
Exhibited: Downtown Gallery, October, 1942
The Dallas Art Museum, October, 1946
Wichita, Kansas Art Museum, October, 1947
Milwaukee Art Institute, January, 1951
(cat. #27.1.1-12)

Sarah Ann Tompkins was the daughter of Daniel D. Tompkins (1774 – 1825), the fourth Governor of New York state from 1807 to 1817, and Vice President of the United States under James Monroe from 1817 to 1825. Wearing the same dress, Sarah is also included in Ames' painting THE CHILDREN OF DANIEL D. TOMPKINS, 1809, now at the Staten Island Institute of Arts and Sciences. Ames was born in Framingham, Massachusetts, started painting in Worcester, Massachusetts between 1790 and 1793, and eventually settled in Albany, New York. He worked as a carriage painter, miniaturist, engraver, and decorator and painted over 450 portraits of New York's governors, legislators, and aristocracy.

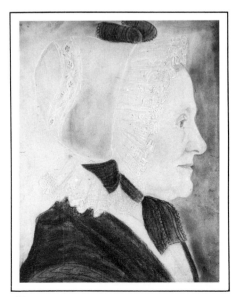

43.

Allston, Washington (1779 – 1843)

MORNING IN ITALY: CLASSICAL LANDSCAPE Fig. 41

H. 17¼″; w. 21″ c. 1817
oil on canvas
signed, l.l.: "W. Allston"
Exhibited: London, 1817·
(cat. #27.1.2-83)

Born in Georgetown, South Carolina, the romantic painter Washington Allston graduated from Harvard College in 1800 and went to Europe to study art until 1808. After a three year stay in Boston, Allston returned to England in 1811 where he remained until 1818. A friend of Samuel Taylor Coleridge, William Wordsworth, Richard Henry Dana and brother-in-law of William Ellery Channing, Allston was very much attuned to the literature of his time, writing poetry and novels himself. This painting illustrates the strong influence which the Venetian painters Veronese, Titian, and Tintoretto inspired in Allston after he became reacquainted with their richly colored works at the Louvre during a six week trip to Paris in 1817. It is undoubtedly the painting exhibited in London in 1817 under the title MORNING IN ITALY, and included as #93 in Edgar P. Richardson's catalogue of Allston works.[1]

[1] H. P. Richardson, *Washington Allston, A Study of the Romantic Artist in America* (New York, 1948), p. 198.

Attributed to

Allston, Washington

FINDING OF MOSES

H. 28¼″; w. 36″
oil on canvas
(cat. #27.1.5-17)

While there has been some question about attributing this unsigned painting to Allston, the handling of the figures and foliage is quite consistent with Allston's early style (1804 – 1812).[1]

Compare with THE ANGEL RELEASING ST. PETER FROM PRISON, 1812, plate XXVII, #71; DIDO AND ANNA, Plate XVI, #45; and REBECCA AT THE WELL, Plate XXXIV, #92. *Ibid.*

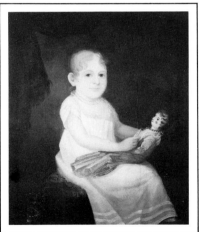

42.

Mr. Anderson (active 1807)

GRANDMOTHER BOYER Fig. 43

H. 13⁵/₁₆″; w. 10½″ 1836 or 1837
pastel on paper
Inscribed (in pencil at bottom): "Grandmother Boyer — drawn by Mr. Anderson at 'Fairplay', W. Va. in 1836 or 37."

(cat. #27.3.1-4)

Mr. Anderson may be the J. B. Anderson that *The Dictionary of Artists in America* lists as a profilist in Richmond, Virginia in 1807.[1]

George C. Groce and David H. Wallace, *The New York Historical Society's Dictionary of Artists in America, 1564-1860* (New Haven and London, 1957), p. 8.

Arnold, Edward (c. 1826–1866)

PADDLE STEAMBOAT *CAMELIA* Fig. 44

H. 30″; w. 40″ 1866
oil on canvas
signed, l.l.: "E. Arnold 1866 pinxit/N. Orleans"
Gift of: Mr. and Mrs. Dunbar W. Bostwick, 1954
(cat. #27.1.4-22)

According to Groce and Wallace, an Edward Arnold from New Orleans worked as a landscape, historical, marine and sign painter in the 1850's and 1860's. He also worked with a J. B. Evans.[1] Originally the paddle-wheel vessel ZEPHYR of 123 tons, built in Wilmington, Delaware in 1852, and sold to the Quartermaster Corps during the Civil War, the steamboat was renamed CAMELIA after being sold out at the close of the war. There is no trace of her beyond 1866.[2]

[1] *Ibid.*, 13.
[2] Information from Harry Shaw Newman, The Old Print Shop, New York City, 1954.

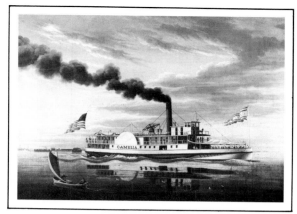

44.

Attributed to

Audubon, John Woodhouse (1812 – 1862)

BOATING ON THE HUDSON

H. 28″; w. 40″ c. 1850
oil on canvas
signed, l.l.: JA
(cat. #27.1.2-39)

RIVERBANK PICNIC

Fig. 45

H. 28″; w. 40″ c. 1850
oil on canvas
signed, l.c.: JA
(cat. #27.1.2-40)

Though the evidence is not definitive, the previous owner assumed the artist of these two paintings to be John Woodhouse Audubon, younger son of John James Audubon. Along with his brother Victor, John was trained by his father, and both sons helped to produce the famous BIRDS OF AMERICA engravings from their father's paintings. Both of the paintings listed above are apparently Hudson River scenes. Residing in New York City after 1838, John took extended trips to Texas (1845-46), England (1846-47), and (with the forty-niners) to California in 1849.

45.

Babbitt, Abbie Maria Stevens (active 1850 – 1898)

CAMEL'S HUMP FROM UNDERHILL, VERMONT

H. 14½″; w. 20¼″ c. 1850
oil on canvas
on verso: "The Camel's Hump, Green Mts. Vermont."
Gift of: Mrs. Helen S. Griggs, daughter of the artist, 1958.
(cat. #27.1.2-18)

LAKE TAHOE, NEVADA Fig. 46

H. 16″; w. 30″ c. 1850
oil on canvas
Gift of: Mrs. Helen S. Griggs, daughter of the artist, 1958.
(cat. #27.1.2-19)

Abbie Stevens Babbitt was born in Greensboro, Vermont. Her parents moved to Baltimore, Maryland and later to Williamsport, Pennsylvania; in both cities Maria taught school. She was married October 5, 1877 in Williamsport and moved to St. Johnsbury, Vermont later that year. She died in Montpelier, Vermont in 1898.[1]

Letter from donor, Mrs. Helen S. Griggs (daughter of artist), Shelburne Museum files, August 17, 1961.

46.

Bacon, Henry (1839 – 1912)

THE QUILTING BEE Fig. 47

H. 7¼″; w. 11½″ 1872
oil on wood
signed, l.l.: "H. Bacon 1872"
(cat. #27.1.7-7)

A Haverhill, Massachusetts native, Henry Bacon served as a field artist for *Leslie's Weekly* during the Civil War. Disabled by war injuries, he went to Europe in 1864 to study painting and remained in Paris for most of the remainder of his life, although he continued to send canvases back to the United States for exhibitions. He forwarded this small oil sketch to America in 1872, accompanied by a letter[1] describing the large, finished version of this painting now in the collection of Jo Ann and Julian Ganz.[2] Their painting is much more polished than this sketch and contains several additional details — it extends further to the right to include another painting and a chair with a bonnet on it, and on the back wall hang two sconces on either side of the central picture.

[1] Henry Bacon to Mr. S. P. Avery, Paris, January 19, 1872, quoted in *Panorama*, I, no. 8, May, 1946, p. 95.
[2] From the catalogue *American Paintings, Watercolors and Drawings from the Collection of Jo Ann and Julian Ganz, Jr.* The Santa Barbara Museum of Art, Santa Barbara, California, June 23-July 22, 1973.

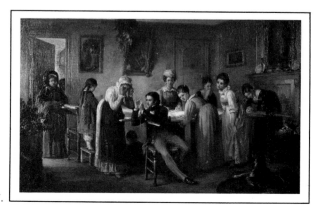

47.

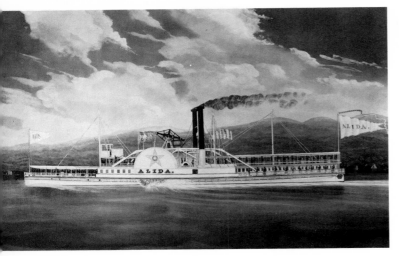

48.

Bard, James (1815 – 1897)

PADDLE STEAMBOAT *BOSTON* (1850 – 1864)

H. 30"; 54¼" March, 1850
oil on canvas
signed, l.r.: "Drawn and painted by James Bard N.Y./March 1850"
(cat. #27.1.4-12)

Built in 1850 by William H. Brown in New York, the BOSTON, commanded by Capt. Thomas B. Sanford, (brother of her owner Menemon Sanford) went into service on the Boston to Bangor route. Weighing 630 tons, the BOSTON was 225' × 28' × 10'6", and had a copper surface over her exceptionally sturdily built hull. She had a gentleman's cabin with 157 berths, a ladies' cabin with forty-two berths, and twenty staterooms. Offered to the Government for war service in 1863, the BOSTON went ashore near Hilton, South Carolina in May of 1864, and was burned to prevent her falling into Confederate hands.

PADDLE STEAMBOAT *ARMENIA*

Fig. 114

H. 27¼"; w. 49" pre-1856 (has 1 stack)
oil on canvas
signed, l.r.: "Bard"
(cat. #27.1.4-9)

The ARMENIA was a wooden hulled, American side-wheel steamboat built at New York for the New York and Peekskill route by Thomas Collyer in 1847 and commanded first by Capt. John F. Tallman and later by Isaac P. Smith of Nyack. She was 181'0" × 27'6" × 8'4" and weighed 398 tons. Her steam engine, built by Henry R. Dunham and Co., N.Y., had one stack and one iron boiler in the hold, but in 1856 another boiler and stack were added. She was placed into day service between New York and Albany, continuing this route until the railroad to Albany was completed. Lengthened to 212' in 1861, she was given a new 40" cylinder, and her stacks were placed fore and aft. She became a towing steamer in the fleet of the Hudson River Steamboat Co. before being sold in 1863 to Commodore Van Santvoord of the Day Line where she served until 1883.[1] Later she was sold to Henry Bros. Co. of Baltimore for service on the Potomac, and burned while laid up in winter quarters at Alexandria, Virginia on January 5, 1886.

[1] Information from Harry Shaw Newman, The Old Print Shop, about 1956 from "Mr. Alfred Van Santvoord Olcott's notebook," New York Historical Society; Dayton, *op. cit.*, p. 60; and Donald C. Ringwald, *Hudson River Day Line, The Story of a Great American Steamboat Co.* (Howell-North Books: Berkeley, Calif., 1965), pp. 15-16.

Bard, John and James
(1815 – 1856) (1815 – 1897)

PADDLE STEAMBOAT *ALIDA* (1847 – 1880) Fig. 48

H. 29"; w. 49" 1847
oil on canvas
signed, l.r.: "J & J Bard"
(cat. #27.1.4-4)

The twin Bard brothers spent their childhood in a house overlooking the Hudson River between West 20th and 21st Street, New York City, where they became familiar with and made drawings of almost every steamer regularly using the port of New York. Their intimacy with most of the ship builders and owners enabled them to make exact measurements of each section of the craft they were depicting. They always drew the vessel in profile, and frequently added stiff, wooden figures t indicate scale. James Bard maintained their studio at 162 Perry Street after the death of John in 1856. James died in White Plains in 1897.

The ALIDA is the only work in Shelburne's collection which both brothers painted. Weighing 640 tons, she was launched on January 9, 1847 by William H. Brown, and measured 265' long overall (lengthened at a later date to 276'), 28'6" wide and 9'9" at the depth of her hold. Her vertical beam engine was built by Henry R. Dunham & Co., New York with a cylinder 56" in diameter and a 12' stroke. A day boat between N.Y. and Albany, in 1849 the ALIDA ran from Caldwells, New York to Pier No. 1, North River, a distance of 43¼ miles, in a record 1 hour, forty-two minutes at ebb tide.

Purchased by Commodore Van Santvoord in November, 1855, she worked the Hudson River Day Line with ARMENIA, afterwards being c down into a towboat. In 1869 she was sold to Robinson, Betts and Leonard, and in 1873 to Thomas Cornell, after which she was laid up a Port Ewen and broken up in the summer of 1880.[1] Five paintings of th ALIDA by the Bards are known — this one; one painted in 1848; one done after she was lengthened, painted in 1856; one painted after he conversion to a towboat done in 1873; and a tracing.[2]

[1] Carl D. Lane, *American Paddle Steamboats* (New York: Coward-McCann, Inc., 1943), 76; and Fred Erving Dayton, *Steamboat Days* (New York: Tudor Publishing Co., 1939), p. 64, 65.
[2] Ref: Harold S. Sniffen and Alexander Crosby Brown, *James and John Bard, Painters o Steamboat Portraits* (Mariner's Museum, Newport News, Virginia, 1949.) p. 24.

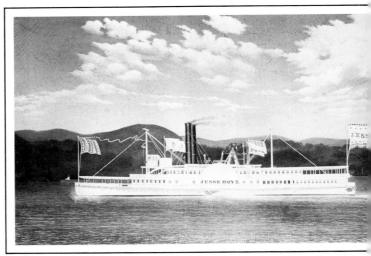

49.

PADDLE STEAMBOAT *NELLIE BAKER*

H. 31"; w. 53" 1854
oil on canvas
On verso (label): "Paddle Steamer Nellie Baker/Built at Greenpoint, N.Y. in 1854/330 Tons. Home Port Boston. She ran/from Nahant to Boston."
(cat. #27.1.4-76)

The NELLIE BAKER was named for the daughter of Mayor Baker of Lynn, Massachusetts, the President of the Nahant Steamboat Company. Built by Samuel Sneden in 1854, she weighed 303 tons, measured 153' × 26' × 8.6', and had an engine with a cylinder 32" in diameter and a 10' stroke. During the Civil War she served as a hospital ship and transport, and was bought by Grey Brothers from the Government in 1866.

Bard, James

PADDLE STEAMBOAT *NANTASKET* (1857 – 1924)

H. 30"; w. 52½" 1857
oil on canvas
signed, l.r.: "Picture, Drawn & Painted BY, James Bard, N.Y. 162 Perry St. 1857"
Inscribed, bottom: "Built by Thomas Collyer, for the Boston & Hingham, Steamboat
Company, Superintended by Cap^n Alfred G. Rouell."
On verso, stencil, l.r.: "S. N. DODGES/ARTIST & PAINTERS./SUPPLY STORE/189
CHATHAM cor/of Oliver St.,/N. York"

(cat. #27.1.4-7)

The NANTASKET was launched March 11th, 1857 for Boston's harbor service. Sold to the U.S. Government during the Civil War, she was later resold and named EMELINE. She returned to Boston briefly, later plied the Hudson, and 1924, turned over on her side at Haverstraw and was never raised. Her smallest dimensions are listed as 146' × 25'4" × 2", weighing 285 tons. About 1886, she was apparently rebuilt, her dimensions increased to 162.5' × 25.8' × 8.1', weighing 383 tons.

PADDLE STEAMBOAT *JESSE HOYT* (1862 – 1889 or 1890)

Fig. 49

H. 30"; w. 50" 1862
oil on canvas
Signed, l.r.: "Picture Drawn and Painted by James Bard/162 Perry St., NY 1862"
Inscribed, bottom: "C. TERRY — BOAT BUILDER. N. J. MESSR FLETCHER —
HARRISON & CO. ENGINE BUILDERS — N.Y. JOHN E.
BROWN JOINER — NY. STEPHEN ROGERS PAINTER NY."
(cat. #27.1.4-13)

The JESSE HOYT of 487 tons, built in 1862 by Benjamin C. Terry at Keyport, New Jersey, was named after the superintendent of light houses at the highlands of Navesink; Sandy Hook; and Prince's Bay, Staten Island, who later became the U.S. Custom's collector at the Port of New York. First employed on the Albany to Newburgh run, the JESSE HOYT was soon sold to the Long Island North Shore Passenger and Freight Transportation Co. commuting between lower Manhattan and Glencove, Long Island. In 1863 she was purchased by the Alliance Steamboat Company, running from Port Monmouth to New York until 1870. Thereafter she went through a succession of owners — the Raritan and Delaware Bay Railroad Company, the Narragansett Steamboat Company, the New Jersey Southern Railroad, the Narragansett Steamship Company, running between New York and Sandy Hook on weekdays, and between New York and Poughkeepsie on Sundays. In January of 1873 a schooner hit the JESSE HOYT on her return trip from Sandy Hook and tore away her side. Lengthened by 22½ feet in 1876, she was replaced by the MONMOUTH in 1888, and in 1890 she was converted to a barge.[1]

[1] Erik Heyl, *Early American Steamers* (Buffalo: Erik Heyl, 1967), V. V, pp. 153-155.

PADDLE STEAMBOAT CITY OF CATSKILL

H. 25⁷/₁₆"; w. 50⅜" 1882
Gouache
Signed l.r.: "J Bard NY 1882"
(cat. #27.2.4-6)

A wooden paddle steamboat built in 1880 by Van Loan and Magee at Athens, New York, the CITY OF CATSKILL's dimensions were 250' × 35'8" × 10'9". She carried a vertical beam engine built by W. and A. Fletcher, with a cylinder 56" in diameter, and a stroke of 12'. First placed in service between New York and Catskill in March, 1882, she burned at her dock in Rondout, February 11, 1883 while under charter to run between Rondout and New York.[1]

[1] Fred Waring Dayton, *Steamboat Days*, (N.Y. Tudor Publishing Co. 1939), p. 79.

PADDLE STEAMBOAT *METAMORA* (1846 – c. 1900)

H. 34"; w. 54" 1859
oil on canvas
signed, l.r.: "Picture Drawn & Painted. By James Bard. 162 Perry St. NY. 1859"
Inscribed, bottom: "STEAMBOAT. METAMORA OF. NEW YORK. AND ALBANY
STEAMBOAT PASSENGER LINE JOHN F. TALLMAN
COMMANDER."

(cat. #27.1.4-2)

The American wooden paddlewheel steamer METAMORA was built in 1846 by Lawrence and Sneden at New York, measuring 165' × 28' × 8'. Her vertical beam engine was built by Pease and Murphy with a 40" cylinder and 19' stroke. She had no cabin on her second deck, but later a saloon was added. In 1846 she served as an independent day boat on the Albany run, in 1847 joining the Citizens New Line on that run. Later she ran to other points on the river, and from 1858 to 1865, returned to the Albany run, after which she was employed in the excursion trade in Baltimore. In 1870 she made daily trips between New York and Rockaway Beach, and a few years later ran from the East River to Coney Island. Converted to a towboat about 1900, she was employed on the Upper Hudson, operated by Blanchard and Farnham,[1] until 1900. METAMORE or "The Last of the Wampanoags" was a melodrama about the death of King Philip, in which the actor Edwin Forrest "made strong men weep for almost forty years."[2] The figures on the flags and paddle box show a standing Indian with a bow and arrow representing Edwin Forrest as Metamora.[3]

[1] Fred Erving Dayton, *Steamboat Days* (Tudor Publishing Co., N.Y. 1939), p. 72.
[2] *American Heritage,* August, 1961, p. 47.
[3] Sniffen and Brown list two Bard oils of the METAMORA; one undated, the other 1855, plus a tracing of the boat, *op. cit.,* p. 28.

PADDLE STEAMBOAT *KAATERSKILL* Fig. 50

H. 26¹³/₁₆"; w. 49¹/₁₆" 1882
Gouache
signed, l.r.: "J BARD NY 1882"
(cat. #27.2.4-1)

The Hudson River steamboat KAATERSKILL of the Catskill Evening Line was built by Van Loan & Magee in Athens, New York, in 1882, weighing 1,361 tons. 270'2" long × 38' wide × 9'8" depth of hold, her engine, built by W. A. Fletcher Company, had a 63" diameter cylinder with a 12' stroke. While in service only a month in August, 1882, near Stony Point, the strap on her walking beam broke, causing the main steam pipe to break. Several persons were scalded, and one died from inhaling the steam. Replaced by the CLERMONT, she was placed on the Albany run. Under Captain Ru Ton, the KAATERSKILL ran with ONTEORA and CITY OF HUDSON in 1914, and was eventually dismantled at New London[1], c. 1915.

[1] Dayton *op. cit.* pp. 79 & 84.

50.

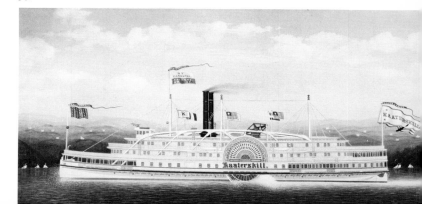

Attributed to

Bascom, Ruth Henshaw Miles (1772 – 1848)

BLOND CHILD OF THE WENTWORTH FAMILY Fig. 51

H. 14⁹/₁₆"; w. 10⁹/₁₆" early 19th century
pastel on paper
(cat. #27.3.1-5)

BRUNETTE CHILD OF THE WENTWORTH FAMILY

H. 14⁹/₁₆"; w. 10⁹/₁₆" early 19th century
pastel on paper
(cat. #27.3.1-6)

These two charming profiles of young children, found in Portsmouth, New Hampshire, are typical of the work of Ruth Henshaw Miles Bascom, born in Leicester, Massachusetts in December, 1772. The daughter of Col. William Henshaw, she was married twice — in 1804 to Dr. Asa Miles, a Dartmouth professor, and after his death two years later, to Rev. Ezekiel Lysander Bascom. She lived in Deerfield, Fitzwilliam, and Gill, Massachusetts, and died in Ashby in 1848. A woman of many talents, she was a skilled needleworker, and according to her diaries[1], began doing these profile portraits at the age of forty-seven. Presumably they were done by projecting the sitter's shadow, in profile, onto a piece of paper which Mrs. Bascom then traced and colored in. Occasionally the profile was cut out and pasted on another paper.

[1] Located at the American Antiquarian Society, Worcester, Massachusetts.

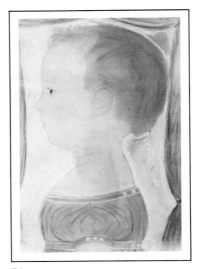

51.

Attributed to

Bears, Orlando Hand (1811 – 1851)

SEA CAPTAIN'S GRANDSON FROM CONNECTICUT

Fig. 52

H. 46¾"; w. 35¾" c. 1840
oil on canvas
(cat. #27.1.1-62)

This portrait has been attributed to Orlando Hand Bears by James Abbe, Jr. Oyster Bay, New York, who has extensively studied Bears' work. Bears, the son of Moses Bears (1786 – 1853) and Miranda Gibbs Bears, was born in 1811 in Sag Harbor, New York, where he died in 1851. He married a Mary Whipple from the New London and Stonington area of Connecticut. From a portrait of Bears' brother, Alfred,[1] in gentlemanly dress with a gold earring his right ear, and carrying a book, it would appear that the family was relativ prosperous and well-educated, and maintained a connection with the sea. portrait of a MARY HAVENS,[2] attributed to Bears, especially resembles S CAPTAIN'S GRANDSON. Both backgrounds appear as stage settings, an the manner in which the doll-like bodies are placed and drawn are alike — positioned slightly off-center with their hands occupied (the boy with a bea hat and book, and the girl with a rose and coins). Their pleasant faces are b intent and warmly alive. Mr. Abbe considers a portrait of EPHRAIM NILES BYRAM[3] of 1834 to be an especially important one, as it is signed and dat While stylistically resembling other Bears' works, its composition is more a bitious. Isaac Sheffield, (see p. 126) like Bears, painted whaling captains the same era, and may have influenced or taught Bears.

[1] ALFRED BEARS (c. 1812-1833), (brother of the artist) 24 × 18", oil, c. 1833. Collection of Ja Abbe, Jr., Oyster Bay, New York.
[2] MARY HAVENS, 32 × 41", oil, c. 1830's, Corwith Homestead, Bridge Hampton, New York.
[3] EPHRAIM NILES BYRAM, 27 × 34", oil, 1834, Suffolk County Whaling Museum, Sag Harbor, N York.

52.

Beeman, Ethel Louise (1845 – 1922)

GIRL WITH HAT

H. 20"; w. 15½" 1860
pencil on paper
on verso: "By my grandmother, Ethel Louise Beeman in 1860, when she was 15
 years old attending New Hampton Institute, Fairfax, Vermont."
Gift of: Ethel L. Prouty Viscione, 1956
(cat. #27.8-12)

The daughter of James N. and Abigail (Lewis) Beeman, Ethel Beeman was attending the New Hampton Institute in Fairfax, Vermont when she drew this portrait. Miss Beeman married John Jacob Wright on November 1, 1866 and spent the remainder of her life in Vergennes, Vermont.

Belton, James, USN

U.S. NAVAL FLEET ON LAKE CHAMPLAIN Fig. 53

H. 3¾"; w. 6⅜" c. 1817
watercolor on paper
On verso: "Lake Champlain about 1817./The fleet is most likely the/same fleet
 which defeated/the British fleet in 1814./Macdonough was the
 American Commander."
(cat. #27.2.4-3)

The scene is presumed to be two miles below Whitehall. This painting came from James Belton's sketchbook.

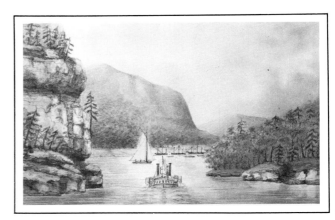

53.

hington, Mrs.

RL WITH BLUE SASH AND HER DOG

H. 9¼″; w. 6¾″ c. 1825 – 1830
watercolor and blue pencil on paper
signed, l.r.: "Mrs. Benington"
(cat. #27.2.1-83)

son

KE CHAMPLAIN, 1813

Fig. 54

H. 9⅝″; w. 14⅛″ 1813
watercolor on paper
signed, l.r.: "Benson"
inscribed, l.l.: "Lake Champlain, 1813" u.r. (in pencil) "Tyler's Farm"
(cat. #27.2.4-5)

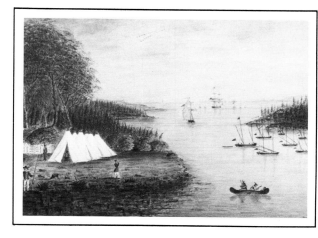

54.

ar Highgate, Vermont, this very early scene depicts a military encampment on
e Champlain. The Tyler Farm is still in existence.

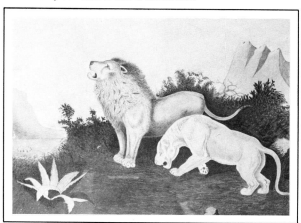

55.

Bickford, N. N.

MISSIONARY ENCAMPMENT IN AFRICA

Fig. 55

H. 11¾″; w. 15″ 1864
watercolor on paper
signed, l.l.: "Drawn by N. N. Bickford"
Inscribed, l.r.: "Danville C. E. 1864"
(cat. #27.2.5-8)

The artist may be Nelson N. Bickford of New York City who
specialized in animal painting.[1]

[1] Mantle Fielding, *Dictionary of American Painters, Sculptors and Engravers* (Flushing, N.Y.: Paul A. Stroock, 1960), p. 27.

stadt, Albert (1830 – 1902)

STPHALIAN LANDSCAPE

Fig. 56

H. 26″; w. 34½″ 1855
oil on canvas
signed, l.l.: "A Bierstadt 1855"
cat. #27.1.2-68)

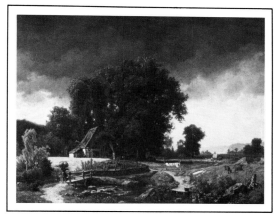

56.

57.

KALLENFELS AMONG THE HILLS, GERMANY

Fig. 57

H. 13¼″; w. 18½″ probably 1856
oil on canvas
signed, l.r.: "ABierstadt"
(cat. #27.1.2-90)

n in Solingen, Germany, Albert Bierstadt spent his childhood in
Bedford, Massachusetts where he had emigrated at the age of
with his family. By the age of twenty he had made painting his pro-
ion. In 1853 he returned to Germany, where, with headquarters in
seldorf, he began four years of study and travel in Europe. Be-
ded by Emanuel Leutze and Worthington Whittredge, Bierstadt
ame part of that interesting coterie of American artists in Europe
found in landscape painting a compelling interest. In April of 1854
stadt set out alone for Westphalia, after which he returned to Dus-
orf and spent the next winter painting from his sketches. This
scape was one of the results. In a letter to his New Bedford
oness, Mrs. Hathaway, Bierstadt described the scene as a view
r Limburg, Westphalia near the Ruhr river with a characteristic old
house in the foreground.[1] He also painted a work entitled AP-
ACHING STORM from a nearly identical vantage point.[2]

Formerly entitled LANDSCAPE WITH HILLS, the locale of this paint-
ing has been identified by Vern Pascal[1] as the village of Kallenfels on
the Nahe River in Germany. The landscape was undoubtedly done on
a trip through Germany, Switzerland, and Italy which Bierstadt, ac-
companied by Whittredge, Enoch Wood Perry, Horace Howard Fur-
ness, and several others, began in June of 1856.

he letter is quoted in Gordon Hendrick's book *Albert Bierstadt, Painter of the American*
(New York: Harry N. Abrams, Inc. and the Amon Carter Museum of Western Art, 1974),

PPROACHING STORM, 1854 (oil on canvas, 16⅜ × 20½″), Arnot Art Museum, Elmira,
York.

[1] Mr. Pascal, of San Luis Obispo, California, has been working on an extensive biography
of Bierstadt.

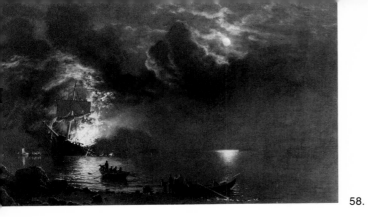

58.

Birch, Thomas (1779 – 1851)

CONESTOGA WAGON
ON THE PENNSYLVANIA TURNPIKE

H. 21¼"; w. 28½" 1816
oil on canvas
signed, l.c.: "T. Birch/1816"
(cat. #27.1.2-14)

Thomas Birch, a marine, landscape, portrait and miniature painter, was trained by his father William Russell Birch (1755-1834), an enamel painter and topographical engraver from England who settled in Philadelphia, Pennsylvania in 1794. By 1804 Birch was listed as a portraitist, and in 1807 became a member of the Pennsylvania Academy of Fine Arts where he exhibited regularly and became Keeper between 1812 and 1817. The wagon he depicts here was a familiar sight in the Conestoga River Valley of Lancaster County, Pennsylvania.

THE SHIP "OHIO" Fig. 59

H. 20¼"; w. 30⅜" 1829
oil on canvas
signed, l.l.: "T. Birch/1829"
(cat. #27.1.4-56)

Birch was much influenced by Dutch marine paintings and the French seaport views of Joseph Vernet (1714-1789). During the War of 1812, he painted a great number of naval engagements such as the BON HOMME RICHARD CAPTURING THE SERAPIS, THE CONSTITUTION FRIGATE ESCAPING FROM A BRITISH SQUADRON, and BATTLE ON LAKE ERIE.[1]

[1] All shown in the October, 1838, exhibit of the Apollo Association, where Birch's address is listed as Locust Street, Philadelphia.

COUNTRY SLEIGH RIDE

H. 17¾"; w. 25½" 1841
oil on canvas
signed, l.r.: "T. Birch/1841"
Gift of: Mr. and Mrs. Dunbar W. Bostwick, 1957
(cat. #27.1.2-7)

The locale of this scene is most likely near Philadelphia. As Charles Sessler noted, Birch was among the first, if not the very first, to make a specialty of winter scenes.[1]

[1] "Shop Talk", The Magazine Antiques, February, 1950. p. 106.

LATE AFTERNOON SLEIGH RIDE

H. 20"; w. 30" 1848
oil on canvas
signed, l.r.: "T Birch 1848"
stenciled on canvas: "W. E. Rogers/16/Arcade/?"
(cat. #27.1.2-78)

Two winter scenes by Birch are listed in the October, 1839, exhibition of the Apollo Association, and others in the American Art Union exhibits of 1847 and 1848. They were evidently much in demand.

Bierstadt, Albert

THE BURNING SHIP Fig. 58

H. 30"; w. 50" 1869
oil on canvas
signed, l.l.: "ABierstadt/1869"
(cat. #27.1.4-64)

By 1869 Bierstadt had reached the peak of his career. In 1866 he had married Rosalie Osborne (the former wife of the journalist Fitz Hugh Ludlow with who Bierstadt had travelled through the West in 1863, illustrating a book of their journey, THE HEART OF THE CONTINENT, published in 1870). Work had begun on their thirty-five room mansion "Maklasten" at Irvington-on-Hudson New York. In June of 1867 Bierstadt was back in Europe, travelling to England, Germany, Switzerland, Austria, Italy, Spain and France, where he was awarded the Legion of Honor by Napoleon III. He returned to New York in summer of 1869.

This painting probably depicts the Civil War incident vividly described in the newspapers in which the Confederate cruiser SHENANDOAH burned seve whalers in the Carolinas. The accurate title is undoubtedly THE REBEL CRUISER "SHENANDOAH" BURNING WHALERS.[1]

[1] Gordon Hendricks, Retrospective Exhibit of the Work of Albert Bierstadt, Amon Carter Museum Western Art, 1972, p. 21.

ICE BREAKING UP

H. 10½"; w. 17¾" 1889
oil on canvas
signed, l.r.: "ABierstadt"
Exhibited: Mead Art Gallery, Amherst College, February 1-March 2, 1975.
(cat. #27.1.4-55)

In 1889 Bierstadt was on board the sidewheeler ANCON (a summer tourist boat which travelled from Tacoma, Washington to Juneau, Glacier Bay, and Sitka and back) when it was wrecked in Loring Bay in the Revillagigedo Islands. On September 18 he wrote to his wife from the Hotel Victoria at Vancouver, "I wrote you of our shipwreck and sent paper about poor Ancon, it w a narrow escape. The steamer brought us back after five days living in Ind huts and salmon canneries. I was busy all the time and have sixty studies color and two books full of drawings of Alaska."[1] This painting was undou edly done at this time.

[1] Letter in the possession of Miss Rosalie Osborne Mayer, Waterville, New York, quoted in M. Karolik Collection of American Paintings, 1815-1865 (Boston: Museum of Fine Arts, 1949), p. 10

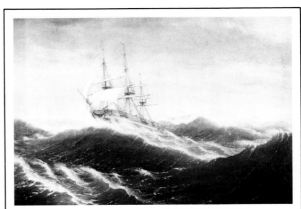

59.

SLEIGH RIDE ON A GRAY DAY Fig. 60

H. 18"; w. 27¼" 1832
oil on canvas
signed, r.c.: "Tho. Birch/1832"
Gift of: Mrs. Frederica F. Emert, 1964
(cat. #27.1.2-114)

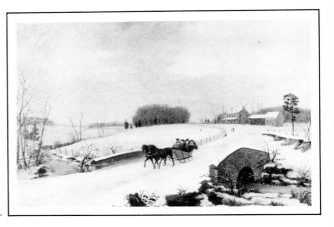

60.

ishop, A. F.

. S. BERKSHIRE AND HENRICH HUDSON'S HALF MOON

Fig. 61

H. 14"; w. 20" c. 1909
oil on canvas
signed, l.l.: "A. F. Bishop"
on verso: "Berkshire Launched 1909; 440-Foot Queen of the Night Line Hudson
 Navigation Co./Henrich Hudson's HALF MOON at right."
(cat. #27.1.4-29)

909 marked the 300th anniversary of the discovery of the Hudson
iver. To celebrate, a replica of the HALF MOON was built. The BERK-
HIRE, also built in 1909, (originally to be named PRINCETON) was
eant to replace the ADIRONDACK. Her hull was built by the New York
hipbuilding Co., Camden, New Jersey; John Englis and Son built the
eck houses, and W. & A. Fletcher built the engine, having a cylinder
5" in diameter with a twelve foot stroke. She weighed 4,500 tons,
easured 440' long, 50.6 feet at the beam, 88' over the guards and the
epth of the hold was 14.6'.[1] Probably the dramatic contrast between
e old and new found its way into print, and this painting was made
om a photograph or was an actual on-the-spot painting.[2]

[1] Fred Irving Dayton, *Steamboat Days* (New York: Tudor, 1939), p. 83.
[2] Dick Owen, "The River Queens", *New York Sunday News* (August 23, 1959), p. 22.

61.

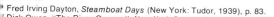

62.
reverse of canvas,
before relining

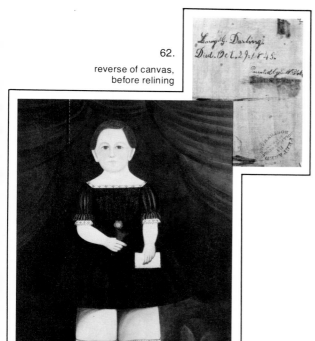

62.

Blake, E. W.

LEROY G. DARLING

Fig. 62

H. 36"; w. 29" c. 1845
oil on canvas
Inscribed, on verso: "Leroy G. Darling/Died. Oct. 29. 1845./Painted by
 E. W. Blake/Boston????".
Stenciled, on verso: "PREPARED/by Hollis & Wheeler/59 Union
 St/Boston, Mass."
(cat. #27.1.1-139)

From the inscription on the reverse of this now relined can-
vas, one would assume that this is a death portrait. E. W.
Blake was an itinerant painter, known to have been in
Philadelphia in 1860. He also worked in New England,
where he was possibly influenced by William Matthew
Prior. This painting is described in Clara Endicott Sears'
Some American Primitives.[1]

[1] Clara Endicott Sears, *Some American Primitives: A Study of New En-
gland Faces and Folk Portraits* (Boston, 1941), p. 287.

63.

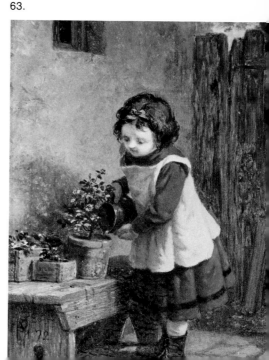

Blauvert, Charles F. (1824-1900)

LITTLE BOY READING

H. 12⅛"; w. 9"
oil on canvas
signed, l.l.: "C. F. Blauvert"
 back, l.l.: "C. F. Blauvert"
(cat. #27.1.1-105)

LITTLE GIRL WATERING FLOWERS

Fig. 63

H. 12⅛"; w. 9"
oil on canvas
signed, l.l.: "C. F. Blauvert"
on verso (on a card): "Watering the Flowers/by C. F. Blauvert/NY./Frame ___"
(cat. #27.1.1-104)

This pair of portraits, acquired in Greenwich, Connecticut, were
painted by the portrait and genre painter, Charles F. Blauvert.
Born in New York City, Blauvert worked there from 1847 to 1862
when he moved to Philadelphia. He returned to New York from
1867-1869, was in Yonkers in 1869 and was later on the faculty of
the Naval Academy at Annapolis. He exhibited in all of the major
art academies, and died in Greenwich, Connecticut in 1900.

64.

Attributed to

Blyth, Benjamin

FRANCIS WARDEN OF SALEM, MASSACHUSETTS

Fig. 65

H. 21½"; w. 16⅜" c. 1765
pastel on two pieces of paper, mounted on a canvas back
on verso: (tag) "Portrait of Francis Warden who was taken prisoner by the British in Revolutionary
 War and died on the Prison Ship NEW YORK at about 18 years of age. This portrait was
 hanging in the sitting room of the old homestead in Salem, Mass. Bequeathed to William
 Francis Warden by his great aunt Anne Warden."
Gift of: Katharine Prentis Murphy, 1958
(cat. #27.3.1-15)

The arrangement of this child's picture, with a bird on his finger and curtained
background, was copied from English portraiture of the 17th century which
was transmitted to America largely through mezzotints. The artist, Benjamin
Blyth, a portraitist in oils, crayons, and miniature, an engraver and ornamental
painter, was baptized in Salem on May 18, 1746. Benjamin may have had
some training from his father, a painter and sailmaker, or his older brother
Samuel, a heraldic and portrait painter, who made harpsichords, spinets, and
other stringed instruments, and later operated a girls' boarding school.[1] Ben-
jamin advertised in the *Salem Gazette* of May 10-17, 1769:

"Benjamin Blyth begs leave to inform the Public, that he has opened a
Room for the Performance of Limning in Crayons at the House occupied by
his Father in the great Street leading towards Marblehead, where speci-
mens of his Performance may be seen. All Persons who please to Favour
him with their Employ may depend upon having good Likenesses and being
immediately waited on, by applying to their Humble Servent, Benjamin
Blyth."[2]

He presumably remained in Salem until 1787, but is last known from his adver-
tisements in July and August of 1786 in the Richmond, Virginia newspaper
where he is described as a limner, gilder, and ornamental painter.

[1] Ruth Townsend Cole, "Limned by Blyth," The Magazine *Antiques* (April, 1956), p. 333.
[2] *Ibid.,* p. 331.

66.

67.

Blunt, John Samuel (1798 – 1835)

IMAGINARY SCENE Fig. 64

H. 15½"; w. 22½" 1824
oil on wood
signed, l.l.: "J. S. Blunt/1824"
(cat. #27.1.2-88)

John Samuel Blunt, born in Portsmouth, New Hampshire, was probably
self-taught. He is listed in Portsmouth's business directory of 1821 (the
same year he married Ester P. Colby in Boston) as "an ornamental and
portrait painter." Advertising in 1822 that he did "profiles, profile minia-
ture pictures, landscapes and ornamental paintings," in the *Portsmouth
Journal* in 1825 Blunt announced he would open a drawing academy to
teach "oil painting on canvas and glass, watercolors, and crayons." He ex-
hibited at the Boston Athenaeum in 1829 where he is erroneously listed as
Joseph S. Blunt, and 1831 when he is called J. F. Blunt. Working in Bos-
ton in 1830-1831, by 1835 he sold part of his property in Portsmouth, and
was negotiating for 4,000 acres of Texas land.[1] While on a trip between
New Orleans and Boston that same year he died. Of his fifteen known
paintings, ten are marines.[2]

[1] Groce and Wallace, *op. cit.*, p. 16.
[2] John Wilmerding, *A History of American Marine Painting* (Boston: Little, Brown, and Co.,
1968), p. 144.

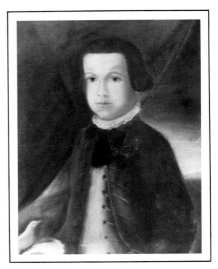

65.

Attributed to

Blyth, Benjamin

MRS. WILLIAM SAMUEL MOOREHOUSE
(Annis Stern)

Fig. 66

H. 24"; w. 18" c. 1780
pastel on two pieces of paper, mounted on canvas
on verso: (label): ". . . held by Moorehouse family from whom
 they were purchased. Mrs. M. was Annis Stern
 of Salem, Mass."
(cat. #27.3.1-2)

WILLIAM SAMUEL MOOREHOUSE

Fig. 67

H. 24"; w. 18" c. 1780
pastel on paper
on verso: "Mr. M. was soldier in/Revolutionary War &
 descendent of early settler engaged in Paleing (?) and
 lumber business."
(cat. #27.3.1-1)

These two paintings were found in Connecticut. The old Moorehouse
home still stands, although greatly remodeled, on Shore Road, Fairfield
Connecticut, (then called Port Road, Newport). Mr. Moorehouse's po
is similar to that of John Adams in a portrait which Blyth painted in 17

Bosanquet, (active 1843)

BOY IN SMOCK WITH HIS SAILBOAT

H. 9¼"; w. 6¾" 1834
watercolor and pencil on paper
signed, l.r.: "Bosanquet/1843"
(cat. #27.2.1-39)

Bostwick, Electra Webb (1910 –)

PINK ROSES

H. 12"; w. 16"
oil on canvas
signed, l.r.: "Electra Bostwick"
on verso (on stretcher): "Pink Roses"
(cat. #27.1.3-27)

GARDEN ROSES

H. 20¾"; w. 18¾"
pastel on grey paper
signed, l.r.: "Electra Bostwick"
(cat. #27.3.3-5)

PINK ROSE AND CARNATIONS IN SILVER PITCHER

Fig. 68

H. 10"; w. 8¼" 1946
oil on masonite
signed, l.r.: "Electra Bostwick — 1946"
(cat. #27.1.3-28)

THE LAUNDRY

H. 16¼"; w. 20" 1949
oil on canvas
signed, l.r.: "Electra Bostwick"
on verso: "The Laundry/South Carolina/1949"
on stretcher: "Atkins, S.C."
(cat. #27.1.2-130)

68.

Electra Webb Bostwick, eldest daughter of Mr. and Mrs. J. Watson Webb, started painting at age eleven when she was in the sixth grade. She first took lessons from Miss Florence Robinson, a member of the McDowell Colony in Peterborough, New Hampshire. When she was a young girl, Electra's grandmother, Louisine W. Havemeyer, used to let her take portfolios of Degas' drawings and Mary Cassatt etchings home to copy. Mrs. Havemeyer also gave her Mary Cassatt's six-tier tray of French pastels with which to work. She thinks many of the colors were used for hopscotch and wishes she had the box now!

When she went to boarding school, Mrs. Bostwick took extra art classes and later in New York studied drawing with Archipenko. After her marriage at twenty-one, she studied with Luigi Lucioni for many years and later with Odgen Pleissner. She has worked all of her life in pastel, oil, watercolor, pencil and ink, specializing in pastels of flowers. Having had four successful one-man shows, Electra Bostwick still finds time to escape to her studio nearly every day to work.[1]

[1] This biography was written by Mrs. Bostwick's eldest daughter, Electra Bostwick McDowell.

g, (?) Fou

EWHEELER S.S. *AMERICA* (1869 – 1872)

Fig. 69

H. 23¼"; w. 40½" c. 1869
oil on canvas
signed, l.r.: "Fou Brag/painter"
cat. #27.1.4-27)

S.S. AMERICA was one of four wooden side wheelers built be-
en 1866-1869 for the Pacific Mail Steamship Co. The boats were
structed in pairs — the CHINA and GREAT REPUBLIC, completed
867, and the JAPAN and AMERICA in 1869. All except the CHINA
e built in the yard of Henry Steers of Greenpoint, Long Island. The
ERICA was 380' long and weighed 4,459 9/100 tons. She had three
decks, with an orlop deck extending fore and aft of the engine room
heads. In addition to coal, the S.S. AMERICA and her sister ships
e also equipped with three masts and carried course, topsails, top-
ants, as well as fore and aft sails.[1]
Yokohama harbor on August 24, 1872, at 11 p.m., after replenish-
her coal supply and discharging and loading cargo, some hay which
stored in the AMERICA'S aft steerage quarters caught fire. Within
utes, the fire was out of control, forcing the ship to be abandoned.
-nine passengers lost their lives — fifty-three Chinese, three Euro-
ns, and three Japanese.
he artist of this painting may be Chinese — the name can be de-
ered in several ways (Beng, Brug, Bray). The intricately carved
e is undoubtedly Chinese. The painting was formerly owned by
garet Doane of Gloucester, Massachusetts, the granddaughter of
AMERICA'S captain Seth Doane.

ohn Haskell Kemble, *Side-Wheelers Across the Pacific*, 1942, pp. 36-37.

69.

Attributed to

Brewster, John Jr. (1766-1854)

NEW ENGLAND WOMAN: THE STRENGTH OF OUR YEARS

Fig. 70

H. 31"; w. 25¾" c. 1800
oil on canvas
Exhibited: "Masterpieces in American Folk Art," Downtown Gallery, New York City, 1941;
"John Brewster, Jr. Exhibition," Connecticut Historical Society, November and
December, 1960
Colby College, Bixler Art and Music Center, January and February, 1961.
(cat. #27.1.1-10)

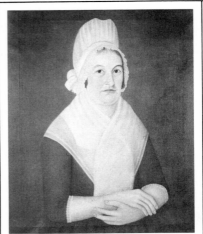

70. 71.

Found in Cambridge, Massachusetts in 1940, this painting was formerly entitled QUAKER COSTUME, and attributed first to Richard Jennys, and later to William Jennys. It is now assumed to be the work of John Brewster, Jr., from Hampton, Connecticut, the son of Mary Durkee and John Brewster. Born unable to hear and consequently speak, Brewster ultimately mastered both writing and sign language. Around 1790, he received painting lessons from Rev. Joseph Steward (1753-1822), a portrait painter in Hampton, and he probably also knew the artist Winthrop Chandler (see p. 41) of Woodstock, Connecticut. From about May 1796 to September 1797, Brewster worked in and around Portland, Maine. In 1797 he advertised in THE PHENIX or WINDHAM HERALD September 28, and October 6 and 13:

John Brewster, jun. Portrait and Miniature Painter, informs, that he is at Hampton [Conn.] ready to serve those, in his art, who may furnish him with business. N. B. For seventeen months past, he has been improving his art in Portland.[1]

Later he worked in Norwich, Connecticut; Newburyport, Boston and Salem, Massachusetts; Vermont, New Hampshire and Maine. In mid April, 1817, the Connecticut Asylum for the Education and Instructions of Deaf and Dumb Persons was opened in Hartford, Connecticut by Rev. Thomas Hopkins Gallaudet. Brewster, at the age of fifty-one, was the sixth pupil to be admitted, and remained there three years. His last known portraits were done in Denmark, Maine.

[1] Quoted in Nina Fletcher Little, "John Brewster, Jr., 1766-1854. Deaf-Mute Portrait Painter of Connecticut and Maine," Connecticut Historical Society *Bulletin* (Hartford, Connecticut: October, 1960) V. 25, No. 4, p. 99.

Brewster, John Jr.

YOUNG LADY WITH BLACK LACE SHAWL

Fig. 71

H. 30"; w. 25" c. 1800
oil on canvas
(cat. #27.1.1-29)

This painting, once also attributed to William Jennys, is now believed to be the work of John Brewster, Jr. It is somewhat crisper and more brightly colored than most of Brewster's known work.

Browere, Albertus Del Orient (1814 – 1887)

RIP VAN WINKLE ASLEEP

H. 22"; w. 28¼"
oil on canvas
signed, l.l.: "A.D.O. Browere"
(cat. #27.1.7-15)

RIP AT THE INN

Fig. 72

H. 36"; w. 50" 1879
oil on canvas
signed, l.l.: "A.D.O. Browere"
(cat. #27.1.7-16)

RIP IN THE MOUNTAINS

H. 30"; w. 44¼" 1880
oil on canvas
signed, l.l.: "A.D.O. Browere/1880"
(cat. #27.1.7-17)

RIP CHASED FROM HOME BY HIS WIFE

H. 36"; w. 50" 1880
oil on canvas
signed, l.l.: "A.D.O. Browere/1880"
(cat. #27.1.7-18)

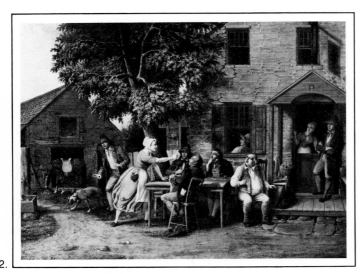

72.

Born in 1814 in Tarrytown, New York, A.D.O. Browere learned the rudiments of painting from his father, John Henry Isaac Browere (1790-1834), a sculptor and painter who is best known for his formula and process of taking plaster life masks.[1] The Broweres' studio and home was at 12 Roosevelt Street, New York City. Albertus began serious study at the National Academy of Design, exhibiting there from 1831 to 1846, and in 1832 he received a silver medal for the most original painting of the year from the American Institute of the City of New York. In 1834 Browere moved his wife and two children to Catskill, where he was to remain for most of his life, with the exception of two extended trips to California — one around Cape Horn and one via mule over the Isthmus of Panama. First clerking in a drug store to support his growing family (there were ultimately eight children), Browere became a buggy, surrey, and sign painter, although he continued his creative work on canvas and wood. Shelburne has four paintings which Browere did in the Rip Van Vinkle series.[2] In RIP CHASED FROM HOME BY HIS WIFE a "ghost" figure of a little girl faintly appears through the over painted canvas.

[1] Among his sitters were Adams, Jefferson, Madison, and Lafayette. Seventeen of these masks have been cast in bronze and are on exhibition at the New York Historical Association at Cooperstown, New York.
[2] A fifth, RIP LEAVING HOME WITH WOLF, is in the Albany Institute of Art. Other versions of RIP VAN WINKLE were obviously done, as Browere exhibited one version at the N.A.D. in 1833 and another in 1839.

Brown, George Loring (1814 – 1889)

THE QUAY AT NAPLES

H. 25¼"; w. 30¼" 1849
oil on canvas
signed, l.c.: "G. L. Brown/Naples/1849"
on verso (under relined canvas): "The Quay at Naples with distant view of the castle of 'S. Elmo' and 'Castle Nouvo' painted from Nature by G. L. Brown/1849"

(cat. #27.1.2-62)

Born in Boston in 1814, George Loring Brown was the third of eight children of Loring and Joanna Pratt Brown. At the age of fourteen, Brown was apprenticed to the wood engraver, Alanzo Hartwell. He probably had his first lessons in oil painting from the nineteen-year-old George P. A. Healy. In 1832 Brown headed for Europe, settling briefly in Antwerp, and then in London. In December, 1832, with the American engraver John Cheney, Brown moved to Paris where he studied with the French marine and town painter Louis Gabriel Eugene Isabey, and copied landscape paintings (particularly of Claude Lorrain) in the Louvre. Back in Boston in 1834 Brown designed illustrations, and painted portraits and landscapes before going to Italy in 1840. After a year in Rome, Brown was in France in 1841, and in the summer of 1844 visited Naples where he became enthralled with its harbor, illustrated here. After a number of years of travel, Brown returned to Italy where he entered his most productive and creative period. This painting, exhibited at the American Art Union in 1852, was described as "The Chiaja, with crowds of people. The Castello del Uovo on the left. Beyond is the estate of St. Elmo. $100.00."[1]

[1] Mary Bartlett Cowdry, *American Academy of Fine Arts and American Art-Union Exhibition Record* (New York: New York Historical Society, 1953), p. 46.
Ref: *George Loring Brown, Landscapes of Europe and America 1834-1880,* October 15-November 14, 1973, The Robert Hull Fleming Museum, Burlington, Vermont.

VIEW OF AMALFI, NEAR NAPLES

Fig. 73

H. 12½"; w. 19" 1856
oil on canvas
signed, l.r.: "G L Brown/Rome/1856."
on verso: "Study/View of Amalfi near Naples/painted from Nature by G. L. Brown/1856."
ink manuscript paper pasted to canvas: "Amalfi/Picture painted by/Brown and given to John O./Sargent by him, for services/rendered in 185?./G. W. Sargent."

(cat. #27.1.2-82)

This painting, undoubtedly done from a pencil or watercolor sketch when Brown was at the height of his artistic capability, is the smaller and earlier of two versions of this view. The larger painting, VIEW OF AMALFI, BAY OF SALERNO, also painted in Rome, is in the Metropolitan Museum of Art.[1]

[1] (33½ x 53¾", 1857), the gift of William Church Osborn in 1903. Mr. Osborn was the father of Mrs. Vanderbilt (Aileen Osborn) Webb, a sister-in-law of the late Mrs. J. Watson Webb.

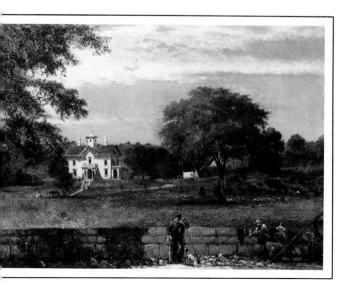

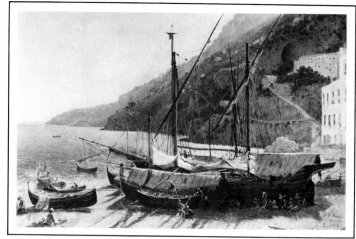

73.

MORNING EFFECT — MEDFORD, MASSACHUSETTS 1862

Fig. 74

H. 14"; w. 21" 1862
oil on canvas
signed, l.l.: "Geo L Brown/Medford 1862"
on verso: "Morning Effect View (here two lines are crossed out) Medford Mass./painted out of doors by Geo. L. Brown/1862"
(cat. #27.1.2-81)

While spending most of his time in 1861 and 1862 in New York City, Brown visited Medford, Massachusetts, where in 1863 he settled for two or three years with his third wife. Done in the same year as his important painting of MEDFORD MARSHES,[1] Brown's technique here is less luministic but exhibits the same careful attention to detail. The building depicted here is the Hastings House on Rock Hill, between High Street and the Mystic River. It burned down in June, 1971, after serving as a nursing home for more than a quarter of a century.[2]

[1] MEDFORD MARSHES, oil on canvas, 21¼ x 43", Boston Museum of Fine Arts, M. & M. Karolik Collection.
[2] Information from Arthur M. Morrissey, President of the Medford Historical Society, 1974.

ITALIAN MOONLIGHT

H. 34½"; w. 60¼" 1865
oil on canvas
signed, l.c.: "Geo. L. Brown/1865"
on verso: " 'Italian Moonlight' View of Paestum. Kingdom of Naples/by Geo. L. Brown. Shore of the Mediterranean/1864"
(cat. #27.1.4-62)

This is one of many Italian scenes which Brown did from memory in the 1860's and 1870's. Most of them were commissioned by Americans who responded to the romance and glamour of the Italian scene. While in some instances the treatment of this theme became hackneyed and dull, Brown experimented with a variety of techniques during this period, creating some paintings of considerable strength and individuality.

FARMYARD, WEST CAMPTON, NEW HAMPSHIRE

H. 20"; w. 48" 1870
oil on canvas
signed, l.l.: "Geo. L. Brown 1870"
on verso: "Farm Yard scene/West Campton N.H./-from nature by/Geo. L. Brown/1870"
(cat. #27.1.2-121)

Moving to South Boston in 1864, Brown continued to travel to New England frequently where he painted this pastoral scene in 1870. West Campton, located in central New Hampshire on the southern edge of the White Mountains, was familiar territory to Brown. He painted there in 1865, 1866, 1868, 1869, 1870, 1875, 1876, 1877, and 1878.[1]

[1] See *Catalogue of Oil Paintings, Water Color Drawings by George Loring Brown,* exhibited and sold by auction at the Hawthorne Rooms, May 7, 8, 9, 10, 1879 by Doll and Richards, 2 Park Street, Boston, Mass.

74.

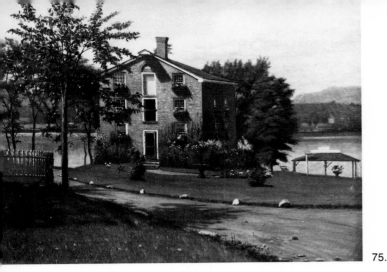

75.

Brown, John George (1831 – 1913)

LAKE CHAMPLAIN FERRY AT LARRABEE'S POINT, VERMONT

H. 19¾"; w. 28" c. 1906
oil on canvas
signed, l.l.: "J. G. Brown N. A."
(cat. #27.1.2-20)

The scene of this painting is Larrabee's Point, Shoreham, Vermont on Lake Champlain. The white building, an old hotel called the Lake House, burned in 1915. Mount Defiance is in the background, and the flag flies over Fort Ticonderoga. The artist, John George Brown, born in England, first studied art at Newcastle-on-Tyne and Edinburgh Academy before moving to Brooklyn to work in a glass factory at the age of twenty. He had a crippled hand, burned in a childhood accident, but this did not prevent his continued study in New York City under Thomas Seir Cummings (1804-1894), later exhibiting at the National Academy of Design, the Boston Athenaeum, and the Pennsylvania Academy of Fine Arts. While most noted for his genre subjects, this painting reflects Brown's love of Vermont and a spot he visited often.

STONE HOUSE, LARRABEE'S POINT, VERMONT

Fig. 75

H. 19¾"; w. 28" 1906
oil on canvas
signed, l.l.: "J. G. Brown N. A. 1906"
(cat. #27.1.2-13)

This painting, another done during one of Brown's visits to Larrabee Point, depicts the first store in Shoreham. Built in 1823 by John Larrabee and Samuel H. Holley, its stones were taken from Fort Ticonderoga, as were those used in the ferry landing.

Browne, Belmore (1880 – 1954)

A BAND OF WHITE GOATS CAME TO THE CLIFFS

H. 18"; w. 24" 1917
oil on canvas
signed, l.r.: "Belmore Browne/1917"
on verso: "Illustration for 'The White Blanket'/Caption: A band of white goats came to the
 Cliffs./Chapter XXI page/Belmore Browne."
stencilled on canvas: E. H. & A. C. FRIEDRICHS CO., ARTISTS' MATERIALS AND PICTURE
 FRAMES. 169 West 57th Street/Telephone, Columbus 6282 and 6283/New
 York"
Gift of: Mr. and Mrs. William N. Beach
(cat. #27.1.5-79)

HERD OF CARIBOU

H. 40¼"; w. 50¼" 1921
oil on canvas, mounted on masonite
signed, l.l.: "Belmore Browne"
Gift of: Mr. and Mrs. William N. Beach
(cat. #27.1.5-80)

NORTHERN INDIAN TRADING POST

Fig. 76

H. 24"; w. 18"
oil on academy board
signed, l.r.: "Belmore Browne"
on verso: "Illustration for page 25 — Caption — They zigzagged through the forest on the trunks of
 fallen trees. Belmore Brown."
Gift of: Mr. and Mrs. William N. Beach
(cat. #27.1.5-65)

Born in Tompkinsville, New York on June 9, 1880, Belmore Browne studied art at the National Academy in New York and Julian Academy in Paris. An associate member of the National Academy by 1928, he won their Ranger purchase prize. From 1930 to 1934 he was the Director of the Santa Barbara School of the Arts, after which he resided in Ross, Marin County, California in the winters and in Banff or Seebe, Alberta in the summers. An author and instructor, Mr. Browne was responsible for several Alaskan travel books and United States' Air Force Manuals between 1951-52. Two of the paintings listed here were illustrations for books.

76.

Bullard, Otis A. (1816 – 1853)

GENTLEMAN AT HIS DESK

Fig. 77

H. 16¼"; w. 13" 1845
oil on canvas
signed, l.r.: "O. A. Bullard/pinx/1845"
(cat. #27.1.1-119)

Otis Bullard, born in Howard, New York in 1816, was apprenticed at the age of fourteen to a sign and wagon painter. He studied under Philip Hewins (1806-1850) in Hartford, Conn., was married in Howard, New York in 1841, and moved to New York City in 1842, where for the next eleven years he exhibited at the National Academy of Design. While he is reported to have painted over 900 portraits, few have been located, although his distinctive and crisp style would make further attributions likely.

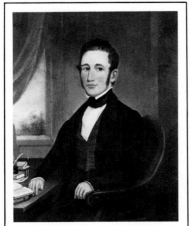

77.

lis, Franklin Howard (1861 – 1937)

RT KENT, NEW YORK, FROM THE LAKE CHAMPLAIN

Fig. 78

H. 36″; W. 96″ 1915
oil on canvas, mounted on homosite
signed, l.l.: "F. H. Bullis/1915
Gift of: Harry DeClue, 1965, in memory of his wife Ruth Bullis DeClue
(cat. #27.1.4-78)

78.

s large painting of Port Kent, New York, showing the ferry dock, Universalist Church, general store, and hotel, was done from a
ncil sketch which Bullis drew while seated in a rowboat on the lake. He also painted two smaller versions of the same scene.
n in Henderson Township, Sibley County, Minnesota in 1861, Bullis was kidnapped by Indians as an infant. Fortunately they
n abandoned him when his parents pursued them. Although he returned to his ancestral home in Port Kent as a youth, Bullis
ms to have had a wanderlust, rarely staying anywhere long. He made a living as a salesman of house paints, among other
gs, and invented a "wave turner" (a device to divert steamboat waves to prevent erosion of river and canal banks); a "butterfly"
early kind of kiddie-car); and went into business producing a water filter which he sold to the Boston Filter Co. of New York City.
er paintings by Bullis — several farm scenes, THE MELTING POT (a painting of the various ethnic groups in New York City),
several other works in the possession of his grandchildren are known to exist.[1]

nformation from the donor, Harry DeClue, West Haven, Vermont, 1965.

idy, Horace

LOMAN SANDERS OF SPRING-
LD, VERMONT (1814 – 1869)

Fig. 79

H. 28″; w. 24″ December, 1845
oil on canvas
signed, on verso: "Solomon
 Sanders/Springfield Vt./Dec.
 1845/by H. Bundy
cat. #27.1.1-75)

ween 1841 and 1850, only seven-
portraits done by Bundy are
wn, and all were done in
ingfield, Vermont or Claremont,
Hampshire. In 1842 he was con-
ed to the Advent Faith, founded by
iam Miller, a religion to which
ther New England painter, William
thew Prior (see pp. 114-116) was
acted. While Bundy was probably
ning enough from painting to sup-
his family of eight children by the
1850's, he was never "free from
duty to do the precious work of
's salvation."[1] The conflict be-
en his desire to paint and preach
to continue throughout Bundy's

loman Sanders, a son of Soloman
Anne Sanders, was a native of
nsend, Massachusetts. With his
Betsey Farrar he lived at 47
ol Street in Bellows Falls, Ver-
t where he operated a restaurant.
ied November 30, 1869 of
matism at the age of fifty-five and
uried in Springfield, Vermont near
Bartonsville line.[2]

hepard, op. cit., 445.
formation from Mrs. Joseph A. Taylor, of Rut-
Vermont — Soloman's great granddaughter.

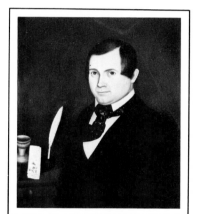

79.

MID-NINETEENTH CENTURY
LADY

Fig. 80

H. 35½″; w. 27¾″ 1852
oil on canvas
signed, on verso: "H. Bundy painter/Nashua N.H./January 1852"
Gift of: Mrs. Brooks Shepard, 1958
Exhibited: The Miller Art Center, Springfield, Vermont, February and March, 1958.
(cat. #27.1.1-60)

80.

MID-NINETEENTH CENTURY GENTLEMAN Fig. 81

H. 35½″; w. 27¾″ 1852
oil on canvas
signed, on verso: "H. Bundy Painter/Nashua N. H. Jany 1852"
Gift of: Mrs. Brooks Shepard, 1958
Exhibited: The Miller Art Center, Springfield, Vermont, February and March, 1958.
(cat. #27.1.1-59)

Bundy, Horace (1814 –1883)

MR. MUNRO

H. 33″; w. 27″ 1837
oil on canvas
signed, on verso: "Mr. Munro/by H. Bundy/Sept. 1837"
Gift of: Mrs. Brooks Shepard, 1960
Exhibited: Chaffee Art Gallery, Rutland, Vermont, August 27-September
 20, 1964
(cat. #27.1.1-113)

Born in Hardwick, Vermont in 1814, the son of Lemuel and
Esther Shipman Bundy, Horace Bundy probably began
painting scenes on country cutters built by the village
blacksmith. His first known portraits were done in the Bos-
ton area. While living in Lowell, Massachusetts, Bundy
married a North Springfield, Vermont, girl — Louisa Lock-
wood, in 1837, and shortly thereafter went to live in North
Springfield in a house provided by his in-laws.[1] Done the
year of his marriage, this portrait
of MR. MUNRO is one of
Bundy's earliest. According to a
former owner, the subject was
"the founder of the first fraternity
at Boston University." The pin
on Mr. Munro's shirt is a mourn-
ing pin, depicting a church be-
side a weeping willow.

[1] Hortense O. Shepard, "Pilgrim's Prog-
ress: Horace Bundy and his Paintings,"
The Magazine Antiques (October, 1964),
445-449.

81.

Another portrait which is companion to this pair and probably their daughter, entitled GIRL WITH DALMA-
TION, is in the Smith College Museum of Art, Northampton, Massachusetts. It is neither signed nor dated.[1]

[1] Shepard, op. cit. 448.

Bundy, Horace

MOTHER AND CHILD

H. 28½"; w. 24¼" 1846
oil on canvas
signed, on verso (under relined canvas): "H M BUNDY Painter Claremont July 1846"
Gift of: Mrs. Brooks Shepard, 1958
Exhibited: The Miller Art Center, Springfield, Vermont, February and March 1958.
(cat. #27.1.1-57)

MID-NINETEENTH CENTURY YOUNG MAN WITH SIDEBURNS

H. 34"; w. 27" 1854
oil on canvas
signed, on verso: "H Bundy/Painter/Townsend, Vt./May 1854"
Gift of: Mrs. Brooks Shepard, 1959
Exhibited: Chaffee Art Gallery, Rutland, Vermont, August 27-September 20, 1964.
(cat. #27.1.1-86)

The way in which this portrait has been handled reflects the influence which the introduction of the daguerreotype had on portraitists like Bundy. Developed by the Frenchman Louis J. M. Daguerre in 1839, the daguerreotype was continually improved until it was superceded by British photographer Frederick Scott Archer's wet collodion method in 1851. By the time of the Civil War, the influence of the photograph was so pervasive that it forced painters to adopt a camera-like style. Unfortunately in the process much of the aesthetic appeal of their work was lost.

THE BLUE MOUNTAINS

Fig. 82

H. 25"; w. 30¼" c. 1855
oil on canvas
signed, on verso: "H. Bundy/Painter"
Stencil, verso, u.r.: "RL & DRAKE/ARTISTS DEPOT/TROY NY"
(cat. #27.1.2-69)

THE BLUE MOUNTAINS and HAYMAKING ON THE HUDSON (see p. 168) were undoubtedly copied after one of two popular engravings of this scene, one done in 1851 by James Smillie (1807-1885) entitled AMERICAN HARVESTING for American Art Union members, and a Currier and Ives version, A SUMMER LANDSCAPE — HAYING, which came out shortly thereafter. Both were taken from an 1849 painting by Jasper Francis Cropsey (see p. 48) entitled AMERICAN HARVESTING SCENERY which he sold to the American Art Union in 1850 for $432.00. Cropsey made several other versions of this painting as well. The conversion of paintings to prints and back to paintings was not uncommon, and as many as one hundred versions of this painting may exist.

83.

Bundy, Horace

PORTRAIT OF A CHILD

H. 23¾"; w. 20"
oil on canvas
signed, on verso: "H. Bundy"
Gift of: Mrs. Brooks Shepard, 1958
Exhibited: The Miller Art Center, Springfield, Vermont, February and March, 1958
(cat. #27.1.1-58)

This portrait may be one of the few which Bundy did later in his life. From 1863 to 1870 he was pastor of the Second Advent Church in Lakeport, New Hampshire, where he was known as a powerful speaker. Giving this up, he moved to Concord, New Hampshire, and during these years is only known to have painted family portraits and a few landscapes. In the last year of his life, Bundy went to Jamaica for his health, where he executed "several pictures for a wealthy English planter, and also made studies of tropical scenery."[1] He died of typhus in Concord in June of 1883.

[1] Shepard, *op. cit.,* 447.

82.

Burleigh, Charles Calistus, Jr. (1848 – 1882)

ARTIST'S WIFE WITH PEACOCK FAN

Fig. 83

H. 27"; w. 21¾" probably 1882
oil on canvas
signed, l.l.: "C C Burleigh/Berlin/1882 (?)"
(cat. #27.1.1-147)

Charles C. Burleigh was born in Bristol, Pennsylvania in 1848, and with his family, moved to Plainfield, Connecticut, and on to Florence, Massachusetts. As a child Burleigh had showed an artistic bent, painting portraits by age fifteen. He studied for two years at the Lowell Institute of Design, Boston, and briefly at the Pennsylvania Academy of Fine Arts in Philadelphia. He is known to have painted frescoes in the Cosmian Hall in Florence, and with Eldridge Kinglsey (1842-1918) did lithographs of local scenes. In 1878 he married Ida A. Aldrich of Florence, after which they honeymooned in Europe, their trip financed by Andrew D. White, then President of Cornell University, who commissioned Burleigh to copy old masters. The one year trip stretched to five, as Burleigh copied the paintings of Rubens, Van Dyke, Bellini, Titian, and Raphael, and did a great deal of sketching. From 1880-1883[1] he exhibited at the Pennsylvania Academy of Fine Arts. His intention to return to the United States was cut short by his early death in Cologne, Germany in 1882. This painting may be LADY WITH FAN, shown at the Pennsylvania Academy of Fine Arts in 1882.[2]

[1] The paintings shown in 1883 were obviously exhibited after Burleigh's death.
[2] "A Memorial Exhibition, May 31-June 25, (undated) Charles C. Burleigh, Jr. 1848-1882," by Vose Galleries of Boston, Inc., 559 Boylston Street, Boston, Mass. Catalogue in the Shelburne Museum pamphlet file.

84.

Camp, Mary Jane (1829 – ?)

FAIRMOUNT WATERWORKS, PHILADELPHIA

Fig. 84

H. 14"; w. 19⅛" 1847
watercolor on paper
signed, l.l.: "Mary Jane Camp"
 l.r.: "April 20, 1847"
Gift of: Mrs. Samuel C. Beame, daughter of the artist, 1958
(cat. #27.2.2-7)

Born in Stowe, Vermont, the youngest child of Rivertus Camp and Hannah Robinson, Mary Jane Camp lived all of her life in Stowe and Waterbury, Vermont. She painted this watercolor while a student at Thetford Academy, Thetford, Vermont, undoubtedly copying J. C. Wild's lithograph of the waterworks, published by J. T. Bowen in 1838. Constructed in 1815, the waterworks were so popular that "three stages have been established which run daily from different parts of the city to Fair Mount and average about six trips a day."[1] The waterworks became the site of the national centennial in 1876.

[1] *American Processional, The Story of Our Country* (The National Capitol Sesquicentennial Commission, The Corcoran Gallery of Art, Washington, D.C., 1950), p. 105.

satt, Mary (1844 – 1926)

JISINE W. HAVEMEYER

Fig. 109

H. 29"; w. 24" 1896
pastel on paper
Gift of: J. Watson Webb, Jr., 1973
Exhibited: M. Knoedler and Co., New York, 1967
 Metropolitan Museum of Art, December 13, 1974-February 16, 1975
cat. #27.3.1-19)

relationship between Louisine Waldron Elder Havemeyer and Mary Cas-
has farther reaching connotations than would usually be true between two
hen of similar backgrounds. Mary Cassatt, the daughter of a wealthy Penn-
ania banker, first studied art at the Pennsylvania Academy of Fine Arts
1861 to 1865 before persuading her family to let her study in Europe in
6. Seven years later she met teen-aged Louisine Elder (later Mrs. Henry O.
emeyer), then a student at a boarding school in Paris run by Madame del
e. The two quickly became intimate friends. Not long afterwards Miss
satt encouraged her young friend to purchase a Degas pastel entitled LA
PETITION DE BALLET for 500 francs (then worth about $100).[1] It was the
of many works of art selected at Miss Cassatt's suggestion and the begin-
of the Havemeyer collection. Some twenty years later, Mary Cassatt
ted this portrait of Louisine with sensitivity and candor. The bold yellow
kground and angular patterns reflect the influence which Japanese prints
on the painter.[2] Rarely returning to America, Mary Cassatt spent most of
life in Paris where she became associated with the Impressionists, exhibit-
with them in 1877, 1879, 1880, 1881, and 1886. Degas in particular was a
r influence in her life. She spent her last years, after 1893, in a country
se called Château de Beaufresne, thirty miles northwest of Paris. Although
never married, Miss Cassatt concentrated on painting women and chil-
n, capturing their relationships with considerable sensitivity.

his pastel sold in 1965 for $410,000.
her portraits which Miss Cassatt painted of the Havemeyer family include: PORTRAIT OF MRS.
EMEYER AND HER DAUGHTER ELECTRA (1895), PORTRAIT OF ADELINE HAVEMEYER
), and PORTRAIT OF ADELINE HAVEMEYER IN A WHITE HAT (c. 1899), all illustrated in Adelyn
e Breeskin, *Mary Cassatt, A Catalogue Raisonné of the Oils, Pastels, Watercolors, and Draw-
(Washington, D.C.: Smithsonian Institution Press, 1970).

MOTHER ROSE NURSING HER CHILD

Fig. 85

H. 28¼"; w. 22¾" c. 1900
pastel on tan paper
signed, l.r.: "Mary Cassatt"
Gift of: Mrs. Dunbar W. Bostwick
(cat. #27.3.1-29)

85.

This is one of the many mother and child portraits by Mary Cassatt. An oil ver-
sion of the same family group is in a private collection in London.[1]

[1] *Ibid.*, MOTHER ROSE LOOKING DOWN AT HER SLEEPING BABY (c. 1900 oil on canvas, 28 x 23,
Collection of Mr. & Mrs. Neville Blond, London), p. 139.

86.

Attributed to

Chambers, Thomas (c. 1815 – after 1866)

VIEW OF WEST POINT Fig. 87

H. 22¼"; w. 30½"
oil on canvas
(cat. #27.1.2-65)

Born in England in 1815, Thomas Chambers came to America in 1832 where for the next nine years he resided in New York City. Between 1843 and 1851 he lived in Boston, from 1852 to 1857 was in Albany, and thereafter returned to New York City. While he is known to have painted portraits, only his marine and landscape paintings have been found. This example was undoubtedly based upon a print which he has, in his unique style, transformed into an extremely decorative expression of design and color. At least two other versions of this painting exist.[1]

[1] (22 x 30") Minneapolis Art Institute, illustrated in Alice Ford, *Pictorial Folk Art, New England to California* (New York: The Studio Publications, Inc., 1949), p. 113; and *Kennedy Gallery Quarterly* (New York: Kennedy Galleries, Inc., January, 1974), V. XIII, no. 1.

ITALIAN SCENE WITH BRIDGE

H. 18"; w. 24"
oil on canvas
(cat. #27.1.2-89)

Another painting undoubtedly copied from a print, this scene was also repeated by Chambers at least twice, but from slightly different perspectives.[1] Nevertheless, each painting maintains a freshness and unique vitality.

[1] See Peter H. Tillou, *Nineteenth-Century Folk Painting: Our Spirited National Heritage* (Storrs: The University of Connecticut, 1973), #130; and *The Kennedy Quarterly* (New York: Kennedy Galleries, Inc., January, 1972), XI, Number 3, p. 153.

88.

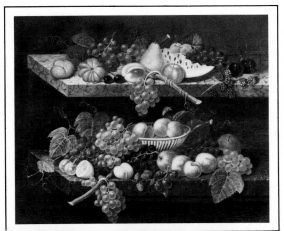

Chace, Lester Merton, Jr. (1925 –)

MRS. HENRY O. (LOUISINE WALDRON ELDER) HAVEMEYER (1855-1929)

H. 21"; w. 17" 1955
oil on canvas
on verso (on stretcher): "painted in 1955"
(cat. #27.1.1-168)

HENRY OSBORNE HAVEMEYER (1847-1907)

Fig. 86

H. 20¾"; w. 17¼"
oil on canvas
(cat. #27.1.1-169)

MRS. HENRY O. (LOUISINE WALDRON ELDER) HAVEMEYER

H. 20¾"; w. 17¼" 1974
oil on canvas
(cat. #27.1.1-188)

MRS. HENRY O. (LOUISINE WALDRON ELDER) HAVEMEYER

H. 30"; w. 18" 1954
oil on canvas
signed, l.l.: "L M CHACE/1954"
(cat. #27.1.1-176)

All of these oil paintings have been done from photographs by Lester M. Chace, Jr., an artist still living in Pekin, Illinois where he was born in 1925. He received a B.A. degree from Columbia College and continued his education at Columbia School of Philosophy and Science. He has exhibited regularly, specializing in portraits.

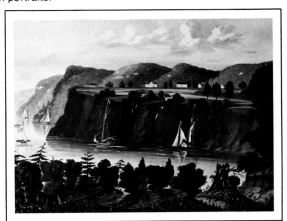

87.

Chandler, Joseph Goodhue (1813 – 1884)

STILL LIFE: VARIOUS FRUITS Fig. 88

H. 25¼"; w. 30¼" 1866
oil on canvas
signed, l.r.: "J. G. Chandler 1866"
(cat. #27.1.3-21)

Joseph Goodhue Chandler was born in South Hadley, Massachusetts in 1813, the second child of Capt. David Chandler Clarissa Goodwin. Originally trained as a cabinet maker, he studied painting under William Collins of Albany. In 1840 he m ried Lucretia Ann Waite of Hubbardstown, Massachusetts (1820-1868) who was also a painter.[1] Settling in Boston betw 1852-1860 in a studio at 69 Bedford Street, Chandler becam adept at painting children's portraits. He is known to have pai a portrait of Daniel Webster (now in the New York Historical S ety) and made thirty copies of it, all of which were readily sold 1860 he purchased a farm in Hubbardstown, Massachusetts where he died in 1884. Another almost identical still life by Ch dler is in the Museum of Fine Arts, Boston.[2]

[1] She exhibited at the Boston Athenaeum and later taught drawing at the Will Academy in Easthampton, Massachusetts. (Groce & Wallace, *op. cit.,* p. 119.)
[2] 25 × 30, M. & M. Karolik Collection, Museum of Fine Arts, Boston.

89.

andler, Winthrop (1747 – 1790)

IELF OF BOOKS

Fig. 89

H. 27″; w. 58″ c. 1769
oil on wood
(cat. #27.1.6-10)

e youngest son of William and Jemima Bradbury Chandler,
nthrop Chandler was born in Woodstock, Connecticut on April
1747. Apprenticed in Boston to a painter-artisan, he became
ll versed in many mediums, doing house painting, heraldic
nting, japanning, gilding, and portrait painting. By 1785 he
led himself a limner.
This painting was the overmantle of the old McClellan house in
uth Woodstock, Connecticut. Chandler painted it for his
ther-in-law, General Samuel McClellan, in the lower southeast
m of the General's new house, built in 1769. In 1814 Rhodes
old bought the house, and ran it as the Arnold Inn for many
rs.[1] When the paneling in the house was taken down to re-
ve the shelf overmantle, a landscape view appeared on the
ster wall underneath. A second painting on plaster was also
ealed behind the paneling in the adjoining room.[2]

Art in America, April, 1947, p. 159.
Letter from Nina Fletcher Little, December 12, 1971, Shelburne Museum, MSS.

ase, F. B.

AMES M. FOSS"

H. 11¾″; w. 27¾″
ink on paper
signed, l.r. on diagonal: "Drawn. By./F. B. Chase.? St. Albans, Vt."
(cat. #27.9-60)

is very carefully drawn pen and ink drawing depicts the
rmont Central Railroad Engine "James M. Foss" in
ofile.

ase, William Merritt (1849-1916)

RS. JAMES WATSON (LAURA VIRGINIA CRAM)
EBB (1826 – 1890)

Fig. 91

H. 24″; w. 20″ c. 1880
oil on canvas
(cat. #27.1.1-170)

91.

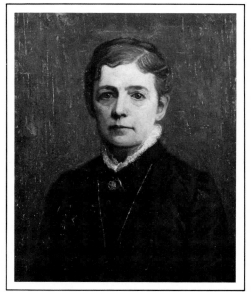

90.

Chase, William M.

GENERAL JAMES WATSON WEBB (1802 – 1884)

Fig. 90

H. 36″; w. 31⅛″ 1880
oil on canvas
(cat. #27.1.1-114)

William Merritt Chase, born in Franklin, Indiana, first studied painting with a local
portrait painter, Benjamin F. Hayes, in Indianapolis and then attended the Na-
tional Academy of Design in 1869. After going to St. Louis where his family had
moved, Chase was sent abroad by some businessmen to study painting in 1872.
There he studied in Munich with Alexander Wagner and Karl von Piloty, sharing a
studio with Frank Duveneck. With Duveneck and John Twachtman he travelled to
Venice in 1877, returning to New York the following year where he was invited to
become a teacher at the newly formed Art Students League. He became ex-
tremely effective as a teacher, and his studio, at 51 West 10th Street, was a noted
meeting place for both other artists and students. He continued to teach — at the
Brooklyn Art School in 1890; at Shinnecock, Long Island; the Chase School in
New York; the New York School of Art; the Pennsylvania Academy of Fine Arts;
and in 1914 in Carmel, California. He was President of the Society of American
Artists from 1885 to 1889 and in 1902 joined Ten American Painters, a kind of
academy of American Impressionism.
 Chase's portrait of General Webb was displayed at the Society of American Ar-
tists' third exhibition in March of 1880,[1] and appeared as an engraving in Harper's
Weekly on April 17, 1880.[2]
 Webb, grandfather of the Museum's co-founder, J. Watson Webb, was born in
Claverack, New York in 1802, son of Samuel Blachley Webb and his second wife,
Catherine Hogeboom. Orphaned at the age of five, James Watson was raised by
his aunt and later by a sister. In 1816 he went to work in his older brother Henry's
general store in Cooperstown, and three years later joined the Army Artillery
Corps. After a successful military career, he married Helen Lispenard Steward in
1823 and resigned his commission in 1827 to become editor and proprietor of the
New York Morning Courier (later the Courier and Enquirer). Following his first
wife's death in 1848 he married Laura Virginia Cram, pictured here. He served
briefly as United States' charge d'affaires at Vienna in 1849 before the Austro-
Hungarian hostilities caused his recall. During the 1850's he made a slow transi-
tion from the Whig to the Republican party, supporting William Seward's bid for
the Presidency in 1860. In 1861 he sold his newspaper to the New York World to
become U. S. Minister in Brazil, serving in that post for eight years.[3]

 [1] The Art Journal (Appleton, 1880), p. 155.
 [2] The illustration depicts a larger portrait, portraying General Webb's knees and more of the chair on the
right. Shelburne's portrait has been cut down.
 [3] James L. Crouthamel, James Watson Webb (Middletown, Connecticut: Wesleyan University Press,
1969).

92.

Attributed to
Church, Frederic Edwin (1826 – 1900)

WOODLAND SCENE

Fig. 92

H. 14"; w. 18¼" 1856
oil on canvas
signed, l.r.: "Frederick E. Church/1856"
(cat. #27.1.5-22)

Frederic Edwin Church was born in 1826 in Hartford, Connecticut where he studied painting c. 1842-1843 with Benjamin Hutchins Coe and Alexander Hamilton Emmons. In 1844 he moved to Catskill, New York, where he became a pupil and great friend of Thomas Cole. By 1845 he was exhibiting at the National Academy of Design, and later at the American Art Union, Boston Athenaeum, and Pennsylvania Academy of Fine Arts. He travelled widely — sketching and drawing in Connecticut, Maine, Vermont, Kentucky, Grand Manan Island and the Bay of Fundy, and in 1853 going to Ecuador and Columbia. He was to continue to travel through the United States and Canada, South America, Jamaica, and Mexico and in Europe, Egypt, Jerusalem, Beirut and Cyprus. A naturalist with a scientist's approach to the study of the natural landscape, Church has in this painting described the play of light through heavy foliage very effectively.

Coates, Edmund C. (active 1837 – 1857)

NIAGARA FALLS

Fig. 93

H. 22¼"; w. 21" c. 1850
oil on canvas
signed, l.l.: "E. C. Coates"
(cat. #27.1.2-80)

Edmund C. Coates is known to have been in New York Ci by 1837 and is listed in the 1837, 1841, and 1842 directories as Edmund C., Edmund F. or Edward Coates. In 1839-1840 he exhibited at the Apollo Gallery, and in 184 at the National Academy of Design. He painted mostly Ne York and Italian scenes, the latter probably from prints. This painting of Niagara Falls depicts a scene which attracted many American artists. The first known represent tion of the Falls was done by Father Louis Hennepin in 1678.

93.

Colman, Samuel (1832 – 1920)

YEATMAN FAMILY

Fig. 94

H. 24"; w. 31½"
oil on wood
signed, l.l.: "S. Colman"
Inscribed, beneath each figure: "1. Sarah Marwood Yeatman.
2. Louisa Woolcut Yeatman, 3. Rhoda Charlton Yeatman, 4. Mary Bogg, 5. Harry Farr Yeatman."

(cat. #27.1.7-3)

Born in Portland, Maine, Samuel Colman was the son of Samuel Colman, Sr., a bookseller and publisher. Moving to New York City, Colman studied painting with Asher Durand, and was soon represented at all of the major exhibitions — the National Academy of Design, the Boston Athenaeum, and the Pennsylvania Academy of Fine Arts. Continuing his study in Europe and North Africa during two trips from 1860-1862 and 1871-1875, Colman later organized the American Society of Painters in Water Color, serving as its first president. In Irving-on-Hudson and Newport, Rhode Island for a brief period upon his return to the United States, Colman then moved to New York City. It was probably at this point that he became the friend of Henry O. Havemeyer. Together they had visited the Philadelphia Centennial in 1876. Having known Louis Comfort Tiffany, the interior designer, from their student days, Colman now began working for him. When the Havemeyers asked Tiffany to design the interiors and furnishings for their 1 East 66th Street home, Colman became very much involved. Using the Japanese textiles which he remembered Mr. Havemeyer buying at the Centennial, Colman made them into a mosaic to cover the library ceiling, outlining them with heavy braid and carved molding. He also invented a method of staining oak with acid in imitation of Japanese lacquer which was especially effective, designed furniture, and carved woodwork for the Havemeyer house.[1]

94.

[1] Aline B. Saarinen, *The Proud Possessors* (New York: Random House, 1958), pp. 154-155.

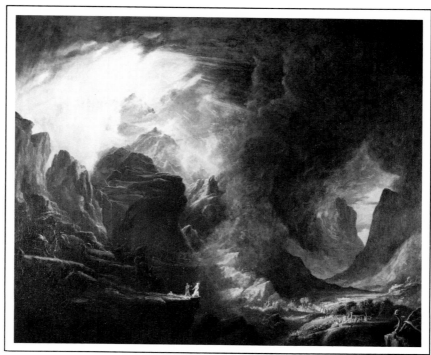

95.

Cole, Thomas (1801 – 1848)

MOSES ON THE MOUNT

Fig. 95

H. 48″; w. 62½″ c. 1827
oil on canvas
signed, l.r.: "T. Cole"
Exhibited: Wadsworth Athenaeum, November 12-January 2, 1949
 Whitney Museum, January 8-January 30, 1949
 "The Best of Shelburne" IBM Gallery, November-December, 1964
(cat. #27.1.2-35)

Cole wrote:
 In the terrible and the grand . . . when the mind is astonished, the eye does not dwell upon the
 minute but seizes the whole. In the forest, during the hour of tempest, it is not the bough playing
 in the wind, but the whole mass stooping to the blast that absorbs the attention: the detail,
 however fine, is comparatively unobserved.[1]
In this very large painting, Cole expresses his concept of the power and mystery of nature so
graphically that the figures are completely overwhelmed. He has selected a Biblical scene from
Exodus 32. The Israelites are shown, in the lower portion of the painting, worshipping the Golden
Calf they had fashioned from their earrings. An old sketch in the New York Historical Society may
be the study for this painting. Possibly it is the MOSES ON THE MOUNT exhibited by Coles (sic) at
the Boston Athenaeum in 1827.[2]

[1] Quoted in Barbara Novak, *American Paintings of the Nineteenth Century* (New York: Praeger Publishers, 1969), p. 63, from
Rev. Louis Noble, *The Course of Empire, Voyage of Life and Other Pictures of Thomas Cole, N.A.* (New York: Cornish, Lampert,
and Co., 1853), p. 117.
[2] Information from Prof. Howard S. Merritt, University of Rochester, letter to the author, October 20, 1974, Shelburne Museum
MSS.

VIEW OF THE ARNO

H. 17″; w. 25¼″ 1838
oil on wood
signed, l.r.: "T. Cole/1838"
(cat. #27.1.2-57)

By the time Thomas Cole painted this scene, he had had considerable artistic experience. He was
first trained as an engraver in England, where he was born in Bolton-le-Moors in 1801. Arriving in
the United States in 1818, he was painting portraits in Steubenville, Ohio; Pittsburgh, and
Philadelphia as early as 1822. Landscapes increasingly attracted his attention, the paintings of
Thomas Birch and Thomas Doughty in particular. By 1825 Cole had settled in New York, after
which he began to travel along the Hudson, in the Catskills and White Mountains, to Lake George
and Niagara. In 1826 he moved to Catskill, New York, and built a home on a bluff overlooking the
mountains and the Hudson River. Returning to England in 1829, he moved briefly to Paris before
spending two years in Italy. After returning to the United States in 1832, he painted this scene of
the Arno six years later, undoubtedly done from a sketch made while abroad. Always caught be-
tween his acute vision of reality in nature but wishing to express the moral good and the ideal
which he felt in it, Cole has in this painting struck a compromise. While bathed in the romantic glow
of a setting sun, this view still candidly depicts a believable place.

Cook, Nelson (1817 – 1892)

LITTLE DANDY

Fig. 96

H. 60½"; w. 43¼" 1840
oil on canvas
signed, on verso (under relined canvas): "Painted by Nelson Cook./*Saratoga
Springs./1840*"
Exhibited: Munson-Williams-Proctor Institute, Utica, New York, October 15
through December 3, 1960
(cat. #27.1.1-121)

Nelson Cook is known to have been painting in Saratoga Springs,
New York from 1840 to 1844, was in Rochester, New York from
1852 to 1856, and was back in Saratoga from 1857 to 1859. *The
Boston Transcript* obituary column of July 29, 1892, describes
Cook as a well-known artist, poet, and portrait painter. He exhib-
ited at the National Academy between 1841-1844, in 1852, and
from 1856 to 1859.

96.

96.

Cook, Robert (active 1830's and 1840's)

C. CHELSEY, ESQ. (1773 – ?)

Fig. 97

H. 24¼"; w. 20" 1830
oil on canvas
Inscribed on verso: "C. Chelsey Age 57/R – t Cook pinxt 1830/A D 60"
(cat. #27.1.1-100)

A portrait painter and lithographic draftsman, Robert Cook in the
1830's was the chief draftsman of Moore's lithographic estab-
lishment in Boston. Prior to 1841 he went into business as a por-
trait painter with his former pupil, Benjamin Champney. The same
year they visited Europe together. This is obviously one of Cook's
earliest works.

97.

Cooke, L. A.

U.S. REVENUE STEAMER NANSEMOND 1869

Fig. 99

H. 24″; w. 36″ 1869
oil on canvas
signed, l.r.: "LACooke"
(cat. #27.1.4-74)

The U.S. Revenue Steamer NANSEMOND of 35 tons was built in Williamsburg, New York in 1862. First called the JAMES F. FREEBORN with a homeport in New York City, the steamer was sold to the U.S. Treasury Department in September of 1865 where she was rechristened NANSEMOND. Nothing is known of L. A. Cooke who painted this careful depiction.

Cooke, George (1793 – 1849)

WEST POINT FROM ABOVE WASHINGTON VALLEY

Fig. 98

H. 24″; w. 32″ c. 1833
oil on canvas
(cat. #27.1.4-67)

This painting was used as a source for a colored aquatint entitled WEST POINT FROM ABOVE WASHINGTON VALLEY, LOOKING DOWN THE RIVER, NEW YORK.[1] Another print of this view was published by Currier and Ives. The artist, George Cooke, was born in St. Mary's County, Maryland, in 1793, the son of a country lawyer. After some training in Washington with Charles Bird King, Cooke began a career as a painter in Virginia and Maryland in 1819. In 1824-1825 he was in Richmond, after which he went to Europe between 1826 and 1831, studying in Italy and France. During the next ten years he travelled about the United States and exhibited at all of the major academies. In the early 1840's Cooke was in Athens, Georgia, and from 1844-1849 had a studio and gallery at 13 Charles Street, New Orleans, where he displayed the works of Sully, Cole, and Doughty, among others. A gallery displaying his own work was built by his patron Daniel Pratt, a manufacturer of cotton gins, in Prattsville, Alabama.[2] In addition to painting portraits of many famous Washington politicians, Cooke was among those commissioned by Thomas L. McKenny of the Indian Department to make portraits of Indians visiting the Capitol. Tragically, on January 15, 1865 a fire destroyed almost all of the 120 portraits, six of which were by Cooke. He died of cholera in New Orleans in March of 1849.

[1] Published by Lewis P. Clover, 180 Fulton Street, 1834, painted by George Cooke, engraved by W. J. Bennett (15¾ x 22¾: 19 x 25, 1834).
[2] The Gallery later suffered dry rot and Cooke's descendants scattered the paintings. A catalogue entitled "Descriptive Catalogue of Paintings in the Gallery of Daniel Pratt, Prattsville, Alabama, Together with a Memoir of George Cooke, Artist" (Prattsville: Howell and Luckett, printers, 1853), is located in the Valentine Museum, Richmond, Virginia.

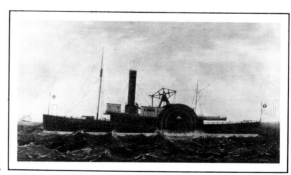

99.

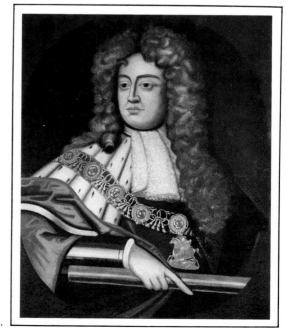

100.

tributed to

per, J. (c. 1695 –)

NCE GEORGE OF DENMARK, QUEEN ANNE'S CONSORT
3 – 1708)

Fig. 100

H. 29¾″; w. 24½″ c. 1714
oil on canvas
n verso: "C.T.E."
Gift of: Mrs. Katharine Prentis Murphy, 1960
cat. #27.1.1-101)

ce George married Anne, second daughter of King James II, reigned over England from 1707-1714. During this time rge bore the title, "His Royal Highness George, Prince of mark, High Lord Admiral of England, General of Her Majesty's es and Lord Ward of the Cinque Porte & C." Another oil por- of Prince George by Cooper is in the collection of the Henry cis du Pont Winterthur Museum, and a mezzotint of him by J. h, c. 1704, after a painting by Sir Godfrey Kneller, is in the dron Phoenix Belknap, Jr. Research Library of American ting at Winterthur.[1]

ustrated in Waldron Phoenix Belknap, *American Colonial Painting*, (Cambridge: ard University Press, 1954), p. XLIII.

101.

Copley, John Singleton (1738 – 1815)

JOHN SCOLLAY (1712 – 1790)

Fig. 101

H. 36″; w. 28½″ c. 1760
oil on canvas
Exhibited: "One Hundred Colonial Portraits," Boston Museum of Fine Arts, 1930
(cat. #27.1.1-78)

By 1760 Copley was beginning to move away from his earlier style of portraiture, the poses and settings of which were taken directly from European mezzotints, to develop a self-assured style of his own. The personality and individuality of his sitter became of primary importance — not his social standing or attire. His subject in this portrait was one of Copley's friends, and one of Boston's leaders in the impending fight with the Crown. The son of James and Deborah Bligh Scollay, John Scollay was a fire warden in Boston. In 1761 he signed a petition protesting the British high tariffs, was elected a selectman in Boston in 1764, was relected in 1773, and from 1774 to 1799 was chairman of the Board of Selectmen. He was one of the four of seven selectmen who remained in Boston throughout the Revolution. Boston's Scollay Square was named after him and his descendants.[1]

[1] Copley did a pastel of John Scollay (now at the Museum of Fine Arts, Boston, loaned by Mrs. Edward Whitney Kimball in 1965), and an oil portrait of MRS. JOHN (MERCY GREENLEAF) SCOLLAY, 1763 (location unknown).

Costa, R. (active 1840's)

WHALE WITH A LONG TAIL

H. 13½″; w. 11″ c. 1840
oil on wood
signed, l.r.: "R. Costa"
Gift of: Otto Kallir, 1957
(cat. #27.1.4-30)

This is one of six known whaling paintings by R. Costa, reputedly a cook on a whaling vessel.

102.

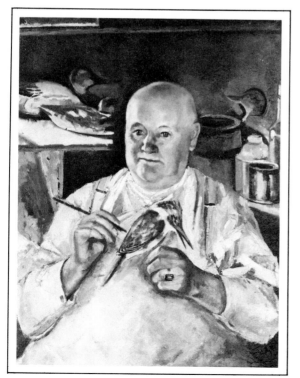

102. Liberty Coach, Shelburne Museum Collection

Crafty, Victor Georges

LIBERTY COACH

Fig. 102

H. 12½″; w. 16½″ 1900 – 1901
watercolor on paper
signed, l.r.: "Crafty"
Gift of: James Hazen Hyde
(cat. #27.2.5-6)

Victor Georges Crafty was the author
of two books — PARIS AU BOIS, writ-
ten in 1890, and PARIS A CHEVAL, in
1883. Shown in France, James Hazen
Hyde is driving the Road Coach "LIB-
ERTY," now in the Shelburne Museum
collection.

Crocker, Martha (active 1936)

A. ELMER CROWELL (1861 – 1952)

Fig. 103

H. 33¼″; w. 25″ 1936
oil on canvas
signed, u.r.: "Martha Crocker/1936"
Gift of: Mrs. Stuart Crocker, in memory of her husband
(cat. #27.1.1-174)

This portrait of A. Elmer Crowell, was painted by the
donor's sister-in-law, a New England portrait
painter, in 1936. The son of a Cape Cod fisherman
and cranberry grower, A. Elmer Crowell was a well-
known decoy carver, and much of his work is exhib-
ited in the Shelburne Museum's Dorset House.

103.

104.

Crockett, Lucy Herndon

SHELBURNE MUSEUM AND THE J. WATSON WEBB FAMILY

Fig. 104

H. 17¼"; w. 29" 1956
decoupage on heavy, lacquered cardboard
signed, l.r.: "LHCrockett/1956"
(cat. #27.15-5)

This large decoupage arrangement was made by Lucy Crockett as a gift for Mrs. Webb from her son, J. Watson Webb, Jr. It includes many of the buildings and objects in Shelburne's collection, as well as photographs of the Webb family. The artist wrote the book *The Magnificent Bastards* which was adapted for the movie "The Proud and the Profane."

Cropsey, Jasper Francis (1823 – 1900)

COUNTRY LANE TO GREENWOOD LAKE

Fig. 105

H. 39¼"; w. 60¼" 1846
oil on canvas
signed, l.l.: "J. F. Cropsey/1846"
(cat. #27.1.2-92)

Jasper Francis Cropsey was born in Staten Island, New York, in 1823. While apprenticed to the architect, Joseph Trench in New York City between 1837 and 1842, he began taking painting lessons with Edward Maury. By 1843 his technique had progressed enough to exhibit ITALIAN COMPOSITION at the National Academy. The same year he opened an architectural office in New York City and made his first visit to Greenwood Lake (a body of water extending across the New Jersey-New York border). In 1844 he became an Associate Member of the National Academy, exhibiting a painting of Greenwood Lake.[1] The Lake became a favorite painting site, as this example confirms, and many paintings of it were exhibited by Cropsey, both at the National Academy and the American Art Union.[2]

[1] #68, 1844, National Academy of Design, VIEW IN ORANGE COUNTY WITH GREENWOOD LAKE IN THE DISTANCE, AFTER A SKETCH TAKEN OCTOBER 4, NEAR SUNDOWN. The same painting was exhibited at the American Art Union that year.
[2] National Academy of Design: 1854 — THE GREENWOOD WATER; 1857 — GREENWOOD LAKE: SUNRISE; 1858 — GREENWOOD LAKE. American Art Union: 1843 — GREENWOOD LAKE, AND GREENWOOD CREEK; 1846 — NEW JERSEY FROM ORANGE CO., NEW YORK, GREENWOOD LAKE IN THE DISTANCE.

105.

Crowell, Anthony Elmer (1862 – 1951)

HUNTER AND RABBITS

H. 8"; w. 12"
oil on wood
signed, l.l.: "E. Crowell"
Gift of: Mrs. Stuart Crocker, 1966
(cat. #27.1.5-48)

ELMER CROWELL'S DUCK AND GOOSE BLIND

Fig. 106

H. 9¼"; w. 24¼" 1908
oil on canvas
signed, l.r.: "A. E. Crowell"
on verso: "I built the Blind 1876/shot from it for/32 years in season/for mark
 Elmer Crowell/Cape Cod"
Gift of: Mrs. Stuart Crocker, 1966
(cat. #27.1.5-47)

A. (Anthony) Elmer Crowell was born in East Harwick, Cape where he lived all of his life. An avid hunter, Crowell was as a young man hired as a guide and later ran hunting camps along the Cape. At about the age of ten, he began carving decoys by about 1908 was making them in quantities. A carver for over forty years, Crowell used white cedar exclusively in his work. about 1918 he began carving miniature song and shore birds eighty-two of which are in the Shelburne Museum's Dorset Ho along with one of Crowell's guns.

106.

107. Charles Deas, THE DEATH STRUGGLE

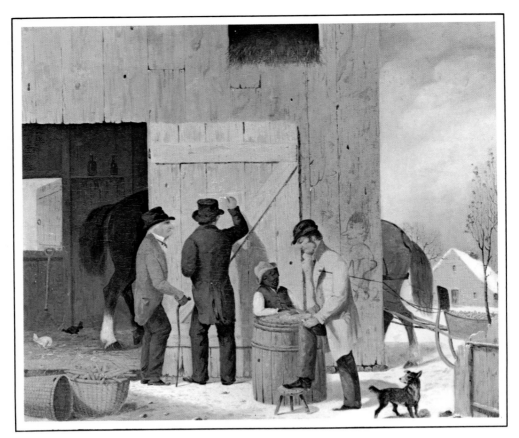

108. George Henry Durrie, SETTLING THE BILL

108. G. H. Durrie's Account Book, Shelburne Museum Collection

109. Mary Cassatt, LOUISINE W. HAVEMEYER

Charles L. Heyde, STEAMER OFF SHELBURNE POINT 110.

111. Erastus Salisbury Field, GARDEN OF EDEN

112. Martin Johnson Heade, COASTAL
SCENE WITH SINKING SHIP

113. Fitz Hugh Lane,
MERCHANTMEN OFF BOSTON HARBOR

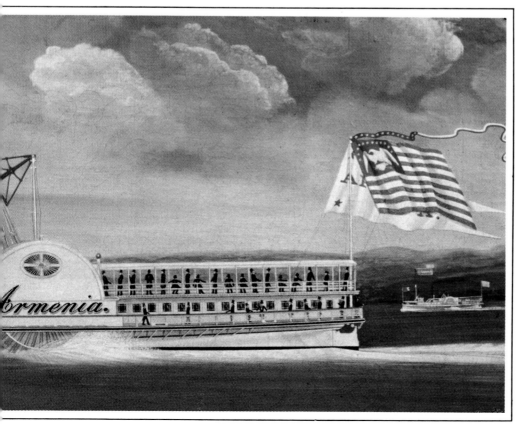

114. James Bard, ARMENIA

115. Edward Lamson Henry, OLD CLOCK ON THE STAIRS

Attributed to

Davis, J. A.

MARY ECCLESTON HOXSIE Fig. 116

H. 6¼"; w. 4¾" c. 1844
watercolor on paper
(cat. #27.2.1-22)

116.

Mary Eccleston Hoxsie of Westerly, Rhode Island was born in Jewett City, Connecticut. Her portrait, according to a past owner, was painted in Norwich, Connecticut. For many years watercolors by this artist were attributed to Eben Davis on the basis of an inscription on one.[1] It is now believed, because of several signatures, that J. A. Davis is the artist. Usually his portraits are in three-quarter view, done with pencil outlines and filled in with watercolor. The hands are ordinarily poorly done. All of the known examples of Davis' work date between 1837 and 1851 and were painted in eastern New Hampshire, Massachusetts, Connecticut, or Rhode Island. The artist is possibly a Joshua A. Davis, listed as a portraitist in Providence, Rhode Island directories from 1854 to 1856.[2]

[1] See the portrait of Mr. and Mrs. Eben P. Davis, inscribed along the frame, "Mr. and Mrs. Eben Davis of Byfield, Mass. Painted by Mr. Davis before their marriage about 1860," illustrated in Norbert and Gail Savage's article, "J. A. Davis," The Magazine *Antiques* (November, 1973), p. 874.
[2] *Ibid.*, p. 875.

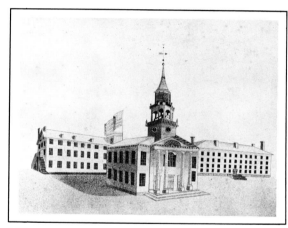

117.

Deas, Charles (1818 – 1867)

THE DEATH STRUGGLE Fig. 107

H. 30"; w. 25" 1845
oil on canvas
signed, l.r.: "C. Deas./1845"
Exhibited: Pennsylvania Academy of Fine Arts, 1852 (#211, owner R. B. A. Hewlings); 1855 (#427, owner E. P. H.); and 1857 (#303 owner E. Hewlings).
Art of the Western Frontier, IBM Gallery, March 23-April 18, 1964.
(cat. #27.1.5-18)

The painter Charles Deas grew up in Philadelphia. He was first exposed to art in visits to Thomas Sully's studio and the Pennsylvania Academy of Fine Arts. In 1836 he studied briefly at the National Academy, and the following year became acquainted with George Catlin's western paintings at the Indian Gallery in Philadelphia. In 1840 he moved west, first to Fort Crawford in Prairie du Chien (now Wisconsin, then Michigan Territory) where his brother was an officer in the Fifth Infantry. He continued to travel — to Fort Atkinson, Rock River, Fort Winnebago, and on to Fort Snelling (at the juncture of Minnesota and Mississippi Rivers) where he may have met Seth Eastman (see p. 62) who was stationed there. Moving south to Fort Leavenworth and the Pawnee Villages along the Platte River, Deas was in St. Louis, probably in 1845 when this painting was done. Romantic and dramatic themes obviously appealed to him. From 1847-1849 he sent pictures from St. Louis to the National Academy and the American Art Union, and later moved back to New York City. Sometime before 1859 he suffered a nervous breakdown and entered an asylum. Although he is known to have done many paintings, few survive. Many of the others were perhaps destroyed in the St. Louis fire of 1849.

Davis, W. W. H. (active 1842)

NORWICH UNIVERSITY, VERMONT

Fig. 117

H. 8¼"; w. 10¼" 1842
pen and ink on paper, mounted on wood
signed, l.r.: "W. W. H. D./Pinxt"
Inscribed: "Norwich University, Vermont"
on verso (on stretcher): "Drawn by W. W. H. Davis 1842"
(on wooden backing): "For Mr. S. A. W. Patterson"
(cat. #27.9-42)

Mr. Davis was a cadet at Norwich University, Northfield, Vermont, in 1841-1842. The Museum has in its manuscript collection his private journal, written in 1841.

117. W. H. H. Davis' Journal, Shelburne Museum Collection

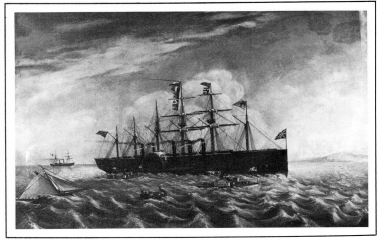

118.

Doughty, Thomas (1793 – 1856)

LATE SUMMER

H. 17½"; w. 24" 1834
oil on canvas
signed, l.c.: "T. Doughty/1834"
(cat. #27.1.2-76)

Thomas Doughty, born in Philadelphia, was apprenticed to a leather merchant at age sixteen. As an artist, largely self-taught, he took a night school drawing course, and a few lessons in oil from Thomas Sully (1783 – 1872). By 1824 he was a member of the Pennsylvania Academy of Fine Arts, and by 1827 was an honorary member of the National Academy of Design. He rarely stayed in one place long, travelling through Pennsylvania, Maryland, New York, and New England, and to Europe in 1837 – 1839 and from 1845 – 1846. In 1830 lithographs of his work were reproduced in a book, published by his brother, John Doughty, in Philadelphia, entitled CABINET OF NATURAL HISTORY AND AMERICAN RURAL SPORTS. From 1832 to 1837 he was in Boston, during which time this painting was done. He exhibited at both the Boston Athenaeum and Chester Harding's Gallery, and spent the rest of his life in New York.

FORMAL GARDEN, PHILADELPHIA

H. 26"; w. 36"
oil on canvas
(cat. #27.1.2-84)

ON THE SUSQUEHANNA Fig. 119

H. 27¼"; w. 20"
oil on canvas, mounted on a cradled reinforcement
signed, l.l.: "T. Doughty"
(cat. #27.1.2-85)

An enthusiastic outdoorsman, Doughty responded with deep emotion to the landscape, and was "one of the first to see this wild and lonely continent as a theme of art."[1] Two views of the Susquehanna by Doughty were exhibited at the American Art Union. This may be one of them.[2]

[1] E. P. Richardson. *A Short History of Painting in America* (New York: Thomas Y. Crowell, 1963), p. 116.
[2] 1838, VIEW ON THE SUSQUEHANNA, NEAR WYOMING, from a recollection, and 1849, SUSQUEHANNA SCENERY.

Attributed to

Leicester C. Douglas

PORTRAIT OF AN UNSMILING LION Fig. 120

H. 16⅛"; w. 16"
oil on canvas
signed, on verso: "L. E. Douglas"
Gift of: E. Grafton Carlisle, 1959
(cat. #27.1.5-6)

While signed with the signature of Leicester C. Douglas, there is some evidence in the Shelburne Museum records that this painting was done by a lady in Waterbury, Vermont. Mr. Douglas lived in Burlington, Vermont, and the painting was acquired from his estate.

Deming, M. J.

GREAT EASTERN Fig. 118

H. 28"; w. 44" 1870
oil on canvas
signed, l.r.: "M. J. Deming, 1870"
(cat. #27.1.4-15)

Five times larger than any ship of her day, THE GREAT EASTERN w 693 feet long, 120 feet wide, had five funnels, six masts, two sets of gines, and carried 6,500 square yards of sail. Built in London begin ning in 1854, her engineer was Isambard Kingdom Brunel. Designe make the 22,000 mile trip to Ceylon without refueling, THE GREAT EASTERN from the first was plagued with difficulties. Launched tw months behind schedule, immediate financial failure put her back in dock where she was redone for the Atlantic crossing with 300 plus staterooms. She began her first trip to New York in August of 1859 blew her forward funnel. In September, 1861, a hurricane tore off h starboard paddlewheel and damaged her rudder, causing twenty-se major bone fractures to her passengers and $300,000 damage. Du her third trip to New York in 1862 she hit bottom near the Montauk li ripping her hull open eighty-three feet. Three corporations went ba rupt because of her. In 1866, her crew began to lay the first Atlanti ble. Success was finally attained on July 27, 1866. In 1867 French capitalists chartered the ship to convert her to a passenger ship, another financial failure. Purchased by Reuters, Ltd. in 1869, she l several other cables, including the British-India cable from Bomba Aden. Idle for many years, THE GREAT EASTERN could not be a tioned, and she was sold for scrap in 1889.

119.

120.

w, Clement (1807 – 1899)

EAM PACKET *INDEPENDENCE* Fig. 121

H. 18″; w. 27¼″ 1836
oil on canvas
on verso (on tag): "Title: Steamboat Independence/Artist: C. Drew"
(cat. #27.1.4-23)

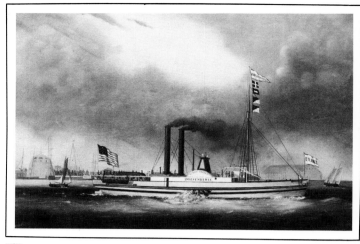

121.

his painting the INDEPENDENCE of 368 tons is shown near the Battery at
southern end of Manhattan. Built in New York in 1827 by Brown and Bell,
was 128 feet long and twenty-six feet across the beam. Her engine, built
John Stevens, had a cylinder forty-four inches in diameter with a ten foot
ke. A liner and towboat for the Hudson River Steamboat Company, she
s abandoned in 1866.

breuil, Victor (active 1888 – 1890)

E ARTIST'S PALETTE (Front Cover)

H. 14″; w. 17″
oil on canvas
signed, l.r.: "V. Dubreuil"
(cat. #27.1.3-26)

e of the most elusive and entertaining of the secondary painters of
Harnett school, Victor Dubreuil had a studio at 196 7th Avenue
n 1887 to 1889, and from 1895 – 1896 was painting at 110 W.
Street, New York City. Although he is known to have painted at
st two portraits, Dubreuil did not handle forms easily, but re-
nded readily to still lifes.

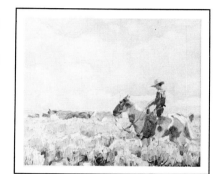

122.

Dunton W. Herbert (1878 – 1936)

THE HORSE WRANGLER

Fig. 122

H. 7¾″; w. 10″
oil on academy board
signed, l.r.: "W. Herbert Dunton"
Gift of: Mr. and Mrs. William N. Beach
(cat. #27.1.5-71)

INDIAN IN WAR BONNET

H. 10″; w. 8″
oil on canvas
signed, l.r.: "W. Herbert Dunton"
Gift of: Mr. and Mrs. William N. Beach
(cat. #27.1.1-186)

NOVEMBER IN THE FOOTHILLS

H. 10″; w. 7¾″
oil on canvas
signed, l.l.: "W. Herbert Dunton"
Gift of: Mr. and Mrs. William N. Beach
(cat. #27.1.5-70)

THE SEGEL — COOPER COWBOY

H. 22¼″; w. 33″
oil on canvas (black and white)
signed, l.l.: "W. Herbert Dunton"
Gift of: Mr. and Mrs. William N. Beach
(cat. #27.1.5-72)

W. Herbert Dunton was born in Augusta, Maine in 1878, the son of William Dunton, a photographer, and Anna K. Dunton. He briefly attended the Cowles School of Art in Boston, and probably was at the Art Student's League in New York City about 1900. Unsuccessful in business, he moved West, working as a cowboy, painter, lithographer, and writer. He was a member of many artists' associations, painted three historical murals for the Missouri State Capitol in Jefferson City in 1850-51, and was a successful illustrator for such magazines as *Harper's, Scribner's,* and *Everybody's*. He also won many art prizes, but perhaps none pleased him more than having his 1934 painting FALL IN THE FOOTHILLS selected by President and Mrs. Franklin D. Roosevelt for the White House. Settling in Taos, New Mexico in 1921, Dunton died there in 1936.[1]

[1] Information courtesy of Mr. Linwood V. Partridge, Maine Department of Economic Development, State House, Augusta, Maine, in letter of June 15, 1966, Shelburne Museum, MSS.

123.

buted to

and, Asher (1796 – 1886)

NTER IN THE WOODS

Fig. 123

1. 52″; w. 38″ c. 1839
il on canvas
cat. #27.1.5-16)

er Durand was born and died in Jefferson Village (now Maplewood),
Jersey. He first studied engraving in his father's silver and watch-
ing shop. Between 1812-1817 he was apprenticed to the lithog-
er and engraver Peter Maverick with whom he formed the printing
pany of Maverick, Durand, & Co., Newark, New Jersey, and New
City in 1817. Several of his etchings achieved renown — THE
LARATION OF INDEPENDENCE, done between 1820-1823 from
Trumbull's famous painting, ARIADNE of 1835 after John Vander-
famous nude painting, in addition to engravings for books and
als such as William Cullen Bryant's THE AMERICAN LANDSCAPE
30. By 1830 he had begun painting, urged on by Luman Reed, who

befriended several artists of the period, particularly Thomas Cole. In 1826 he helped to found the National Academy of Design, serving as its President from 1845-1861. This painting was probably done shortly before Durand's 1840-1841 trip to Europe with his students John Frederick Kensett, (see p. 85), Thomas Pritchard Rossiter (see p. 120) and John William Casilear. It was one of a number of landscape paintings which inspired the comment, "These are paintings that owed nothing to the glory of Italian painting, or the art of Greece — they were the outcome of love and study of American scenery."[1]

[1] *Appleton's Journal,* Saturday, May 7, 1870, No. 58, Vol. III.

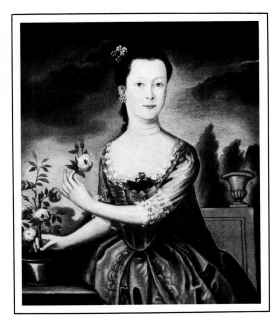

124.

Durrie, George Henry (1820 – 1863)

SELF-PORTRAIT AS A YOUNG MAN Fig. 125

H. 25¼"; w. 19¾" c. 1839
oil on wood
on verso (note): "Portrait of/Geo. H. Durrie/at age of 19 years/painted by
 himself./correct information/from my mother/wife of Geo.
 H. Durrie/to their daughter. (signed) Mary Clarissa
 Durrie."
Exhibited: New Haven Colony Historical Society, April 20-June 1, 1966.
Gift of: George G. Frelinghuysen, in memory of Mrs. P. H. B.
 Frelinghuysen.
(cat. #27.1.1-158)

Born in New Haven, Connecticut in 1820, George Henry Durrie began
studying painting in 1839 with Nathaniel Jocelyn (1796-1881). This
self-portrait was done during this period. Beginning as a portraitist, he is
today best known for his landscape paintings, ten of which reached a
wide audience when they were lithographed by Currier and Ives. First
painting in Connecticut, Virginia, and Upper New York and New Jersey
between 1840-1842, Durrie made New Haven his permanent home. He
first exhibited two winter scenes at the New Haven Horticultural Society
in 1844, and the following year exhibited at the National Academy. Like
many other painters, Durrie increased his income by painting window
shades, signs, coats of arms, firescreens, and theatrical scenery, as
well as still lifes, genre scenes, portraits and landscapes. In his later
years Durrie concentrated primarily on painting winter landscapes,
using the same compositional elements in his landscapes to depict a
romantic nostalgia for a simpler way of life.[1]

[1] Material from Martha Hutson, who is completing a book on Durrie, October 27, 1971. Her
article, "George Henry Durrie, An American Winter Landscape Painter," appeared in The
Magazine *Antiques,* November, 1973, pp. 300-306.

SETTLING THE BILL Fig. 108

H. 19½"; w. 24" 1852
oil on wood
signed, l.r.: "Durrie/1852"
Exhibited: Wadsworth Atheneaum, Hartford, March 12-April 13, 1947
 New Jersey Historical Society, February 5-March 14, 1959
 New Haven Colony Historical Society, April 20-June 1, 1966
Gift of: Mrs. Frederica Emert, George G. Frelinghuysen, P. H. B. Frelinghuysen, Jr., and Henry O.
 Frelinghuysen in memory of their parents, 1963
(cat. #27.1.7-23)

Formerly entitled SELLING CORN, this fine genre scene shows a skill and technique that compares
favorably with paintings by Durrie's contemporaries, Eastman Johnson and William Sidney Mount. Un-
doubtedly it is the second version of two paintings entitled SETTLING A BILL listed in Durrie's ledger in
1851 and 1852. A third version, painted in August of 1857, FARMYARD IN WINTER, SELLING CORN,
differs only slightly from Shelburne's painting.[1] Durrie frequently repeated compositions, or incorporated
elements from earlier works in new paintings. The humorous profile on the side of the barn appears in
SLEIGH ARRIVING AT THE INN, of 1851, now in a private collection.

[1] See the catalogues from Hirschl and Adler Galleries, Inc., New York City, "Forty Masterworks of American Art," October 28-
November 14, 1970, #19; or "Faces and Places, Changing Images of Nineteenth Century America," December 5, 1972-January 6, 1973,
#23.

Attributed to
Durand, John (active 1766 – 1782)

ELIZABETH BANCKER (1757 – 1781) Fig. 124

H. 30"; w. 25½" c. 1777
oil on canvas
(cat. #27.1.1-40)

John Durand, a descendant of French Huguenots whose family settled in Conne
icut, is first known by a painting of the six James Beekman children done in 176
New York City. In 1767 he announced in the *New York Journal* the opening of a
school where "Any young Gentleman inclined to learn the Principles of Design, s
as to be able to draw any objects and shade them with India Ink or Water-colou
which is both useful and ornamental may be taught by JOHN DURAND . . . at hi
House in Broad Street, near City Hall, for a reasonable Price."[1] He was first in V
ginia between 1770-1772, in Milford, Connecticut in 1772, and returned to Virgi
between 1775 and 1782. Either prior to or during his stay in Virginia, Durand wa
evidently in New York City where he painted Richard and Sara Duyckinck Banc
and probably this portrait of their daughter, Elizabeth. Richard was a leading Ne
York City merchant and the largest owner of lands in the Kayaderosres Patent (w
included Saratoga). His wife Sara, the daughter of Evert Duyckinck IV, was a de
scendant of the colonial painter Evert Duyckinck I (1621-1702). The first wife of
Washington's aide-de-camp, Samuel Blanchley Webb (1753-1807), Elizabeth
Bancker was married on October 20, 1780. Samuel wrote:
 "If ever we may be allowed to say, that marriages are made in Heaven, it mus
 when the union is formed upon a disinterested affection; a love that cannot be
 scribed even by those who have felt it. My own heart tells me that it is beyor
 description. Sure I am, that the flame is kindled, and cherished by a superio
 power."[3]
On November 18, 1781, Elizabeth died in childbirth, and her infant a few days l

[1] Albert T. E. Gardner and Stuart Feld, *American Paintings, A Catalogue of the Collection of the Metrop
Museum of Art* (New York: 1965), p. 55.
[2] Waldron Phoenix Belknap, *op. cit.,* p. LXVI
[3] *REMINISCENCES of General Samuel B. Webb of the Revolutionary Army,* by his son, J. Watson We
(published for his family, 1882), p. 321.

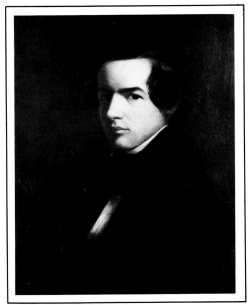

125.

G. H. Durrie's tra
Shelburne Museum Col

rie, George Henry

THERING WOOD

1. 22½"; w. 30" 1859
il on canvas
igned, l.l.: "G. H. Durrie/1859"
cat. #27.1.2-128)

rger version of this scene entitled WINTER LANDSCAPE, GATHERING
OD of the same year, is now in the Boston Museum of Fine Arts.[1] An earlier
ting entitled WINTER LANDSCAPE, GETTING WOOD, was exhibited in
8 at the National Academy of Design, and may be a third version of this
ne, while WOOD FOR WINTER, a variation of this theme, dated 1860, is in
New-York Historical Society Collection.

. & M. Karolik Collection of American Painting, (28 × 34¼, oil, 1859).

OLD INN: TEN MILES TO SALEM

1. 15½"; w. 25¼" c. 1860 – 1863
il on canvas
igned, l.r.: "Durrie"
xhibited: Wadsworth Athenaeum, Hartford, March 12-April 13, 1947
 New Jersey Historical Society, February 5-March 14, 1959
Given in Memory of Mr. and Mrs. P. H. B. Frelinghuysen by their children.
cat. #27.1.2-111)

ast three other versions of this scene are known, attesting to its
popularity.[1]

ese are:
larger version (26 × 36", oil, on canvas, 1863, private collection)
smaller version with only one pair of oxen (14 × 20", oil on canvas, 1862, private
collection)
smaller version with only one pair of oxen (12 × 20", oil on academy board,
Frick photographic file) and dated 1865 and thus was probably finished by Durrie's
son or brother, John.

TER IN THE COUNTRY: A COLD MORNING Fig. 127

1. 26"; w. 36" 1862
il on canvas
igned, l.r.: "Durrie/1862"
xhibited: Wadsworth Athenaeum, Hartford, March 12-April 13, 1947
 New Jersey Historical Society, February 5-March 14, 1959
iven in Memory of Mr. and Mrs. P. H. B. Frelinghuysen by their children.
cat. #27.1.2-112)

ast four versions of this painting are known — all of approximately
ame dimensions. One version was exhibited at the National
demy in 1857, another dated 1861 is now in a private collection, this
dates 1862, and a fourth was painted in 1863.[1] Currier and Ives
the 1861 painting as the source for a lithograph, published in 1864.
y copies were made of this scene, largely because of the popularity
is print.

e fourth is illustrated in "Quality, An Experience in Collecting," Hirschl and Adler Gal-
, Inc., Catalogue, November 12-December 7, 1974, Number 12.

buted to

rie, George Boice (1842 – 1907)

MER FARM SCENE

. 15"; w. 25¼" 1860 or 1866
il on canvas
gned on verso: "G. H. Durrie/1860 (or 1866)"
xhibited: Wadsworth Athenaeum, Hartford, March 12-April 13, 1947
 New Jersey Historical Society, February 5-March 14, 1959
ven in Memory of Mr. and Mrs. P. H. B. Frelinghuysen by their children
at. #27.1.2-110)

THE HUNTER Fig. 126

H. 17"; w. 19¾" (oval opening 13" × 15½")
oil on canvas
signed, l.l.: "Durrie"
(cat. #27.1.2-127)

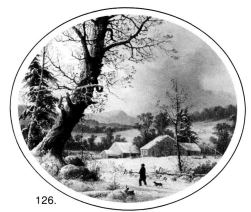

126.

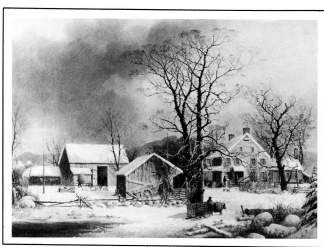

127.

Manner of
Durrie, George Henry

THE OX SLEDGE

H. 11¾"; w. 14¾"
oil on canvas
signed, l.r.: "G. H. Durrie"
Exhibited: New Jersey Historical Society, February 5-March 14, 1959
Given in Memory of Mr. and Mrs. P. H. B. Frelinghuysen by their children.
(cat. #27.1.2-115)

Although characteristic Durrie elements appear in this
painting, a number of factors suggest that this is not the
work of George Henry Durrie. The painting appears to be
crowded and awkward, the handling of the anatomy of the
oxen is unlike Durrie's work, the house is out of proportion,
the chickens are undecipherable while Durrie's small ani-
mals are always legible, the trees and bushes are carica-
tures of Durrie's work, and the signature is placed higher
than normal in a Durrie painting. The figure of the man car-
rying hay on a pitchfork does not appear until 1861 in Dur-
rie's WINTER IN THE COUNTRY, A COLD MORNING,
making it improbable that this is an early Durrie. It is more
likely the work of his son, George Boice Durrie, his grand-
son George Henry Durrie (1872-1928), who is also known
to have painted, or a copy by an amateur from one or more
Durrie paintings and prints.[1]

[1] Observations of Martha Hutson, October 27, 1971, and concurred with by
the author.

umber of factors suggest that this painting might be the work of George Boice Durrie, George Henry's eldest child. Little is known of his life —
s known to have been a painter in New Haven and later in New York City. An early sketchbook has survived, (private collection) and he wrote
letters to the Macbeth Gallery in 1894 inquiring after the possible sale of his winter landscapes. He mentions having sold "quite a number" of
ter scenes in Philadelphia and New York and that his father was the well known painter of winter scenes. The letters are signed Geo. *H.*
rie.[1] Since he obviously adopted his father's initials, and as the date of 1860 on this painting can be read as 1866, three years after his
er's death, it is quite possible that George Boice rather than George Henry Durrie is the painter of this scene.

rchives of American Art, 5200 Woodward Avenue, Detroit, Michigan.

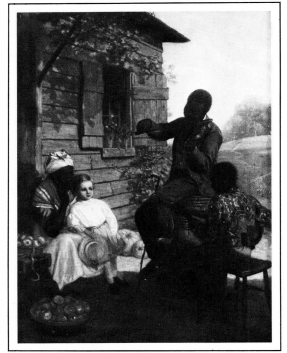

Eastman, Seth (1808 – 1875)

NEW YORK HARBOR IN 1874:
CASTLE WILLIAM ON GOVERNOR'S ISLAND

Fig. 128

H. 22″; w. 32″ 1874
oil on canvas
signed, l.l.: "S. Eastman / 1874"
(cat. #27.1.4-61)

A native of Brunswick, Maine, Seth Eastman was educated at West Point, after which he was stationed at Fort Crawford, Prairie du Chien, Michigan Territory (now Wisconsin) where he probably met George Catlin in 1833 and Charles Deas after 1840. Eastman made topographical maps and began painting and sketching the Indians who came to the Fort, and later, those near Fort Snelling, where he was transferred. From 1833-1840 he was an assistant teacher of drawing at West Point, during which time he began exhibiting at the National Academy of Design. He continued to paint Indians and their habitats — in Florida in 1840-1841 during the Seminole War, back at Fort Snelling from 1841-1848, and later in 1848 in New Orleans and San Antonio. Many of his paintings of Indian subjects were acquired by the American Art Union. He also illustrated Henry R. Schoolcraft's six volume THE HISTORY, CONDITIONS, AND FUTURE PROSPECTS OF THE INDIAN TRIBES OF THE UNITED STATES, published between 1853-1856. In 1855-1856 he was in Texas, returning to Washington, D.C., where in 1861 he was promoted to Lieutenant-Colonel. After serving in the Civil War, he retired in 1863. He continued to work for the Government, completing a series of paintings illustrating episodes from Indian life, and had begun work on another series, illustrating forts on the frontier (commissioned by Congress), when he died in Washington in 1875. Shelburne's painting is from this last series, showing the fortifications of Castle Williams in New York harbor. The fort, built in 1811, was named for its architect, Lt. Col. Jonathan Williams, a nephew of Benjamin Franklin.

Attributed to

Eddy, Mrs.

A PASTORAL SCENE

H. 6⅞″; w. 8⅞″ c. 1810
watercolor on paper
signed, on verso u.l.: "Mrs. Eddy"
(cat. #27.2.2-1)

Found in Dedham, Massachusetts, this small watercolor has been backed with a calendar from the "Dedham Fire Insurance Co., S.Y. Noyes, President."

Edwards, G. C. (1852 – 1939)

THE THOMAS W. LAWSON

H. 7¼″; w. 9¾″ after 1902
reverse painting on glass
signed, l.l.: "G. C. Edwards"
(cat. #27.11-3)

The THOMAS W. LAWSON of 5,218 tons was the only se masted sailing vessel ever built. Launched at Quincy, Mas sachusetts in 1902, she set sail November 27, 1907 on he first and last deep water voyage, reaching her end on De cember 13, 1907 off the Scilly Islands, some twenty-five mi from Cornwall, England. Of the two survivors, one, Edward Rowe, has recounted his story in a tale written by Capt. W liam P. Coughlin.[1] The artist of this painting, G. C. Edward was born in Kent, England, and went to sea as a cabin bo the age of twelve. He sailed all over the world, married an Australian girl, and with their four-year-old son, came to th United States in 1895.

[1] Edward L. Rowe as told to Captain William P. Coughlin, "The *LAWSON* First and Last Voyage", *Yankees Under Sail*, ed. by Richard D. Heckman (Du N.H.: Yankee, Inc., 1968) pp. 140-145.

Ehninger, John Whetten (1827 – 1889)

OLD KENTUCKY HOME

Fig. 129

H. 15¼″; w. 9″ 1863
oil on canvas
signed, l.r.: "J. W. Ehninger, 1863"
on verso (stencil): "Prepared by / WINDSOR & NEWTON. / ? ont
 Place / ??"
(cat. #27.1.7-13)

John W. Ehninger graduated from Columbia College in 1847, afterward painting in Italy; Germany — where he studied with Emanuel Gottlieb Leutze; and France — where he studied with Thomas Couture. In 1853 he had a studio in New York City and began exhibiting widely, becoming a member of the National Academy in 1860. After a brief residence in Newport, Rhode Island where he worked in William Hunt's old studio, Ehninger moved to Saratoga about 1872 where he married and remained the rest of his life. While also doing portraits, illustrations, and etchings, Ehninger is best known for his rural scenes.

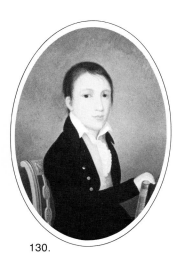

130. 131.

Attributed to

Eicholtz, Jacob (1776 – 1842)

BROTHER IN BRIGHT RED CHAIR

Fig. 130

H. 15″; w. 12″ c. 1830
oil on canvas
(cat. #27.1.1-19)

BROTHER IN BRIGHT RED CHAIR

Fig. 131

H. 15″; w. 12″ c. 1830
oil on canvas
(cat. #27.1.1-20)

These portraits of two brothers, found in Pennsylvania, are lighter, more colorful, and more sharply defined than much of Eicholtz' work, yet similar enough in style to several of the painter's portraits to substantiate this attribution. Eicholtz was born in Lancaster, Pennsylvania where he was given some training as a sign painter, became a coppersmith, and in 1808 took a few painting lessons from Thomas Sully (1783-1872). In 1812 he met and was encouraged by Gilbert Stuart (1755-1828) in Boston, was in Baltimore in 1820, in Philadelphia for ten years between 1821-1831, and spent the remainder of his life in Lancaster. Sully wrote, "I have no doubt that Eicholtz would have made a first-rate painter had he begun early in life with the usual advantages."[1]

[1] Quoted in *M. and M. Karolik Collection of American Painting 1815 to 1865* (Cambridge: Harvard U. Press, 1849) p. 246.

er, Edwin Romanzo (1852 – 1923)

SAN SMITH ELMER (1807 –1878), mother of the artist

Fig. 133

H. 12″; w. 10¾″ c. 1870
oil on canvas
Exhibited: Smith College Museum of Art, Northampton, Massachusetts,
 October 1-24, 1952
(cat. #27.1.1-103)

san Smith Elmer moved with her parents from
mont to Upper Buckland, Massachusetts, at-
ded school in the "Griswold House", and when
 was about sixteen, helped Mary Lyon to teach
re. Susan and her husband moved into the Mary
 n farm (see below) on Put's Hill, in 1856. She
te poetry, some of it printed in local newspapers.
 e of her children died before the age of ten — the
ngest, Edwin Romanzo Elmer, was born in
field, Massachusetts, in 1850.[1] When he was
een, Edwin and his brother Samuel went to Ohio
vork in their brother Ansel's silkspool business.
en the business failed, the two boys returned to
East, building a home for themselves and their
ents in Shelburne Falls, Massachusetts, in 1876.
vin painted this remarkable portrait of his mother,
well as the one of his father listed below, about
 time.

Maude Valona Elmer, *Edwin Romanzo Elmer As I Knew Him*
ublished biography by the daughter of Elmer's brother Samuel),
burne Museum Library (27-554).

ASTUS ELMER (1797 – 1890), father of the artist

Fig. 132

H. 12″; w. 11″ c. 1870
oil on canvas
Exhibited: Smith College Museum of Art, Northampton, Massachusetts,
 October 1-24, 1952
(cat. #27.1.1-102)

scending from Edwin Elmer, (born about 1610 in
intree, England and settling in 1632 in Hartford,
nnecticut) Erastus Elmer was a farmer who wove
kets and straw hats to supplement the family in-
ne. After accidentally losing an eye, he, un-
inted, peddled spectacles. In later years he was
small, frail, bent old man with gentle ways who
s fond of children and always ready to tell stories
ioneer days, especially of the Indians. He would
e his cane, try to straighten up, and shuffle ac-
s the kitchen floor to show their dances."[1]

Maude Valona Elmer, *Ibid.*, pp. 3 and 4.

132. 133.

Elmer Edwin Romanzo

MOUNT OWEN IN ASHFIELD, MASSACHUSETTS

Fig. 134

H. 9⅛″; w. 24¾″ 1906
pastel on paper
signed, l.r.: "E R Elmer / 1906"
Gift of: Maude Valona Elmer, 1961
Exhibited: Smith College Museum of Art, Northampton, Massachusetts
 October 1-24, 1952
(cat. #27.3.2-5)

134.

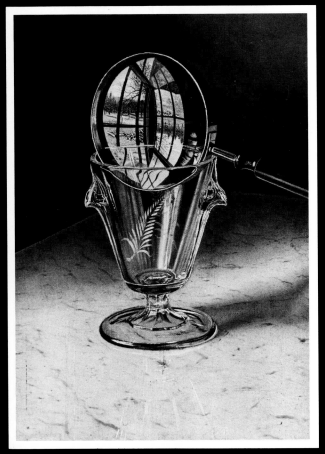

135.

Elmer, Edwin Romanzo

BIRTHPLACE OF MARY LYON

H. 3½"; w. 5¾"
pencil on paper
Gift of: Richard Gipson, 1960
(cat. #27.8-4)

The drawing, probably done quite early in Elmer's career, was undoubtedly made from a lithograph entitled BIRTHPLACE OF MARY LYON, published by Sarony and Major, New York in 1846. Mary Lyon (1797-1849) was born in Buckland, Massachusetts, attended three academies in Pennsylvania, later taught at Ashfield, Massachusetts; Londonderry, New Hampshire and Ipswich, Massachusetts, and became the founder of Mount Holyoke College. Edwin Romanzo Elmer lived in this house as a youth and painted several versions of this scene.

MAGIC GLASSES Fig. 135

H. 14"; w. 10" c. 1891
oil on canvas
Exhibited: Smith College Museum of Art, Northampton, Massachusetts, October
1-24, 1952
(cat. #27.1.3-14)

In Shelburne Falls, Massachusetts, Elmer had married Mary Jane Ware in 1879; their only child, Effie Lillian, born in 1880, died of spinal meningitis in 1888. For a short while the couple lived in Baptist Corner, Massachusetts with Mary's family, before returning to Shelburne Falls in 1890. A creative man, Elmer invented a double action butter churn, a shingling bracket, and a whip snap machine, painting in his spare time.[1] Always interested in mathematics and mechanics, Elmer easily mastered perspective. This extraordinary painting perhaps best exemplifies this talent, as well as his interest in photography.

[1] Maude Valona Elmer, *Ibid*.

IMAGINARY SCENE

H. 17"; w. 13¾" 1892
oil on canvas
signed, l.l.: "E. R. Elmer/1892"
Exhibited: Smith College Museum of Art, Northampton, Massachusetts, October
1-24, 1952
(cat. #27.1.2-38)

A certain sense of sadness pervades this scene as the woman stands quietly on the porch, looking off into the night. It was perhaps an attempt on Elmer's part to cope with the grief caused by his daughter's death.

FULL MOON ON THE RIVER

H. 14"; w. 17" 1892
oil on canvas
signed, l.l.: "E. R. Elmer/1892"
(cat. #27.1.2-52)

APPLES AND CIDER

H. 11¼"; w. 17¼" 1904
pastel on paper
signed, l.r.: "E R Elmer/1904"
Exhibited: Smith College Museum of Art, Northampton, Massachusetts, October 1-24, 1952
(cat. #27.3.3-2)

In 1899 Elmer studied with Benjamin Wells Champney at the American Academy of Design in New York City, and William Satterlee, a portrait painter, both of whom interested him in working with pastel. In 1901 Elmer returned to Shelburne Falls, holding his first exhibition a year later in an ice cream parlor there. Moving back to Baptist Corner, Elmer painted and ran an apple orchard. In 1923 he fell twenty feet while pruning a tree, and later suffered another accident in the barn. Shortly thereafter, it was discovered that he had cancer, and Elmer eventually shot himself, ending a painting career which was to go unrecognized for thirty years.[1] This pastel, and the ones listed below, demonstrate how quickly Elmer mastered this medium. No doubt this still life's props are products from his orchard.

[1] Maude Valona Elmer, *Ibid*.

WATERMELONS AND FLOWERS

H. 15¼"; w. 23⅛" 1904
pastel on paper
signed, l.l.: "E. R. Elmer/1904"
(cat. #27.3.3-3)

STRAWBERRIES AND FLOWERS

H. 9"; w. 15¼" 1905
pastel on paper
signed, l.r.: "E R Elmer/05"
(cat. #27.3.3-1)

MOONLIGHT ON THE RIVER

H. 11"; w. 19" 1905
pastel on paper
signed, l.r.: "E R Elmer/1905"
(cat. #27.3.2-3)

GIRL WEAVING RUG

H. 14¾"; w. 22½" 1906
pastel on paper
signed, l.r.: "E R Elmer/1906"
Exhibited: Smith College Museum of Art, Northampton,
Massachusetts, October 1-24, 1952
Gift of: Mrs. P. H. B. Frelinghuysen, 1960
(cat. #27.3.1-25)

SUNLIGHT THROUGH THE TREES

H. 9½"; w. 19¼" 1907
pastel on paper
signed, l.l: "E. R. Elmer/1907"
(cat. #27.3.2-4)

OSCAR BARDWELL

H. 19½"; w. 15½"
charcoal on white paper
signed, l.r.: "E. R. Elmer"
Gift of: Richard Gipson, 1960
(cat. #27.3.1-28)

ARAB MODELING

H. 24"; w. 20½"
oil on canvas
(cat. #27.1.1-116)

According to Maude Valona Elmer, the artist's niece, Elmer painted this model in an art class. It was probably done while he was in New York City in 1899.

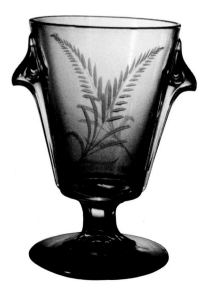

135.
Glass spoon holder,
Shelburne Museum Collection

136.

Fairchild, F. Leslie (active 1961)

CLOWNS MAKING UP

Fig. 136

H. 40″; w. 30″ 1961
oil on canvas
signed, l.l.: "Leslie Fairchild 1961"
on verso: "To Shelburne Museum from Leslie Fairchild, 1961 #2"
Gift of: the artist, 1961
(cat. #27.1.7-20)

A native of Bridgeport, Connecticut, Mr. Fairchild is a successful businessman and artist. Brought up around the old circus winter quarters in Bridgeport, Fairchild had some experience as high-wire walker, and is considered by the circus people as one of their own. His familiarity with the world of the circus enables him to bring to his canvases some of the spirit of "the Greatest Show on Earth."

Falco, Michael J. (1931-)

AUNT NELLY'S CAKE SALE

Fig. 137

H. 18″; w. 23¾″ 1971
oil on canvas
signed, l.l.: "AUNT NELLY'S CAKE SALE/ — M. Falco — 1971"
Gift of: the artist, 1972
(cat. #27.1.2-125)

A contemporary primitive artist, Mr. Falco, a resident of Scottsdale, Arizona, has in this painting captured some nostalgia of the past.

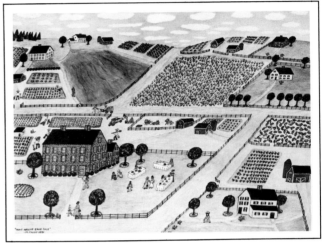

137.

Attributed to

Feke, Robert (1707 – c. 1752)

LADY IN ROSE DRESS WITH BLUE BOSOM KNOT

Fig. 138

H. 35¾″; w. 28¾″ c. 1749
oil on canvas
(cat. #27.1.1-109)

The second son of Robert Feke, a Baptist minister and blacksmith of Oyster Bay, Long Island, this painter went to New York City around 1733. His earliest known dated painting, ISAAC ROYALL AND HIS FAMILY, was done in 1741, although probably a painting of his niece PHAINY COCKS is earlier. On September 25, 1742, he married Eleanor Cozzens of Newport, Rhode Island, who bore him five children. They are known to have been in Newport between 1742-1745 where Feke may have worked as a tailor with his father-in-law. For the next several years Feke was in Boston, Philadelphia, and Newport, and c. 1750 or 1751 may have been in Virginia. He was probably the teacher of John Hesselius, and influenced both John Greenwood and Gustavus Hesselius, and indirectly, John Singleton Copley. This painting came from Germantown, Pennsylvania. R. Peter Mooz has noted that the technique, costume and colors are similar to Feke's work, while the frontal pose and treatment of space are unlike those in other Feke paintings. It could possibly be the work of John Hesselius or another painter (James Claypoole, John Meyer, or John Winter, all of whom were in Philadelphia c. 1750) who adopted Feke's style.[1]

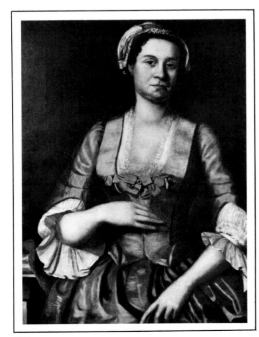

138.

[1] R. Peter Mooz was a teaching associate at the Henry Francis du Pont Winterthur Museum, is now the Director of the Bowdoin College Museum of Art, Bowdoin, Maine, and has written extensively on Feke.

ton, Permelia

E WORLD

H. 28½"; w. 42¾" 1821
pen and ink on paper, glued to canvas
signed, l.c.: "Permelia Fenton/1821"
(cat. #27.9-41)

doubtedly a school project, this large hand-drawn
p depicts two views of the earth, with comments
historical charts on each side. At the top there is
rawing of two girls feeding chickens.

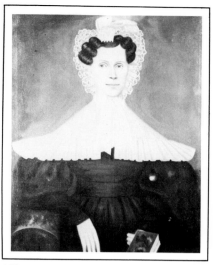

139.

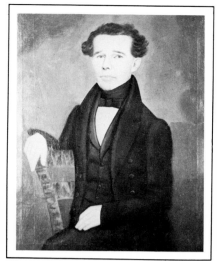

140.

d, Erastus Salisbury (1805 – 1900)

MIRA DODGE BASSETT (1802 – 1883)

Fig. 139

H. 35"; w. 28½" c. 1835
oil on canvas
on verso (tag): "subject born Lee, Massachusetts (Dodgetown)
 June 6, 1802. Granddaughter of John and
 Martha Crosby, who moved with their family in
 1780 to Capt. St. Lee, Mass. from Barnstable,
 Mass. Almira's mother married Mr. Elisha
 Dodge. Almira died in Lee, Mass. Oct. 3, 1838 of
 Phthisis (pulmonary consumption)"
Exhibited: Abby Aldrich Rockefeller Folk Art Collection,
 Williamsburg, Virginia, January 20-March 17, 1963.
(cat. #27.1.1-38)

JOSEPH BASSETT (1801 – 1873)

Fig. 140

H. 34¾"; w. 28½" c. 1835
oil on canvas
on verso (tag): "Portrait of Joseph Bassett 2nd — son of/Nathaniel and Bethia Bassett, was born in/Lee,
 Massachusetts March 22, 1801. Married/Almira Dodge October 2, 1823 for second/wife he
 married Mrs. Juliette Hollister Flinn September 12, 1848. He died in Lee/Massachusetts,
 September 3, 1873/painted by Erastus Salisbury Field."
Exhibited: Abby Aldrich Rockefeller Folk Art Collection, Williamsburg, Virginia, January 20-March 17, 1963.
(cat. #27.1.1-37)

Born in Leverett, Massachusetts in 1805, Erastus Salisbury Field had his only formal training as a painter in 1824 when he studied for three months in New York City with Samuel F. B. Morse. His earliest known work is a portrait of his grandmother, c. 1825.[1] Between 1826 and 1840 Field worked as an itinerant painter, travelling across Massachusetts, Connecticut, and eastern New York. In 1831 marrying Phebe Gilmur (also spelled Gilmore and Gilman), herself an amateur painter, the Fields lived briefly in Hartford, and then settled in Monson, Massachusetts. During the 1830's when these portraits were done, Field's canvases usually measured 35 × 29", while his usual charge was $5.00. At the same time as these portraits, Field also painted portraits of Nathaniel Bassett and Bethiah Smith Bassett.

Mrs. Stephen (Elizabeth Virtue Billings) Ashley (1745 – 1836) (oil, 24½ × 22½, c. 1825), Museum of Fine Arts, Springfield, Massachusetts.

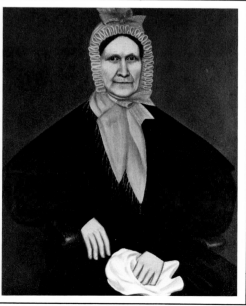

41.

AUNT DOLLY

Fig. 141

H. 35"; w. 29" c. 1843
oil on canvas
(cat. #27.1.1-163)

Between 1841-1848 the Fields were in New York City where Erastus exhibited twice at the American Institute of the City of New York and perhaps studied photography. During this period he must have returned to Massachusetts where this portrait was painted. Acquired in Burlington, Vermont in 1962, this is a portrait of Mrs. Oliver (Dorothy Whiting) Dickinson of North Amherst, Massachusetts. She married Squire Oliver Dickinson (1757 – 1843) in 1831. His companion portrait was traditionally painted posthumously, and was given to a North Amherst Church in 1926 where it was destroyed by fire in 1954.[1]

[1] Reginald F. Frank, "Erastus Salisbury Field, 1805 – 1900," Connecticut Historical Society Bulletin, October, 1963.

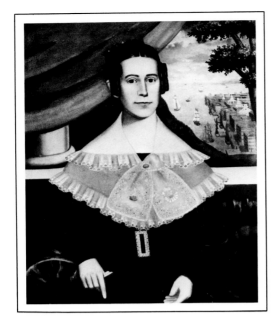

142.

THE GARDEN OF EDEN

Fig. 111

H. 35"; w. 41½" c. 1865
oil on canvas
Gift of: Mr. and Mrs. Dunbar W. Bostwick, 1960
Exhibited: Abby Aldrich Rockefeller Folk Art Collection, January
 20-March 17, 1963; The Flowering of American
 Folk Art." Whitney Museum of American Art,
 1974
 Fine Arts Center, State University of New York
 at Geneseo, February 27 to April 6, 1968.
(cat. #27.1.2-86)

In 1854 Field opened a studio in Palmer, Mas-
sachusetts, where he began photographing and
then painting subjects. After his wife's death in
1859, Field and his daughter, Henrietta, moved to
Plumtrees, Massachusetts, where he built a studio
and is believed to have given art lessons. From 1870
he lived on in Sunderland, Massachusetts. The
influence of the daguerreotype became increasingly
important to his portrait paintings, causing them to
lose much of their spontaneity and appeal.[1] At the
same time, Field was beginning to do some religious
and historical paintings which are extremely imag-
inative and impressive.[2] This is one of two versions
which Field painted of THE GARDEN OF EDEN.
The other lacks the *trompe l-oeil* border, has trees of
gigantic proportions, and has Adam looking away
from Eve toward a herd of animals on his left.[3] In
these delightful paintings, Field has "borrowed and
combined" a Bible illustration of THE TEMPTATION
after a painting by the English artist John Martin, a
print of THE GARDEN OF EDEN after Thomas Cole,
and a Bible illustration after Jan Brueghel the Elder
which inspired the addition of paired creatures.[4]

[1] Prior to the point when photographs were important in Field's
portraits, his works had several stylistic characteristics which iden-
tify them readily, as Agnes Dods, of Leverett, Massachusetts has
observed. His fingers are wooden with square tips, his faces are
pleasantly serious with wide-opened eyes, and his poses are stiffly
formal with a triangular effect to their sloping shoulders. Miss Dods
has done much to uncover material about Field.
[2] One of the most extraordinary is HISTORICAL MONUMENT OF
THE AMERICAN REPUBLIC, a gigantic canvas, now in the Museum
of Fine Arts, Springfield, Massachusetts.
[3] THE GARDEN OF EDEN (oil on canvas, 33¾ × 46"), M. & M.
Karolik Collection of American Paintings, Museum of Fine Arts, Bos-
ton.
[4] Mary Black and Jean Lipman, *American Folk Painting* (New
York: Clarkson N. Potter, Inc., 1966), p. 174.

Field, Erastus Salisbury

LOUISA ELLEN GALLOND COOK (1816 – 1838) Fig. 142

H. 34"; w. 28" c. 1838
oil on canvas
Exhibited: (as Almira Gallond Moore) Abby Aldrich Rockefeller Folk Art Collection,
 January 20-March 17, 1963.
(cat. #27.1.1-127)

Found in a Petersham, Massachusetts dump in the fall of 1952, this por-
trait was first believed to be Mrs. Joseph (Almira Gallond) Moore be-
cause of its close relationship with the woman in another Field portrait,
JOSEPH MOORE AND HIS FAMILY, in the Museum of Fine Arts, Bos-
ton. The daughter of Mr. and Mrs. Jeremiah Gallond (whose portraits by
Field are in the Petersham Historical Society), Almira had two sisters —
Clarissa (1804-1855) who married William Cook in 1824, and Louisa
Ellen (1816-1838) who married William's brother Nathaniel Cook in
1834. It is now believed, thanks to a letter of a relation,[1] that Shelburne's
portrait is of Louisa Gallond Cook, while the two Field portraits called
NATHANIEL AND LOUISA COOK in the National Gallery of Art are ac-
tually William and Clarissa Cook. Louisa died in 1838, leaving two chil-
dren, Frederick and Louisa Ellen, who are believed to be included in the
family portrait of the Joseph Moores along with the Moores' two boys.
As Louisa (in Shelburne's portrait) and Almira Moore (in the Moore fam-
ily portrait) are wearing identical dresses and accessories, it is logical to
assume that Louisa's portrait is a posthumous one. Field most probably
gave Louisa the same dress and paraphernalia as her sister wore in the
family portrait of the same period. The seaport behind Louisa remains a
mystery, but Nathaniel Cook's father, Samuel, was captain and owner of
the schooner SARAH TAINTOR, sailing the Hudson out of Poughkeep-
sie.

[1] Letter from Miss Helen M. Cook, July 22, 1966, Shelburne Museum MSS.

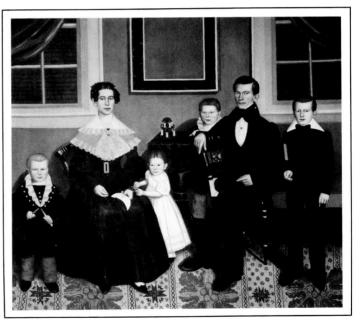

JOSEPH MOORE AND HIS FAMILY, 1839 (Courtesy of 142.
Museum of Fine Arts, Boston, M. & M. Karolik Collection)

her, Alvan (1792 – 1863)

AR ISLAND, MAINE Fig. 143

H. 18″; w. 24″ 1851
oil on canvas
signed, l.c.: "AF 1851"
on verso: "View of Bear Island/A reminiscence of pleasant/days in the year 1848 and/a
 token of friendship and slight/return for past favors."
Stencil, on verso, u.r.: "From/J. J. ADAMS/99 WASHINGTON ST./BOSTON"
(cat. #27.1.2-72)

n in Needham, Massachusetts in 1792, Alvan Fisher grew up in
dham and by 1812 was studying with John Ritto Penniman, a Rox-
y portraitist, ornamental painter, and lithographer. First producing
traits, Fisher by 1815 was painting landscapes, genre, and animal
nes, "a decided novelty to the general public."¹ In 1817 he exhibited
ooth the Pennsylvania Academy of Fine Arts and the American
ademy of Design. A year later he began travelling widely — in New
gland, Niagara Falls, and Charleston, South Carolina, finding paint-
bulls and race horses lucrative. With his younger brother, John Dix
her, a physician, Fisher went to Europe in 1825 where he copied old
sters. Returning to the United States in 1826, he is believed to be
e first landscape painter to hang out a professional sign in Boston."²
hibiting at the major academies and continuing to travel and paint, he
tled in Dedham, Massachusetts in 1840. Not only were engravings
de from his paintings, but he made designs for the Staffordshire pot-
y made by Enoch Wood and Sons in England. This painting is of Bear
nd in Penobscot Bay, about eleven miles from Camden, Maine. As
most of his other work, this painting was probably done in Fisher's
dio from pencil sketches, water-color notes and written descriptions
ie in Maine.

———
ssay by Robert C. Vose, Jr., for exhibition catalogue of Alvan Fisher's paintings at the
necticut Historical Society and Museum of Fine Arts, Boston, 1962 – 1963.
bid.

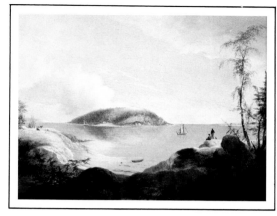

143.

Fletcher, Aaron Dean (1817 – 1902)

MRS. SILENCE BINGHAM, AGE 63 (1775- ?) Fig. 144

H. 28¼″; w. 24″ 1839
oil on canvas
on verso (on relined canvas): "Mrs. Silence Bingham/Age 63 Jan 1831/By A. D. Fletcher"
(cat. #27.1.1-146)

Aaron Dean Fletcher was born September 15, 1817 in Springfield, Ver-
mont, the youngest of the eleven children of David and Sarah Lovell
Fletcher. As a young boy he began playing the violin, and by the age of
fifteen, was painting portraits in Springfield and the neighboring villages
of Rockingham and Saxtons River. Around 1840 Fletcher had moved to
Keeseville, New York which was to remain his home for the rest of his
life. He never married or owned his own home, but, as was true of many
artists, earned board and room by painting the portraits of his benefac-
tors. Eccentric, he is remembered striding down the center of the
streets, wearing a long cape and a high silk hat.¹ In 1855 and 1856
Fletcher visited his brother, Peter, in La Porte, Indiana where he is
known to have executed several paintings. Thereafter, he returned to
Keeseville, and continued to paint for about ten years. None of his work
is known to date after 1862. At his death he left a portion of his estate
to the Home of the Friendless in Plattsburgh, New York.²

 Silence Bingham was the third of thirteen children born to Levi Har-
low and Silence Cobb Harlow in Springfield, Vermont. She married
John C. Bingham of Springfield on October 23, 1810, and bore him six
children.³

———
 ¹ Donald Demers, "A Sketch of the Life and Works of Aaron Dean Fletcher, 1817–1902,"
(unpublished manuscript, New York State Historical Association, Cooperstown, New York).
 ² The author is greatly indebted to Mrs. Virginia Mason Burdick of Plattsburgh who has
gathered together much of this data on Fletcher.
 ³ Charles H. Hubbard and Justus Dartt, *History of the Town of Springfield, Vermont* (Bos-
ton, 1895), pp. 222 and 321.

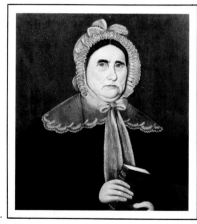

144.

Fletcher, Aaron Dean

THE NEEDLE-WORKER'S VASE OF FLOWERS

H. 20¾″; w. 16″ 1862
oil on canvas
signed, on verso: "A. D. Fletcher/painter Sept. 1862"
(cat. #27.1.3-6)

Painted twenty-three years after his portrait of Mrs. Bingham, in this
painting Fletcher has obviously improved his technique immensely,
particularly in his handling of space.

Forbes, Edwin (1839 – 1895)

FRUIT IN A CRYSTAL COMPOTE Fig. 145

H. 14¼″; w. 11¾″ 1864
oil on wood
signed, l.r.: "E. F. 64"
(cat. #27.1.3-15)

145.

By the age of eighteen Edwin Forbes was studying art, and in 1859 was a student of Arthur Fitzwilliam Tait (1819-1905) who had come
to New York in 1850. While a staff artist for *Frank Leslie's Illustrated Newspaper* between 1861-1865, Forbes painted this still-life. He
spent the post-war years making engravings and illustrations from his Civil War sketches. In 1877 he was made an honorary member of
the London Etching Club, and beginning about 1878 concentrated on landscapes and paintings of cattle.

Francis, John F. (1808 – 1886)

PLETHORA OF FRUIT

H. 23″; w. 30″ 1857
oil on canvas
signed, l.r.: "J. F. Francis, pt. 1857"
Gift of: Mrs. P. H. B. Frelinghuysen, 1960
(cat. #27.1.3-7)

Born in Philadelphia in 1808, John F. Francis' first known painting is a portrait done in 1838. From 1841 to 1866, he painted in many towns in Pennsylvania, and was in Delaware, Washington, D.C., and Nashville, exhibiting at the Pennsylvania Academy of Fine Arts in 1854, 1855, and 1858. From 1866 on, he resided in Jeffersonville, Pennsylvania. His will, located by Alfred Frankenstein, made known thirty-one more of his paintings, and revealed that he also painted "fancy signs, Banners and scarfs for different Societies."[1] Of the paintings that have been discovered, twenty are portraits, one is of a house in Jeffersonville, while the remainder are still-lifes. This is the third compositional type of Francis still-life discussed by William H. Gerdts and Russell Burke[2] in which he uses a market basket with fruit as a prop. When Francis used more than one kind of fruit, as here, he painted some of it either quartered or peeled.

[1] Alfred Frankenstein, *After the Hunt* (University of California Press, 1953), p. 136.
[2] William H. Gerdts and Russell Burke, *American Still-Life Painting* (Washington: Praeger Publ., 1971), pp. 60-61. The other two types are the "dessert" composition (see below) and the luncheon piece with liqueur and wine bottles, fruits, nuts, cheeses, and oyster crackers.

STRAWBERRIES AND CREAM

Fig. 146

H. 25″; w. 30″ 1879
oil on canvas
signed, l.r.: "J. F. Francis, P¹. 1879."
(cat. #27.1.3-16)

Two other versions of this painting are known, almost identical to this except in the landscape backgrounds.[1] Both of the others are called THE DESSERT and represent the first basic kind of still-life composition which Francis employed.[2] Unusually sensitive to color, Francis played gentle pastels against richer hues and worked with considerable vitality to achieve a very painterly surface.

[1] THE DESSERT (1860, 25 × 31″, oil on canvas, private collection, Piermont, New York), and THE DESSERT (1872, 25 × 30¼″, oil on canvas, Collection of Mr. and Mrs. J. William Middendorf II, New York).
[2] Gerdts and Burke, *op. cit.,* pp. 60-61. This compositional type includes a white table cover with a napkin spread over it, a cream pitcher, sugar bowl, bowl of fruit, and cake plate with jelly roll and cookies.

146.

Freeman, Bessie C. (active 1850's)

DRAWING OF TWO GIRLS

H. 8¾″; w. 6⅞″ 185- ?
pencil on paper
on verso (tag): "Bessie C. Freeman/Spring
 Hill/Somerville/May 185?"
(seal): "J. F. Robey, manufacturer and dealer in
 rosewood, mahogany and gilt./Picture Frames &
 Looking Glasses/Main Street/118/Concord,
 N.H."
Gift of: Redfield Proctor, 1954
(cat. #27.8-65)

Frost, Arthur Burdett (1851 – 1928)

AMERICAN COUNTRY STORE

Fig. 147

H. 28″; w. 42″
oil on canvas
signed, l.l.: "A. B. Frost"
Given in Memory of Mr. and Mrs. P. H. B. Frelinghuysen
by Mrs. Frederica F. Emert, George G. Frelinghuysen,
P. H. B. Frelinghuysen, Jr., Henry O. Frelinghuysen,
1963
(cat. #27.1.7-21)

Born in Philadelphia in 1851, A. B. Frost began working as a lithographer in 1874, the same year he illustrated Max Adeler's book, *Out of the Hurley Burly.* In 1875-1876 he worked for *New York Graphic,* and for the next ten years in the art department of Harper & Bros. During this period Frost made his first watercolor and gouache drawings. After studying in London in 1877-1878, he became a student of Thomas Eakins (1844-1916) at the Pennsylvania Academy of Fine Arts. From 1879-1889 he was again with Harper & Bros. where Howard Pyle and Frederick Remington were also working. He married an artist, Emily Louise Levis Phillips of Philadelphia in October, 1883, and moved to Huntington, Long Island. The same year he illustrated Louis Carroll's *Rhymes and Reasons,* published and illustrated his own book called *Stuff and Nonsense,* and made the first illustrations for Joel Chandler Harris' Uncle Remus and Brer Rabbit stories. In 1885 Frost illustrated Theodore Roosevelt's *Hunting Trips of a Ranchman,* and in 1891 became a student of William Merritt Chase. Several sporting books and portfolios followed — his *Shooting Pictures* portfolio in 1895-1896, *Sports and Games in the Open* in 1899, and *A Day's Shooting* in 1903. In 1906 the Frosts and their two sons were in England and France,[1] returning to the United States in 1914. In 1919 they moved to Pasadena, California where Frost continued to illustrate, doing his last work for *Scribner's* Magazine in 1927. He died in 1928.[2]

[1] Both of Frost's sons became artists. Arthur, the eldest, joined Matisse's class in Paris in 1908 and was later influenced by Cezanne and Delauney. Both boys contracted tuberculosis in 1911 and spent some time in a Swiss Sanatorium, Arthur dying in New York in 1917. John died in 1937, and his son, John, Jr. is now an artist in southern California.
[2] Ref: Henry M. Reed, *The A. B. Frost Book* (Rutland, Vermont: Charles E. Tuttle Co., 1967).

Frost, Arthur Burdett

FINDING THE BEAR

H. 12½"; w. 18¾" 1884
watercolor on paper
Gift of: Mr. Donald Ryan, 1969, in memory of John Berry Ryan
(cat. #27.2.5-11)

SHOOTING THE MOOSE

Fig. 148

H. 16½"; w. 21½"
watercolor on paper
Gift of: Mr. Donald Ryan, in memory of John Berry Ryan
(cat. #27.2.5-10)

47.

8.

Frost, John Orne Johnson (1852 – 1929)

GEESE FLYING OVER A WILD SEA WITH AMERICAN SAILING SHIPS

H. 15⅞"; w. 33½"
oil on beaver board
(cat. #27.1.4-71)

SWIMMING WHALES AND SAILING SHIPS

H. 16"; w. 35¾"
oil on beaver board
(cat. #27.1.4-72)

INDIAN ENCAMPMENT AT SALEM HARBOR SIDE

Fig. 149

H. 47½"; w. 70½"
oil on beaver board
(cat. #27.1.5-11)

John Orne Johnson Frost was the youngest of the eleven children of a Marblehead shoemaker. He went to sea at the age of sixteen, but about 1870 returned to Marblehead to work for an uncle as a carpenter's apprentice. After marrying Ann Lillibridge in 1873, he went into his father-in-law's restaurant business, thereafter opening his own restaurant which burned in a fire in 1888. Following a severe illness in 1895, Frost and his wife raised flowers and vegetables (their sweet peas were especially famous) to sell to summer tourists. After his wife's death in 1919, Frost continued to garden, began to write for the *Marblehead Messenger* in 1921, and to paint in 1922. These very extraordinary canvases were done from remembered tales, history lessons, and newspaper clippings and represent vast panoramas of people, places and times. Proud of his achievements, Frost opened a museum of his paintings and sold curios and souvenirs of the sea in his backyard. The paintings did not sell well, and when Frost died on November 3, 1929, his son Frank donated eighty of his paintings to the Marblehead Historical Society. It was not until 1940 that the vigor and charm of Frost's work began to be appreciated.

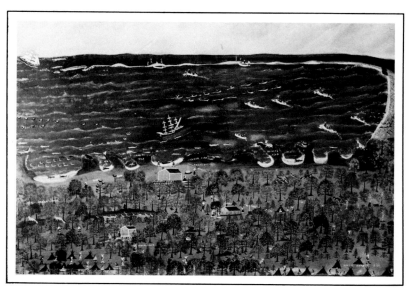

149.

Giles, Howard (1876 – 1955)

ROCKY COVE WITH GULLS

Fig. 150

H. 16″; w. 20″
oil on canvas
Gift of: Mrs. Evelyn Giles, widow of the artist, 1959
(cat. #27.1.4-36)

A native of Brooklyn, New York, Howard Giles was the son of
Frank Warren and Ella Bennett Giles. After study at the Art Stu-
dent's League in New York, Giles did illustrations for many
magazines including *Scribner's* and *Harper's* and in 1912 began
teaching at New York School of Fine and Applied Art. With intro-
duction to Jay Hambridge who had rediscovered the principles of
Dynamic Symmetry (utilizing mathematic principles as the basis
of design) Giles was stimulated to apply these concepts to his
own painting and his teaching. In 1921 he met Mr. Denman W.
Ross, associated with the Museum of Fine Arts, Boston and the
Fogg Museum in Cambridge, whose ideas of using a set palette
of limited colors Giles also adopted. He became Dean of the art
department at the Roerich Master Institute, an Academician of
the National Academy of Design in 1929, and won several prizes
including the Carnegie International Exhibit Award of 1921 for his
painting YOUNG WOMAN. In 1934 Mr. Giles moved to South
Woodstock, Vermont where he spent his remaining years in an
eighteenth century brick house he named "Foursquare." This
painting was probably done prior to 1933 when Giles spent con-
siderable time along the Maine coast.[1]

[1] Information from biographical notes written by Giles' wife, Evelyn, courtesy of
Nina Parris, Curator of the Robert Hull Fleming Museum, Burlington, Vermont. The
Fleming Museum held a special exhibit of Giles' work from June 5 to 26, 1960.

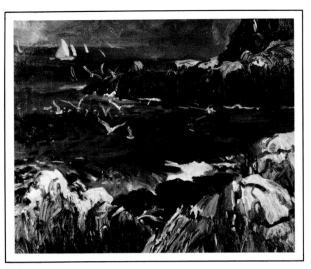

150.

Gillette, William B. (1864 – 1937)

FLIGHT O'MALLARDS

H. 12¼″; w. 9¾″
watercolor on paper
signed, l.r.: "W. B. Gillette"
(cat. #27.2.5-18)

Born in Nova Scotia, William B. Gillette
was both a painter and etcher who is
best known for his paintings of marine
life. He died in Troy, New York on July
31, 1937.

Goucher ?, C. W.

THE EMILY REED

Fig. 151

H. 18″; w. 23½″ c. 1881
oil on canvas
on verso: "The Emily Reed/Built in Waldoboro,
Maine c. 1881. One of the last of the
sailing ships. 'Sailed the Seven
Seas.'/April 21, _____. 1966"
pencilled on stretcher: "C. W. Goucher/The
Emily Reed/Hong Kong
Gift of: Mrs. F. H. Shepardson, 1966
(cat. #27.1.4-75)

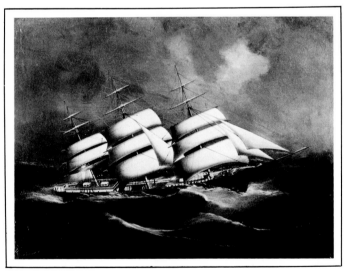

151.

Gulley, Adolphus (1789- ?)

RULE OF LIFE

Fig. 152

H. 13½″; w. 11¾″ 1799
watercolor and brown ink on paper
Inscribed: "RULE OF LIFE./Debates and Quarrels always
shun;/(crossed out) No one by Peace was e'er
undone/Adolphus Gulley/Aged 10 years/Charlton Sept. 25th
1799″
(cat. #27.13-14)

Master Gulley has depicted two ornate pillars supporting
several arch-like designs in this pleasant watercolor done
while a student in Miss Meriam's school, Charlton, Mas-
sachusetts.

152.

Attributed to

Hamilton, James (1819 – 1878)

FISHERMAN OFF GLOUCESTER Fig. 153

 H. 22"; w. 36" c. 1869
 oil on canvas
 signed, l.r.: "Fitz H. Lane"
 (cat. #27.1.4-50)

Although this canvas bears the name "Fitz H. Lane," which is not Lane's usual way of signing his work, this painting is believed to be the work of James Hamilton. Born in Entrien, Ireland in 1819, Hamilton was in Philadelphia by age fifteen. Self-taught, he began teaching, painting, and engraving c. 1840, and began exhibiting his work in galleries of major coastal cities from Boston to Washington about the same time. Between 1854 and 1855 he was in London, where he was influenced by the paintings of Joseph Mallord William Turner (1775-1851). Back in the United States, Hamilton illustrated two books — Elisha Kent Kane's *Arctic Explorations* of 1857 from the author's sketches, and John Charles Fremont's *Memoirs* of 1887. Hamilton painted several marine battle scenes during the Civil War, after which he travelled and painted along the Atlantic Coast, especially in New England. This painting was undoubtedly done during this time. In 1875 he auctioned over one hundred of his paintings to finance a trip around the world, but died unexpectedly at the start of the journey.

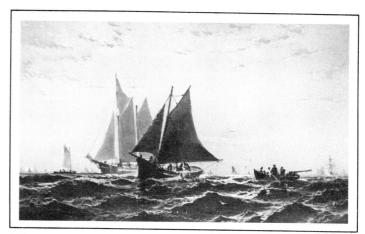

153.

Hamlin, Amos Jr.

WILLIAM A. PALMER, GOVERNOR OF
VERMONT (1831 – 1837)

 Fig. 154

 H. 34"; w. 30" 1834
 oil on canvas
 signed, on verso: "Painted by Amos Hamlin Jr./Feb. 7-1834/Gov. Wm. A.
 Palmer/Nov. 1831 – 1835/No. 1"
 (cat. #27.1.1-82)

Amos Hamlin was a physician who became a painter, preferring the latter career. He was also a Whig politician. Groce and Wallace list a Dr. A. C. Hamlin as a landscape painter from Bangor, Maine. He exhibited a painting entitled MT. KATAADEN, SUNRISE at the National Academy of Design in 1859.[1] William A. Palmer was an Anti-Mason Governor who served Vermont between 1831 and 1837.

 [1] Groce and Wallace, *op. cit.*, p. 207.

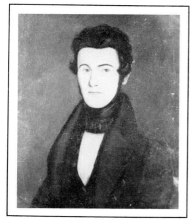

154.

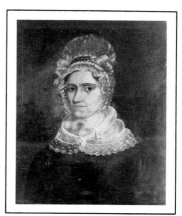

155.

Hanks, Jarvis (Jervis) F. (1799 – 1852 or after)

PORTRAIT OF A WOMAN Fig. 155

 H. 29¼"; w. 24" 1826
 oil on canvas
 signed, l.l.: "Hanks./pinx/*1826*"
 (cat. #27.1.1-108b)

PORTRAIT OF A MAN Fig. 156

 H. 29"; w. 24" 1826
 oil on canvas
 (cat. #27.1.1-108a)

Born in Pittsford, New York, Jarvis Hanks served with the Army during the War of 1812 before moving to Wheeling, Virginia (now West Virginia) in 1817 where he taught school and began painting signs. In 1823 he visited Philadelphia, and between 1825 and 1826 was in Cleveland and Cincinnati, Ohio where he began cutting silhouettes and painting portraits. In New York from 1827-1834 (his address in 1829 listed as 144 Bowery) Hanks exhibited several portraits of ladies and gentlemen at the National Academy. During the same period he apparently worked in Salem, Massachusetts; Charleston, South Carolina; and New Orleans. By 1838 he returned to Cleveland, continuing to make winter trips to the South.[1]

 Ref.: Groce and Wallace, *op. cit.*, p. 239.

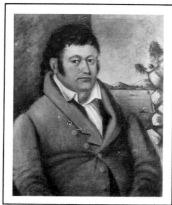

156.

Hartman, M.

SPRINGER SPANIEL (Dickey ?)

 H. 22"; w. 28"
 oil on canvas
 signed, l.r.: "M. Hartman"
 (cat. #27.1.5-75)

Havemeyer, Frederick C. 2nd

GEESE IN FLIGHT

 H. 15⅝"; w. 19⅝" 1942
 oil on canvas
 signed, l.l.: "FCH 42"
 on verso: "Towards evening at Currituck, the geese
 came down off the sand dunes to feed in the
 bay. Frederick C. Havemeyer 2nd."
 Gift of: Henry O. Havemeyer
 (cat. #27.1.5-1)

Heade, Martin Johnson (1819 – 1904)

SEASCAPE: SUNSET Fig. 158

H. 26"; w. 44" 1861
oil on canvas
signed, l.l.: "M. J. Heade/1861"
on verso (stencil): "VOSE & JENCKES/DEALERS IN/artist materials/frames engravings &
c/? St/Prov. R.I."

(cat. #27.1.4-54)

A loner, with a compulsion for travel, Martin Johnson Heade was born in Lumberville, Pennsylvania in 1819, the son of a farmer and lumber dealer. Obtaining his first artistic training as a coach painter from the Quaker Edward Hicks (see p. 78) in Newton, Pennsylvania in 1837, Heade was soon on his own, travelling as an itinerant portrait painter. Before the age of twenty Heade was in Europe, spending two years in Rome with visits to England and France. By 1841 he was exhibiting at the Pennsylvania Academy of Fine Arts, and for the next seven years moved frequently — to New York City; Trenton, New Jersey; Philadelphia and Brooklyn before returning to Europe in 1848. Back in the United States he continued to move about — to St. Louis, Chicago, Trenton and Providence, painting continuously. By the 1850's Heade was seriously concerned with landscape painting. His move to New York City in 1859 was to accelerate this interest as he acquired a studio in the 10th Street Building where artists such as John F. Kensett and Frederic Edwin Church also painted. Church was especially influential and became a life-long friend. An 1860 Church canvas, TWILIGHT IN THE WILDERNESS, was to have an impact not only on Heade, but on other landscape painters who were impressed by its low horizon and the vivid contrasts between the hot colors of the sky and the soft-toned land. This influence is particularly evident in the Heade canvas of 1861 illustrated here. It was probably painted in Rhode Island.

COASTAL SCENE WITH SINKING SHIP Fig. 112

H. 40¼"; w. 70¼" 1863
oil on canvas
signed, l.l.: "M. J. Heade — 63"
(cat. #27.1.4-58)

HAZY SUNRISE AT SEA Fig. 157

H. 20"; w. 50" 1863
oil on canvas
signed, l.l.: M. J. Heade 63"
Exhibited: Munson-Williams-Proctor Institute of Art, Utica, New York, October 15-December 31,
1960
"Martin Johnson Heade" Exhibition, Museum of Fine Arts, Boston; University of
Maryland Art Gallery; and Whitney Museum of American Art, 1969.
(cat. #27.1.4-63)

1863 was to be a particularly busy and productive year for Heade, as Theodore E. Stebbins has pointed out.[1] It is probable that he met Fitz Hugh Lane during this time. These two paintings, probably of the same site, were done just after and long after a storm. The romance and melodrama of the site appealed to Heade; the same appeal, along with his life-long interest in hummingbirds, was to take him to Brazil later that year where he began illustrations for a never-to-be published book entitled *Gems of Brazil*.

[1] Theodore E. Stebbins, Jr., *Martin Johnson Heade,* Exhibition Catalogue for the 1969 exhibition of Heade paintings at the Museum of Fine Arts, Boston, University of Maryland Art Gallery, and Whitney Museum of American Art, unnumbered pages.

159.

157.

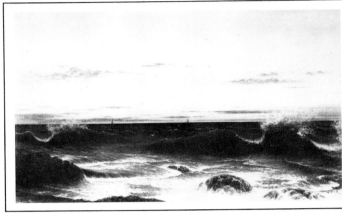

158.

SOUTH AMERICAN SCENE

H. 8½"; w. 15½" 1864
oil on canvas
signed, l.l.: "M J H/1864"
(cat. #27.1.2-94)

Done during his first South American trip, this scene probably is of Rio de Janeiro. These early Brazilian paintings show the extent to which Heade's ability and technique had improved.

BRAZILIAN HUMMINGBIRDS Fig. 159

H. 14"; w. 13" 1866
oil on canvas
signed, l.l.: "M H 66"
(cat. #27.1.5-21)

Perhaps one of three versions of Brazilian hummingbirds which Heade exhibited at the National Academy of Design in 1866, this painting was done on his second South American trip (having been in London and Belgium in the interim). Hummingbirds were an obsession of Heade's. In his later years he wrote articles on their behavioral patterns for *Forest and Stream,* and spent considerable time feeding, taming and photographing them.

ORCHID AND HUMMINGBIRD

H. 18¼"; w. 10¼" c. 1875-1885
oil on canvas
signed, l.l.: "M. J. Heade"
(cat. #27.1.5-20)

Using the 10th Street Studio as a base of operations, Heade continued his travels — a third trip to South America, in Jamaica, Colon, and Panama in 1870, and later in British Columbia, Vermont, and San Francisco. Heade continued to paint landscapes and about 1871 began a new hummingbird series, of which this is one. There is no evidence that Heade painted orchids until the 1870's. Hummingbirds were to appear in his canvases through Heade's last years, the later paintings becoming somewhat repetitive.

Heade, Martin Johnson

THIMBLE ISLAND, CONNECTICUT

(Back Cover)

H. 15¼"; w. 29¼" 1875 or 1876
oil on canvas
(cat. #27.1.2-66)

One of three Heade paintings done off Long
Island Sound, the location is the Thimble Is-
lands, a cluster of 565 islands some five miles
off the coast of Stony Creek, Connecticut.
Theodore Stebbins remarks, "These are
small, sensitive views of the sea and among
Heade's most luminous paintings. . . . Here is
a pure painter of light. He stays strictly within
the American style, allowing no sign of his ef-
forts with the brush to appear on the canvas,
yet he is paralleling, quite on his own, the
aims of French impressionism."[1]

Ibid. The other two paintings, almost identical in size to
this are BECALMED, LONG ISLAND SOUND, and THIM-
BLE ISLANDS NEAR NEW HAVEN.

FLORIDA SUNSET

Fig. 160

H. 17½"; w. 36¼" c. 1886 or 1887
oil on canvas
signed, l.r.: "M. J. Heade"
(cat. #27.1.2-91)

This painting, originally entitled TROPICAL
SUNSET, is now believed to be Florida, and
may be the canvas SUNSET, FLORIDA,
exhibited at the National Academy in 1886.

160.

ORCHIDS AND A BEETLE

H. 12"; w. 20" c. 1885-95
oil on canvas
signed, l.r.: "M. J. Heade"
(cat. #27.1.5-15)

Between 1880 and 1886 no dated pictures by
Heade have been found. He is known to have
been in New York; Philadelphia; Bridgeport,
Connecticut; Washington, D.C. and in 1883
first visited St. Augustine, Florida which was
to become his winter home for the rest of his
life. A bachelor until the age of sixty-five, Con-
Heade married Elizabeth Smith in 1883. Con-
tinuing to travel in the summers, Heade
painted landscapes and many of these lush,
tactile still-lifes of flowers and birds.

Henry, Edward Lamson

A LOVER OF OLD CHINA Fig. 161

 H. 14"; w. 12" 1889
 oil on academy board
 signed, l.r.: "E L Henry 89"
 Exhibited: "The Best of Shelburne," IBM Gallery, New York,
 November-December, 1964.
 (cat. #27.1.7-2)

161.

After another trip to Europe in 1871, Henry continued to paint in New York City. In 1875 he married Frances Livingston Wells in Johnstown, New York, and went to England and France to honeymoon and paint. After returning to New York City the Henrys were again in Europe in 1881-1882, after which Henry designed and built "Cragsmoor" — to become their permanent summer home near Ellenville, New York. Winters were spent in New York, where this painting was done in 1889. A photograph of this painting in the Henry Collection is inscribed on the back:

Finding rare examples in the lady's cupboard, the gentleman in this picture was Richard Ely, cor. 5th Avenue and 35th St. and who was attaché of Legation at the Court of Louis Phillipe, 1839-40- & 41. The old lady was Mrs. Livingston Murray (Mrs. Henry's aunt) & who lived to nearly 101 years of age. Painted by E. L. Henry, in 1886-8.[1]

[1] Quoted in _Ibid.,_ p. 189.

CARRIAGE RIDE ON A COUNTRY LANE Fig. 162

 H. 7"; w. 10" 1906
 oil on academy board
 signed, l.l.: "E L Henry 1906"
 (cat. #27.1.2-23)

This vehicle in this painting appears in several Henry paintings and may be one of many which Henry collected (now in the Suffolk Museum, Stony Brook, Long Island Carriage Museum). An architectural buff, Henry was an early proponent of preserving historic buildings. He also collected costumes (now in the Brooklyn Museum), played the flute, and was an accomplished photographer.

163.

Henry, Edward Lamson (1841 – 1919)

OLD CLOCK ON THE STAIRS Fig. 115

 H. 20¾"; w. 16¼" 1868
 oil on canvas
 signed, l.l.: "E L Henry./MDCCCLXVIII"
 Exhibited: National Academy of Design, 1869, (no. 406).
 International Exhibition, Philadelphia, 1876, (no. 258).
 (cat. #27.1.6-7)

Orphaned at seven, Edward Lamson Henry left Charleston, South Carolina where was born in 1841 to live in New York City with some cousins. By 1855 he began stu_ ing art with Walter M. Oddie, a landscapist, and in 1858 became a student at the Pennsylvania Academy of Fine Arts. The next year he exhibited at the National Academy of Design where he was to continue to show his work for most of his life. Europe in 1860-1862, Henry studied with Suisse, Charles Gleyre, and Gustave Courbet, and travelled in Italy, Holland, and England. In New York he opened a stu_ in the Tenth Street Building in 1862. He continued to paint and exhibit except for brief hiatus during the Civil War when he served as a Captain's clerk, after which returned to his studio.

Two paintings of this scene were done by Henry — this one, and a second own_ by Emil B. Meyrowitz, to whom on July 12, 1917 Henry wrote:

The original of this painting was made from nature in an old Philadelphia hous_ built in the latter part of the eighteenth century on Spruce Street. It was the re_ dence of the noted antiquary William Kulp, and was exactly as it appeared the_ His old aunt, sitting in her back private room, reading the morning paper, her _ on a stool close to her.

It struck me at the time as so picturesque that I painted the work from life and was afterwards sold to Mr. Robert Gordon of London, where the painting is no_ The title was the OLD CLOCK ON THE STAIRS.

 E. L. Henry, N_

[1] Quoted in Elizabeth McCausland, _The Life and Work of Edward Lamson Henry, N.A._ 1841-1919 (Albar_ The University of the State of New York, September, 1945), Bulletin 339, p. 228. A drawing for the paintin_ also illustrated on p. 307.

162.

Heyde, Charles Lewis (1822 – 1892)

NORTH WILLISTON, VERMONT

 Fig. 163

 H. 20½"; w. 35" mid 1850's
 oil on canvas
 Given in Memory of the Honorable and Mrs. Theodore Eli
 Hopkins by their daughter, Mrs. Edith Hopkins Walker, 1959
 (cat. #27.1.2-32)

The woodburning locomotive in the painting is reputedly the first train through North Williston on the tracks of the Vermont Central Railroad Co., founded in 1848. The painting once hung in the home of Eli Chittenden, grandson of Vermont's Governor Thomas Chittenden.

...UNT MANSFIELD, VERMONT Fig. 164

H. 34¼″; w. 20″ c. 1863
oil on canvas
signed, l.l.: "Heyde"
(cat. #27.1.2-29)

...s view of Mount Mansfield is from Jericho, near Brown's River.
...e road is called the "Raceway." South Hill is on the right, Un-
...hill Center is in the middle distance, and Pleasant Valley is to
... left.

...TASH BROOK IN 1855

H. 8¼″; w. 12″ 1855
...oil on canvas
signed on verso: "Potash Brook in 1855/C L Heyde/21 Pearl St. Burlington Vt"
(cat. #27.1.2-46)

...e tranquil, clear skies and soft, pastel tones of mountains, hills
...d rivers which Charles Lewis Heyde repeatedly painted stand
...marked contrast with the hardships and pathos with which he
...s continually confronted. Little is known of his early years ex-
...t that his father, a sea captain, was lost at sea. By the late
...30's he was writing poetry and came to know William Cullen
...ant, Walt Whitman, and Whitman's sister, Hannah, who was to
...come his wife.[1] By 1850 Heyde was exhibiting at the National
...ademy, living in Hoboken, New Jersey, and beginning in 1851
...Brooklyn. His first visit to Vermont was probably from August
...ough October, 1852, when he visited North Dorset. Back in
...oklyn, he exhibited two Vermont winter scenes in the National
...ademy in 1853. By the mid 1850's Heyde made Vermont his
...me, painting in Bellows Falls, Rutland, Clarendon Springs, and
...rlington. These two paintings are among his earliest Vermont
...vases.

...Hannah told Miss Marguerite Hagar of Burlington that she and Heyde eloped in
...9, while Whitman's Bible gives April 16, 1852 as the date of the marriage. Most of
...information has come from the late Alice Cooke Brown, Professor at Green Moun-
...College, Poultney, Vermont.

...AL OF VERMONT

...H. 23¾″; w. 18″ c. 1862
...oil on canvas
...Gift of: Vanderbilt Webb, 1955
...(cat. #27.1.6-4)

...e Vermont Legislative Directory of 1943 states that in 1862 or
...rtly thereafter "a painting intended to be the official version (of
... seal of Vermont) was made by Mr. Heyde of Burlington, and
...ced in the custody of the Secretary of State. It was replaced by
... present painting in that office dated 1898; and the painting by
... Heyde seems to be lost. Fortunately, there is a detailed de-
...iption of the Heyde painting, furnished by Charles Reed soon
...er it was made. . . ."[1] That description matches this painting
...fectly. Somehow it came into the possession of Dr. William
...ward Webb, and hung in his Shelburne home until given to the
...seum by his son Vanderbilt.

...Vermont Legislative Directory, 1943, pp. 186-187.

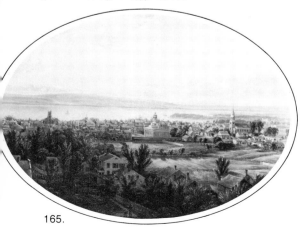

165.

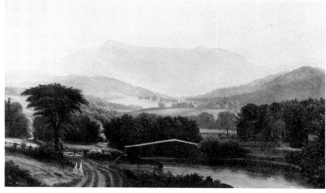

164.

SHELBURNE POINT: ADIRONDACK MOUNTAINS ACROSS BURLINGTON BAY FROM OVER WILLARD STREET

H. 17¾″; w. 34¼″ 1884
oil on canvas
signed, on verso: "Adirondack Mountains./Burlington Bay./over Willard
St./Sketch Vermont/1867" and "Heyde/1884"
(cat. #27.1.2-6)

COVERED BRIDGE OVER WINOOSKI GORGE NEAR BOLTON, VERMONT

H. 16″; w. 12″
oil on canvas
signed, l.r.: "Heyde"
(cat. #27.1.2-42)

SHELBURNE BAY

H. 6½″; w. 9″ (oval) 11½″; 13½″ (stretcher)
oil on canvas
Gift of: Mrs. Dunbar W. Bostwick, 1957
(cat. #27.1.2-15)

WINOOSKI RIVER AT BURLINGTON, VERMONT

H. 20″; w. 34″
oil on canvas
signed, l.r.: "Heyde"
(cat. #27.1.2-30)

BIRD'S-EYE VIEW OF BURLINGTON, VERMONT

Fig. 165

H. 25¼″; w. 34¾″ (oval opening)
27″; 35¼″ (stretcher)
oil on canvas
(cat. #27.1.2-44)

STEAMER OFF SHELBURNE POINT

Fig. 110

H. 17″; w. 34″
oil on canvas
Gift of: Richard Gipson, 1959
(cat. #27.1.4-35)

APPLE TREE POINT

H. 6½″; w. 9″
oil on canvas
Gift of: Mrs. Dunbar W. Bostwick, 1956
(cat. #27.1.2-16)

LAKE CHAMPLAIN AND ISLANDS

H. 12¼″; w. 21¼″
oil on canvas
(cat. #27.1.4-42)

POTASH BROOK

H. 17¼″; w. 26¼″
oil on canvas
(cat. #27.1.2-131)

By 1859 Heyde had settled in Burlington, Vermont. Plagued by financial difficulties and the recurrent emotional problems of his wife, the remainder of his life was extremely unhappy. In 1863 he had a studio on Church Street (described by James R. Hickok in *Hemenway's Gazeteer*), and was painting near Ottawa. Some time later he bought a brick house at 21 Pearl Street, Burlington, which had once housed officers during the War of 1812. The continued strain of dealing with Hannah prevented Heyde from painting periodically. "She invades my room with such offensive demeanor at times that I am forced to quit my painting and take to the street."[1] Serious problems brought Mrs. Whitman to visit in 1865, and in 1872 Walt Whitman visited Mrs. Heyde after giving Dartmouth's commencement address. Forced to please his patrons, most of Heyde's later paintings are repetitions of the same well-loved scenes. Even so, he was often unable to make ends meet and was forced to write repeatedly to both Walt and George Whitman for financial help. In his last years, he was utterly despondent; on December 27, 1889 he wrote Walt Whitman that he had only seventy-five cents after "purchasing coal and a few sundries for our table. . . . No probability of selling a painting now."[2] Dependency on alcohol caused much inconsistency in his later work, some painted very thinly and carelessly with inattention to detail.

[1] Quoted in Alice Cooke Brown's "Charles Lewis Heyde, Painter of Vermont Scenery," The Magazine *Antiques* (June, 1972), p. 1028, from the Heyde-Whitman correspondence, in the Trent Collection of the William R. Perkins Library, Duke University, Durham, North Carolina.
[2] *Ibid.*, p. 1029.

Hicks, Edward (1780 – 1849)

PENN'S TREATY WITH THE INDIANS

Fig. 166

H. 25"; w. 30½" c. 1840-1845
oil on canvas
Inscribed: "PENNS TREATY with the INDIANS, made 1681 with/out an Oath, and
 never broken. The foundation of/Religious and Civil LIBERTY, in the
 U.S. of AMERICA."
(cat. #27.1.6-1)

Today largely known for his charming and naive paintings of the Peaceable Kingdom, Penn's Treaty with the Indians or placid farmyards, Edward Hicks in his own life was more widely known as a coach painter and Quaker preacher of deep religious conviction. Born in 1780 in Attleboro, Pennsylvania, the son of Isaac and Catherine Hicks, Edward Hicks was raised by Elizabeth and David Twining near Newton, Pennsylvania after his mother died in 1781. At the age of thirteen he was apprenticed to a coachmaker William Tomlinson and his brother Henry and by 1800 was in business for himself in Attleboro. In 1801 he was the junior partner of Joshua Canby as a coachmaker in Milford (now Hulmeville) Pennsylvania. Marrying a Quaker, Sarah Worstall, in November, 1803, by 1806 Hicks was painting floor cloths, street signs, and painting and decorating furniture. In 1811 he moved to Newton and was instrumental in establishing the Newton Friend's Meeting. Increasingly compelled to preach, particularly after meeting his cousin Elias Hicks, founder of the Quaker Hicksite movement, Hicks continued to paint as a livelihood. Canvases, fireboards, clock faces, carriages, alphabetical blocks, gilded and ornamental furniture all were decorated by his brush. Between 1819-1820 Hicks travelled 3,000 miles on horseback through western Pennsylvania to Niagara Falls, preaching and visiting Elias across the border in Ontario. Painting primarily for spiritual reasons, the first of the PEACEABLE KINGDOM paintings were created in the early 1820's. For the rest of his life, the need to articulate his religious philosophy was to conflict with Hick's financial needs which he could only meet by painting. Despondent in his last years, he predicted the date of his death accurately, his funeral attracting one of the largest groups of admirers recorded in that area.

Hicks undoubtedly painted PENN'S TREATY after a popular engraving made from Benjamin West's painting of the same title. It was probably the Hall-Boydell engraving, published by John Boydell in 1775. Nine versions of this scene by Hicks are known; the smaller ones are done on wood and date from 1831, and the larger ones are on canvas dating between 1840-1845.

166.

Hicks' Published Memoirs, 166.
Shelburne Museum Collection

Attributed to

Hidley, Joseph Henry (1830 – 1872)

VIEW OF CANTON, MASSACHUSETTS

Fig. 167

H. 27"; w. 34" c. 1850
oil on canvas
(cat. #27.1.2-59)

According to the former owner, this scene was painted for Lyman Kinsley in 1850 by Joseph Henry Hidley. It shows a "view west. Houses of Lyman Kinsley and Uriah Billings in center, enclosed in white fence. Shows train to Stoughton on left and train to Providence on extreme right."[1]

Joseph Hidley spent most of his life in Poestenkill, New York. A man of varied interests, Hidley was a taxidermist, did wood carvings, made shadow-box pictures, and painted views of New York towns. His early scenes are true primitives, with little sense of perspective or tonal variation. Later his technique improved and his efforts were much more sophisticated. This painting is a departure from his usual aerial perspectives of towns, and it is not known when Hidley was in Massachusetts.

Hicks, Edward

INDIANS SHOOTING JAGUAR IN A TREE

H. 17"; w. 24½" 1847
oil on canvas, mounted to masonite
signed, on verso: "Painted by Edw.
 Hicks/In the 67 Year of
 His Age"
Gift of: Mrs. Brooks Shepard, 1958
(cat. #27.1.5-84)

While unlike most of Hicks' paintings, the handling of the jaguar, foliage, and sky in this painting is not inconsistent with Hicks' style. The signature on the reverse looks very much like that on the back of a Hicks' painting of the same year entitled DAVID AND JONATHAN AT THE STONE EAZEL, which he has signed "Painted by Edward Hicks in his 67th year."[1]

[1] L. L. Beans, *The Life and Work of Edward Hicks* (Trenton, New Jersey: L. L. Beans, 1951), p. 21.

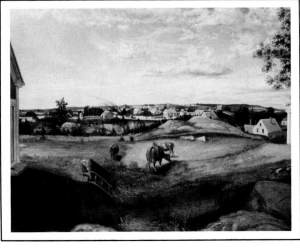

167.

[1] Letter from John Levy Galleries, Inc., New York, April 13, 1951, Shelburne Museum MSS.

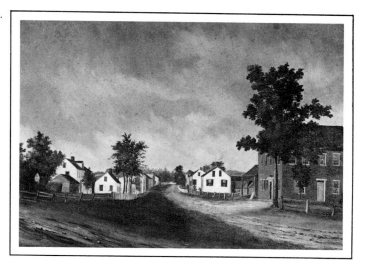

168.

Higgins, George Frank (active 1850 – 1884)

ATLANTIC, MASSACHUSETTS

Fig. 168

H. 14¼"; w. 19½" c. 1884
oil on masonite
signed, l.l.: "G. Higgins"
(cat. #27.1.2-31)

George Higgins was an artist from Boston who exhibited at the Boston Athenaeum from 1859-1862. He was in Boston in 1873 and is known to have been active until at least 1884.

Hill, Thomas (1829 – 1908)

FOUR HORSE HITCH

Fig. 169

H. 25"; w. 30¼" 1854
oil on canvas
signed, l.l.: "T. Hill/1854"
on verso: "Prepared by/THEO. KELLEY/16 ARCADE/PHILAD." on
 business card tacked to stretcher: "Theodore Kelly/Artist's
 Emporium/No. 16 Arcade, West Avenue,
 Chestnut,/Philadelphia./Artist's Materials of every
 description."
(cat. #27.1.2-48)

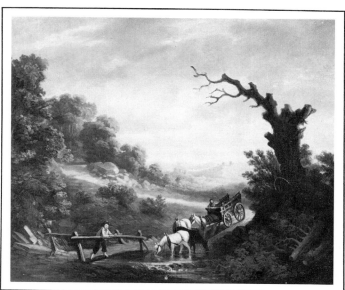

169.

Born in England in 1829, Thomas Hill came to Taunton, Massachusetts with his parents in 1841. By 1844 he was a decorative painter in Boston, later moved to Philadelphia where he painted portraits and flowers, and was exhibiting in Philadelphia and Baltimore in the 1850's. In 1861 Hill moved to California and began painting the enormous landscapes for which he became famous. In Paris for a year in 1866, Hill returned briefly to Boston before again heading for California. He resided there until his death by suicide in 1908.

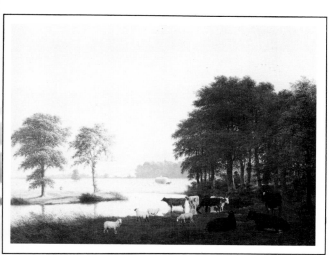

170.

Hinckley, Thomas Hewes (1813 – 1896)

SHEEP GRAZING — COWS LAZING Fig. 170

H. 26"; w. 36" 1854
oil on canvas
signed, l.l.: "T. H. Hinckley/1854"
(cat. #27.1.2-87)

Born in Philadelphia in 1813, Thomas Hewes Hinckley was unable to become an artist until his father's death because of the latter's distaste for the profession. Until that point, Hinckley was apprenticed to a Philadelphia merchant beginning in 1829 and finally began studying painting with William Mason, a Philadelphia drawing master. First a portraitist, Hicks early became an accomplished animal painter. Soon after he established a studio in Milton, Massachusetts in 1845, Daniel Webster asked him to Marshfield "to make drawings of his famous Ayrshire herd."[1] Some of these sketches were incorporated in paintings bought by the American Art Union. He studied animals intently, exhibiting his paintings of them at the National Academy and Pennsylvania Academy of Fine Arts. In 1851 he went to England to see the animal paintings of Sir Edwin Landseer, and to Belgium to see Flemish canvases of animals. Two of his paintings were exhibited at London's Royal Academy. In 1870 he journeyed to California in order to study elk. Shelburne's records indicate that this scene was "taken from Paul's Bridge, Milton, Massachusetts."

[1] *M. & M. Karolik Collection of American Paintings, 1815 to 1865* (Cambridge: Harvard University Press, 1949, p. 354.

Hinds, Amanda (active 1817)

PIN PRICK LAMB

H. 6⅜"; w. 8⅝" 1817
watercolor on paper; lamb done with pin pricks
signed, l.l.: "Amanda/Hinds/1817 -"
(cat. #27.2.6-24)

The artist of this delightful watercolor
has imaginatively made pinpricks
through the drawing of the lamb to
simulate his curly fleece.

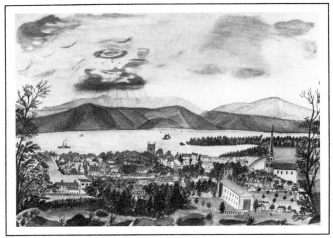

171.

Holt, Louisa M.

VIEW OF BURLINGTON, VERMONT

Fig. 171

H. 10"; w. 14"
pencil on paper
signed, l.r.: "Louisa M. Holt"
Inscribed: "View of Burlington, VT."
(cat. #27.8-5)

This is a delightful, rather naive draw-
ing of Burlington from the hill looking
across the Bay toward Rock Point. It
was unquestionably done from the print
illustrated, entitled VIEW OF BUR-
LINGTON, VERMONT.[1]

[1] (uncolored lithograph, 3½ × 7"), Shelburne
Museum, (cat. #27.6.2-19). The print first appeared
in *Graham's Magazine*, V. III, 1852.

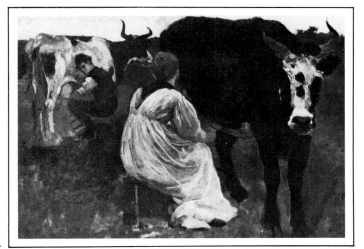

172.

Hoit, Albert Gallatin (1809 – 1856)

BLACK AND BROWN: ONE UP, ONE DOWN

H. 5½"; w. 8" c. 1830's
oil on canvas
Gift of: Richmond G. Wright, 1969
(cat. #27.1.5-51)

This painting by Albert Gallatin Hoit was probably done
shortly after his graduation from Dartmouth in 1829. A na-
tive of Sandwich, New Hampshire where this painting is
supposed to have been done, Hoit was painting portraits
as early as 1830, and during the next nine years painted in
Portland, Belfast, Bangor and Howland, Maine, and St.
John and Frederickton, New Brunswick, before settling in
Boston. In Europe from 1842-1845, Hoit returned to Boston
and became the first President of the Boston Art Club.
Hoit's most famous painting is a full-length portrait of
Daniel Webster in the Union League Club in New York City.

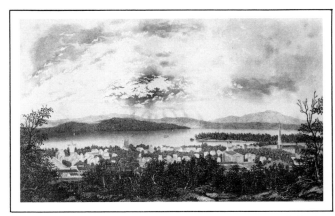

171. VIEW OF BURLINGTON, lithograph, Shelburne Museum Collection

Homer, Winslow (1836 – 1910)

MILKING

Fig. 172

H. 15½"; w. 22¾" c. 1875
oil on canvas
Exhibited: "The Best of Shelburne," IBM Gallery, New York,
 November-December, 1964.
(cat. #27.1.7-11)

As much as any American artist, Winslow Homer
was pragmatic, with an overriding concern for physi-
cal reality. His desire to paint action out-of-doors
had been present from his earliest illustrations for
Harper's Weekly and was intensified by his sketches
at the Front during the Civil War, in France in 1866,
and in Gloucester in 1873 where he did his first
watercolors. The freedom and spontaneity which
Homer's rapid mastery of watercolor provided is
reflected in the well-balanced, earthy colors of this
oil. Although not one of Homer's great paintings,
MILKING shows how well he composed masses
within a small space. A similar theme is seen in a
painting called MILKING TIME in the collection of
the Delaware Art Museum.[1]

[1] (24 × 28", oil, 1875), Delaware Art Museum, Wilmington, Dela-
ware. This painting was exhibited at the National Academy of Design
in 1875.

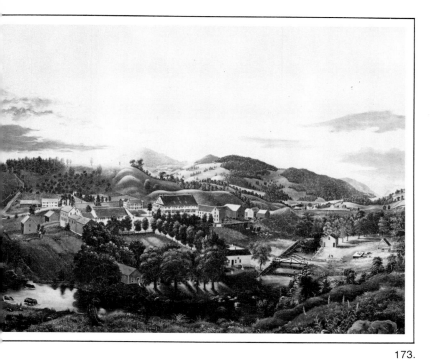

173.

174.

Hopkins, Bishop John Henry (1792 – 1868)

THE FOUR ANGELS Fig. 174

H. 46"; w. 36" c. 1840-3
oil on wood
(cat. #27.1.1-157 a, b, c, d)

These four paintings of the daughters of John Henry Hopkins were painted after their father became Episcopal Bishop of Vermont in 1832. The only child of Thomas and Elizabeth Fitzakerly Hopkins, John Henry, born in Dublin, Ireland, was raised by his paternal grandmother until the age of six, and was taken to Philadelphia by his parents in 1800. Hopkins was a very precocious and lonely child who very early exhibited a wide range of interests and abilities which remained with him his entire life. He went through a series of careers, first as a merchant, then artist, later superintendent of the furnace operation of an iron manufacturer, was a member of the Pennsylvania bar by 1818, Deacon of Pittsburgh's Trinity Cathedral in 1823, and Bishop of Vermont in 1832. In Burlington his energies never flagged — he bought a brick house on Church Street (today the Converse Home) and rapidly added on to it, making space for an oratory and theological seminary. Losing all of these in the financial panic of 1837, Hopkins went on to purchase 100 acres of land at Rock Point and began to build the impressive structures which remain today.

Always artistic, Hopkins not only drew and painted, but was extremely interested in architecture, writing an essay on Gothic architecture in 1836 and designing many buildings in his diocese himself. He lithographed a drawing book of Vermont landscapes in 1837 and some lovely wild flower prints in 1846-1847 which he prepared and printed in his basement. These four oil paintings were painted to decorate the Chancel of St. Paul's Cathedral in Burlington. About 1946 they were removed. Depicting the four Hopkins' daughters as angels, the children are: Charlotte Emily, born 1817; Matilda Theresa, born 1819; Melusina Elizabeth (depicted here), born 1824, and Caroline Amelia, born 1838.

pe, James (1818 – 1892)

ARENDON SPRINGS, VERMONT Fig. 173

H. 26"; w. 36" c. 1853
oil on canvas
(cat. #27.1.2-99)

rn in Drygrange, Roxboroughshire, Scotland, James Hope came to nada as a child with his father who died c. 1831 of cholera. Shortly reafter, Hope is said to have walked to Fairhaven, Vermont, where he ved a five-year apprenticeship with a wagon maker. In 1839 he was a dent at Castleton Seminary, Castleton, Vermont and one year later gan teaching school in West Rutland, Vermont. After marriage to Julia M. ith in 1841, Hope began painting portraits professionally in West land in 1843. He continued to paint in Montreal from 1844-1846, re- ing to Castleton afterward to begin painting landscapes. From 1849- 2 he taught drawing and painting at Castleton Seminary, and in 1848 ibited for the first time at the American Art Union. He made reference to artists, "one famous through color power, the other through majesty of , who helped me with most grateful results," and claimed "it was only r subtleties of technique I had needed. From then on the transcription ature was the transcription of my thoughts."[1] One of these artists was er Durand; the other was undoubtedly Frederic Church who had ex- ted two Vermont scenes in the National Academy in 1850 and in 1851 lt a house in Castleton. In 1852 Hope gave up teaching and late in that r opened a winter studio in New York City. During the Civil War, Hope ved as Captain, Company B, 2nd Vermont Regiment, as a topographi- engineer, and sketched action scenes. In ill health, he returned to Ver- nt in the spring of 1863. From 1872 Hope lived in Watkins Glen, New k, painting landscapes.

Clarendon Springs, the site of this painting, was an important spa, at- cting mainly wealthy southerners before the Civil War. The Clarendon use, the largest structure in the painting, was built in the 1830's. Another sion of this scene by Hope is exhibited in the Currier Gallery, Manches- New Hampshire.[2]

David S. Brooke, "A View of Clarendon Springs by James Hope," The Currier Gallery Art LETIN, Manchester, New Hampshire, Autumn, 1970.
The Currier Gallery version has "A. M." in one corner.

Hoyt, Thomas R., Jr. (active 1835 – 1845)

SKEAG VILLAGE, NEW HAMPSHIRE Fig. 175

H. 7¾"; w. 12⅜" 1836
watercolor on paper
signed, l.r.: "Drawn by T. R. Hoyt, Jr. 1836"
(cat. #27.2.2-20)

Thomas R. Hoyt, Jr. is known to have been painting watercolor scenes in New Hampshire for about ten years between 1835 and 1845. This is actually Amoskeag, a village on the Merrimack River, opposite Manchester. It became a part of the city about 1850.

175.

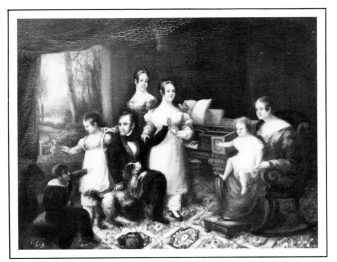

Hubbard, Charles (1801 – 1875)

THE ARTIST CHARLES HUBBARD AND HIS FAMILY Fig. 176

H. 10¾″; w. 14″ 1841
oil on wood
Inscribed on verso: "Hon. Charles Hubbard and his family. (of Chelsea, Mass.)/Wife, Amelia Jane (Ripley) Hubbard. Born 1806/Children: James Ripley Born 1827. Ellen Maria (born) 1828./Abigail James (born) 1831./Charles (born) 1835./Elizabeth Capen. (born 1838). Picture painted by Chas. Hubbard/just before birth of last child, Florence Amelia. Born 1841."

(cat. #27.1.1-128)

The son of Elizabeth and William Hubbard, Charles Hubbard was born in Brighton, Massachusetts in 1801. He probably had his first artistic training with the Curtis brothers, Samuel, a clock painter, and Benjamin, a painter. By 1822 the firm of "Curtis & Hubbard" was listed in the Boston Directory, a partnership which lasted one year. After marrying Amelia Jane Ripley in 1826, Hubbard bought a home in Boston in 1827 and by 1829 was exhibiting paintings at the Boston Athenaeum. In 1831 Hubbard advertised that he was a "sign, block, ornamental, military standard & Masonic painter. Druggists' Ware and Glass painting neatly executed. Constantly on hand a good assortment of Timepiece Dials and Glasses."[1] Hubbard is believed to have painted most of the glass panels in Aaron and Simon Willard's clocks. In 1831 he was instrumental in forming the Winisimmet Co., a land developing company in Chelsea, Massachusetts where Hubbard built the house depicted in this painting. A selectman in Chelsea, Hubbard served in the General Court in Massachusetts and in 1851 was elected to the State Senate. The same year he became the director of the New England Life Insurance Company, but continued to paint, primarily doing seascapes along the Boston and Maine coast.

[1] This quote plus most of the information on Hubbard's life came from an unpublished manuscript by Leeds Wheeler, entitled *Charles Hubbard — A Nineteenth Century Boston Artist.* A copy was given to the Shelburne Museum Library by Mrs. Wheeler in 1971.

Huffaker, Eugene (active 1935)

FOUR HORSES AND A CARRIAGE

H. 14¼″; w. 18¼″ 1935
ink and crayon on paper
(cat. #27.9-57)

Huntington, Daniel (1816 – 1906)

EDGE OF A WOOD Fig. 177

H. 40″; w. 53″ c. 1851
oil on canvas
Exhibited: National Academy of Design, 1851
(cat. #27.1.2-63)

An historical, religious, landscape, portrait and genre painter, Daniel Huntington was born in New York City on October 14, 1816. While a student at Hamilton College in Utica, New York, he was persuaded by Charles Loring Elliot to become a painter, and at the age of nineteen he became a pupil of Samuel F. B. Morse (see pp. 93 & 94). Four years later he, like so many others, headed for Europe (with Henry Inman and G. P. Ferrero) to study the great masters. After two years in Rome, he returned to the United States. He was to make three more trips abroad — from 1842-1845, in the 1850's, and in 1882. Huntington, whose paintings were often idealistic or pietistic, was to perhaps make his greatest contribution to American art in his long tenure as President of the National Academy from 1862-1870 and from 1877-1890, and as the first Vice-President of the Metropolitan Museum of Art in New York City from 1870-1903.

Hurd, Clement (1908-)

HORSESHOE BARN

H. 16″; w. 21½″ c. 1952
pen and ink on paper
signed, l.l.: "Clement Hurd"
Gift of the Artist
(cat. #27.9-35)

VARIETY UNIT

H. 12″; w. 18″ c. 1952
pen and ink on paper
signed, l.l.: "Clement Hurd"
Gift of the Artist
(cat. #27.9-34)

VERGENNES SCHOOLHOUSE Fig. 178

H. 12″; w. 18″ c. 1952
pen and ink on paper
signed, l.r.c.: "Clement Hurd"
Gift of the Artist
(cat. #27.9-33)

Clement Hurd is best known as an illustrator of children's books written by his wife, Edith Thatcher Hurd, including *Three Ducks in a Pond*; *The Christmas Bells, Being a Vermont Story*; and *The Mother Beaver.* During his tenure as a trustee of the Shelburne Museum between 1948 and 1955, Mr. Hurd did these drawings of three of the Museum's buildings. Now living in California, he spends his summers in Starksboro, Vermont.

Hutchins, J. N. (active 1911)

WEBB BREEDING BARN

Fig. 179

H. 10¾"; w. 24" 1911
watercolor on paper
signed, l.l.: "J N Hutchins '11"
Gift of: J. Watson Webb
(cat. #27.2.6-9)

Known as the Ring Barn, the very large and impressive barn was designed by the architect R. H. Robertson for Dr. William Seward Webb in Shelburne, Vermont c. 1893. 418 feet long and 108' wide, the barn contained an exercise ring 375' by 85'. It had thirty-two box stalls on each side, twenty-one at one end, and ten larger ones at the other. Still standing today, it now houses a large herd of purebred Herefords.

179.

180.

Jacobsen, Antonio (1850 – ?)

HUDSON RIVER PADDLE STEAMBOAT CHAMPLAIN (active 1832 – 1840)

Fig. 181

H. 23¾"; w. 42" 1889
oil on canvas
signed, l.r.: "A. Jacobsen 1889"
(cat. #27.1.4-6)

A day boat between New York and Albany, the CHAMPLAIN was put into service on June 12, 1832. Her owner was the North River Steamboat Co. Built by Brown and Bell of New York, her engine was constructed by the West Point Foundry Co. of New York. She had a wooden hull, weighed 471 tons, and travelled at speeds up to fifteen miles per hour. For eight years the CHAMPLAIN served well and then was laid up in the summer of 1840 and converted to a barge in 1843.

Born in Copenhagen, Denmark in 1850 the artist, Antonio Nicolo Gasparo Jacobsen, (a descendant of a long line of violin makers) was named by the violinist Ole Bull. While demonstrating musical talent and encouraged to play the violin as a child, Jacobsen's greater interest was painting ships, and he began study at the Royal Academy of Design. To escape military service, Jacobsen came to America in 1871 and got a job at the Marvin Safe Co., decorating safe doors. Later he was employed by the Old Dominion, White Star and other steamship lines to paint ship portraits. After 1880 when he moved to West Hoboken, New Jersey, Jacobsen usually included his address with his signature. He was a close friend of two other ship painters, Fred Cozens and James E. Butterworth.

Inman, Henry (1801 – 1846)

HENRY LIVINGSTON WEBB Fig. 180

H. 2½"; w. 3" 1825
watercolor on ivory (miniature)
signed, left margin on vertical: "Inman 1825"
(cat. #27.2.1-31)

The very handsome, charming and humorous Henry Inman was born of English parents in 1801 in Utica, New York. Moving to New York City in 1812 where his father operated a brewery, Inman soon received an appointment at West Point. Two years later he began a seven-year apprenticeship with John Wesley Jarvis (see p. 84). Travelling through America's major cities — Boston, Philadelphia, Baltimore, and New Orleans, Inman collaborated with Jarvis in painting portraits, usually doing the costumes and backgrounds while his master painted the figures. Independent by 1823, Inman established his own studio in 1824. In 1826 he formed a partnership lasting four years with his own pupil, Thomas Seir Cummings, a miniature specialist. The same year he was instrumental in forming the National Academy of Design, serving as its Vice President from 1826-1831 and from 1838-1844. In 1851 Inman moved to Philadelphia where he became a printer with Col. Cephas G. Childs in the lithographic firm of Childs & Inman. In 1834 he served as Director of the Pennsylvania Academy of Fine Arts and later that year returned to New York City where he became a noted portrait and miniature painter. Plagued with chronic asthma, Inman's health began to deteriorate in the early 1840's. Nevertheless, he accepted a commission to go to England to paint, among others, Macaulay and Wordsworth. Although he carried out this task, his health was so impaired by the journey that he died shortly after his return.

Henry Livingston Webb, the son of Joseph and Abigail Chester Webb, was born in 1795 and married Frances Delord in Trinity Church, Plattsburgh, New York, on August 13, 1832. An oil painting of Henry Livingston Webb by Inman painted in 1830 hangs in the Kent DeLord House Museum in Plattsburgh.

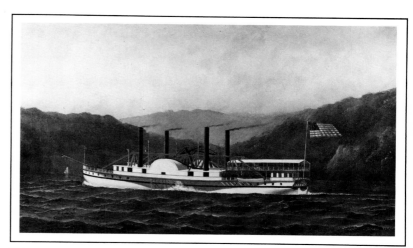

181.

Jarvis, John Wesley (1780 – 1840)

WILLIAM COLE COZZENS (1811 – 1876)

Fig. 182

H. 30"; w. 25¼" c. 1833 – 1834
oil on canvas
(cat. #27.1.1-122)

John Wesley Jarvis was probably born in South Shields, England in 1780, the son of an English mother and American father. Brought to Philadelphia in about 1785, while still a boy he worked for the painter Matthew Pratt (see p. 104) before being apprenticed to the engraver and portrait painter Edward Savage on Chestnut Street between 1796-1801. From 1803-1810 he was in partnership with Joseph Wood, engraving and painting portraits and miniatures. In 1807 he was assisted by Thomas Sully. After three years in Baltimore from 1810-1813, Jarvis went to New York City, but made trips to New Orleans, Richmond, and Charleston, South Carolina. The next fifteen years were to be his most profitable. Although his relations with pupil John Quidor (see p. 106) did not work out successfully, Henry Inman served a long apprenticeship with him from 1814-1822. Thereafter Jarvis' life was plagued with problems. While charming, witty, and fond of animals (at one time keeping a pet alligator), Jarvis was reckless and extravagant. His second wife left him and took custody of his daughters. Turning to alcohol for solace, he gradually lost his friends, faculties, and health. After suffering a paralytic stroke in 1834, he spent his last years with his sister, Mrs. Lewis Child, and son by his first marriage, Charles Jarvis.

The subject of this painting, William Cole Cozzens, came from a long established Newport, Rhode Island family. He became Mayor of Newport in 1854; a State Senator from 1861-1863; Governor briefly from March 3 to June 1, 1863; and was President of both the Redwood Athenaeum and the Rhode Island Union Bank.

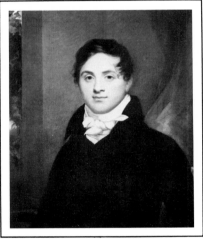
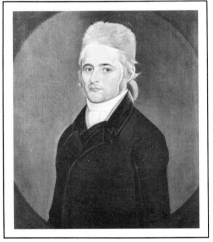
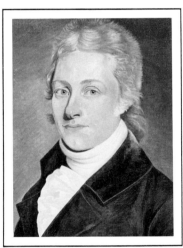

182. 183. 184.

Jennys, William (active 1774 – 1810)

GENTLEMAN OF THE BREWER
FAMILY OF HARTFORD, CONN.

Fig. 183

H. 29"; w. 24½" c. 1800
oil on canvas
(cat. #27.1.1-15)

This painting was entitled MAN IN FUR CAP in a checklist of Jenny's portraits compiled by William L. Warren in the *Connecticut Historical Society Bulletin,* April, 1956.

YOUNG MAN OF THE NEW REPUBLIC

Fig. 184

H. 17⅛"; w. 12¾" c. 1800
oil on canvas (has been cut down)
on verso: "J. William (sic) Jennys/Found in Hopkington/New Hampshire"
(cat. #27.1.1-46)

The background of the painter William Jennys remains in obscurity despite the continued interest and research by students of American art. The problem has been intensified by the close stylistic relationship of William's work with that of Richard Jennys in the late 1790's when both of them were painting near New Milford, Massachusetts. One assumption has been that Richard was William's father; however since William's earliest known paintings have a strong affinity with contemporary English canvases and are quite different from Richard's earlier works, this seems unlikely. Possibly William was trained in England, came to America where he was influenced by Richard (a relative) and then established his own style. As William moved up the Connecticut Valley into New Hampshire and Vermont, his portraits became increasingly realisic. Showing a mastery of drawing, Jennys' works were sometimes unflattering to his sitters but always straightforward. Jennys came at least as far north as Middlebury, Vermont and spent his last years in Newburyport, Massachusetts.

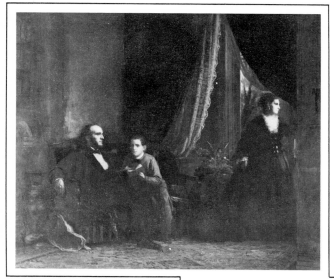

185.

186.

Johnson, Eastman

JOSEPH MABBETT WARREN FAMILY
OF TROY, NEW YORK

Fig. 185

H. 39¾"; w. 49¼" 1874
oil on canvas
signed, l.r.: "E. Johnson/1874"
Gift of: Miss Mary Rogers Warren, 1966
(cat. #27.1.1-173)

Painted in the library of their home "Montairy" (now
part of Rensselaer Polytechnic Institute) this canvas
depicts Joseph Mabbett Warren (1813-1890),
Adelaide Phelps Warren (1815-1891), and their son
Stephen Warren (1852-1885).

Kensett, John Frederick (1816 – 1872)

VIEW ON THE HUDSON AT DOBB'S FERRY

Fig. 187

H. 12"; w. 23½"
oil on canvas
on verso: "Kensett (J F) deceased . . . New York 21.
 View on the Hudson _____ Dobb's Ferry."
(cat. #27.1.2-73)

Born in Cheshire, Connecticut in 1816, John Frederick
Kensett learned engraving from his father Thomas, who
came to America from Hampton Court, England in 1812.
After further training from his uncle Alfred Daggett of New
Haven, Kensett went to work for the American Bank Note
Co. of New York but painted in his spare time. With his
friendly, sympathetic and unselfish nature he easily met a
number of artists, and in 1840 went to Europe with John
Casilear, Asher B. Durand, and Thomas P. Rossiter. After
seven years abroad, in France, England, Switzerland,
Germany and Italy, Kensett returned to New York City but
took sketching trips in the White Mountains, Catskills,
Adirondacks, Green Mountains, Newport, and Narragan-
sett. Through the rest of his life Kensett travelled widely —
to Niagara and Canada, along the Great Lakes, up the Mis-
sissippi and to the headwaters of the Missouri, in England
and Scotland, and Colorado. He helped found the Artists'
Fund Society, serving as its President between 1865 and
1870, and was a Founder and Trustee of the Metropolitan
Museum of Art.

Johnson, Eastman (1824 – 1906)

THE FIFER AND HIS FRIEND

Fig. 186

H. 20¼"; w. 16¼"
oil on canvas
signed, l.r.: "E. J."
(cat. #27.1.7-12)

LITTLE GIRL WITH GOLDEN HAIR

(Inside Front Cover)

H. 15"; w. 11½" 1873
oil on academy board
signed, l.r.: "E. Johnson/-73"
Exhibited: IBM Gallery, "The Best of Shelburne," November-December, 1964
(cat. #27.1.1-185)

Eastman Johnson was born in Lovell, Maine in July 29, 1824,
grew up in Fryeburg and Augusta, and later worked briefly in a
Concord, New Hampshire dry goods store. At the age of sixteen
his father sent him to Boston to learn lithography in the firm of J.
H. Bufford and Co. At eighteen Johnson was making accurate
crayon and pencil portraits, and returning to Maine, was able to
portray some of Maine's more prominent citizens, his family and
friends. In 1844 or 1845, Johnson was in Cambridge, Mas-
sachusetts and Newport, and then headed for Washington, D.C.
where he used a Senate committee room for a studio, painting
such noteworthy personalities as Mrs. Alexander Hamilton, John
Quincy and Dolly Adams, and Daniel Webster. In Europe in 1849
with his friend George H. Hall, Johnson studied at the Royal
Academy in Dusseldorf. In January of 1851 he, like so many
Americans, entered the studio of Emanuel Leutze (see p. 89) but
later in the year moved to the Hague to study the old masters. He
painted many portraits during his three and one-half year stay in
Holland and was asked to become painter to the Dutch Court. Re-
fusing this, Johnson was briefly in Paris before the death of his
mother in 1855 called him home. Upon his return to the United
States Johnson travelled to Superior, Wisconsin (where his mar-
ried sister lived) in the summers of 1856 and 1857 and did some
extraordinary drawings of the Chippewas while there. At the end
of 1857, Johnson was in Cincinnati, and was back in New York
City by April, 1858 where he established a studio in the University
Building, Washington Square — to remain his winter headquar-
ters for most of the rest of his life. Between 1861-1865 he did
leave New York during the maple sugaring season to draw and
paint near Fryeburg, Maine. Summers were spent travelling in the
1860's and 1870's in the Catskills; Murray Bay, Ontario; and
Kennebunkport. After marriage to Elizabeth Buckley of Troy, New
York in 1869, most of Johnson's summers were spent on Nantuc-
ket where some of his most powerful paintings were done. The
altarpiece on which this little girl is seated, the carpet, and panel-
ing (and possibly the same child at an earlier age) appear in a
painting entitled BO-PEEP of 1872.[1]

[1] Oil on board (21½ × 25½) illustrated in *Kennedy Galleries Bulletin.* "Rare Mas-
terpieces of the 18th, 19th, and 20th Centuries," V. II, 1974.

187.

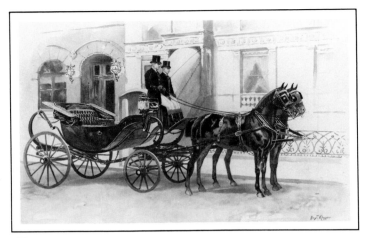

188.

189.

Lane, Fitz Hugh (1804 – 1865)

YACHT "NORTHERN LIGHT" IN BOSTON HARBOR

Fig. 190

H. 18¼"; w. 20¼" 1845
oil on canvas
signed, on verso: "Painted by F H Lane from a sketch by/Salmon/1845"
(cat. #27.1.4-60)

Christened Nathaniel Rogers Lane, Fitz Hugh Lane was born in Gloucester, Massachusetts in 1804, the son of an old New England family. Crippled as a child, probably from infantile paralysis, Lane was apprenticed to the Boston lithographer William S. Pendleton in 1832, where he undoubtedly met the Englishman Robert Salmon (note signature above). Between 1837-1845 Lane was employed by Keith & Moore in Boston, and from 1845-1848 was a partner of John White Allen Scott who also apprenticed at Pendleton's. Returning to Gloucester by 1849, Lane and his brother-in-law built a stone house where he remained for the rest of his life. This painting, after a sketch by Salmon, was done for Stephen Winchester Dana who gave it to Col. William Parson Winchester, the owner of the yacht.

Klepper, Max Francis (1861 – 1907)

BERLIN

H. 15"; w. 23" 1893
watercolor on paper
signed, l.r.: "Max. F. Klepper"
(cat. #27.2.5-7)

CALECHE Fig. 188

H. 15½"; w. 24¼" c. 1893
watercolor on paper
signed, l.r.: "Max F. Klepper"
(cat. #27.2.5-4)

Max Francis Klepper was born in Zeitz, Germany on March 1, 1861 and came to the United States with his parents in 1876. After serving an apprenticeship with a lithography firm in Chicago, Klepper went to New York City in 1880, three years later marrying Emilie van Rhein. Studying painting first at the Art Students' League in New York from 1887-1889, Klepper was in Europe at the Royal Academy in Munich, Germany from 1887-1889 where, at the same time he took a course at the Munich Veterinary College. As is evident in these paintings, he made a specialty of painting horses. Both of these examples are painted in black and white and depict vehicles made for Dr. William Seward Webb by Million and Guiet in Paris c. 1890.

Kollm, M. W.

WOLF, A HUSKY

H. 14⅛"; w. 13 1/16"
watercolor on paper
signed, l.r.: "M. W. Kollm"
Inscribed, u.r.: "Wolf"
Gift of: Mr. and Mrs. William N. Beach
(cat. #27.2.5-19)

Kreiser, Simon and Shultz, Ruth

E PLURIBUS UNUM LIBERTY
EAGLE WITH FLAGS

Fig. 189

H. 6½"; w. 8¾"
watercolor and ink on paper
signed in center as part of design: "Ruth
 Shultz"
and lower bottom: "Simon
 Kreiser"
label on verso: "OMAJA, ORIENTE,
CUBA"
Gift of: George G. Frelinghuysen, 1969
(cat. #27.9-47)

190.

Lane, Fitz Hugh

OFF MOUNT DESERT, MAINE

H. 20″; w. 33″ c. 1850's
oil on canvas
(cat. #27.1.4-59)

While forced since childhood to use crutches, Lane was
not prevented from travelling. He is known to have sailed to
Maine with friends during the summers of 1850, 1851,
1852, 1855, and 1863 sketching in or near Penobscot Bay,
Castine, Blue Hill, Owl's Head and Mount Desert. This
painting was probably done during one of these earlier
trips.

VIEW OF BALTIMORE Fig. 191

H. 19¼″; w. 28½″ c. 1850
oil on canvas
Exhibited: Baltimore Museum of Art.
(cat. #27.1.2-33)

Two prints were made from this painting — a lithograph
"View of Baltimore from Federal Hill" published by A. Co-
nant in 1850 and signed "sketched from nature by F. H.
Lane" and "Lith & printed in colors by Sarony & Major New
York"; and a colored aquatint by W. J. Bennett of 1831 en-
titled "Baltimore From Federal Hill."

191. VIEW OF BALTIMORE, Sarony & Major lithograph

SUNRISE THROUGH MIST

H. 24¼″; w. 36½″ 1852
oil on canvas
signed, l.r.c.: "F. H. Lane/1852"
Exhibited: M. Knoedler and Co., 1954 "Commemorative
 Exhibition of Karolik Private Collection Paintings by
 Martin J. Heade, Fitz Hugh Lane."
 "American Painting of the Nineteenth Century,"
 Whitney Museum of American Art, April, 1954.
(cat. #27.1.4-57)

NEW YORK YACHT CLUB REGATTA Fig. 192

H. 28″; w. 48″ c. 1856
oil on canvas
(cat. #27.1.4-69)

John Wilmerding in *A History of American Marine Painting* illus-
trates three NEW YORK YACHT CLUB REGATTA paintings, all
bearing the date 1856. William Bradford's version is almost the
identical reverse of Shelburne's painting. Both give the sloop
JULIA prominence and both introduce the excursion steamer
NATIONAL EAGLE into their paintings. The race was held on Au-
gust 8, 1856 off New Bedford. It is also portrayed in a pencil and
watercolor drawing by Albert Van Beest (1820-1860) and William
Bradford. "The wash drawing is a unique document in associating
Lane with the two New Bedford artists."[1]

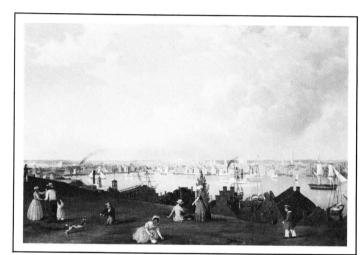

191.

[1] John Wilmerding, *A History of American Marine Painting* (Boston: Little, Brown &
Co.), p. 194. He notes that Lane had been in New Bedford to make a lithograph in 1845
and may have met the two men then or in Boston in the mid 1850's.

MERCHANTMEN OFF BOSTON
HARBOR

Fig. 113

H. 24¼″; w. 39¼″ 1863
oil on canvas
signed, l.r.: "F H Lane/1863"
Exhibited: Karolik Private Collection of Early
 19th C. American Paintings — loan
 exhibition to six mid-western
 museums in 1953.
(cat. #27.1.4-49)

SHIPS LEAVING BOSTON HARBOR

H. 20″; w. 30″ 1867
oil on canvas
signed, l.l.: "F H Lane 1867"
(cat. #27.1.4-52)

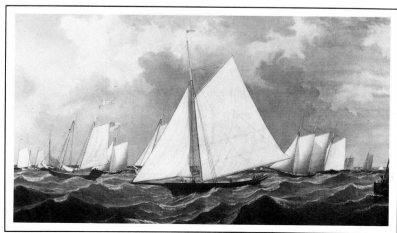

92.

193.

WINTER MORNING

Fig. 193

H. 20"; w. 16" 1926
oil on canvas
signed, l.l.: "Sydney Laurence"
on verso (torn label): "WINTER MORNING/Sydney Laurence/
Anchorage/1926"

(cat. #27.1.2-133)

Laurence, Sydney Mortimer (1865 – 1940)

THE WINTER TRAIL, ANCHORAGE, ALASKA

H. 10"; w. 8" 1922
oil on academy board
signed, l.l.: "Sydney Laurence"
on verso (label): "The Winter Trail, Alaska/Sydney Laurence
R.B.A.C.H.A.M.E.F.A.S./Anchorage, Alaska/1922"
Gift of: Mr. and Mrs. William N. Beach
(cat. #27.1.5-68)

AURORA BOREALIS #1

H. 16"; w. 20" c. 1926
oil on canvas mounted on masonite
signed, l.l.: "Sydney Laurence"
Gift of: Samuel B. Webb, 1973
(cat. #27.1.2-147)

AURORA BOREALIS #2

H. 8"; w. 9⅞" c. 1926
oil on masonite
signed, l.l.: "Sydney Laurence No 2"
Gift of: J. Watson Webb, 1958
(cat. #27.1.2-26)

LONE PINE AGAINST MOUNT McKINLE

Fig. 194

H. 20"; w. 15⅛"
oil on canvas
signed, l.r.: "Sydney Laurence"
Gift of: Mr. and Mrs. William N. Beach
(cat. #27.1.2-135)

194.

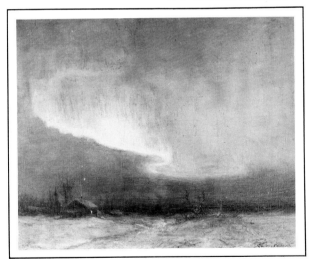

195.

THE NORTHERN LIGHTS

Fig. 195

H. 16¼"; w. 20¼" 1926
oil on canvas
signed, l.r.: "Sydney Laurence"
on verso (label): "THE NORTHERN LIGHTS/Sydney Laurence/
Anchorage/1926 Alaska"
(cat. #27.1.2-49)

TRAPPER IN THE WILDERNESS OF ALASKA

H. 22"; w. 28"
oil on canvas
signed, l.l.: "Sydney Laurence"
Gift of: Mr. and Mrs. William N. Beach
(cat. #27.1.5-69)

The contrast between the quiet and lyrical paintings of Sydney Laurence and his dramatic, adventuresome life is astonishing. Born in Brooklyn, New York in 1865, Laurence was the grandson of a Governor of New South Wales and son of the founder of the New York Life Insurance Co. As a boy he ran off to sea, was shipwrecked, saved the Captain's life and thereafter became his first mate. After four years before the mast, Laurence returned home at the age of twenty-one and began studying painting at the National Academy. Between 1889-1894 while a student in Paris at the Ecole des Beaux Arts, Laurence quickly gained distinction and won several prizes. From Paris he proceeded to St. Ives, England, where he painted off and on for thirteen years. His next undertaking was to become a war correspondent for the London periodical *Black & White.* While covering the Zulu war he was clubbed on the head and lost his hearing; during the Boer War he was wounded twice, and he also visited China. Seeking some quiet, Laurence returned to England (Kent) until his wanderlust led him to Seward, Alaska in 1906 to pan gold, a venture which proved unsuccessful. While sailing along the Alaskan coast, his boat capsized, but he managed to swim ashore where some natives found him and nursed him for fourteen days. Later in a hospital in Valdez he barely recuperated in time to prevent his legs from being amputated. Undaunted by so many misadventures, Laurence bought a dog team and sled and began a four month trip which was to take him to Talkeetna, Alaska, where "the view of Mt. McKinley was startlingly beautiful."[1] There he built a cabin and painted for a year on an easel made from a dog sled. He was to return to this cabin, where most of these paintings were done, many times. In 1928 Laurence married a French girl he met in Southern California. He died in 1940.

[1] This quote and most of this information came from Wendy Jones, "Sydney Laurence, Alaska's Celebrated Painter," *American Artist,* April, 1962, p. 46.

Leutze, Emanuel Gottlieb (1816 – 1868)

CARTOON FOR "WESTWARD THE COURSE OF EMPIRE MAKES ITS WAY"

Fig. 196

H. 39½"; w. 33½" c. 1860
pencil on paper
Gift of: Ogden M. Pleissner in memory of his mother, Cristine Minton
 Pleissner, 1969
(cat. #27.8-67)

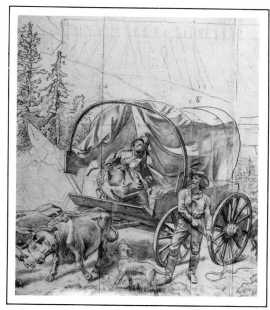

196.

Born in Gmünd, Wurttemberg, Bavaria in 1816, Emanuel Gottlieb Leutze was taken to Philadelphia by his parents in infancy. At the age of fifteen he painted his first oil, a portrait of an Indian, and later received instruction from John Rubens Smith. Returning to the country of his birth in 1841, Leutze went to Dusseldorf, studying painting under Karl-Friedrich Lessing. He took many sketching trips — to the Swabian Alps, the Tyrol, and Italy and married the daughter of a German officer. Between 1845-1849 he made his home in Dusseldorf, painting historical canvases, many of which he exhibited at the National Academy, and instructing many American students in painting. In New York City by 1859, Leutze received government approval to paint WESTWARD THE COURSE OF EMPIRE MAKES ITS WAY for the United States House of Representatives in July, 1861. This drawing for the canvas includes only a small portion of the original design. It was given to the donor's grandfather, Mr. Francis L. Minton, a close friend of the artist, and descended in his family.

Lincoln, Thomas

CAPTAIN THOMAS MACDONOUGH

H. 25¼"; w. 20⅛" 1937
oil on canvas
signed, l.r.: "After Gilbert Stuart./by/Thomas Lincoln. 1937"
(cat. #27.1.1-162)

This a copy of Gilbert Charles Stuart's portrait of Macdonough exhibited in the Century Club, New York City, loaned by Augustus C. Macdonough.

Lucioni, Luigi (1900 –)

FOWL AND GLASS OF RED WINE

Fig. 197

H. 23"; w. 30" 1940
oil on canvas
signed, l.l.: "Luigi Lucioni 1940"
Painted for Mrs. Electra Havemeyer Webb
Exhibited: Shelburne Museum, June 1-August 21, 1968
(cat. #27.1.3-25)

SILVER ANNIVERSARY

H. 14¼"; w. 14" 1935
oil on canvas
signed, l.r.: "Luigi Lucioni 1935"
on verso (stretcher): "Anniversary Luigi Lucioni. For
 Mrs. Webb February 8th 1910 —
 February 8th 1935 Luigi"
Gift of the artist to Mr. and Mrs. James Watson Webb on their twenty-fifth wedding anniversary, February 8, 1935.
Exhibited: Shelburne Museum, June 1-August 21, 1968
(cat. #27.1.3-8)

HOUSE IN THE TREES

Fig. 198

H. 16"; w. 25" 1948
watercolor on paper
signed, l.r.: "Luigi Lucioni 1948"
Exhibited: Shelburne Museum, June 1-August 21, 1968
(cat. #27.2.2-16)

Linsley, William (active 1883)

QUEEN OF THE RUTLAND IN 1864

H. 13"; w. 29" 1883
watercolor on paper
signed, l.r.: "Wm. Linsley — 1883"
Inscribed, above: "Built By Amoskeag Manufacturing of
 Manchester, N.H. 1851 CYLINDER 15 x 22
 DRIVERS 6 FEET/PASSENGER MAIL
 SOUTH IN 70 MINUTES MAKING FOUR
 STOPS./N.L. DAVIS ENGINEER (T. J.
 CURTIS) foreman."
Inscribed, below: "QUEEN OF THE RUTLAND IN 1864"
(cat. #27.2.6-22)

The SAMUEL HENSHAW was built by the Amoskeag Manufacturing Co. in 1851. She was named after the man who had been treasurer of the Rutland and Burlington Railroad.

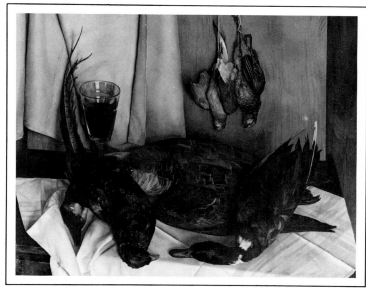

197.

Lucioni, Luigi

Born in 1900 in Malnute, Italy, Luigi Lucioni was the son of Angelo and Maria Beati Lucioni. At the age of six he was given watercolor instruction by his teacher and was studying geometrical drawing from ages eight to eleven. In 1911 he came to America with his family, settling in North Bergen, New Jersey. He attended private drawing classes in Jersey City and entered Cooper Union for four years of study in 1915. The following year he began working in an engraving house, first doing lettering, and later commercial art. In early 1918 he studied oil painting with William Starkweather and two years later, spent the summer in Barre, Vermont painting landscapes. This was the beginning of a long love affair with Vermont. In 1920-1921 he was studying at the National Academy of Design, working in the art department of a trade newspaper in the afternoons and taking composition classes at Cooper Union in the evenings. In 1924 he won the L. C. Tiffany Foundation scholarship, and painted for three months at the Tiffany estate in Laurelton, Long Island. In Europe for two months in 1925, by fall Lucioni had a studio in Washington Square, New York City which he was to maintain until 1945. In Italy again in 1929, he returned the following summer to northern Vermont. At a 1932 spring exhibition at the Metropolitan, some paintings of Lucioni's attracted Mrs. Webb's attention. She invited him to Shelburne where he was to return for the next several summers, painting the Webb family home, the house of their daughter, Electra Bostwick, and the spectacular views of the Lake, Adirondacks, and trees which their property provided. In 1939 Mr. Lucioni purchased a home in Manchester Depot, Vermont where he spends his summers doing landscape paintings. He winters in New York City where he attends the opera, paints still-lifes, and makes at least one etching a year. A large number of his Vermont etchings, all gifts to Mr. and Mrs. Webb from the Artist, are in Shelburne's Webb Gallery. In the summer of 1968 Mr. Lucioni had a one-man show at the Museum.

199.

McConkey, Benjamin M. (c. 1821 – 1852 ?)

MOHAWK TERRITORY

Fig. 200

H. 32"; w. 52¼" 1849
oil on canvas
signed, l.r.: "B. McConkey/1849"
Gift of: J. Watson Webb, Jr., 1961
(cat. #27.1.2-51)

A native of Maryland, born in 1821, Benjamin McConkey had settled in Cincinnati by the early 1840's. By 1846 he was a pupil of Thomas Cole along with Frederic Edwin Church, for the next two years was back in Cincinnati and travelled to Dusseldorf, Germany in 1851.

198.

Luthy, Captain L.

SIP HOMESTEAD AT HOBOKEN, NEW JERSEY

Fig. 199

H. 28¾"; w. 36" 1854
oil on canvas
signed, l.l.: "Captᴺ L. Luthy Fecit./Hoboken. 1854-"
(cat. #27.1.2-96)

Little is known of this artist; he may be related to the Swiss-born artist Johannes Luthy (1803-1863). Dutch settlers named the part of New Jersey depicted here *Hobocan Hackingh,* the land of the tobacco pipe because of the stone pipes made by the Leni-Lanape Indians nearby. Hoboken was planned as a town in 1784 and was chartered in 1855. Luthy painted meticulously, but the lack of any form of life in the painting and the tightly shuttered house are somewhat eerie.

Dougalle, Hugh

.ITH, HOPE AND CHARITY

H. 22⅝"; 17⅜" 1806
oil on wood with archshaped top
Inscribed, on verso: "Hugh McDougalle/Aug¹ 14th 1806/Cleaned and
varnished and/Framed by J W Watson/September
1874/Lectur (sic) room repainted in colors May 15th
1879/by J W Watson"

(cat. #27.1.6-14)

this rather primitive painting the words "Faith, Hope, and
arity" surrounded by sunrays rest on a Holy Bible, lying
its side. This was probably used in a school room.

bbe, Mrs. Minnie K.

GER KITTEN IN A BOOT

H. 12"; w. 18½"
oil on cardboard
Gift of: Mrs. Lilian Baker Carlisle, 1959
(cat. #27.1.5-8)

quired from the daughter of the artist in Burlington, Ver-
nt, this painting sentimentally captures the playfulness
a much-loved pet.

Mahony, M.

S.S. ONTARIO Fig. 201

H. 14⅜"; w. 18½" c. 1880
oil on composition
signed, l.r.: "M. MAHONY"
on verso (tag): "M. Mahony/Artist/Oswego, N.Y. Flags flying are ONTARIO, OSWEGO AND
THOUSAND ISLANDS."
(cat. #27.1.4-19)

201.

Built by John Oades of Clayton, New York, the ONTARIO's engine with a fifty-
inch cylinder and eleven-foot stroke was built by T. F. Secor and Co., of New
York. Originally 222' long and weighing 832 tons, she ran on the U.S. Express
line running between Kingston, Ontario and Lewiston, Rochester, Oswego,
Sackett's Harbor and Ogdensburg, New York. On September 25, 1853 she
was off St. Vincent when she was hit by the steamer VERMONT, carrying
away most of her side. After being repaired she continued in service until 1867
when she was sold to Bethune's Canadian Navigation Co. Renamed the
ABYSSIAN, she was rebuilt, becoming eight feet longer. On November 13,
1883 on the Montreal to Quebec run she sank at anchor at Chenaille du Moine,
Sorel, Quebec when ice cut through her hull, and she was abandoned.[1]

[1] Eric Heyl, *Early American Steamers* (Buffalo, 1964), V. III, pp. 265-66.

Mare, John (1789 – c. 1802 or 1803)

JOHN COUVENHOVEN (1752 – 1805) Fig. 202

H. 15¾"; w. 13¼" 1774
pastel on paper, mounted to canvas
signed, on verso: "John Mare/Pinxt, 1774"
(cat. #27.3.1-10)

202.

The son of John and Mary Bes Mare, John Mare was born
in New York City in 1739. His sister Mary married a William
Williams in 1757, probably the portrait painter who inspired
Benjamin West. Williams may have taught his brother-in-
law Mare who was also influenced by John Wollaston, par-
ticularly after being paid to copy Wollaston portraits. In
1759 Mare married Ann Morris, and between 1761 and
1772 he is known to have been in New York City, where, in
1765 he became a freemason, described as a "a limner."
The following year on June 19, Mare was commissioned to
paint a portrait of JOHN KETELAS, which, because of a
realistically painted fly on his cuff, is the first widely known
trompe l'oeil painting in America. While he may have been
in Boston briefly, Mare was definitely in Albany in 1772
where he joined the Albany Masonic Lodge, and in
Philadelphia in 1786 and 1790. He probably went to Eden-
ton, North Carolina from 1778 to 1802 or 1803 where he

went into the mercantile business. He became the town
postmaster, treasurer, town commissioner, justice of the
peace, and in 1789 represented Edentown at the state
convention which ratified the Constitution and chartered
the University of North Carolina. By 1799 he apparently
suffered an injury or illness and died by 1803.[1] There is no
evidence that he painted in North Carolina.

John Couvenhoven is believed to be the son of John and
Catherine (Remsen) Couvenhoven, born February 2,
1752. On October 6, 1774 he married Catherine Clopper. A
Brooklyn obituary of February 1, 1805 refers to him as
Major John C. Couvenhoven.

[1] Helen Burr Smith and Elizabeth V. Moore, "John Mare: A Composite Por-
trait," North Carolina Historical *Review*, winter, 1967, quoted in The Magazine
Antiques, November, 1970, pp. 808-809.

203.

204.

Mason, Benjamin Franklin (1804 – 1871)

MRS. LEBBEUS HARRIS (1776 – 1850) Fig. 204

H. 27¼"; w. 22½" c. 1831-1832
oil on canvas
Exhibited: Sheldon Museum, Middlebury, Vermont
(cat. #27.1.1-112)

Benjamin Franklin Mason was born in 1804 in Pomfret, Vermont where, at age nine, he was crippled, probably from polio. He appears to have had little or no professional training, but his friend Thomas Ware briefly studied under Abraham G. D. Tuthill (see p. 133) and "passed on what he learned as best he could to Mason."[1] His first painting was a portrait of his father done in 1820. The following year he taught school in Rochester, Vermont, in 1822 attended a young men's academy in Randolph, Vermont, and by 1825 became an itinerant painter. He continued his training under Joseph Greenleaf Cole (1806-1858), a Newburyport, Massachusetts artist who was in Burlington, Vermont between January and April, 1831. Mason then moved to Middlebury where this portrait was painted. He thereafter moved about often — in Montpelier, Woodstock, and Rutland before going to Boston in 1834. There he met Washington Allston and exhibited at the Boston Athenaeum in 1836. Continuing to travel, Mason was in Troy, New York; Woodstock and Pomfret, Vermont; in Buffalo, New York in 1842-1843; and back in Middlebury intermittently — in 1841, 1844, and 1846. He is listed in the Boston City Directory in 1851-1852, visited Sheboygan, Michigan and Milwaukee, Wisconsin c. 1852, and returned to Buffalo between 1855-1857. His last years were spent in Woodstock where he built a house in 1861.

Mrs. Harris, the subject of this painting, married twice, first Lebbeus Harris of Middlebury, and second, Benajah Douglas of Brandon. Both were devout Methodists.

[1] Alfred Frankenstein and Arthur K. D. Healy, *Two Journeymen Painters* (Middlebury, Vermont: The Sheldon Museum, 1950), p. 9.

Marston, (active 1959)

WEBB HALL, NORWICH UNIVERSITY

H. 12½"; w. 21" 1959
watercolor on paper
signed, l.l.: "Marston"
Inscribed, l.r.: "Webb Hall/Academic Building/Norwich University/milton lee crandell, a.i.a., architect/19
(cat. #27.2.6-26)

This is an architectural drawing of a classroom, seminar building, office, and auditorium at Norwich University, Northfield, Vermont, built in 1959. It was named for Watson Webb, a trustee and major benefactor of the University. The architect, Milton Lee Crandell, was from Glens Falls, New York.

Martin, Homer Dodge (1863 – 1897)

THE LOGGING CAMP Fig. 203

H. 20¼"; w. 30¼" c. 1865
oil on canvas
signed, l.r.: "H. D. Martin"
(cat. #27.1.5-19)

Born in Albany, New York in 1836, Homer Dodge Martin was first encouraged to paint by the sculptor Erastus Dow Palmer (1817-1904). After two weeks of study in Albany with James Hart, Martin began to paint seriously in 1852. From 1862-c. 1881 he had a studio in New York City and studied with William Hart. The influence of John Kensett and Jean Baptiste Camille Corot, whose work he saw in New York in the 1870's, was to affect Martin strongly. In 1876 he went to London where he became a friend of James Abbott McNeill Whistler (1834-1903) and came to know the paintings of John Constable. In France between 1881-1886, Martin was exposed to the Impressionists whose experiments with light and color in the out-of-doors impressed him greatly as did the earlier works of the Barbizon School. Despite the loss of one eye in 1890 and a cataract in the other, Martin did some of his finest work after his return from France. He settled in St. Paul, Minnesota in 1893 where he spent his last few years.

205.

Attributed to
Mellen, Mary B.

MOONLIGHT ON THE BAY Fig. 205

H. 14"; w. 20" c. 1870's
oil on canvas
(cat. #27.1.4-53)

Once attributed to Fitz Hugh Lane, Lane's biographer John Wilmerding believes that this painting is probably the work of Mary B. Mellen.[1] The wife of the Gloucester minister Rev. C. W. Mellen, Mary Mellen became Lane's pupil in the 1850's. She occasionally worked on a canvas with Lane and was remembered in his will. An even hardness in the painting, water, a metallic and rigid handling of color and occasional weakness in handling such details as rigging, distinguish her work from her master's.

[1] John Wilmerding, *Fitz Hugh Lane* (New York: Praeger Publishers, 1971), p. 82, and illustration 90.

Meneghelli, E. (?)

THE BLACKSMITH SHOP

Fig. 206

H. 14″; w. 18″ 1878?
oil on canvas
signed, l.l.: "E. Meneghelli" (?)
Gift of: Mr. and Mrs. Albert Partridge, 1964
(cat. #27.1.7-10)

Moody, J. M.

TWO GIRLS HOLDING HANDS

H. 13½″; w. 9¼″
pen and ink with touches of watercolor on paper
Inscribed, at bottom: "EXECUTED with the PEN/by/
 J. M. MOODY"

(cat. #27.9-39)

This drawing shows a close relationship with some of Currier and Ives' prints.

206.

207.

Attributed to

Morse, Samuel Finley
Breese (1791 – 1872)

THE BREESE HOMESTEAD IN POUGHKEEPSIE, NEW YORK

H. 17¼″; w. 21¼″ c. 1805-1808
oil on canvas
signed, on verso: "Saml F. B. Morse"
Stencil on verso. l.l.: "From/J.J. ADAMS/99
 WASHINGTON ST/
 BOSTON"

(cat. #27.1.4-40)

Traditionally, this painting was done by Morse in his teens. The house is supposed to be in Poughkeepsie, but it has also been suggested that the site is in Shrewsbury, New Jersey. It relates closely to a print of the Hobuck Ferry House, New Jersey, printed by Jukes in London from a drawing by Archibald Robertson.[1]

[1] Illustrated in Old Print Shop *Portfolio*, February, 1946, V, No. 6, p. 126.

Morrison, George W. (1820 – 1893)

MARY EMMA AND HARRY WOODWARD OF NEW ALBANY, INDIANA

Fig. 207

H. 72″; w. 54″ c. 1863
oil on canvas
Gift of: Dr. and Mrs. E. William Davis, 1960
(cat. #27.1.1-79)

The Baltimore-born painter George W. Morrison had settled in New Albany, Indiana by 1840 where he rapidly became the town's leading artist. Of Scotch ancestry, handsome and genial "with long curling hair" and "a talent for poetry"[1] Morrison sketched landscapes and painted portraits of most of the important citizens in and around Nw Albany. Among them were Mary Emma (1845-1917) and Harry Woodward (1861-1934). Painted when Mary Emma was sixteen and Harry two-and-a-half, Morrison included in this painting the toy horse which the little boy loved, and rather glamorized the scenery. Mary Emma married Capt. Wilford Welman in 1868, a man twenty-five years her elder who had served in the Civil War. Lazy and overbearing, Capt. Welman demanded a meticulous house and the complete attention of his wife. Childless, Mary Emma spent her last years as a widow, maintaining the twenty-four room house, and weaving, sewing and embroidering. Young Harry, wearing a dress now in Shelburne's collection,[2] married Fannie Berkeley Cochran Dudley in 1886.

[1] Wilbur D. Peat, *Pioneer Painters of Indiana* (Indianapolis: Art Association of Indianapolis, 1954), p. 53.
[2] Gift of his daughter, Miss Kathrine Woodward from whom most of the information on the Woodwards came.

207.
Dress worn by Harry Woodward in painting, Shelburne Museum Collection

208.

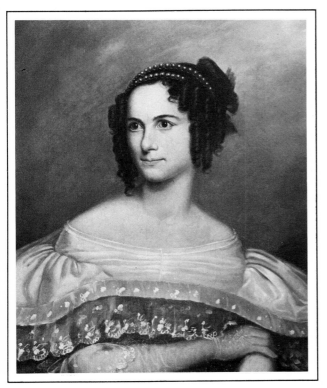

209.

Morse, Samuel F. B.

PORTRAIT OF A YOUNG WOMAN Fig. 209

H. 27¾"; w. 22¾" 1831
oil on canvas
signed, on verso (under relining of transparent fiberglass): "Sam¹ F. B. Morse/1831/129½
GRANT ? ST./NY" and "National
Academy/No. 138-1835/P.A. Jay"
Exhibited: National Academy of Design, 1835, #138, owned by Peter Augustus Jay
(cat. #27.1.1-89)

This portrait must have been painted just after Morse's return from Europe in 1831. The subject is probably one of Jay's daughters, either Mary Rutherford Jay (1810-1835) who married Frederick Prime in 1829, or her sister Sarah Jay (1811-1846). It is more likely the former, as the portrait was purchased in 1880 by John Jay Rutherford of Albany, New York.

Born in April, 1791 in Charlestown, Massachusetts, Samuel F. B. Morse attended Phillips Academy in Andover, Massachusetts and began painting miniatures at Yale, from which he graduated in 1810. His father, Jedidiah, a Congregational Minister, was not sympathetic with Morse's desire to paint, but both Gilbert Stuart and Washington Allston encouraged him. Travelling to London with Mr. and Mrs. Allston in 1811, Morse began to study painting with Benjamin West and also Allston. In 1813 he won a gold medal for a clay statuette *The Dying Hercules.* Back in the United States in 1815, Morse established a studio in Boston and became an itinerant portrait painter in New England. After marrying in 1818, he spent the next four winters in Charleston, South Carolina as a portraitist. In 1823 he was in New York City where in 1825 he was commissioned to paint the Marquis de Lafayette. A founder of the National Academy of Design in 1826, Morse not only taught there but became its President from 1826-1845 and from 1861-1862. After painting in Italy and France in 1829-1831, Morse returned to New York City where, in 1835, he was appointed Professor of Literature of the Arts of Design at New York University. Shortly thereafter Morse gave up painting for his electrical experiments and was also responsible for popularizing the daguerreotype in America.

210.
Grandma Moses at Shelburne
Museum

210.

Moses, Anna Mary Robertson (1860 – 1961)

AFTER THE WEDDING

H. 17½"; w. 30¼" 1942
oil on masonite
Gift of: Mrs. Frederica Emert, 1965
(cat. #27.1.7-25)

CAMBRIDGE

H. 19"; w. 23" March 4, 1944
oil on masonite
signed, l.r.: "Moses"
on verso: label written by the artist
 with title, number and date
(cat. #27.1.2-54)

TRAMP ON CHRISTMAS DAY

H. 16"; w. 19⅞" March 26, 1946
oil on academy board
signed, l.l.: "Moses"
(cat. #27.1.2-55)

THE MAILMAN HAS GONE

Fig. 243

H. 16¾"; w. 21½" March 2, 1949
oil on masonite
signed, l.l.: "Moses"
on verso (tag): "Rec'd 3-2-52 Gone for
 the/Mail"
Exhibited: "The Best of Shelburne,"
 IBM Gallery,
 November-December,
 1964.
(cat. #27.1.2-56)

HAYING

H. 11⅞"; w. 15¾" November 23, 19[5]
oil on masonite
signed, l.r.: "© Moses"
Gift of: Mrs. Frederica Emert, 1965
(cat. #27.1.7-26)

OLD HOME

Fig. 210

H. 11⅞"; w. 15⅞" October 7, 1957
oil on masonite
signed, l.r.: "Moses"
Inscribed, u.r.
in ball point pen: "To my dear
 friend/Electra
 Havemeyer
 Webb/Merry
 Christmas
 1957/Grandma,
 Moses"
Gift of the artist to Mrs. E. H. Webb,
Christmas, 1957.
(cat. #27.1.2-25)

Moses, Anna Mary Robertson

COVERED BRIDGE WITH CARRIAGE

Fig. 211

H. 27½"; w. 21½" November 16, 1946
oil on masonite
signed, l.r.: "Moses" with copyright sign to the right and below it
Exhibited: Galerie St. Etienne, 1964
(cat. #27.1.5-12)

Drawing from vivid memories of her life on the farm, Grandma Moses (Anna Mary Robertson Moses) has created on her canvases a warm world of humor and anecdote, congeniality and pride in her work. As is well known, Grandma Moses did not begin painting until about 1920. Born in 1869 in Washington County she was working as a hired girl on a neighboring farm by the age of twelve and in 1887 married Thomas Salmon Moses. For the next eighteen years they lived in the Shenandoah Valley, Virginia, and had ten children, five of whom died in infancy. In 1905 they purchased a farm in Eagle Bridge, New York where Grandma Moses made her first painting on a fireboard in her parlor. After her husband's death in 1927, she began painting in earnest. Her first canvases were exhibited among her jars of preserves and jelly at local fairs. A 1939 exhibit of her work in a Hoosick Falls drugstore window attracted the attention of Louis J. Caldor who introduced her work to Dr. Otto Kallir.[1] The rest is legendary. Her first one-woman show was held in 1940, and a second, "What a Farmer's Wife Painted" was held at the Galerie St. Etienne in 1941. From that time forward there were to be many exhibits, prizes and awards including two Honorary Doctorates, from Russell Sage College in Troy, New York in 1947 and the Moore Institute of Art, Philadelphia in 1951. Despite fame and attention, Grandma Moses continued to live simply and paint from her deepest feelings. She died in 1961 at the age of 101.

[1] Dr. Kallir's latest book, *Grandma Moses*, has a complete catalogue of all her paintings (New York: Harry N. Abrams, Inc., 1973).

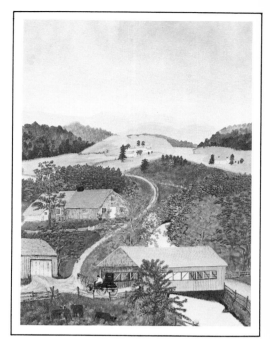

211. Copyright Grandma Moses Properties, Inc., New York

Munzig, George Chickering (1850 –)

MRS. WILLIAM SEWARD WEBB AND HER SON JAMES WATSON

Fig. 212

H. 81"; w. 51" 1889
oil on canvas
signed, l.r.: "G. C. Munzig/1889"
Gift of: J. Watson Webb, Jr., 1973
(cat. #27.1.1-84)

Born in Boston in 1850 the son of Ernest and Anna Marie (Kuhn) Munzig, George Chickering Munzig was a student at the Brimmer Art School in Boston before going to Paris to study at the Académie Julian under Boulanger and Lefebre. In 1872 he returned to Boston where he specialized in crayon portraits and later in oils. A member of the Boston Art Club and Committee on Design for the "School for Art Needlework", Munzig painted portraits of many prominent Bostonians. Toward the end of his life he moved to New York City where he had a studio at 527 Madison Avenue. A bachelor, Munzig was a founder of the Tavern Club, Park Square, Boston, serving as its first President.

The lady in this portrait, Eliza (Lila) Osgood Vanderbilt Webb (1860-1936) was the youngest daughter of William Henry Vanderbilt (1821-1885), and granddaughter of Commodore Cornelius Vanderbilt. She married Dr. William Seward Webb on December 20, 1881. Their son J. Watson Webb (1884-1960), co-founder of the Shelburne Museum, was five when this portrait was painted.

212.

212. detail of above

Nariassons,(?)

BABY OF OLD MANHATTAN

H. 3½"; w. 3¼"
watercolor on paper with bits of material and ribbon trim
signed, l.r.: "Nariassons" (?)
Inscribed, l.c.: "Baby of Old Manhattan"
(cat. #27.2.1-43)

Neagle, John (1796 – 1865)

TIRED OF PLAY (CELEBRATING THE FOURTH OF JULY)

Fig. 213

H. 25¼"; w. 31¼" 1840
oil on canvas, mounted on a panel
signed, l.r.: "J. Neagle 1840"
on verso: "Tired of Play/original portrait of the/artist's 3rd son
 (John)/March 1840 Phila"
Exhibited: Artist's Fund Society, Philadelphia's 5th Exhibition, 1840, #43
(cat. #27.1.1-120)

Born in Boston 1796 while his parents were on a trip from their home in Philadelphia, John Neagle studied with Edward F. Peticolas (1793-c. 1853) in Philadelphia, and with Pietro Ancora (active c. 1800-1843) who managed Bell & Ancora's Art Gallery and drawing academy in the same city. Between 1813-1818 Neagle was apprenticed to Thomas Wilson, a coach and ornamental painter in Philadelphia. In 1818 he began painting portraits professionally and travelled to Lexington, Kentucky and New Orleans for the next two years before establishing a studio in Philadelphia. There he married Mary Chester Sully, Thomas Sully's step-daughter and appears to have been somewhat influenced by Sully's brushwork. In 1825 he visited Gilbert Stuart with Washington Allston and painted his portrait, now at the Boston Athenaeum. He was Director of the Pennsylvania Academy of Fine Arts in 1830-1831 and was one of the founders of the Artists' Fund Society. A paralytic stroke ended his painting career in 1853.

WILLIAM SCARLET

Fig. 214

H. 30"; w. 25" 1822
oil on canvas
signed, u.l.: "J. Neagle 1822./Baltimore."
(cat. #27.1.1-126)

William Scarlet is supposed to be from Philadelphia but no details have been learned of his life.

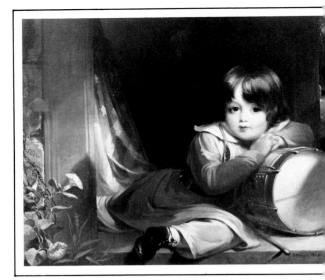

213.

214.

Neilson, Raymond Perry Rodgers (1881– c. 1962)

JAMES WATSON WEBB, MASTER OF THE HOUNDS (1884 – 1960)

Fig. 215

H. 41"; w. 31" 1953
oil on canvas
signed, l.r.: "Raymond P. R. Neilson, N. A. '53"
(cat. #27.1.1-171)

When Mr. Webb was Master of the Fox Hounds Association, Raymond P. R. Neilson was commissioned to paint his portrait for the Club. Mrs. Webb liked the portrait so well that she asked Mr. Neilson to do this one for her.

MRS. WILLIAM N. BEACH (1872 – 1960)

Fig. 216

H. 40"; w. 30¼" 1961
oil on canvas
signed, l.l.: "Raymond P. R. Neilson N. A. '61"
(cat. #27.1.1-130 a)

This is a posthumous portrait done from a very small snapshot of Mrs. Beach. Marie Beach was born in New York City on August 15, 1872 and died in Scotland on September 19, 1960.

MRS. WILLIAM N. BEACH (1872 – 1960)

H. 38"; w. 30"
oil on canvas
Gift of: Mr. Rodman A. Heeren, 1959
(cat. #27.1.1-175)

(An oil sketch for the painting illustrated on the next page.)

WILLIAM N. BEACH WITH SPANIEL ANG

Fig. 217

H. 40¼"; w. 30¼"
oil on canvas
signed, l.l.: "Raymond P. R. Neilson, N. A. '60"
(cat. #27.1.1-130b)

215.

aymond Perry Rodgers Neilson, born in New York
ty in 1881, was a pupil at the Art Students League
th George Bridgman, George Bellows, Luis Mora,
d Frank Dumond; attended the Académie Julian,
olorossi Academy and Grande Chaumiere in Paris;
d in New York studied with William Merritt Chase.
e won many awards, including a silver medal at the
ris Salon in 1914 and a silver medal at the Pan-
acific Exposition in San Francisco in 1915. An in-
ructor at the Art Students League in 1926 and
27 and the National Academy in 1928-1938, he
rved on the Council of the National Academy from
37 to 1941.

William N. Beach was an avid hunter and fisher-
an who, before his retirement, sold cement for the
w York subway system. Many of his and his
fe's hunting trophies are on display in the
useum's Beach Lodge, a building named after the
achs' for their generous donation to Shelburne's
llections. They also donated the wonderful selec-
n of western and wildlife paintings exhibited in the
ach Gallery.

216.

217.

218.

Neves, G. (active 1890's)

GIRL PLAYING WITH SINGING BIRD

Fig. 218

H. 19"; w. 16⅝" c. 1890
oil on wood
signed, l.r.: "G. Neves"
(cat. #27.1.7-8)

This painting of a child in a late Victo-
rian dress looking at a caged bird is
primitive but very detailed. It is done on
a wooden board with rounded corners,
supported in back with battens.

Attributed to
Newell, Hugh (1830 – 1915)

MAPLE SUGARING

Fig. 219

H. 22"; w. 36"
oil on canvas
(cat. #27.1.5-37)

219.

Born near Belfast, Ireland in 1830, Hugh Newell was edu-
cated there at Queen's College before coming to America
about 1851. First working as a portraitist in Baltimore be-
tween 1853 and 1860, he studied painting in Europe for the
next ten years — in Antwerp, with Thomas Couture in
Paris, and in London. Returning to the United States, he
became principal of the Women's School of Design in
Pittsburgh in 1870. In 1879 he returned to Baltimore as
head of the Maryland Institute of Art and Design, later be-
coming Professor of Drawing at Johns Hopkins University.
He first exhibited at the Maryland Historical Society be-
tween 1853 and 1858, at the National Academy in New
York in 1858, and at the Pennsylvania Academy two years
later. In 1903 he lived in Wilkinsburgh, Pennsylvania, mov-
ing thereafter to Bloomfield, New Jersey where he died in
1915. Another maple sugaring scene by Newell, exhibited
at the University of Maryland Art Gallery in 1970, is entitled
GATHERING SAP.[1]

[1] Marchal E. Landgren, *American Pupils of Thomas Couture* (University of
Maryland Art Gallery, 1970), p. 54.

North, Noah (1809 – 1880)

MRS. EUNICE EGGLESTON DARROW SPAFFORD (1778 – 1860)

Fig. 235

H. 28″; w. 23⅜″ 1834
oil on wood
signed, on verso: "N° 40 by N. North/Mrs. Eunice Spafford/AE 55 years/Holley./1834"
Exhibited: Whitney Museum of American Art, "The Flowering of American Folk Art,"
 February 1-March 24, 1974.
(cat. #27.1.1-13)

Noah North was a New York portraitist who worked briefly in Ohio and
perhaps Kentucky in the 1830's. He spent most of his life in western
New York state where, in addition to painting, he was a teacher, lumber
dealer, and justice of the peace.

Eunice Eggleston Darrow Spafford, born in 1778 in Dutchess County,
New York, was the third wife of John Darrow, a widower with eleven
children whom she married in 1798 or 1799. Darrow, born in New Lon-
don or Greenwich, Connecticut, served in the Revolutionary War and
was a blacksmith. After his death Eunice moved to what is now Claren-
don, New York and married Bradstreet Spafford who had arrived there
from Connecticut in 1811. She had six sons and one daughter by Mr.
Darrow, and one daughter by Mr. Spafford. The portrait, inscribed
"Holley" on the reverse, was probably painted in Holley, New York
where Eunice was buried in 1860. For many years the portrait hung in
the home of her son, Nicholas Eggleston Darrow, outside of Holley
along with a portrait of her daughter-in-law, also by North, which is now
owned by a descendant. The chair in which Eunice is sitting has
actually been stencilled.

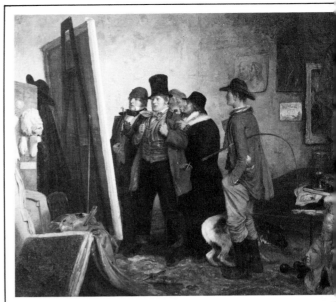

220.

Oertel, Johannes Adam Simon (1823 – 1909)

COUNTRY CONNOISSEURS Figs. 37 and 220

H. 36″; w. 42″ 1855
oil on canvas
signed, l.l.: "J A Oertel"
Exhibited: National Academy of Design, 1855, #100.
 Pennsylvania Academy of Fine Arts, 1856, #108.
(cat. #27.1.1-148)

Born in Furth, Bavaria in 1823, Johannes Adam Simon
Oertel studied painting and engraving in Munich, German
with Johann Michael Enzing-Müller (1804-1888). Followir
the German Revolution of 1848 he came to the United
States, settling in Newark, New Jersey. Between 1848-
1868 Oertel taught painting, did portraits, and engraved
bank notes. From 1857-1858 he designed ceiling decora
tion for the United States House of Representatives. Dur
ing the Civil War he painted army life in Virginia, bringing
him much success. Ordained as a priest in the Episcopa
Church in 1871, Oertel had parishes in many states, inclu
ing North and South Carolina, Tennessee, Missouri, and
Maryland. Settling in St. Louis for two years, he continue
to paint, and after retiring from his parish duties in 1795,
did a great number of religious works (some of which wer
the source of lithographs) and carved church decoration
He spent his last years at Vienna, Virginia where he died i
1909.

This painting was exhibited at the National Academy i
1855 where Oertel is already listed as Reverend, with hi
address listed as Madison, New Jersey. With an obvious
sense of humor, Oertel has here captured the amazeme
of the uninitiated as they discover "culture."

221.

Operti, Albert Jasper Ludwig
Roccabigliere (1852 – 1927)

FARTHEST NORTH Fig. 221

H. 90″; w. 120″ 1886
oil on canvas
signed, l.r.: "ALBERT OPERTI. NY./COPYRIGHTED. AUGUST 26.
 1886"
Exhibited: Chicago Exposition, 1893
 United States Capitol
Gift of: J. Watson Webb, Jr., 1961
(cat. #27.1.5-31)

The son of Guiseppi and Amelia Operti, Albert Operti was born in Turin, Italy in 1852 and as an infant moved with his family to
England where his father directed the Italian Opera Company of London. After attending schools in Dublin, in Glasgow at the In-
stitute of Art and in Paris, he specialized in scenic, fresco, and portrait painting. In 1875 he arrived in the United States where he
continued to study and began doing newspaper cartoons. By the 1880's he was designing sets for Niblo's Garden Theatre and the
Metropolitan Opera House. Impressed by William Bradford's Arctic paintings, Operti began to collect books on, and make a serious
study of Arctic history and exploration. His first Arctic painting, THE FINDING OF DELONG, was done after interviewing Admiral
George W. Melville, a survivor of the Jeannette expedition. Soon afterwards the United States Government commissioned two
scenes from the tragic Greely Expedition of 1881-1884, THE RESCUE OF LIEUTENANT A. W. GREELY AND PARTY (Explorer's
Club, New York City) and Shelburne's FARTHEST NORTH. The leader of the expedition, Adolphus Washington Greely (1844-1935),
without previous Arctic experience, had on this journey charted many unknown miles of the Greenland Coast and crossed to the
western shore of Ellsmere Island before sending three of his men on alone. This painting depicts Lieutenant James S. Lockwood,
Sergeant David Brainard, and the Eskimo Frederick Christiansen of the Lady Franklin Bay Expedition who reached Lockwood Island,
North Greenland on May 13, 1882, a new northern record at 83° 24′ N. 40° 46′ W. The trio joined the others at Cape Sabine where
two relief ships failed to reach them. When a third vessel, commanded by Winfield Scott Schley, arrived in 1884, all but Greely and
six others had died of starvation, and one of these died on the homeward journey.[1] Operti continued to paint Arctic scenes as well as

(Operti, continued)

theatre sets, and joined Commander Robert E. Peary's Arctic expeditions of 1896 and 1897 as the official artist. In addition to sketches and photographs, Operti made the first casts ever taken of the Greenland Eskimos, and later assisted Perry in designing settings for their exhibition at the American Museum of Natural History. He also wrote several magazine and newspaper articles of these journeys. In 1912, joining the staff of the American Museum of Natural History, Operti worked as an artist and cartographer, making murals, friezes and exhibition backgrounds from his carefully recorded data on natural habitats. In addition, he illustrated several books including Frederick Cook's *Through the First Antarctic Night* and Perry's *Nearest the Pole, Northward Over the Great Ice,* and *Snow Land Folk.*

[1] This unhappy saga is related in two sources — Greely's *Three Years of Arctic Service* in 1886 and the diary of David L. Brainard, published as *Six Came Back,* edited by B. J. James in 1940.

almer, Celinda Ball Tucker (active 1850's)

HRIST AT THE WELL

H. 13⅞"; w. 9¹⁵/₁₆" early 1850's
pencil and white chalk on bristol board
on verso (tag): "Work of Celinda Ball/Tucker (Palmer) some where/in the early 1850's/with the original frame. 1853 from your Aunt/Eliza Palmer Harrington/Burlington, Vermont."
"Christ at the Well"
Gift of: Mrs. Eliza Harrington, 1952
(cat. #27.8-2)

MOTHER, CHILD AND HORSE

H 9¼"; w. 6¾" 1870 – 1876
pencil on paper
on verso (Tag): "Work of Celina Ball Tucker/Palmer-between 1870 and 1876/for her daughter Eliza/Palmer when she was/around 9 years old"
(in pencil) "Now Mrs. Eliza Harrington who presents this to your Museum."
Gift of: Mrs. Eliza Harrington, 1952
(cat. #27.8-8)

222.

ale, Charles Willson (1741 – 1827)

HN B. DePEYSTER (1765 – 1846 or 1849) Fig. 223

H. 30"; w. 25" 1792
oil on canvas
(cat. #27.1.1-18)

e extremely versatile and ever optimistic Charles Willson Peale was born in
een Anne's County, Maryland in 1741. When he was nine his father died,
d he was later apprenticed to a saddle maker. It was only the first of many
des at which he excelled, becoming a silversmith, upholsterer, har-
ssmaker, brass caster, clock and watch repairer, taxidermist, archaeologist,
mer, and painter. He served with the Continental Army where he came to
ow (and paint) most of the leaders of the Revolution, including George
ashington whom he painted many times. His interests were many, and he
rsued them with characteristic enthusiasm, establishing the first art school
d gallery in the United States in 1782, opening this country's first museum of
and natural history in Philadelphia, and in 1805 founding the Pennsylvania
ademy of Fine Arts. Two other museums which he established in New York
ty and Baltimore were managed by his sons. He sired seventeen children in
ee marriages and endowed them with names of artists like Rembrandt, Ti-
n, Raphaelle, and Rubens; or gave them names of scientists like Charles
naeus and Franklin. Among his countless inventions were porcelain false
eth, a polygraph, a steam bath; he experimented with health remedies, eye
sses and ear trumpets; and supervised the excavation of a mastadon in
01 which he reconstructed and displayed in his Museum. Outliving all three
ves, Peale died in 1827, nearing the age of eighty-six.
The subject of this portrait was the twin of Elizabeth DePeyster (Betsy)
om Peale took as his second wife in 1791. Peale began this portrait in New
rk City to help his wife overcome the loneliness which separation from her
other brought. In his diary he wrote on June 6, 1792, "began a Portrait of
other John DePeyster, which I intended only to take the first sitting of, and to
ve it to be finished when he should pay us a visit at Philada."[1] He finished
e portrait on June 17th. Peale painted a second portrait of John in 1798.

Quoted in Waldron P. Belknap's *American Colonial Painting* (Cambridge, 1959) p. 53, from
arles Willson Peale's Diary, XVI, p. 31.

Parkhurst,

JOHN FITCH'S STEAMBOAT *EXPERIMENT* ON COLLECT POND, NEW YORK CITY, 1796 Fig. 222

H. 33"; w. 50" 1796
Oil on canvas
signed, l.r.: "Parkhurst"
Inscribed, below: "JOHN FITCH'S STEAMBOAT ON COLLECT POND, NEW YORK/CITY, 1796."
(cat. #27.1.4-65)

John Fitch (1743-1798), born in East Windsor, Connecticut, was a man of many talents, working as a laborer, worker in brass, manufacturer of potash, watchmaker, gunsmith, surveyor, soldier of fortune, and designer of steamboats. In 1785 at the age of sixty-two, he built his first steamboat and in 1787 built another at Philadelphia, the first to run on the Delaware River. It was defective but was improved the following year. His 1790 steamboat operated successfully between Philadelphia, Burlington, Bristol, Bordentown, and Trenton, New Jersey, occasionally calling at Chester and Wilmington, but Fitch had difficulty securing passengers. In 1796 he built his screw-propeller steamboat the EXPERIMENT, illustrated here, testing her on Collect Pond (the location today of the "Tombs" prison, the land being filled in between 1803-1811). In 1798 Fitch built the first steamboat to navigate the Ohio River at Bardstown, Kentucky, but his last years were very unhappy. "The distress of mind and mortification he suffered from the failure of his protracted exertions and poverty were too much for him, and to drown his reflections, he had recourse to the common but deceptive remedy, strong drink, in which he indulged to excess, and retiring to Pittsburg (sic), he ended his days by plunging into the Allegany (sic)"[2] in 1798.

[1] Quoted in John Warner Barber, *Connecticut Historical Collections,* (New Haven: John W. Barber and Hartford: A. Willard, 1836), pp. 81-82.

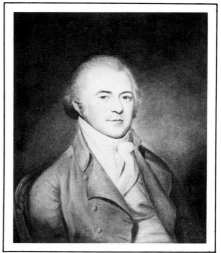

223.

Peale, Rubens (1784 – 1865)

LADYBUG AMONG GOOSEBERRIES AND OTHER FRUIT

Fig. 224

H. 8¼"; w. 6¾" c. 1845
oil on wood
(cat. #27.1.3-20)

Born in Philadelphia on May 4, 1784, Rubens Peale was the fifth son of Charles Willson and his first wife Rachel Brewer Peale. Poor eyesight dissuaded him from pursuing painting with his father and brothers — instead he managed the Peale Museums, in Philadelphia from 1810-1822, in Baltimore from 1822-1825, and in New York City from 1825-1837. Bankrupted by the financial crisis of 1837, the Museums folded (the New York one being taken over by P. T. Barnum). Peale retired to the Pennsylvania farm country in a home provided by his wife Elizabeth Bund Patterson's family. There he finally began painting in 1855 under the instruction of his seventh child, Mary Jane, who had studied with her uncle Rembrandt. Peale produced about 135 paintings, mostly still-lifes and of animals during his last ten years, recording them carefully in his diary. Many of them were copies of works by other members of the family. After his wife's death in 1864 Mary Jane moved with him to Philadelphia where he took lessons in landscape painting from one of the Moran brothers.

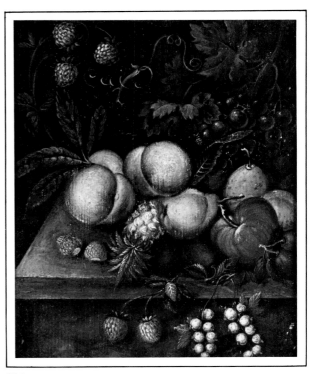

224.

Perry, Enoch Wood Jr. (1831 – 1915)

THE PEMIGEWASSET COACH

Figs. 237 and 225

H. 42½"; w. 66¼" c. 1899
oil on canvas
Exhibited: New York Graphic Society, Greenwich, Connecticut.
(cat. #27.1.7-9)

A native of Boston, Massachusetts where he was born in 1831, Enoch Wood Perry, Jr. was in New Orleans between 1848-1852 where he clerked in a commission house. With the $1,100 he saved he was able to go abroad from 1852-1858 to study painting with Emanuel Leutze in Dusseldorf for two and a half years, with Thomas Couture in Paris for two years, followed by three months in Rome, and three years in Venice where he served as United States Consul from 1856-1858. Returning to the United States, he settled in Philadelphia in 1860, went briefly to New Orleans where his father was a furniture dealer, and by 1862 was in San Francisco where he remained for three or four years. Travelling to Hawaii, he turned back to the mainland, and after a brief visit to Salt Lake City where he painted some of the Mormon leaders, was in New York City where he established a studio in 1865. In 1869 he became a Member of the National Academy. About 1880 he again visited California and Europe. Primarily a genre painter, Perry also did still-lifes, portraits, and landscapes.

Eric Sloane discovered this painting, depicting a Concord Coach, probably on its way to the Pemigewasset House at Plymouth, New Hampshire. Originally the Webster Tavern, in 1841 the building was purchased by Denison R. Burnham and named the Pemigewasset House. It burned twice — in 1862 and 1908, and opened after rebuilding the third time in 1913.[1] Two versions of this painting exist (the other the mirror opposite of this one). Eric Sloane received one from a friend and found this version, torn and soot covered, hanging in a hot dog stand in New York City. A print, illustrated here, was made from the first painting. Shelburne's was never completed — the horses have no harnesses, the lady on the top of the carriage has no hand, and several other details have been left unfinished.

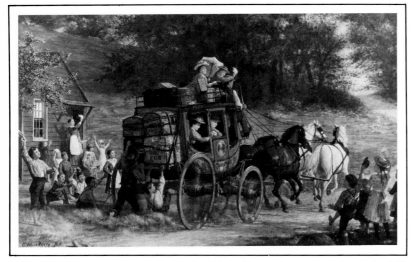

Print made from first PEMIGEWASSET COACH painting, 225.
copyright Artistic Picture Publishing Co., Inc.

[1] Frederick W. Kilbourne, Chronicles of the White Mountains (Boston: Houghton Mifflin Co., 1916), pp. 173-174.

226.

Peto, John Frederick (1854 – 1907)

ORDINARY OBJECTS IN THE ARTIST'S CREATIVE MIND

(Inside Back Cover)

H. 56"; w. 33" 1887
oil on canvas
signed, l.l.: "John F. Peto/1887"
(cat. #27.1.3-19)

Born in Philadelphia, the son of a gilder and dealer in picture frames,
John Frederick Peto became the second most important painter of the
American *trompe l'oeil* school. As a child Peto began playing the
coronet, an instrument which appears in this canvas. By the 1870's he
was studying at the Pennsylvania Academy of Fine Arts where he be-
came friends with and was strongly influenced by *trompe l'oeil*'s leading
exponent, William Harnett. Travelling to Cincinnati in 1887, Peto mar-
ried Christine Pearl Smith in Larado, Ohio, and returned to Philadelphia
until 1889 when he moved to Island Heights, New Jersey. He never quit
painting but was largely employed as a professional coronet player at
camp meetings in Island Heights. His paintings, increasingly introspec-
tive, were frequently unfinished or hastily done. The same objects re-
peatedly appear in his canvases — books, candlesticks, ink wells —
usually old, worn, or faded. "They are the most powerful reflections of
post-Civil War pessimism in American Still-life."[1]

In this painting Peto has included his coronet and a wood engraving of
THE BATHERS by Winslow Homer which appeared in *Harper's Weekly*
on August 2, 1873.

[1] William H. Gerdts and Russell Burke, *American Still-Life Painting* (New York: Praeger
Publishers, 1971), p. 144.

Persico, Gennaro (? – 1859)

JAMES WATSON WEBB (1802 – 1884)

Fig. 226

H. a. 3¾"; w. 3¼" b. H. 3¼"; w. 2½"
watercolor on ivory
Gift of: a. Samuel B. Webb, 1954
 b. J. Watson Webb, Jr., 1974
(cat. #27.2.1-29 a and b)

Painted by the Italian born miniaturist Gen-
naro Persico, these two miniatures are almost
identical. Probably 27.2.1-29 b is the original,
the other having been copied from it. Persico
came to Pennsylvania from Naples, Italy
about 1820 and worked in Lancaster,
Philadelphia, and Reading during that dec-
ade. After marrying the daughter of a Reading
banker. Persico moved to Richmond, Vir-
ginia where he ran an English and French
Academy for young women. After his wife's
death in 1842, he returned to Naples but was
back in Richmond by 1852 where he was ac-
tively painting as late as 1859. This small por-
trait of James Watson Webb (also see pp. 41
& 152) was painted in 1824 when Mr. Webb
was a First Lieutenant in the Third United
States Infantry.

227. Photograph of John Frederick Peto in his Studio,
Shelburne Museum Collection

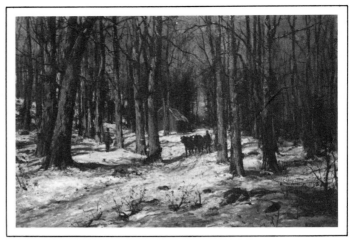

228.

Phelps, William Preston

SUGARING OFF

Fig. 228

H. 20"; w. 29½" c. 1890
oil on canvas
signed, l.r.: "W. P. Phelps"
(cat. #27.1.5-44)

William Phelps was born in New Hampshire and was later a sign painter in Lowell, Massachusetts. He spent three years studying painting in Germany, during which time he sent two canvases from Munich to the National Academy of Design in 1878 and 1880. Thereafter he returned to Lowell. This painting may have been done in Vermont, as a similar scene, MAPLE SUGARING — A SCENE IN VERMONT, was illustrated in the March, 1963 issue of The Old Print Shop *Portfolio*.

Attributed to

Phillips, Ammi (1788 – 1865)

MAN WITH FAIR HAIR

Fig. 244

H. 30"; w. 24" c. 1818
oil on canvas
Exhibited: "Ammi Phillips Portrait Painter," Museum of
 American Folk Art and Albany Institute, October
 1968-January, 1969.
(cat. #27.1.1.-16)

Ammi Phillips, born in Colebrook, Connecticut in 1788, was painting by 1811 when his first known portrait was signed and dated. Two years later he married Laura Brockway Schodack in Nassau, New York, and in 1817 bought a lot in Troy, New York. During this period he painted in Hoosick and Troy, New York, and Bennington, Vermont. This painting was done during Phillips' "border period." "The use of the drape . . . is relatively unusual, and limited strictly to these early portraits, and very few of those."[1]

[1] Letter from Mr. and Mrs. Lawrence B. Holdridge, January 11, 1966, Shelburne Museum MSS.

229.

Attributed to

Phillips, Ammi

ELMORE EVERITT, M.D. OF SHARON, CONNECTICUT

Fig. 229

H. 31"; w. 25" c. 1832
oil on canvas
(cat. #27.1.1-26)

Between 1820-1828 Phillips' style became meticulously realistic as he painted mostly in Columbia, Rensselaer and Dutchess Counties, New York. In 1829 he bought land in Rhinebeck, New York, and painted in the Hudson and Housatonic River Valleys. After his first wife's death in 1830, Phillips married Jane Ann Caulkins of Northeast, New York in 1834, and four years later bought land in Amenia, New York. Gradually his style became bolder and more vigorous, with a new warmth in tonality. Painting in northwest Connecticut and Berkshire County between 1848-1850, he was in northeastern New York in 1850-1851. Unknown for the next nine years, he was in Curtisville (now Interlaken), Massachusetts in 1860, Stockbridge, Massachusetts in 1863, and died in Berkshire County in 1865.

The former owner of this painting wrote:
This painting is of my ancestor, Dr. Elmore Everitt. b. — Ellsworth (Sharon, Conn.) April 21, 1790. Studied medicine with Dr. Curtiss J. Hurd and left Ellsworth in 1820, going to Amenia, New York where he practiced until 1832. Returned to Ellsworth 1832, practicing until 1853. Member of General Assembly 1837-40. Died Waverly, New York, April 21, 1860. Ebenezer Everett, Elmore's father, served in Continental Army in 1775. This painting came to me from my mother who was Mary Everitt.[1]

[1] Letter from Mabel B. Waldron, August 8, 1956, Shelburne Museum, MSS.

Phipps, Susie (1940 –)

TICONDEROGA ON THE LAKE

H. 4¼"; w. 6" 1953
watercolor on paper
signed, l.r.: "S.P."
on verso: "To Mrs. Webb/from Susie Phipps/1953" (in
 pencil); "Aged 13 years"
(cat. #27.2.4-9)

This small painting by a young girl captures
the exuberance of life on a moving vessel on
a warm summer's day.

Pitcher, M. C.

PLAYFUL PUPPY Fig. 230

H. 14¼"; w. 18"
pastel on paper
signed, l.r.: "M. C. Pitcher"
(cat. #27.3.4-1)

This pastel by the unknown M. C. Pitcher is another
which sentimentalizes the pleasure which pets
bring. It was found in Vermont.

230.

Pleissner, Ogden Minton (1905 –)

TUSCANY FARM Fig. 239

H. 9¼"; w. 14¼" 1960
watercolor on paper
signed, l.r.: "Pleissner"
Inscribed, l.l.: "To Ma and Pa Webb/Feb. 8, 1960
 Congratulations! Ogden"
Gift of the artist to Mr. and Mrs. J. Watson Webb on their fiftieth
wedding anniversary, February 8, 1960.
Exhibited: Columbus Museum of Arts and Crafts, Columbus,
 Georgia, February, 1963.
 "The Best of Shelburne," IBM Gallery, November-
 December, 1964.
(cat. #27.2.2-12)

This watercolor is a study for the oil painting listed
below.

31.

TUSCANY FARM Fig. 231

H. 24"; w. 40" 1961
oil on canvas
signed, l.l.: "Pleissner"
Awarded First Prize, Gold Medal of Honor, Annual Exhibition,
 National Arts Club, 1961
(cat. #27.1.2-37)

Born in Brooklyn, New York on April 29, 1905,
Ogden Pleissner studied at the Brooklyn Friends
School, and the Art Students League in New York
City with F. J. Boston, George Bridgman and Frank
V. DuMond. During World War II he served as a
combat artist for the Army Air Force and *Life*
Magazine. Mr. Pleissner has won a great many
awards and honors, including the Audubon Artist's
Medal of Honor in 1950, a gold medal from the
American Water Color Society in 1956, the Century
Club's Medal of Honor in 1958, the National
Academy's Samuel F. B. Morse Medal of Honor, the
Altman Prize in 1959, and the Saportas Prize in
1961. He has served as Vice President and Director
of the Louis Comfort Tiffany Fund and as a member
of the Fine Arts Committee of the National Collection
of Fine Arts. While he has painted often in Europe
(particularly in France, Italy, and Portugal), Mr.
Pleissner has spent considerable time painting in
New York City where he maintains a winter studio; in
Dubois, Wyoming; Nova Scotia; and Pawlet, Ver-
mont where he spends his summers. He has been a
trustee of the Shelburne Museum since 1963.

103

Potter, David

FAMILY REGISTER OF DAVID POTTER, 1832

Fig. 232

H. 11"; w. 7¼" 1832
watercolor on paper
signed, l.l.: "D P/1832"
(cat. #27.2.6-16)

This family register includes the names, native land, and birth dates of members of the Potter family. It was probably painted by David Potter, Jr., who would have been fourteen years old in 1832.

232.

Powers, Asahel L. (1813 – 1843)

NUDE

Fig. 233

H. 19"; w. 13" 1837
oil on cardboard, mounted on masonite
on verso, in pen: "William Henry Joh ???/Rod(man) Park
 Woodstock/?/Miss Deston S. Smith/Jonathan
 Winsor/William ?/Painted by A L Powers/? May 14th
 1837"

(cat. #27.1.1-80

This crude, rather mysterious painting was found in the attic of a home in Chippenhook (near Clarendon Springs) Vermont. Powers' family and the owners were related. The artist was the third generation to carry the name Asahel Powers. His grandfather, born in Shirley, Massachusetts, came to Springfield, Vermont with his family in 1772 where he became a sharp "justice lawyer."[1] His father, Asahel, Jr., was a farmer in Springfield, migrating to Olney, Illinois in the early 1840's. Asahel L. Powers began painting as a youth, his first portrait probably done in 1831. His paintings were generally done on wood until 1835, and no work of his has been found in Vermont dating after 1839. By the early 1840's he, too, was on his way to Olney, painting in Clinton and Franklin Counties in New York, especially in the towns of Plattsburgh and Malone on his journey West.

[1] Nina Fletcher Little, "Asahel Powers, Painters of Vermont Faces," The Magazine *Antiques* (November, 1973), p. 846.

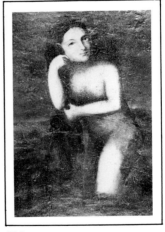

233.

234.

Pratt, Matthew (1734 – 1805)

JOSEPH TALCOTT

Fig. 234

H. 29⅞"; w. 24½"
oil on canvas
(cat. #27.1.1-25)

Spending most of his life in Philadelphia where he was born in 1734, Matthew Pratt was apprenticed to his uncle James Claypoole in 1749 from whom he learned sign painting. An active portrait painter in New York between 1758 and 1764, Pratt went to London in 1764 where he spent two and a half years in the studio of Benjamin West and painted portraits in Bristol, England. Returning to Philadelphia in 1768, Pratt remained there for most of his life except for brief trips to England and New York City in the early 1770's, and a journey to Williamsburg, Virginia in 1773 when he advertised in a local newspaper in March. By 1787 he was teaching in Philadelphia, and in 1796 announced the formation of a partnership of Pratt, Rutter and Co., portrait and ornamental painters. Only forty of his portraits have been recorded. This one is of Joseph Talcott, but inquiries in Philadelphia have yielded no information on his background.

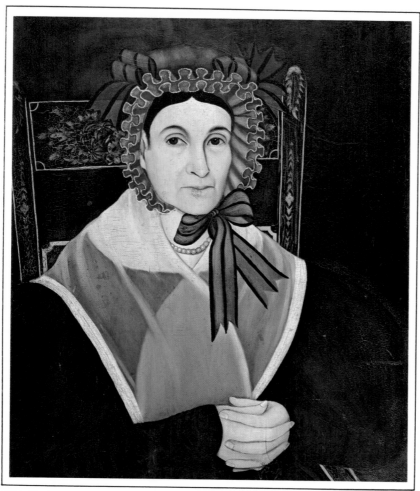

235. Noah North, EUNICE EGGLESTON DARROW SPAFFORD

236. John Quidor, EDICT OF WILLIAM THE TESTY AGAINST TOBACCO

Enoch Wood Perry, THE PEMIGEWASSET COACH 237.

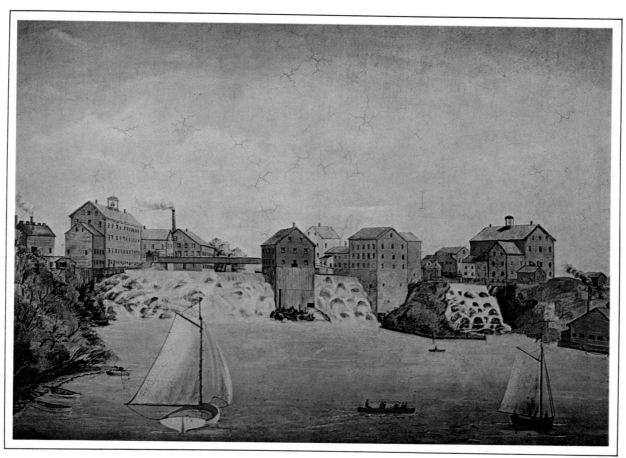

S. H. Washburn, FALLS AT VERGENNES, VERMONT 238.

239. Ogden Pleissner, TUSCANY FARM

240. Andrew Wyeth, SOARING

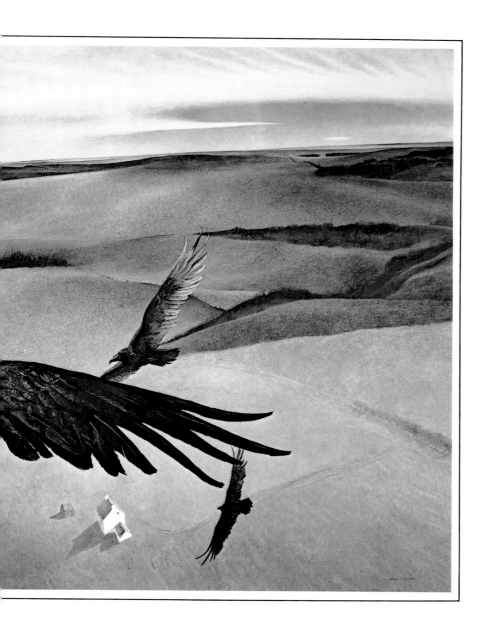

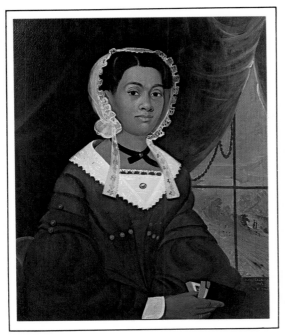

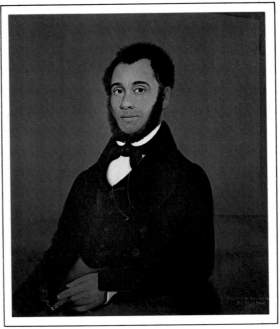

241. William Matthew Prior,
MRS. NANCY LAWSON

William Matthew Prior, 242.
THE REV. W. LAWSON

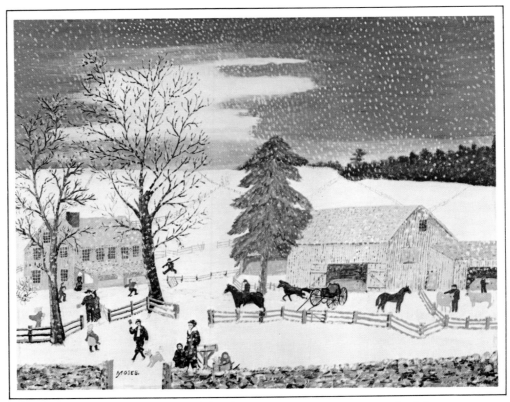

243. Grandma Moses, THE MAILMAN HAS GONE, Copyright Grandma Moses Properties, Inc., New York

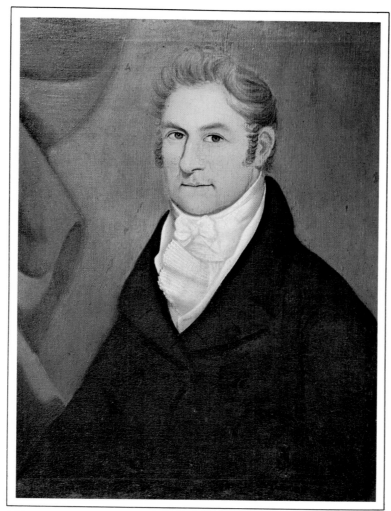

244. Ammi Phillips, MAN WITH FAIR HAIR

Arthur Fitzwilliam Tait, MINK TRAPPING PRIME 245.

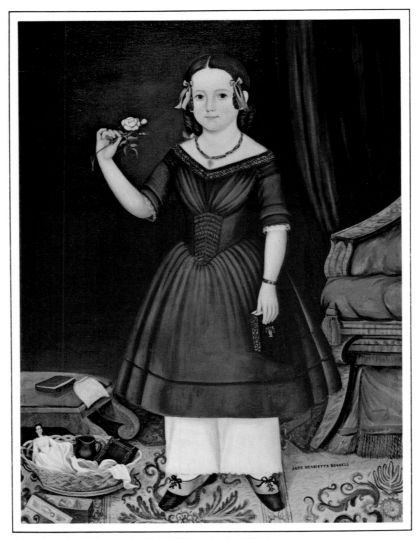

246. Joseph Whiting Stock, JANE HENRIETTA RUSSELL

246. reverse of canvas

entice, Levi Wells (1851 – 1935)

KE LILA IN THE ADIRONDACKS

Fig. 247

H. 10"; w. 20" c. 1877
oil on canvas
signed, l.l.: "L. W. Prentice"
Gift of: The Adirondack Museum, 1968
(cat. #27.1.4-77)

ginally called Smith's Lake, Lake Lila received its
w name when it and 50,000 acres surrounding it
re purchased by W. Seward Webb in 1893 and
amed in honor of his wife.
Born December 18, 1851 at Harrisburgh, New
rk, Levi Wells Prentice was the son of Samuel
bb and Rhoda Robbins Prentice. In the 1860
. Census records, the family is listed as living at
penhagen, town of Denmark, Lewis County, New
rk. From 1871 the Prentices were in Syracuse
ere Levi Wells Prentice is listed as a landscape
nter from 1872 through 1879. In 1879, 1880 and
3 Prentice and his father are listed in the Buffalo,
w York, City Directory. Prentice married Emma
seloe Sparks of England in 1882 who bore him
children, Leigh Wells, born in 1887, and Im-
ne, born in 1889. The *Syracuse Standard* of
e 10, 1894 stated: "L. N. Prentice now of Brook-
, who lived for a long time in Johnson Street
racuse) has made considerable of a reputation
his work in still life."[1] As his son graduated from a
ladelphia High School in 1907, Prentice was
bably living there. He is also known to have had a
mmer studio near Bridgeport, Connecticut. After a
aract operation c. 1923, Prentice continued paint-
, and died on Thanksgiving Day, 1935.
his painting has been dated by Mr. William K.
ner c. 1877 because its relatively early style of
nature compares with that on a painting entitled
ENANGO VALLEY, SHERBURN, NEW YORK
ch is dated 1877. A larger version of the same
w of this lake, from a slightly higher vantage point
l dated 1883, is in the Adirondack Museum.

Letter from Mr. William K. Verner, February 25, 1968, Research
stant, the Adirondacks Museum, who is preparing a biography
rentice. Most of this information on Prentice has come from him.

247.

Pringle, James Fulton (1788 – 1847)

SAND'S POINT, LONG ISLAND

Fig. 248

H. 20½"; w. 48¼" 1834
oil on canvas
signed, l.l.: "J Pringle 1834"
(cat. #27.1.4-39)

James Fulton Pringle was born in 1788 in
Sydenhan, Kent, England, the son of the English
marine and portrait painter James Pringle with
whom he studied. He began painting harbors and
marine scenes for the British Admiralty before com-
ing to the United States with his family in 1828, set-
tling in Brooklyn at Fulton and Jackson Streets near
the East River. He painted many vessels during their
construction and launching for East River shipbuild-
ers, but to supplement his income worked as a nur-
seryman between 1836-1837. In the latter year sixty
Pringle "Paintings, comprising subjects of Late
Events at Sea" were exhibited at 333 Broadway,
New York City.[1] Between 1838 and 1844 Pringle
was to exhibit at the Apollo Gallery; Clinton Hall,
New York; and the National Academy of Design.

[1] Information from Frederick Fried, whose book *James Fulton
Pringle, Marine Artist, New York,* is in preparation.

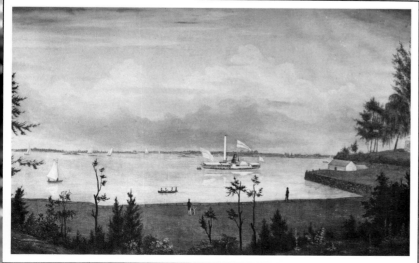

248.

Prior, William Matthew (1806 – 1873)

THE ARTIST'S DAUGHTER, ROSAMOND CLARK PRIOR
(1829 – ?)

H. 15¾"; w. 12" c. 1836
oil on academy board
on verso (postal mailing tag): "AUNT ROSAMOND CLARK PRIOR/BORN NOV.
 15, 1829 (AGE 7 or/9 according/to
 EDITH/PRIOR/PAINTED BY
 GRANDFATHER/WILLIAM MATHEW (sic) PRIOR"

(cat. #27.1.1-133)

Rosamond was the eldest of Prior's eight children.

THE REVEREND W. LAWSON Fig. 242

H. 30"; w. 25" 1843
oil on canvas
signed, l.r.: "W. LAWSON. May 2nd 1843/BY W. M. PRIOR"
(cat. #27.1.1-125)

MRS. NANCY LAWSON Fig. 241

H. 30"; w. 25" 1843
oil on canvas
signed, l.r.: "Nancy Lawson. May 11 1843./W. M. Prior"
(cat. #27.1.1-124)

The Frick Art Reference Library's records indicate that Rev. William Lawson was a prominent New England abolitionist. There is a painted tray at the Rhode Island School of Design on which a black man is shown preaching to a white congregation which may be Rev. Lawson, or another minister named Samuel Haynes. Since Prior was a Millerite, many of whom supported the abolitionist cause, he perhaps sympathetically painted a fellow-parishioner and his attractive wife.[1] The Lawsons obviously have an aura of respectability and a relatively high social position.

[1] Another black family which Prior painted is THREE SISTERS OF THE COPLAN FAMILY (26¾ x 19½, oil, Museum of Fine Arts, Boston) which again probably illustrates his Millerite stance.

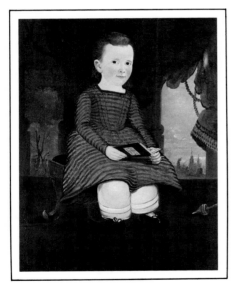

250.
LITTLE GIRL FROM MAINE

Fig. 250

H. 29"; w. 25¾" 1846
oil on canvas
signed, on verso: "Painted By/Wm. M. Prior East Boston/Apr 1846/Value $20.00"
Gift of: Dr. and Mrs. Fletcher McDowell, 1959
(cat. #27.1.1-72)

Because of the high value ascribed to it, this must have been one of Prior's better efforts at this time. Between 1845 and 1846 Prior is not listed in the Boston Directories and was probably travelling as an itinerant. In 1846 he purchased "The Painting Garret" in East Boston where this painting was done.

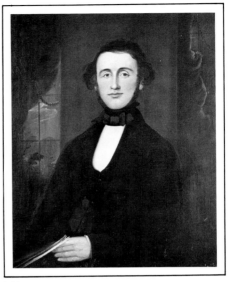

249.

JAMES ALLEN OF BOSTON Fig. 249

H. 34"; w. 27" c. 1843
oil on canvas
(cat. #27.1.1-117)

This portrait was purchased from a member of the Allen family who ha[d] inherited the painting along with Prior's signed painting of two-year o[ld] WILLIAM ALLEN, now in the Boston Museum of Fine Arts. James All[en] lived on Beacon Hill when Prior painted this portrait of him.

Born in Bath, Maine in 1806, William Matthew Prior was the son of [?] Sarah Bryant, and Matthew Prior whose forefathers had come to Dux[bury], Massachusetts from England in 1638. After his father was lost [at] sea in 1816, William Matthew took up painting, producing his first knov[n] portrait in 1824 in Portland. He advertised in the Maine Inquirer on Ju[ne] 5, 1827, "Ornamental painting, old tea trays, waiters re-japanned an[d] ornamented in a very tasty style. Bronzing, oil gilding, and varnishing . . ."[1] In 1828 Prior married Rosamund Clark Hamblen in Bath, and w[as] to become very close to her brothers, Nathaniel, Eli, Joseph, and St[ur]tevant, all of whom painted. Moving to Portland between 1831 and 18[?] the Priors were living with Nathaniel on Green St. by 1834 and soon established their own home where they were joined by Joseph and St[ur]tevant about 1837. After Eli's death in 1839, the Priors and Hamblens went to Boston in 1840 where they began painting as a team, mass pr[o]ducing portraits. At first they all lived with Nathaniel, and between 1842-1844 they lived together in East Boston. The inconsistencies in style are explained by their willingness to charge one quarter price "[?] a flat picture . . . without shade or shadow."[2] The four paintings listed above were presumably all painted by Prior himself.

[1] Nina Fletcher Little, "William M. Prior, Traveling Artist," The Magazine Antiques, Janua[ry] 1948, p. 44.
[2] Ibid., p. 45.

250. reverse of canvas

or, William Matthew

DY WITH PINK RIBBON TIE

H. 26″; w. 20½″ 1849
oil on wood
signed, on verso: "Retouched by/W. M. Prior/1849"
(label): "Joseph Stowers, Gilder, Essex
Street, Salem, Mass."
(cat. #27.1.1-98)

NTLEMAN WITH BLACK WATCH CORD

H. 26″; w. 20½″ c. 1849
oil on wood
on verso (label): "Joseph Stowers, Gilder, Essex Street, Salem,
Mass."
(cat. #27.1.1-97)

er his wife's death in 1849, Prior maintained his
st Boston studio on 36 Trenton St. until the end of
life and married Hannah Frances Walworth of
dover, Massachusetts about 1851. While mainly
nting in Boston, Prior did travel in the eastern part
Massachusetts, especially in Fall River, New Bed-
d, and Sturbridge. About 1855 he is known to
e been in Baltimore.

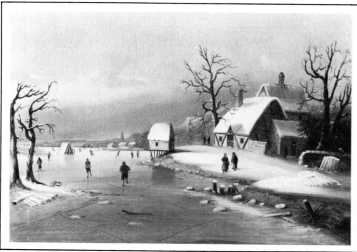

251.

Attributed to Prior, William Matthew
CHILD WITH RABBIT

Fig. 252

H. 27⅜″; w. 22⅜″ c. 1845
oil on canvas
(cat. #27.1.1-136)

Prior-Hamblen School

WOMAN WITH UNTIED BONNET

H. 15″; w. 11½″ c. 1850
oil on academy board
on verso (label): "From the Wheeler Family, Provincetown,
Mass. Photo in Provincetown Museum."

Inquiries about this portrait to the Provincetown
Museum have proved negative. A dark red and gold
border paper has been pasted around the edges of
the painting to look like a fancy liner.

Prior, William Matthew

GAMES ON ICE

Fig. 251

H. 15½″; w. 22¾″ c. 1855
oil on canvas
signed, on verso under relining "By Wm. M. Prior. Baltimore."
(cat. #27.1.2-104)

Originally this painting was entitled BALTIMORE
SCENE because of the inscription of the back of the
canvas. Since the scene is definitely not Baltimore,
it is probably an imaginary scene which Prior did
while he was visiting that city.

MOONLIT BRIDGE

H. 19″; w. 25″
oil on canvas
(cat. #27.1.2-105)

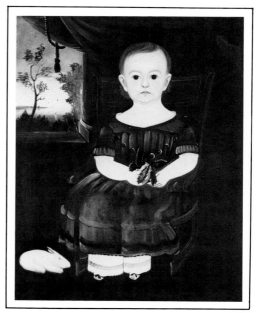

252.

CAPT. JOHN SNOW

H. 14¼″; w. 10¼″ c. 1846
oil on academy board
on verso: "Captain John Snow"
(cat. #27.1.1-93)

EPHRAM SNOW

H. 14½″; w. 10½″ c. 1846
oil on academy board
on verso: "Ephram Snow"
(cat. #27.1.1-96)

NANCY SNOW

H. 14¼″; w. 10¼″ 1846
oil on academy board
on verso: "Nancy Snow. Bath: Dec. 17, 1846"
(cat. #27.1.1-94)

JOHN SNOW

H. 14½″; w. 10½″ c. 1846
oil on academy board
on verso: "John Snow"
(cat. #27.1.1-95)

The Clark and Snow family portraits and WOMAN WITH UNTIED BONNET are all done in a rather flat, freshly colored, literal manner and were probably done by one of the Hamblens or as a Prior-Hamblen collaboration.

Prior – Hamblen School

CAPTAIN JEREMIAH
CLARK (1805 – 1883)

Fig. 253

H. 16''; w. 12'' c. 1856
oil on academy board
on verso: "Captain Jeremiah Clark of/Andover,
 Vermont, and/New Bedford,
 Massachusetts/born 1805 — Died
 1883/Painted about 1856"
(cat. #27.1.1-90A)

DIANA PIERCE CLARK (1818 – 1907)

Fig. 254

H. 15''; w. 11¼'' c. 1856
oil on academy board
on verso: "Diana Pierce Clark/born 1818 — died
 1907/Resident Bedford, MASS and/Andover,
 Vt./Painted about 1856"
(cat. #27.1.1-90)

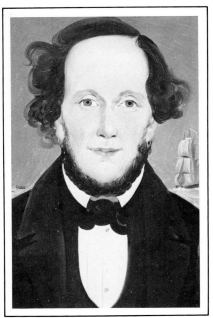

253.

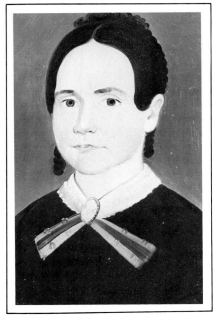

254.

EDGAR CLARK (1854 – 1906)

Fig. 255

H. 15¼''; w. 11'' c. 1856
oil on academy board
on verso: "Edgar Clark, 1854-1906/Son of/Captain
 Jeremiah Clark and/Diana Pierce
 Clark/Painted about 1856"
(cat. #27.1.1-92)

F. CLARK

Fig. 256

H. 16½''; w. 12½'' c. 1856
oil on academy board
on verso: "_____ Clark, son of Captain/Jeremiah
 Clark and Diana Pierce Clark/Painted 1855 or
 56"
(cat. #27.1.1-91)

255.

2

In the manner of William Matthew Prior

YOUNG WARREN CROSBY

H. 39¼''; w. 30¼'' c. 1845
oil on canvas
(cat. #27.1.1-141)

This painting has a close stylistic relationship with paintings by Prior or the Hamblens, but is different enough to make a more definite attribution difficult.

idor, John (1801 – 1881)

ICT OF WILLIAM THE TESTY AGAINST TOBACCO Fig. 236

H. 27¼″; w. 34¼″ c. 1865
oil on canvas
(cat. #27.1.7-14)

e rather nervous calligraphy and amber tones of this Quidor painting of WILLIAM
E TESTY reflect the personal and distinctive technique of the artist. Born in Tap-
n, New York in 1801, Quidor moved with his family to New York City in 1811 and
tween 1818 and 1822 studied portrait painting with John Wesley Jarvis. Proving an
happy experience to Quidor, he turned to painting signs, banners, and panels for
engines and steamboats. Between 1827-1834 he is listed in New York City direc-
ies as a portrait painter and began exhibiting widely. Charles Loring Elliott and
omas Bangs Thorpe studied briefly with him about 1830, after which Quidor is
own to have tried farming in Quincy, Illinois in 1835. In 1844 he agreed to paint
ven large Biblical paintings in exchange for farm land in Illinois, three of which were
npleted and exhibited at the National Academy in 1847. In 1848 he returned to
w York where between 1851-1868 he is again listed in directories as a painter.
tiring, he spent his last years with a daughter in Jersey City.
Like Albertus D. O. Browere (see p. 34) whose father was a close friend of Quidor,
s painter was long intrigued by Washington Irving's tales. In 1830 his ICHABOD
ANE PURSUED BY THE HEADLESS HORSEMAN won second prize in an exhibi-
n sponsored by the American Institute of New York City. In this painting Quidor
icts William Kieft, known as William the Testy, a Dutch Director General of New
sterdam about whom Irving wrote the following:
. . . Once upon a time in one of his fits . . . (William) framed an unlucky law to pro-
hibit the universal practice of smoking. . . . a mob of factious citizens had even the
hardihood to assemble before the governor's house, where, setting themselves
resolutely down, like a besieging army before a fortress, they one and all fell to
smoking with a determined perseverance that seemed as though it were their in-
tention to smoke him into terms. The testy William issued out of his mansion like a
wrathful spider, and demanded to know the cause of this seditious assemblage,
and this lawless fumigation; to which these sturdy rioters made no other reply than
to loll back phlegmatically in their seats and puff away with redoubted fury. . . .[1]

Washington Irving, *Knickerbocker's History of New York* (New York: The Co-Operative Publication Society,
n.d.), p. 186.

257.

Rauschner, John Christian (1760 –)

DR. JOHN SCUDDER (– 1823)

Fig. 257

3⅝″ round
wax, covered with convex glass
signed, l.r.: "Rauschner"
(cat. #27.19-14)

dall, Wallae (?) E.

ONDEROGA

. 29½″; w. 39⅓″ 1953
atercolor on paper
igned, l.r.: "WALLAE E. RANDALL, 1953"
ift of: Sterling D. Emerson
cat. #27.2.4-10)

large watercolor of the Shelburne Museum's
wheel paddle boat TICONDEROGA was probably
e from a photograph. Built in the Shelburne Shipyard in
6, the TI plied Lake Champlain for forty-seven years,
ying passengers and freight before making her over-
voyage to the Museum grounds in the spring of 1955.
is painting many flags fly from her deck, including her
and that of the Shelburne Museum.

k, William

ENT FOR A SIDEWHEELER

. 6⅛″; w. 5⅛″ 1821
atercolor, pencil, and brown ink on paper
igned, u.: "Boat Drawn/by/William Rank 1821"
scribed, bottom: "A Boat that will work up Stream/by the Weels
(sic) fixed to the Sides as per/Plate"
cat. #27.2.4-2)

is a very early drawing of a self-propelled boat.

The modelling of bas-relief busts in wax was a popular eighteenth century art in Eng-
land and on the Continent. John Christian (Johann Christoph) Rauschner was born in
Frankfort, Germany in 1760 and brought this art with him to America by 1799. He was
in New York City between 1799 and 1808 and travelled to Philadelphia, New Eng-
land, and possibly as far south as South Carolina, making wax portraits of many sub-
jects.
His wax was coloured all the way through in the mediaeval style, and not merely
tinted on the surface. When he did a portrait, he first made an intaglio mould and
pressed the wax in colour by colour. The form was them removed and the portrait
finished by little touches of real lace or seed pearls, and finally mounted on glass.
When the portrait business was dull, Rauschner worked as a hairdresser and
barber.[1]
Rauschner's career after 1811 is undocumented. His subject in this instance was Dr.
John Scudder, founder of the American Museum in New York. The Museum was
founded in March, 1810, at 21 Chatham Street. In 1817 it was moved to the New York
Institution, and in 1820 consolidated with the Grand Museum. The Museum was con-
tinued by John Scudder Jr. until 1841 when it was purchased by P. T. Barnum.[2]

[1] Richardson Wright, *Hawkers and Walkers in Early America* (Philadelphia: J. B. Lippincott Co., 1927), p. 136.
[2] *Scudder Association Bulletin,* Vol. X, (May, 1947) pp. 6-8.

258.

Remington, Frederic Sackrider (1861 – 1909)

SOLDIER'S CHARGE

Fig. 258

H. 27"; w. 40" 1900
oil on canvas (black and white)
signed, l.r.: "Frederic Remington"
Inscribed, above signature: "To my friend Everett Little" l.l.:
 "COPYRIGHT P. H. COLLIER 1900"
on verso (stencil): "PREPARED BY/F. W. DEVOE & CO.,/NEW
 YORK/MANUFACTURERS/AND
 IMPORTERS/ARTISTS' MATERIAL"
Gift of: Mr. and Mrs. William N. Beach
(cat. #27.1.5-81)

This painting was reproduced in *Harper's Weekly*, June 10, 1899, with the title "In the Philippines — A Bayonet Charge."

UNEXPECTED SHOT

Fig. 259

H. 22¼"; w. 30"
wash and ink on paper
signed, l.l.: "Frederic Remington"
Gift of: Mr. and Mrs. William N. Beach
(cat. #27.9-61)

This wash drawing appeared in *Harper's Weekly*, October 3, 1896 under the title "Moose Hunting — An Unexpected Shot."

Frederic Sackrider Remington was born in Canton, New York on October 4, 1861 and at an early age moved to Ogdensburg where his father was Collector of the Port. After attending a military academy at fifteen, he entered Yale at sixteen where he participated in intercollegiate football, was a heavy weight boxer, and received some training at Yale's Art School and the Art Students League. Quitting college at nineteen, Remington headed West, roaming from Mexico to Canada. He became an excellent cowboy, learning to ride, throw a lariat, and handle a gun with proficiency. Among other occupations, he prospected for gold in the Apache country of the Arizona Territory, worked as a hired cowboy, operated a small ranch in Kansas, and was part owner of a saloon in Kansas City. In New York City in 1885, Remington began doing illustrations of the West for *Harper's Weekly*, and *Outing* magazine of which his friend Poultney Bigelow was editor. Hale, hard-riding and heavy eating, Remington spent his winters writing and painting in New York City and summers in the West, Canada or Mexico. It was a sad day indeed when his prodigious bulk prevented his riding a horse. Remington went abroad with Bigelow, — to North Africa, Europe, and London, where he saw Buffalo Bill's Wild West Show; but the museums, cathedrals, and the required social protocol of Europe made him uncomfortable. He much preferred the rough and ready atmosphere of the West. In 1898 William Randolph Hearst sent him to Cuba to cover the Spanish American War. In his lifetime, Remington did 2,739 paintings, illustrated 142 books, and completed twenty-five bronze sculptures. He died in Ridgefield, Connecticut on December 26, 1909, at the age of forty-eight following surgery for an emergency appendectomy.

259.

Reynolds, H.

"S. W. VIEW, OF MIFFLINVILLE, PA. 1836"

Fig. 260

H. 11¾"; w. 18 7/16" 1836
watercolor on paper
signed, l.r., on diagonal: "H. Reynolds Pinxet."
(cat. #27.2.2-10)

Mifflinville is southwest of Berwick, Pennsylvania, close to the Susquehanna River. The house in the center of the painting was built by Alfred Hess, a wheelwright, and his brother Whitney. On the right is the Methodist Church on Main Street.

260.

261.

Richards, William Trost (1833 – 1905)

ITALIAN HILL TOWN

Fig. 262

H. 17¼"; w. 24" 185?
oil on canvas
signed, l.l.: "Wm T. Richards/Phil — /185?"
(cat. #27.1.2-93)

Richards, Thomas Addison (1820 – 1900)

VIEW OF THE FRENCH BROAD RIVER, NORTH CAROLINA

Fig. 261

H. 36"; w. 54"
oil on canvas
Gift of: J. Watson Webb, Jr.
(cat. #27.1.2-117)

Thomas A. Richards was born in London and from an early age showed a talent for painting. He published his first book, an illustrated guide to flower painting at age eighteen. Coming to America in 1831, he was in Hudson, New York and Denfield, Georgia before teaching and painting at Charleston, South Carolina between 1843 and 1844. In the latter year he moved to New York City where he studied at the National Academy for two years. He became an Academician of the National Academy in 1851 and from 1852 on, served as its Corresponding Secretary for forty years. Primarily a landscape painter, he travelled widely in the United States and Europe, painting and writing, and illustrating travel articles. Between 1867 and 1887 he was an art professor at New York University, and died in Annapolis in 1900. The French Broad River, illustrated here, begins in the Blue Ridge Mountains of North Carolina, and flows into Tennessee to join the Tennessee River.

The Philadelphia born painter William Trost Richards received his earliest instruction in painting from the German artist Paul Weber. First employed as a designer for Archer, Warmer, and Miskey, (manufacturers of gaslight fixtures, lamps and chandeliers), by the 1850's Richards was painting landscapes in the Catskills. In 1853 he made his first trip to Europe where he visited Paris, Florence and Rome, and made a second trip in 1856 where in Dusseldorf he met Emanuel Leutze and Albert Bierstadt. This painting was done on one of these trips. Returning to America, Richards settled in Germantown, Pennsylvania and painted in the Adirondacks where his work showed the strong influence of Frederic Church. Between 1870 and 1880 he spent considerable time in Cape May and Atlantic City, New Jersey experimenting in painting water and in 1874 was first in Newport where in 1890 he built a summer home, "Gray Cliff" on Conannicut Island. With characteristic energy, he continued to travel — to England from 1878-1880, the Pacific West Coast in 1885, back to the British Isles several times, and to Norway in 1900. Humorous, keen sighted, and poetical, Richards is described by Barbara Novak as typical if not the archtype of the nineteenth century landscape painters.[1]

[1] Barbara Novak, "William Trost Richards: History Confirmed," Art in America, November-December, 1973, pp. 104-106.

262.

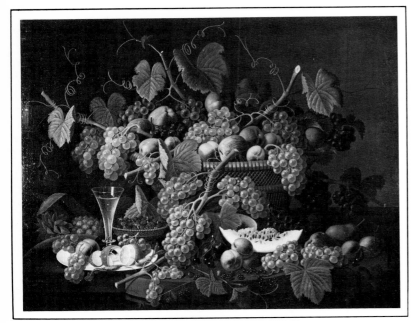

263.

Roesen, Severin (? – c. 1871)

ECSTATIC FRUIT Fig. 263

H. 34"; w. 44" 1852
oil on canvas
signed, l.l.: "S. Roesen./1852."
(cat. #27.1.3-5)

Probably born in or near Cologne, Germany, Severin Roesen began painting porcelain, enamelware, and still-lifes in Cologne, and by 1847 was exhibiting there. Coming to America the following year, Roesen sold several still-lifes to the America Art Union between 1848 and 1850. From 1850 to 1857 he was in New York City, and from 1858 to 1870 in Williamsport, Pennsylvania. He is known to have painted only one portrait; all the rest of his paintings were still-lifes and of these all but one was of flowers and fruit. With extreme devotion to detail, Roesen painted very realistically, noting where leaves had yellowed or were eaten by insects. He probably knew William Harnett who worked in Williamsport during the same time period.

Rossiter, Thomas Pritchard (1818 – 1871)

TWILIGHT IN THE WILDERNESS Fig. 264

H. 28½"; w. 45¾"
oil on canvas
(cat. #27.1.2-79

Born in New Haven, Connecticut in 1818, the portrait, religious, and historical painter Thomas Pritchard Rossiter was apprenticed first to a Mr. Boyd in Winsted, Connecticut, and then became a pupil of Nathaniel Jocelyn in New Haven. He had a studio of his own in New Haven by the age of twenty, and in 1839 was painting in Troy, New York. In 1840 he headed to Europe with Asher Durand, John F. Kensett, and John Casilear where he spent six years in London, Paris, Rome, Germany and Switzerland. Returning to America in 1846, he shared a New York City studio with Kensett and Louis Lang. He returned to Europe in 1853 for three years' study in Paris. Back in New York in 1856, he painted historical and religious canvases, including a series on the life of Christ. This painting may be either EVENING, A COMPOSITION exhibited at the National Academy in 1839, or TWILIGHT HOURS, exhibited at the Academy in 1847. Rossiter established a studio in 1860 at Cold Spring, New York where he died in 1871.

Attributed to

Rowley, Reuben (active 1825 – 1838)

MRS. SALLY HAYES BOSTWICK Fig. 265

H. 24½"; w. 22¼" 1827
oil on canvas
on verso (label): "Sally Bostwick painted 1827. She was/daughter of Sally Hayes who came from England to/United States — before the Revolutionary/War — married Captain Bostwick. She was the sister of Thomas Hayes — father of Isaac Hayes who departed/Sep 28th 1837. This portrait is Minerva Arnolds/when/called for Oct. 9th 1883. A.S.W."
(second label): "Property/of/Rev'd Allen J. Hollay/hold for safe keeping."
(cat. #27.1.1-23)

Reuben Rowley was an itinerant portrait and miniature painter who is known to have worked in New York, Massachusetts, and in Chenango and Susquehanna Valley towns of New York State in the mid 1820's. He was in Albany in 1832 where he probably instructed Philip Hewins, and in Boston from 1834 to 1838 where he exhibited at the Athenaeum in 1834, 1835 and 1836.

Sally Hayes Bostwick was the daughter of Amos Bostwick and his second wife, Sally Hayes of Unadilla, New York.

264.

265.

ungius, Carl (1869 – 1959)

T THE FORKS

 H. 25″; w. 30″
 oil on canvas, mounted on masonite
 signed, l.r.: "C. Rungius"
 Gift of: Mr. and Mrs. William N. Beach
 (cat. #27.1.2-136)

OW RIVER, ALBERTA

 H. 16″; w. 20″
 oil on canvas
 signed, l.r.: "C. Rungius"
 Gift of: Mr. and Mrs. William N. Beach
 (cat. #27.1.2-142)

ROWN BEAR Fig. 268

 H. 45″; w. 60″
 oil on canvas, mounted on masonite
 signed, l.r.: "C. Rungius"
 Gift of: Mr. and Mrs. William N. Beach
 (cat. #27.1.5-62)

ANADIAN MOUNTED POLICEMAN

 H. 36″; w. 30″
 oil on canvas
 signed, l.r.: "C. Rungius"
 (cat. #27.1.5-61)

ARIBOU IN THE MOUNTAINS

Fig. 267

 H. 32¼″; w. 46″
 oil on canvas, mounted on masonite
 signed, l.r.: "C. Rungius"
 Gift of: Mr. and Mrs. William N. Beach
 (cat. #27.1.5-63)

E CHALLENGER

 H. 9 7/16″; w. 12 11/16″ c. 1942
 pencil on paper
 signed, l.r.: "C. Rungius"
 Inscribed, l.l.: "To Marie Beach from
 C. R./Banff. Aug. 15th 1942"
 Gift of: Mr. and Mrs. William N. Beach
 (cat. #27.8-68)

HILDREN OF THE SAGE

 H. 9 7/16″; w. 12 11/16″ c. 1942
 pencil on paper
 signed, l.r.: "C. Rungius"
 Gift of: Mr. and Mrs. William N. Beach
 (cat. #27.1.5-58)

LL RAM

 H. 16″; w. 11″
 oil on canvas (black and white)
 signed, l.l.: "C. Rungius"
 Gift of: Mr. and Mrs. William N. Beach
 (cat. #27.1.5-66)

OWN THE BRAZEAU

 H. 40¼″; w. 50¼″
 oil on canvas, mounted on masonite
 signed, l.r.: "C. Rungius"
 Gift of: Mr. and Mrs. William N. Beach
 (cat. #27.1.2-144)

K: THE CHALLENGER

 H. 30¼″; w. 40½″
 oil on canvas, mounted on masonite
 signed, l.l.: "C. Rungius"
 Gift of: Mr. and Mrs. William N. Beach
 (cat. #27.1.5-57)

GRIZZLY BEAR

 H. 30″; w. 40″
 oil on canvas
 signed, l.r.: "C. Rungius"
 Gift of: Mr. and Mrs. William N. Beach
 (cat. #27.1.5-77)

HEAD OF BED'S CREEK

 H. 9″; w. 11″
 oil on canvas, mounted on poster board
 signed, l.r.: "C. Rungius"
 Gift of: Mr. and Mrs. William N. Beach
 (cat. #27.1.2-141)

LOWER WATERFOWL LAKE (BED'S CREEK)

 H. 7¾″; w. 11″
 oil on canvas, mounted on poster board
 signed, l.r.: "C. Rungius"
 Gift of: Mr. and Mrs. William N. Beach
 (cat. #27.1.2-138)

MOOSE ON HIGH Fig. 269

 H. 32¼″; w. 46¼″
 oil on canvas
 signed, l.r.: "C. Rungius"
 Gift of: Mr. and Mrs. William N. Beach
 (cat. #27.1.5-59)

MOUNT ATHABASKA

 H. 50¼″; w. 60″
 oil on canvas, mounted on plasterboard
 signed, l.r.: "C. Rungius"
 Gift of: Mr. and Mrs. William N. Beach
 (cat. #27.1.2-145)

MULE DEER IN WOODS

 H. 25″; w. 30″
 oil on canvas
 signed, l.r.: "C. Rungius"
 Gift of: Mr. and Mrs. William N. Beach
 (cat. #27.1.5-60)

ON TOP OF THE WORLD

 H. 6½″; w. 57½″
 oil on canvas
 Gift of: Mr. and Mrs. William N. Beach
 (cat. #27.1.2-134)

This painting was once
framed as three separate
panels.

SIX STONE RAMS Fig. 266

 H. 25″; w. 30″
 oil on canvas
 signed, l.r.: "C. Rungius"
 Gift of: Mr. and Mrs. William N. Beach
 (cat. #27.1.5-67)

SPANIEL DICKEY WITH PHEASANT

 H. 16″; w. 14″
 oil on canvas
 signed, l.r.: "C. Rungius"
 Gift of: Mr. and Mrs. William N. Beach
 (cat. #27.1.5-64)

STONE RAMS AND TENT

 H. 12″; w. 20″
 oil on canvas
 signed, l.r.: "C. Rungius"
 Gift of: Mr. and Mrs. William N. Beach
 (cat. #27.1.2-137)

266.

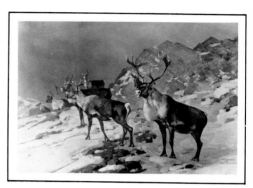

267.

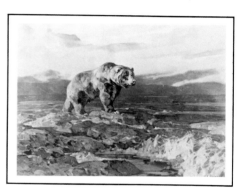

268.

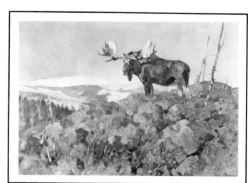

269.

TWO COWBOYS IN THE SADDLE

 H. 24″; w. 32″
 oil on canvas
 signed, l.r.: "C. Rungius"
 Gift of: Mr. and Mrs. William N. Beach
 (cat. #27.1.5-78)

UPPER BOW LAKE: UNDER BIG GOAT

 H. 9″; w. 11″
 oil on canvas, mounted on poster board
 signed, l.r.: "C. Rungius"
 on verso (in pencil): "Upper Bow Lake: Under Big Goat"
 Gift of: Mr. and Mrs. William N. Beach
 (cat. #27.1.5-65)

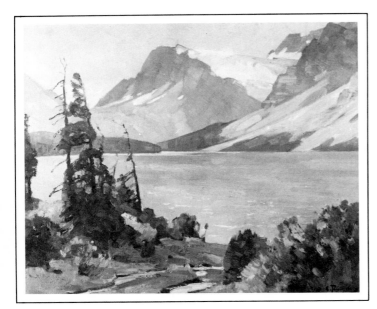

270.

CARIBOU'S DEATH STRUGGLE

Fig. 271

H. 30¼″; w. 46½″
oil on canvas
signed, l.r.: "C. Rungius"
Given in memory of Mr. and Mrs. Charles Sheldon by
members of the family, 1966
(cat. #27.1.5-46)

271.
Intertwined horns which inspired Rungius
to paint CARIBOU'S DEATH STRUGGLE,
Shelburne Museum Collection

Rungius, Carl

UPPER BOW LAKE

H. 7¾″; w. 11″
oil on canvas, mounted on poster board
signed, l.r.: "C. Rungius"
Gift of: Mr. and Mrs. William N. Beach
(cat. #27.1.2-139)

BOW LAKE, ALBERTA Fig. 270

H. 16″; w. 20″ 1923
oil on canvas
signed, l.r.: "C. Rungius"
on verso, on stretcher: "Bow Lake, Alberta/Feb. 1923"
Gift of: Mr. and Mrs. William N. Beach
(cat. #27.1.2-143)

Carl Rungius, born August 18, 1869 near Berlin, Germany serve
as a Prussian Cavalry Officer and studied at the German
Academy of Art with Paul Meierheim, a recognized wild life
painter before coming to the United States at the age of twenty
five. First in Wyoming, he settled in Banff, Alberta where he wa
to spend most of his life. In addition to painting, Rungius was a
sculptor and big game hunter. He hunted with President Theo-
dore Roosevelt, Charles Sheldon, and William N. Beach, using
the trophies shot by himself or his companions as models for h
paintings. He continued to hunt until late in life, shooting a grizz
bear at age seventy-eight. Between 1912 and 1935 he painted
twenty wild life scenes commissioned by the New York Zoologic
Society. In 1951 he participated in a wild life survey of Alaska
the United States Government, photographing wild animals fro
a helicopter. Rungius won great recognition from his painting,
cluding the National Academy of Design Prize, 1920; the Ellen
Speyer Memorial Award at the National Academy of Design ar
nual exhibition, 1925; the Carnegie Prize, 1926; the Saltus Priz
1929; and the Salamagundi Club's Vezin and Plimpton prizes.
1957 he went to New York City where he died at his easel two
years later. His Banff studio is today a museum dedicated to h
work.

Nearly all of these paintings were gifts to the Museum from
Marie and William N. Beach, long time friends of the artist. Th
paintings are on exhibit in the Museum's Beach Gallery, and
many of the Beachs' hunting trophies can be seen in the Beac
Lodge.

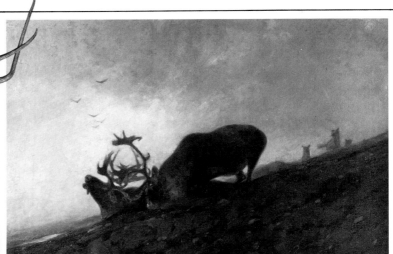

271.

Salmon, Robert (1775 – c. 1845)

SAILBOATS IN A STORM

H. 16¼″; w. 24½″ 1840
oil on wood
signed, on verso: "No. 38/Painted by R. Salmon./1840"
(cat. #27.1.4-46)

(This painting is no. 1038 on Salmon's list)

SHIPWRECK ON A ROCKY COAST Fig. 272

H. 16¼″; w. 24¾″ 1840
oil on wood
signed, on verso: "No. 46/Painted by R. Salmon./1840"
(cat. #27.1.4-48)

(This painting is no. 1046 on Salmon's list)

Robert Salmon, born in Whitehaven, England on November 5, 1775, was exhibiting at the Royal Academy by 1802, and was in Liverpool, producing about twenty canvases a year from 1806 to 1811. Between 1811 and 1822 he was in Greenock, Scotland, painting there and in the Firth of Clyde, among other locales. In 1822 he was in Liverpool, in 1825 in Greenock, in 1826 in London, Southampton, and North Schields, and travelled widely through England and Scotland. From mid 1826 to mid 1828 he painted 118 canvases, some of which were sold at auction a few years later in Boston, a city in which he arrived in August, 1828. Settling in South Boston, Salmon had a studio overlooking the harbor and painted theater backdrops, panoramas, and made sketches, paintings, and lithographs of local views plus remembered scenes in England. Most of his paintings involved the harbor scene he regularly viewed, leaving a vivid pictorial record of the variety of vessels which plied its waters. In 1839 he recorded his 900th painting on a list begun in 1806. His eyesight failing, Salmon had to curtail his activity as an announcement in the *Daily Advertiser* of July 16, 1840 indicates:
> Gentlemen wishing to possess pictures of Mr. Salmon, must improve this opportunity to purchase, as it is the last sale he will have of small paintings, his physicians having forbidden him to paint any small work.[1]

Salmon left Boston in 1842 and returned to Europe where he is known to have painted views of Venice and Palermo, possibly as late as 1845. He was to leave behind him a solid body of work which was to have lasting impact on America's marine painters.

[1] Quoted in John Wilmerding, *Robert Salmon, Painter of Ship and Shore* (Peabody Museum of Salem and Boston Public Library), p. 53.

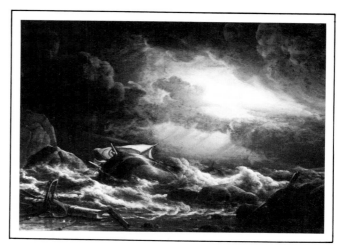

272.

Sanborn, Edward

FORT TICONDEROGA

H. 6½″; w. 9″ 1964
pencil on paper
(cat. #27.8-14)

SUGAR HOUSE

H. 6½″; w. 7½″
pen and ink on scratchboard
signed, l.r.: "EDWARD SANBORN"
(cat. #27.9-53)

COVERED BRIDGE

H. 8½″; w. 8¼″
pen and ink on paper
signed, l.r.: "EDWARD SANBORN"
(cat. #27.9-54)

UNITARIAN CHURCH, SUMMER

Fig. 273

H. 8⅞″; w. 6¾″
pen and ink on paper
(cat. #27.9-52)

THE WINTERBOTHAM HOUSE

H. 10⅞″; w. 9¾″
pen and ink on paper
(cat. #27.9-55)

UNITARIAN CHURCH, WINTER

H. 8⅜″; w. 6¼″
pen and ink on bristol board
signed, l.r.: "EDWARD SANBORN"
(cat. #27.9-45a)

INTERIOR OF A COUNTRY STORE

H. 6¼″; w. 5¾″
pen and ink on bristol board
(cat. #27.9-45b)

MOUNTAIN, COVERED BRIDGE, HOUSE AND SLEIGH

H. 8⅝″; w. 7″
pen and ink on bristol board
signed, l.l.: "EDWARD SANBORN"
(cat. #27.9-45c)

HOUSE AND BARN IN WINTER

H. 7⅜″; w. 7 3/16″
pen and ink on bristol board
signed, l.l.: "EDWARD SANBORN"
(cat. #27.9-45d)

MAILBOX AND HOUSE

H. 6½″; w. 6⅜″
pen and ink on bristol board
signed, l.r.: "EDWARD SANBORN"
(cat. #27.9-45e)

In addition to the pen and ink drawings listed above, the Burlington, Vermont artist Edward Sanborn has done a great many drawings for the Museum of its buildings and a great many individual objects in the collection. He illustrated *Life in the Colchester Reef Lighthouse,* and has made the drawing of the map in the Museum brochure.

Sauerwein, Charles D. (1839 – 1918)

WINE AND OYSTERS Fig. 274

H. 15″; w. 18¼″
oil on canvas
signed, l.r.: "C. D. S."
(cat. #27.1.3-11)

REVERIES OF A BACHELOR

H. 13″; w. 18″
oil on canvas
signed, l.r.: "C. D. S."
(cat. #27.1.3-10)

Relatively little is known of this still-life painter, Charles D. Sauerwein. He had a studio in Baltimore in 1857 and 1858, and in 1860 travelled to Europe where he married and remained for ten years. Returning to the United States in 1870, he settled in Baltimore where he undoubtedly knew Andrew John Henry Way (see p. 136). Both have painted oysters, and their work has a certain manly appeal. In 1880 Sauerwein was living in Red Bank, New Jersey, and he died in 1918, being buried in Baltimore.

274.

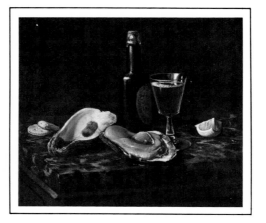

273.

Sawyer, Emily C.

WINOOSKI FALLS

Fig. 275

H. 6½"; w. 8¼"
pencil on paper
signed, l.r.: "Emily C. Sawyer"
Inscribed: "Winooski Mills — Woolen Factory and Flour Mill"
(cat. #27.8-64)

MANSFIELD MOUNTAIN

Fig. 276

H. 6½"; w. 8¼"
pencil on paper
signed, l.r.: "Emily C. Sawyer"
Inscribed, bottom: "Mansfield Mountain"
(cat. #27.8-64)

These two delicate but precise pencil drawings done in northwestern Vermont have been mounted together in one frame.

275.

27(

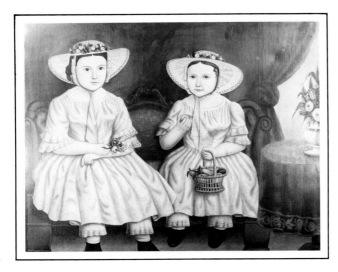

277.

278.

Schmid, Jean (active 1852)

ANDREW SISTERS

Fig. 277

H. 34"; w. 44" August, 1852
oil on canvas
signed, l.l.: "Peint par J. Schmid/August, 1852."
on verso, l.r.: "Peint Par/Jean Schmid/Rheinfelden 1852 1882"
 stencil: "WILLIAM & STEVENS/353/BROADWAY/NEW-YORK"
(cat. #27.1.1-61)

When Jean Schmid came from Rheinfelden, Switzerland to the United States is unknown. Records indicate that this painting wa once owned by a family named Sawyer from Newton, or Newto Center, Massachusetts.

Schmitt, Carl (1889 – ?)

SELF PORTRAIT

H. 24⅛"; w. 20"
oil on canvas
(cat. #27.1.1-111)

While this painting has been described by the former owner as being a self-portrait of "Carl Schmidt," it is probably rather "Ca Schmitt" of Norwalk, Connecticut. Born in Warren, Ohio in 188 Schmitt studied at the National Academy of Design and in Italy a the Solon Borgium. He exhibited frequently at the Carnegie Insti tute and has made contributions to several nationally known magazines.

Searle, Ronald (1920 –)

SUNDAY PAINTERS

Fig. 278

H. 13"; w. 15" c. 1959
pen and brown ink on paper
signed, l.l.: "Ronald Searle"
Gift of: Dr. and Mrs. Fletcher McDowell
(cat. #27.9-38)

This drawing was the original illustration for a book entitled *By Rocking Chair Across America*[1] by Alex Atkinson and Ronald Searle. A classic! Mr. Searle, born in Cambridge, England, has illustrated over forty books, including *From Frozen North to Filth Lucre*; *Searle's Cats*; *The Square Egg*; *The Great Fur Opera, A nals of the Hudson's Bay Company, 1670-1970*; and *The Addic A Terrible Tale*. He has also designed sets and costumes for films, has done illustrations for many American, French, and German magazines, and has produced his own cartoon entitle "John Gilpin."

[1] Alex Atkinson and Ronald Searle, *By Rocking Chair Across America* (New Yo Funk and Wagnalls, 1959), p. 25.

279.

Attributed to

Severance, Benjamin J. (active 1823)

BARNYARD COCK FIGHT Fig. 279

> H. 15"; w. 11" c. 1860
> oil on canvas
> signed, l.r.: "B. J. S./N.Y."
> (cat. #27.1.7-1)

Benjamin J. Severance is known to have settled in Northfield, Massachusetts in 1823. A general and fancy painter, his work included Masonic paintings, carriages, signs, portraits, overmantels, and landscapes. From this inscription he must have also been in New York.

harp, James (active 1867)

OWERS AND BUTTERFLY Fig. 280

H. 32½" middle and 25¾" each end; w. 52¾" (arch shaped design) 1867
oil on wood
signed, l.r.: "Jaˢ Sharp Pinˑ/Watertown 1867"
(cat. #27.1.3-18)

James Sharp, a Boston artist who exhibited at "Simple ttage Scene" at the Boston Athenaeum in 1831 is pos-ly the same person as James Clement Sharp (1818-97), a Boston lithographer and science teacher. ether he is the painter of this unusually shaped canvas, ich was probably used as a head or foot board for a bed, unknown. James Clement Sharp, born in 1818 in Dor-ester, Massachusetts, was the son of Edward and Mary arp and elder brother of the painter William C. Sharp. mes Sharp was doing lithography in Boston in the early 40's but is absent from directories until 1866 when he is ed as a teacher of natural sciences.

280.

81.

283.

282.

Attributed to

Sharples, James (c. 1751 – 1811)

FATHER Fig. 281

> H. 9⅝"; w. 7½" (oval) 18th c.
> pastel on paper
> (cat. #27.3.1-41a)

MOTHER Fig. 283

> H. 9⅝"; w. 7⅝" (oval) 18th c.
> pastel on paper
> (cat. #27.3.1-41b)

DAUGHTER Fig. 282

> H. 9½"; w. 7½" (oval) 18th c.
> pastel on paper
> (cat. #27.3.1-41c)

These three portraits are probably the work of James Sharples. An Englishman, Sharples (c. 1751-1811) came to America in the 1790's with his third wife, Ellen Wallace, and their two children, James and Rolinda. Traveling with his son by his second marriage, Felix Thomas, a carriage designer, Sharples began a trip through New England into the South doing pastel and oil portraits, primarily in profile. Between 1797 and 1798 he was living in New York and in 1801 returned to Bath, England. In 1806 Felix and James, Jr. returned to America, followed by their parents and Rolinda in 1809. Mrs. Sharples and the children apparently helped with the pastels and did their own and copied each other's works. In addition modern copies exist of these competently done portraits. After Sharples' death in 1811, Mrs. Sharples and her two children returned to England while Felix remained in America.

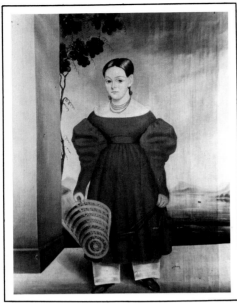

Attributed to

Sheffield, Isaac (1798 – 1845)

MISS WHITE OF GROTON, CONNECTICUT

Fig. 284

H. 47″; w. 36″ c. 1835
oil on canvas
(cat. #27.1.1-115)

Isaac Sheffield, a native of Guilford, Connecticut, was a portrait and miniature painter in Guilford, Stonington, and New London, Connecticut, where he specialized in portraits of sea captains, their wives and children. He settled in New Haven about 1835 and worked there until his death in 1845.

284.

Shoffstall, Donald

BLUEBILLS FLYING OVER LANDSCAPE

H. 21½″; w. 14½″ October, 1971
watercolor on paper
Gift of: the artist, 1971
(cat. #27.2.5-12)

Shoumatoff, Elizabeth (1888 –)

PORTRAIT OF ELECTRA HAVEMEYER WEBB

Fig. 285

H. 18¼″; w. 15½″ 1964
watercolor on paper
signed, l.r.: "Elizabeth Shoumatoff"
(cat. #27.2.1-28)

This portrait of the co-founder of the Museum was copied by Mme. Shoumatoff from a portrait of Mrs. Webb which she had previously painted for Mrs. Electra Webb Bostwick. Of Russian descent, the artist was painting a watercolor portrait of President Franklin Delano Roosevelt in Warm Springs, Georgia, when he suffered his fatal stroke on April 12, 1945.[1]

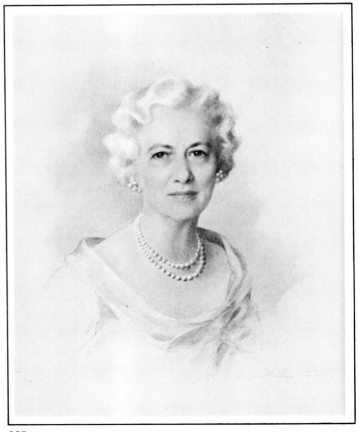

285.

[1] James MacGregor Burns, *Roosevelt, the Soldier of Freedom,* 1940-1945 (New York: Harcourt Brace Jovanovich, Inc., 1970), pp. 599-600.

Sieleinas, or Siekinas, A. (active 1865)

AMERICAN PADDLE STEAMBOAT *JOSEPHINE*

Fig. 286

H. 14½"; w. 20½" c. 1865
watercolor on paper
signed, l.r.: "Sketched by A. Sieleinas" (or Siekinas)
(cat. #27.2.4-4)

This is a view of another JOSEPHINE (see p. 194).

Simpson, Maxwell Stewart (1896-)

ASA CHEFFETZ (1896 – 1965)

H. 11½"; w. 8½" 1919
oil on canvas
Gift of the Artist, 1970
(cat. #27.1.1-180)

Born in Elizabeth, New Jersey, the son of Dr. and Mrs. Maxwell Gayley Simpson, Maxwell Stewart Simpson studied at the National Academy of Design from 1914 to 1918 where he became a close friend of the subject of this painting, Asa Cheffetz. He took a landscape class at the Art Students League in 1916, and with Cheffetz, studied etching with Auerbach Levy in 1917. In 1919 Simpson and Cheffetz shared a studio on the second floor of a building at 17 East 15th Street, New York City, where this portrait was done. After working as a farm hand in New York state, Simpson went to Paris in 1923, went on to Italy, and returned to Paris in 1924 where he exhibited at the Paris Spring Salon. He was in London and Oxford in 1924, returning to the United States later that year. In Paris again in January of 1929, Simpson returned to New York City where his first one man show was held at the Dudensing Gallery in October, 1930. In 1936 he had a studio in Elizabeth, New Jersey, taught at the Newark School of Fine and Industrial Arts from 1936 to 1946, and in 1948 purchased a farm on the Raritan Road near Scotch Plains, New Jersey where he continues to paint. He has won many awards, including the Speyer Award of the National Academy in 1953 and the Grumbacher Award of the National Arts Club of New York in 1957. His friend Asa Cheffetz was an extraordinary wood engraver, primarily making prints of New England landscapes. Cheffetz lived most of his life in Springfield, Massachusetts where his widow still resides. A large collection of his engravings, a gift to the Shelburne Museum from Maxwell Simpson, is on display in the Webb Gallery. The Museum also has an etching of Cheffetz by Simpson.

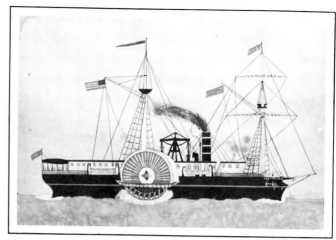

286.

Sloane, Eric (1910 –)

COVERED BRIDGE OVER GREEN RIVER, VERMONT

Fig. 287

H. 24"; w. 31"
oil on masonite
signed, l.r.: "Eric/Sloane"
Inscribed: "Eric/Sloane/_____/Brookfield/Conn."
Exhibited: Rutland Art Gallery, November, 1966
(cat. #27.1.2-119)

EARLY TOBACCO BARN TYPES

H. 13"; w. 9⅝"
pen and ink on paper
Inscribed: a) 1859 New England
 b) Open Log Barn, Va.
 c) "Top hat" barn, N. Carolina (two drawings)
 "Rainhood" and "Open vent"
Gift of the Artist
(cat. #27.9-59)

Born in New York City in 1910, Eric Sloane received his training at the Art Students League, New York City; the School of Fine Arts, Yale University; and the New York School of Fine and Applied Arts. He has written and illustrated such well-known books as *Our Vanishing Landscape, A Reverence For Wood, American Barns and Covered Bridges, The Seasons of America Past,* and *Return to Taos.* He was television's first weatherman, has written books on meteorology, built the "Hall of Atmosphere" in the American Museum of Natural History, and established a Museum of Early American Tools in Kent, Connecticut. In 1965 he won the Leadership Award of the Freedoms Foundation. He resides today in Cornwall Bridge, Connecticut.

287.

Sixth Grade, C. P. Smith School, Burlington, Vermont

MURAL OF THE SHELBURNE MUSEUM

H. 6'; w. 11'
pencil, ink, and crayon on paper
Gift of: C. P. Smith Sixth Grade, 1969
(cat. #27.8-9)

This large mural, created by the Sixth Grade of the C. P. Smith School in Burlington, Vermont in 1969, was presented by the class to the Shelburne Museum. Under the direction of their teacher, Jeffery D. Buehner, each child helped to design, draw, and color the mural, inspired by their fall visit to the Museum. The mural, incorporating many of the buildings at the Museum plus objects in its collection, helped the children to utilize their knowledge of social studies and geometry in a visual way. In addition the students presented the Museum with a proclamation expressing their hope that the Museum would some day have an exhibit area in which student work might be displayed.

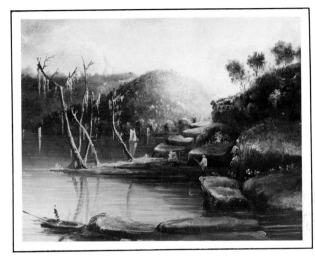

288.

Smith, S. R.

WATCHING FOR THE NEW YEAR

H. 8⅝"; w. 6⅜"
pencil on yellow paper
signed, l.r.: "S. R. S."
(cat. #27.8-13)

From this tentative drawing it is difficult to draw any conclusions as to the identity of S. R. Smith. Several American artists had these initials.

Stacy, William Corning (1836 – 1919)

THE STEAMYACHT *ELFREIDA* ON LAKE CHAMPLAIN

Fig. 289

H. 15"; w. 25" 1894
oil on canvas
signed, l.r.: "W. C. Stacy, 94"
Gift of: Frederick P. Smith, 1958
(cat. #27.1.4-32)

The ELFREIDA belonged to William Seward Webb and is shown anchored near the family's summer home in Shelburne, Vermont. It was named after his wife Eliza (Lila Vanderbilt Webb) and his daughter, Frederica. The artist, William Corning Stacy, was born in 1836 in Burlington, Vermont and studied art in Providence, Rhode Island. He painted the Vermont state Coat-of-Arms which hung for many years over the Speaker's chair in the House of Representatives. Most of his life was spent in Burlington where he died in 1919, and many of his paintings are in the possession of Burlington's older residents.[1]

[1] This information came from the donor's father, Levi P. Smith, Sr., in a letter of February 24, 1961, Shelburne Museum MSS.

Smith, John Rowson (1810 – 1864)

THE EVENING Fig. 288

H. 8¾"; w. 11¼" 1837
oil on wood
signed, l.r. (on rock): "J R Smith 1837"
on verso: "The Evening/J R Smith
(cat. #27.1.2-77)

John Rowson Smith, born in Boston in 1810, was a fourth generation painter; his great-grandfather, Thomas Smith of Derby, England was a landscape painter; his grandfather, John Raphael Smith was a mezzotint engraver; and his father, John Rubens Smith (under whom he studied in Brooklyn and Philadelphia) was a portrait, miniature, and topographical painter, engraver and lithographer. Smith became a theatrical scene painter and after 1832 was in Philadelphia, New Orleans, St. Louis, and other cities. By the late 1830's he was painting panoramas, the largest of which, LEVIATHAN PANORAMA OF THE MISSISSIPPI RIVER, was four miles long when finished in 1844. He exhibited it in this country and abroad in 1848, earning about $20,000 in six weeks.

Sprague, Huldah M.

MOURNING PICTURE TO NATHANIEL AND LYDIA SIMMONS

H. 14⅝"; w. 17½" 1838
watercolor on paper
signed, bottom: "huldah M. Sprague, N. Marshfield, 1838"
Inscribed on pedestal of urn: "In Memory of/Nathaniel Simmons, who died/in Duxbury, Jan
22nd, 1834. Aged 79 y./and/Lydia Simmons, who died in/Dux
Nov. 29th 1829. Aged 68."

(cat. #27.2.6-29)

In this mourning picture for her great-grandparents, Huldah Sprague has cluded her house in Duxbury, Massachusetts. The memorial includes the lowing poem:

Come weeping friends, your flowing tear refrain
None can escape from death's dread, vast domain,
Hush every murmur, check each rushing sigh,
Remember all are mortal, born to die.

289.

Stanton, Samuel Ward (1870 – 1912)

FLYERS OF THE HUDSON: STEAMBOATS
*ROBERT FULTON, MARY POWELL,
HENDRIK HUDSON* AND *ALBANY*

Fig. 290

H. 18″; w. 48″
oil on canvas
(cat. #27.1.4-83)

290.

S. Ward Stanton, born in Newburgh, New York in 1870, made a great many clear and accurate sketches of American steamboats which were published in *American Steam Vessels,* published in New York in 1895. Many of his works were copied from the paintings of James Bard (see pp. 26-27) whose obituary he undoubtedly wrote for *Seaboard* magazine, April 1, 1897. The Museum has a lithograph of this painting by Stanton of the same title and inscribed: "Hudson River Day Line between New York and Albany." Stanton died on the TITANIC in 1912.

Steere, William T.

THE NARROWS, LAKE GEORGE

Fig. 291

H. 12¼″; w. 15¾″ c. 1860
charcoal on paper
signed, l.r.: "William T. Steere"
(cat. #27.3.2-9)

Probably based upon a print, the original source for this landscape is possibly an oil by the French painter Victor de Grailly entitled LAKE GEORGE.[1]

[1] Old Print Shop *Portfolio* (New York, September, 1952) p. 7.

Stevens, O.

MISS MINDWELL CASWELL

Fig. 292

H. 8¾″; w. 7⅜″
pen and ink and watercolor on paper
Signed and inscribed at bottom: *MISS MINDWELL CASWELL"*
 Merit for amiable behavior and good
 improvement in school
 May friendly Angels their kind wings
 display,
 And be your guide in every dangerous way;
 In every state most happy may you be
 And when far distant sometimes think of me.
 O. Stevens

?? among them each man recived (sic) 1332
?? what was the sum of money taken 5
 6660
(cat. #27.9-5)

This charming watercolor not only praises this little girl, but it includes an arithmetic lesson.

292.

Stock, Joseph Whiting (1815 – 1855)

JANE HENRIETTA RUSSELL Fig. 246

 H. 48"; w. 36¼" 1844
 oil on canvas
 signed, on verso, under relined canvas: "By J W Stock/1844"
 Inscribed, l.r.: "JANE HENRIETTA RUSSELL"
 (cat. #27.1.1-129)

This portrait was painted after Jane's death, and she appropriately holds *A Child's Pictorial Bible.*

BOY IN BLUE DRESS WITH WHIP AND DOG Fig. 293

 H. 45"; w. 36" c. 1842-45
 oil on canvas
 (cat. #27.1.1-50)

In Springfield, Massachusetts in 1815 the fourth of thirteen children was born to John and Martha Whiting Stock. Paralyzed from the hips down on April 9, 1826, Joseph Whiting Stock described the accident:

 My brother, Isaac, Philos B. Tyler and myself were standing near the body of an ox-cart which leaned against the barn . . . when suddenly I perceived it falling which, instead of endeavoring to avoid, I attempted to push it back, and was crushed under it.[1]

In 1832 his physician Dr. Loring encouraged Stock to study art, and he received instructions from Francis White, a student of Chester Harding. Four months later he painted his sister Eliza. For the next two years he did fifty-one paintings "of which more than half were copies"[2] and in 1836 began anatomical drawings for a Dr. Swan who invented a wheel chair for Stock. In 1836 he painted 143 portraits, usually charging $8.00. On January 1, 1839 Stock badly burned himself, and shortly after was operated on for an infected hip, preventing his painting for six months. For the next several years he painted in Warren and Bristol, Rhode Island, New Bedford, New Haven, Providence, and Springfield, and in 1846 established a partnership with O. H. Cooley, a daguerreotypist in Springfield. He later worked in Port Jervis, New York. His last entry in his diary was August 4, 1845 at which time he had listed 912 portraits. His health began to deteriorate around 1850, and in 1855 he died of tuberculosis.

 ───────────
 [1] James Lee Clarke, Jr. "Joseph Whiting Stock," The Magazine *Antiques* (August, 1938), p. 83.
 [2] *Ibid*.

293.

294.

THE HUNTER'S DILEMMA

Fig. 294

 H. 33¾"; w. 44¼" 1851
 oil on canvas
 signed, l.r.: "A. F. Tait. 1851"
 Gift of: William H. Scoble, Esq., 1961
 (cat. #27.1.5-32)

Tait, Arthur Fitzwilliam (1819 – 1905)

MINK TRAPPING PRIME Fig. 245

 H. 20¼"; w. 30¼" 1862
 oil on canvas
 signed, l.r.: "A. F. Tait/1862"
 Gift of: Richard H. Carleton in Memory of Mr. and Mrs. P. H. B. Frelinghuysen, 1969
 Exhibited: Adirondack Museum, summer, 1974
 (cat. #27.1.5-50)

A rare Currier and Ives print, MINK TRAPPING PRIME 1862 was done from this painting. An earlier, and slightly different oil version, entitled MINK TRAPPING IN NORTHERN NEW YORK,[1] was completed, according to Tait's diary, on January 29, 1862 and the Museum's painting about six months later.[2]

 ───────────
 [1] MINK TRAPPING IN NORTHERN NEW YORK is in the Munson-Williams-Proctor Institute in Utica New York (oil on canvas, 20¼ × 30¼" Signed, l.r. "A. F. Tait/N.Y. 1862").
 [2] Letter from Edward H. Dwight, Director of Munson-Williams-Proctor Institute, January 7, 1971, Shelburne Museum MSS.

YOUNG QUAIL

 H. 8"; w. 12¼" 1864
 oil on academy board
 signed, l.l.: "A F Tait/1864"
 on verso (label): "YOUNG QUAIL AND BUTTERFLY"
 Gift of: Dr. and Mrs. E. William Davis, 1964
 (cat. #27.1.5-36)

RACQUETTE LAKE

 H. 30¼"; w. 50"
 oil on canvas
 signed, l.r.: "A. F. Tait"
 on verso (label): "Racquette Lake/by/Arthur F. Tait."
 Given in memory of Mr. and Mrs. P. H. B. Frelinghuysen by Mrs. Frederica Emert, George G. Frelinghuysen, P. H. B. Frelinghuysen, and H. O. O. Frelinghuysen, 1963.
 (cat. #27.1.5-33)

Tait exhibited a painting entitled RACQUETTE LAKE, IN THE ADIRONDACKS, at the National Academy in 1873 may well be this painting.

DEER FAMILY

 H. 13½"; w. 22" 1877
 oil on wood
 signed, l.l.: "A. F. Tait./N.Y. 1877"
 Inscribed on verso: "N⁰ 38./A. F. Tait./Y.M.C.A./23-St/N.Y."
 (Label): "Prepared Panel/Winsor & Newton/Artist Colourmen/To Her Majesty/and to/T. R. H. The Prince and Princess of Wales/88, Rathbone Place, London"

 (cat. #27.1.5-23)

295.

THE OLD PIONEER: UNCLE DAN AND HIS PETS Fig. 295

H. 20"; w. 30¼" 1878
oil on canvas
signed, l.r.: "A. F. Tait/N.Y. 1878"
on verso: " 'The Old Pioneer', 'Uncle Dan & his pets'/Long Lake/Hamilton Co/N.Y. by/
 A. F. Tait./Y.M.C.A./23ˢᵗ NY"
Given in memory of Mr. and Mrs. P. H. B. Frelinghuysen by their children, 1963.
Exhibited: Adirondacks Museum, summer 1974
(cat. #27.1.7-22)

PORTRAIT OF A STAG

H. 30"; w. 25" 1880
oil on canvas
signed, l.l.: "A. F. Tait/1880/NY"
on verso (stencil): "WILLIAMS & STEVENS/ 353/BROADWAY/NEW YORK"
Gift of: Harry Havemeyer Webb, 1958
(cat. #27.1.5-39)

CAPTAIN PARKER, THE ARTIST'S ABLE ADIRONDACK GUIDE FOR
TWENTY YEARS

H. 36"; w. 24" 1881
oil on canvas
signed, l.l.: "A. F. Tait/NY./81"
on verso: "E. M./Study from Nature/A. F. Tait/1881" and "Adirondacks/Capt. Parker/my
 able Guide/for 20 years/Long Lake/Hamilton Co./N.Y."
Given in memory of Mr. and Mrs. P. H. B. Frelinghuysen by their children
Exhibited: Adirondack Museum, summer, 1974
(cat. #27.1.5-34)

Born in 1819 near Liverpool, England, Arthur Fitzwilliam Tait as a youth
worked for a picture dealer in Manchester, practiced drawing, and
copied works at the Royal Institution. As he grew older, he taught draw-
ing and lithography, assisted a firm of ecclesiastical architects, and in
1845 published a folio volume of panoramic railroad views. Coming to
New York City in 1850, he soon established a studio in the city and a
camp in the Adirondacks where he vacationed for many years, fre-
quently accompanied by Captain Parker, (see above). Occasionally he
collaborated in his work with James M. Hart (1828-1901) and other ar-
tists. A painter of animals and the out-of-doors, Tait sold many of his
paintings to Currier and Ives to be made into prints, the most popular
probably being AMERICAN FOREST SCENE — MAPLE SUGARING.
These reproductions frequently dissatisfied him as he felt they inter-
fered with his painting sales. His last years were spent in Yonkers and
New York City where he painted pastoral scenes and animals. A large
collection of his work was on exhibition at the Adirondack Museum, Blue
Mountain Lake, New York in the summer of 1974.

296.

Taylor, George A. (active early twentieth century)

ARTILLERIE — SVF, CORP DE 400 and ARTILLERIE,
SOMME, SEPT. 15.

H. 12⅛"; w. 9 15/16"
watercolor on paper & pencil on paper
Inscribed, below (in pencil): "Artillerie — SVF, Corp de 400"
 "Artillerie, Somme, Sept. 15"
(cat. #27.2.6-27)

Both of these works are on a single sheet of paper. Signed on the mat is
the inscription: "To Major J. Watson Webb 365th F.A., from George L.
Taylor, Colonel 365th F.A." The artist served with Major Webb in France
during World War I.

Taylor, A. J. (active 1855)

...ON WITH LANDSCAPE Fig. 296

H. 18"; w. 22" August, 1855
calligraphic steel pen drawing on paper
signed and inscribed, l.c.: "Executed with the pen of A. J. Taylor"
Inscribed, u.l. (in pencil): "Aug 1855"
(cat. #27.9-30)

Taylor, Elizabeth Edith (1875 – 1938)

...TLE BOY WITH BALL Fig. 297

H. 3⅝"; w. 2⅞"
watercolor on paper
signed, l.l.: "Edith Taylor"
(cat. #27.1.1-178)

...N WITH CENTER PART IN HIS HAIR

H. 3½"; w. 3"
watercolor on paper
(cat. #27.1.1-179)

...th Taylor was from Bristol, Vermont where she spent
...st of her childhood and her final years. Born in Middle-
...y, she began painting as a child and was an avid read-
... particularly of English history. After marriage and di-
...ce, Mrs. Taylor moved to New York City before 1920
...ere she continued to paint, undoubtedly with some ad-
...onal training. In the late 1920's and early 1930's she
...d and painted in Pensacola, Florida, thereafter return-
...to Bristol, Vermont to care for her aging parents. She
...d in Bristol in 1938.[1]

...nformation from Mrs. Helen Williams, Charlotte, Vermont, who is a de-
...dant of the artist.

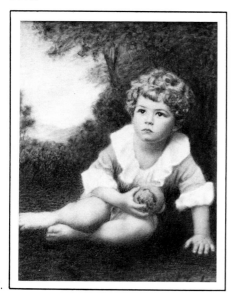

297.

131

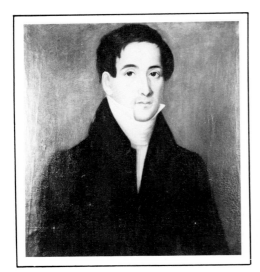

298.

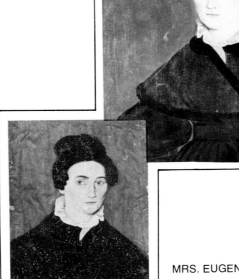

299.

Attributed to

Teft, Mrs.

EUGENE F. WARNER (c. 1800-after May 1, 1872)

Fig. 298

H. 25¼"; w. 24⅛"
oil on canvas
(cat. #27.1.1-48)

299.
Daguerreotype of
Minerva Clark Warner

299.

MRS. EUGENE (MINERVA CLARK) WARNER

Fig. 299

H. 28"; w. 24"
oil on canvas
(cat. #27.1.1-49)

Eugene Warner of Whitehall, New York, was the s●
of Gideon Warner who migrated from northern to
southern Vermont and later to Champlain, New
York. Gideon was half-brother to Seth Warner, or
of the Green Mountain Boys. In the Museum's Co●
lection there is a daguerreotype of Minerva Clark
Warner from which her portrait appears to have
been done. Since her portrait is somewhat larger
and is proportioned differently than Eugene's, it i●
probable that the pair were painted at different
times. Nevertheless, the artist, believed to be a M●
Teft of Whitehall, has attempted to unite them by
painting the backgrounds identically.

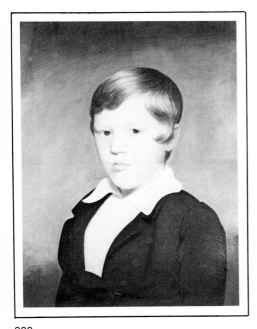

300.

Attributed to

Thompson, Cephas (1775 – 1856)

MASTER PAGE

Fig. 300

H. 22½"; w. 18" c. 1825
oil on canvas
Gift of: Dr. and Mrs. Fletcher McDowell 1958
(cat. #27.1.1-31)

When this painting was acquired, pasted to the back of its
stretcher was a tag inscribed "Master Page, circa 1825,
Josephus Thompson, Middleboro, Massachusetts." It is
now believed to be the work of Cephas Thompson (1775-
1856). A native of Marlboro, Massachusetts, Thompson
was largely self taught. His successful career as a por-
traitist took him to the South in the winter where there are
records of his being in Baltimore in 1804, Charleston in
1804, 1818, and 1822, Richmond in 1809 and 1810, and
New Orleans in 1816. In 1806 he received a patent for a
delineating machine for copying charts, landscapes and
profiles. After 1825 he remained in Middleboro, Mas-
sachusetts until his death in 1856. His three children,
Cephas Giovanni, Jerome B., and Marietta were all artists,
as was his brother Arad.

Thrall, R. P.

MINNIE FROM THE OUTSKIRTS OF THE VILLAGE

Fig. 301

H. 27¼"; w. 19¼" 1876
oil on canvas
signed, l.l.: "By R. P. Thrall/1876
(cat. #27.1.5-9)

When Mrs. Webb first looked at this painting, she
exclaimed with humor what the title now proclaims.
The former owner said that Thrall came from near
Woodstock, New York.

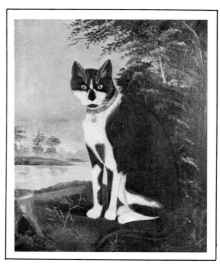
301.

Tucker, Jane L. N.

THE WORLD Fig. 302

H. 20½"; w. 15½" c. 1830
ink and watercolor on paper
Inscribed and signed, in arch at bottom: "EXECUTED/BY/JANE L.N.
 TUCKER,/RADOLPH (sic).
 VERMONT/UNDER THE
 DIRECTION/OF M. L. KIMBALL"
 (cat. #27.2.6-4)

This example of school girl art combines a geography lesson with
an imaginative use of local scenes and decorative elements.
Double hemispheres of the world are framed by columns, each
sprouting large, lush, flower bearing vines. The village depicted
below includes houses, an elaborate public building with an out-
sized weathervane, a school, and a church.

302.

…hill, Abraham G. D. (1776 – 1843)

…NJAMIN WEST (1738 – 1820)

H. 28"; w. 21¾" c. 1798
oil on wood
on verso (note): "Benjamin West/Painted from
 life/By his pupil/Abraham G.
 D. Tuthill" (in old brown script)
 and "Probably/about
 1798/while studying with West
 in London" (in blue ink)
(cat. #27.1.1-63)

THE ARTIST'S WIFE

H. 28"; w. 22" c. 1825
oil on wood
on verso (note): "Portrait of his/wife by A. G. D.
 Tuthill/about 1825."
(cat. #27.1.1-66)

…OVERNOR DEWITT
…LINTON (1769 – 1828)

H. 30"; w. 25" c. 1825
oil on canvas
on verso (note): "Portrait of Dewitt ? Clinton by
 Abraham G. D. Tuthill —
 painted/from life about 1825"
(cat. #27.1.1-64)

THE DOCTOR: (DR. THOMAS VAIL,
MIDDLEBURY, VERMONT?)

H. 30"; w. 25"
oil on canvas
(cat. #27.1.1-110)

Known for generations as simply "The
Doctor," this portrait is probably of
Tuthill's sister Bethia's husband, Dr.
Thomas Vail.

…OVERNOR CLINTON

Fig. 303

H. 91"; w. 67½" c. 1825
oil on canvas
on verso (note): "painted from life by Tuthill"
(cat. #27.1.1-69)

…is huge, full figure portrait of Gover-
…r Clinton shows him at the opening of
… Erie Canal, Lockport, New York, in
…25.

SELF PORTRAIT

H. 20"; 25½" c. 1840
oil on canvas
on verso (note): "Self portrait of Abraham/G. D.
 Tuthill/painted probably/about
 1840"
(cat. #27.1.1-65)

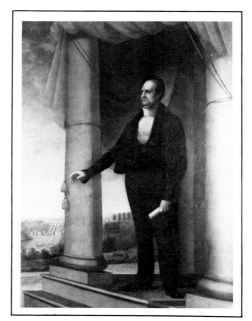
303.

Born in Oyster Pond (now Orient) Long Island to John and Elizabeth Dominy, Abraham Gulielmus
Dominy Tuthill was probably a student of Benjamin West in London about 1798 and followed that
study with a year in Paris. Returning to New York where he painted from 1808-1810, Tuthill moved
to Pomfret and Middlebury, Vermont about 1815. For the next ten years he travelled considerably
— in 1820 in Plattsburgh, New York, in 1822 in Buffalo, and in 1825 in Detroit, Michigan, after
which he returned to Buffalo. In 1827 he was in Rochester, New York, in 1831 in Cincinnati, Ohio,
and back in Buffalo between 1837 and 1840. Tuthill's last years were spent with a sister, Mrs.
Joshua Y. Vail, in Montpelier, Vermont, from whose great-great granddaughter these paintings
were acquired.

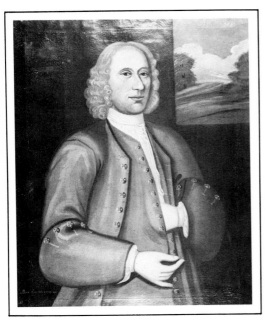

304.

Attributed to

Vanderlyn, Pieter (1687 – 1778)

COLONEL JACOBUS VAN SLYKE (1704 – 1771?) Fig. 304

H. 39½"; w. 31½" c. 1735
oil on canvas
Inscribed, l.l.: "Born. May: 26 1704 —"
Exhibited: Springfield Art Museum, September 1935
 Dartmouth College, October, 1935
 Vassar College, March, 1938
 Downtown Gallery, "American Ancestors" November, 1938
 Bennington College October, 1938
 University of Michigan, May, 1940
 Rochester Memorial Art Gallery, April, 1943
 Grand Rapids Art Museum, April, 1943
 Downtown Gallery, California branch, June, 1946
(cat. #27.1.1-9)

To ascribe a portrait with any certainty to Pieter Vanderlyn (vander Lyn as he spelled it) i
difficult since no signed paintings of his have ever been found. The fact that he painted
certain portraits has been handed down verbally, as in this case, and from a biography o
his grandson (the painter John Vanderlyn) written by Robert Gosman. In this biography
Gosman describes going with John to see a painting by John's grandfather, Pieter. Tha
painting was almost certainly MRS. PETRUS VAS (ELSIE RUTGERS) now in the Albani
Institute of History and Art. Several other portraits resemble these and have traditionall
been attributed to Vanderlyn including those of ANTHONY VAN SCHAICK and his wife
MARGARETA VAN VECHTEN, and MATTHEW TEN EYCK. A comparison of Shel
burne's portrait of Jacobus Van Slyke with the others reveals certain stylistic
similarities, particularly with the portrait of Mrs. Vas. The handling of the sleeve
fabric and features are particularly alike.[1]

Pieter Vanderlyn's career has been largely traced through records of marriages, birth
baptisms, and property transfers. Born in Holland in 1687, he served in the Dutch Navy
the African coast and immigrated to New York City from Curacoa in the Dutch West Indi
by 1718. He married twice — Gerritje Van den Berg in 1718 and Geertruy Vas in 1722. I
1730 he was appointed Fire Warden of the second ward in Albany, and by 1738 was a
private in the Kingston Militia. After a fire in Kingston in 1777, the ninety year old Vander
lyn lived with his son Jacobus in Shawagunk, New York.

Jacobus Van Slyke, portrayed here, was born May 26, 1704 and married Cathlyna,
daughter of Samuel Bratt on September 2, 1732. He was commanding officer at Schene
tady in 1754, and a member of the Assembly in 1750 and 1771.

[1] However similarities can be seen with several other early Dutch portraits — see MRS. HENRY VAN
RENSSELAER by Gerardus Duyckink I (?) c. 1732, New-York Historical Society, illustrated in Belknap, op. c
Plate XXIX, 28B; or WYANT VAN ZANDT and MRS. WYANT VAN ZANDT, c. 1725, New-York Historical So
ety, Belknap, op. cit., Plate LXII, 3 and 4. Ona Curran attributes Shelburne's portrait to the Van Epps Limne
see "Schenectady Ancestral Portraits", (Schenectady County Historical Society, September, 1966), X, No.

Attributed to

Waldo, Samuel Lovett (1783–1861)

FIGURE OF A MAN

H. 21"; w. 6"
pencil on paper
Gift of: Mrs. Alice Dibble, 1960
(cat. #27.8-7)

(Preliminary sketch for a portrait).

MILITARY OFFICER

H. 9¼"; w. 8"
pencil on paper
Gift of Mrs. Alice Dibble, 1960
(cat. #27.8-6)

(Preliminary drawing for a portrait).

MRS. ELIZABETH TYLEE MAPES Fig. 305

H. 30"; w. 25" c. 1825
oil on canvas
on verso (stencil): "Prepared by/Theo Kelley Rear 35¹ Wooster S./New-York"
(cat. #27.1.1-166)

GENERAL JONAS MAPES (1768 – 1827) Fig. 306

H. 30"; w. 24" c. 1825
oil on wood
(cat. #27.1.1-165)

305. 3

The paired portraits of Jonas and Elizabeth Mapes have been attributed to Samuel Lovett Waldo, the son of Esther Stevens and Zacheus
Waldo, born in Windham, Connecticut in 1783. At sixteen Waldo went to Hartford, Connecticut to study drawing and painting under
Joseph Steward a retired minister in the old Museum Hall. By 1830 Waldo was painting portraits, moved briefly to Litchfield, and was then
persuaded to move to Charleston, South Carolina for three years by the Hon. John Rutledge. In London in 1806, Waldo roomed with
Charles Bird King and was befriended by Benjamin West and John Singleton Copley. Returning to the United States in 1809, Waldo
established a studio in New York City, but travelled frequently to Hartford and once visited Alabama. Hiring the carriage painter William
Jewett to help him grind colors, Waldo began training him. They formed a partnership which was to last forty years. Waldo was Director
of the Academy of Fine Arts in 1817 and was an associate of the National Academy from 1840 to 1861. (cont.)

Waldo's wife, Deliverance Mapes, was a niece of Jonas Mapes (the daughter of Jonas' brother, James Hawkins Mapes). Another pair of portraits of Jonas and Elizabeth Mapes, nearly identical to these, is in the possession of other descendants of the Mapes family as are portraits of Jonas and Elizabeth's son, James Jay Mapes, and his wife Sophia Furman. All four of these portraits, and Shelburne's portrait of Jonas, were painted on wood of nearly equal dimensions and are attributed to Waldo. Elizabeh Tylee Mapes' portrait at Shelburne is painted on canvas and is one inch wider than the others. Shelburne's pair of portraits came originally from Mrs. Webb's great grand-mother, Adeline Deliverance Mapes Waldron, a daughter of Jonas and Elizabeth.

Jonas Mapes was born in Southhold in 1768. In New York City by nineteen, Jonas rapidly rose to prominence, commanding forces to defend the city during the War of 1812. He became a Major General in 1816. His wife Elizabeth was the daughter of James Tylee, who was imprisoned by the British in the Old Bridewell prison at the time of the Revolution.

307.

Walker, Emma (c. 1850 – 1937)

PAINTING OF THE STATE HOUSE OF VERMONT

Fig. 307

H. 9½"; w. 13¾" c. 1880
oil on academy board
On verso (label): "Academy Board, Frost & Adams,
Importers of Artists Tube Colors,
etc./37 Cornhill and 32 Brattle
St./BOSTON"
Gift of: Joseph Winterbotham, 1949
(cat. #27.1.2-126)

Emma Walker, a native of Montpelier, Vermont, married Lavenssler Walker, who, with his brother K. B. Walker, owned a stone cutting business in downtown Burlington. K. B. Walker was later the first manager of the Howard Opera House. Emma was apparently self-taught but enjoyed painting very much. Her paintings, and the African violets which she raised, adorned her Victorian parlour on both her South Willard Street home, and later, her Maple Street home in Burlington. This painting was done looking east along the Winooski River toward the State House.

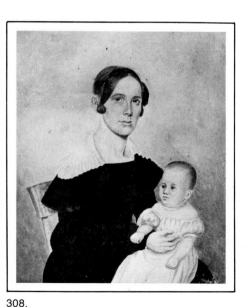

308.

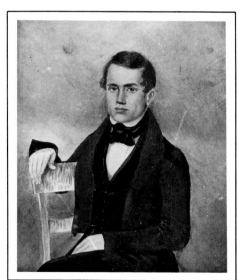

309.

Attributed to

Walton, Henry (1804 – 1865)

MOTHER AND INFANT IN A CHAIR

Fig. 308

H. 6⅜"; w. 4⅞" c. 1840's
watercolor on paper
(cat. #27.2.1-26)

MAN IN A TIGER-MAPLE CHAIR

Fig. 309

H. 6⅜"; w. 4⅞" c. 1840's
watercolor on paper
(cat. #27.2.1-25)

Henry Walton was born in 1804, probably the son of Judge Henry Walton (1768-1844) of New York City, Ballston Spa, and Saratoga Springs, New York.[1] Among Walton's earliest works are lithographs of Flat Rock Springs, a pagoda, and the Pavilion Hotel in Saratoga, built by the Judge. Apparently he studied architectural draftsmanship, possibly in England, and by 1836 had settled in the Finger Lakes region of New York state. In addition to lithographs of towns, Walton painted portraits in Ithaca, Elmira, Big Flats, and Painted Post, New York, and Addison and Athens, Pennsylvania. His portraits are all very literal and extraordinarily detailed. In 1851 he joined the gold rush to California where he did at least two lithographs of that state. Both he and his wife, Jane Orr, are buried in Cassopolis, Michigan, where Walton probably moved about 1857.[2]

[1] Leigh Rehner, "Henry Walton, American Artist," The Magazine Antiques, March, 1970, p. 414.
[2] Ibid.

Washburn, S. H.

FALLS AT VERGENNES, VERMONT

Fig. 238

H. 29"; w. 41" c. 1875 – 1876
oil on canvas
signed, l.l.: "S. H. Washburn"
Gift of: Clement Hurd
(cat. #27.1.2-4)

S. H. Washburn is listed in *Walton's Register* as a
Vergennes painter in 1875 and 1876. One of the fac-
tory tradesigns in this painting advertises
"Washburn Paint Shop". The print, illustrated here,
depicts nearly an identical scene.[1]

[1] Lithograph of J. L. Giles & Co., No. 111 Nassau St., New York,
published by Sidney M. Southard, "Vergennes, Vt." Dated 1881.

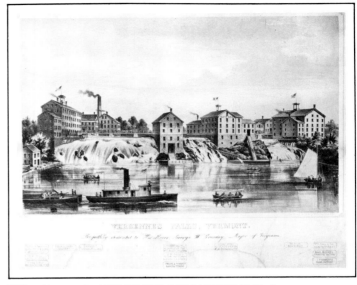

310. Lithograph of VERGENNES FALLS VERMONT, Shelburne
Museum Collection

Way, Andrew John Henry (1826 – 1888)

ALE AND OYSTERS WITH A SLICE OF LEMON Fig. 311

H. 11"; w. 9"
oil on canvas
signed, l.l.: "A J H Way"
(cat. #27.1.3-12)

Born April 27, 1826 in Washington, D.C., Andrew John Henry
Way was a student of John Peter Frankenstein in Cincinnati
about 1847 and in the late 1840's studied with Alfred Jacob Miller
in Baltimore. Between 1850-1854 Way studied in Paris and Flor-
ence and in the latter year returned to Baltimore, painting minia-
tures and portraits and eventually turning to still-lifes upon the en-
couragement of Emanuel Leutze. In the Philadelphia Centennial
of 1876 two panels of grapes by Way were given medals for "ex-
cellence in still-life". William Gerdts and Russell Burke, comment-
ing on another Way oyster still-life, observe that he "concerns
himself with the succulence of the meat on the nearly pearly oys-
ter shell. He included the lemon that would flavor the oyster, thus
emphasizing the edible meal and not the accessories."[1] Shel-
burne's painting is probably OYSTERS AND ALE which Way
exhibited at the National Academy of Design in 1883 where his
address is listed as 99 N. Charles Street, Balimore. He died in
that city five years later.

[1] OYSTERS, (1872, private collection) in William H. Gerdts and Russell Burke,
American Still-Life Painting (Washington: Praeger Publ., 1971) p. 72.

311.

Webb, Grace

TICONDEROGA COMING TO SHELBURNE

H. 15"; w. 22" March 12, 1955
watercolor on paper
signed, l.r.: "Grace Webb/3-12-55/c/GAW"
(cat. #27.2.4-7)

Grace Webb has painted this attractive watercolor of the TICON-
DEROGA being moved to the Shelburne Museum in 1955. She is no
relation of the Webb family who founded the Museum.

Webb, H. T.

LADY, AGE FORTY-THREE

Fig. 312

H. 29¾"; w. 25¾" 1838
oil on canvas
signed, l.l.: "AE 43/1838"
on verso: "P. by H. T. Webb/1838"
(cat. #27.1.1-77)

GENTLEMAN, AGE FORTY-SIX

Fig. 313

H. 29¾"; w. 24¾" 1838
oil on canvas
signed, l.r.: "AE. 46/1838"
on verso: "Pt. by H. T. Webb/1838"
(cat. #27.1.1-76)

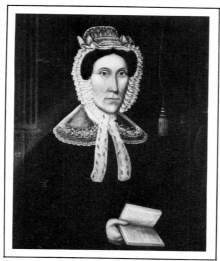

312.

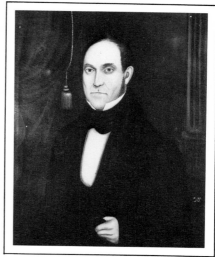

313.

H. T. Webb is known to have been in Wilton, Connecticut in 1840.

West, William Edward (1788 – 1857)

WILLIAM CONNER OF LINDEN (NATCHEZ) MISSISSIPPI

Fig. 314

H. 11¼"; w. 9½" 1818
pastel on paper
on verso: "Wm. Conner, father of Wm. Carmichael Conner, grandfather
 of L. P. Conner, Sr., great grandfather of L. P. Conner III of
 Clover Nook."
(cat. #27.3.1-14)

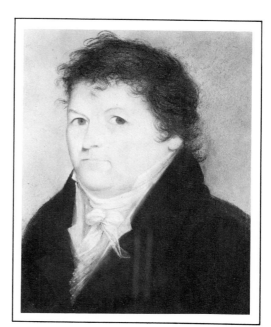

314.

A native of Lexington, Kentucky, the portraitist William Edward West was born in 1788 and received his first training with Thomas Sully in Philadelphia in 1807. He remained in Philadelphia until 1818 when he moved to Natchez, Mississippi where this portrait was drawn. The following year he left Mississippi for Italy where he spent the next four years, during which time he painted portraits of such notables as Lord Byron and Percy Bysshe Shelley. From Paris where he spent a year in 1824, West went to London where he established a studio from 1825 to 1838. In the latter year he lost a great deal of money from an unfortunate investment which forced him to return to the United States. He had a studio in Baltimore until moving to New York City in 1841, painting portraits there until 1855. Retiring to Nashville, Tennessee, West spent his last years painting and died in 1857.

Whistler, James Abbott McNeill (1834 – 1903)

THE GREEK SLAVE GIRL

Fig. 315

H. 10¼"; w. 7⅛⅛"
pastel on paper
signed: butterfly
On verso: "46Y"
Exhibited: Copley Society, Boston Memorial Exhibition of the
Works of Mr. Whister, 1905
Metropolitan Museum of Art, summer, 1961
Knoedler Gallery, 1966
(cat. #27.3.1-40)

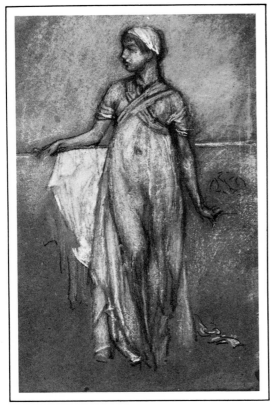

315.

Gregarious, quarrelsome, witty and extravagant, James Abbott McNeill Whistler was easily bored, little disciplined, but completely dedicated to his art. While claiming birth in Baltimore to bolster his social pretensions, Whistler was actually born in Lowell, Massachusetts in 1834, the son of Mr. and Mrs. George Washington Whistler. As his father, an engineer, supervised the construction of the Moscow to St. Petersburg Railroad for Czar Nicholas I, Whistler spent his formative years in Russia but returned to the United States following his father's death in 1849. Entering West Point in 1851, Whistler showed his characteristic distaste for regimentation. He left without graduating after three years, finding employment as a draftsman in the Coast and Geodetic Survey. Except for the experience he gained in this job in etching, Whistler found little challenge and after three months was to leave for Paris where he was to spend the next five years beginning in 1855. There he was to meet the greatest artistic minds of this time — Degas, Mallarmé, Pissaro, and Debussy, but by 1859 Whistler moved to London where his greater social status better satisfied his aristocratic taste. First living with his brother-in-law Sir Seymour Hayden, Whistler then shared a studio with George DuMaurier, ultimately settling in Chelsea. Except for occasional trips to the Continent, Whistler never left England. While in conflict with such English art critics as John Ruskin, Whistler won recognition for some of his work. His THE WHITE GIRL, rejected by the Salon in 1863, hung in the Salon des Refuśes where it was enthusiastically received. His well known etchings of the Thames and Venice earned him great respect, and in 1884 he was elected a member of the Royal Society of British Artists, becoming its President two years later. He was also the first President in 1898 of the International Society of Sculptors, Painters, and Gravers, and won several honors abroad, — the most important perhaps, (through the negotiations of Clemenceau and Mallarmé) was the acquisition of PORTRAIT OF THE PAINTER'S MOTHER for the Luxembourg Museum. Shelburne's pastel was probably done in the late 1860's or early 1870's when Whistler did a series of studies of classical figures, inspired by both Tanagra statuettes and the Elgin marbles at the British Museum.

315.

Cover of *Art and Art Critics* by Whistler, inscribed to Louisine Havemeyer by the author, Shelburne Museum Collection

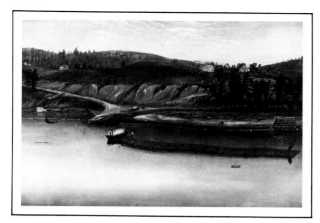

316.

hitefield, Edwin (1816 – 1892)

ROM BURLINGTON, VERMONT, LOOKING ACROSS AKE CHAMPLAIN Fig. 317

H. 6⅞"; w. 9⅞"' 1852
watercolor on paper
signed, l.l.: "E. Whitefield"
Inscribed, u.r.: "From Burlington, Vermont, Looking Across Lake Champlain"
(cat. #27.2.2-9)

orn and trained in England, Edwin Whitefield first studied both law and medicine to please his parents before turning to painting. In America by 836, he spent the next two years painting views of Hudson River Valley states. In 1844 he was in New York City and the following year illus- ated *American Wild Flowers In Their Native Haunts* by Emma C. Em- ury. One year later the first of his well known large folio views of North merican cities were lithographed by Endicott. On April 15, 1852 hitefield described in his diary a trip to Montreal by way of Burlington, t. Albans, and Rouse's Point.[1] This watercolor was undoubtedly done n this trip. By November of that year he was in Canada where he taught chool, marrying one of his pupils, Lillian Stuart of Blair Athol, Scotland. ontinually on the move, Whitefield moved west through Illinois and wa and into Minnesota. There in 1856 he and twenty companions or- anized the Kandiyohi Town Site Co. and staked out several towns. For e next several years Whitefield wrote articles for *Harper's* and the ew York Times to foster migration to these towns. Continuing his avels, Whitefield moved about the United States and Canada, sketch- g and drawing homes for inclusion in three volumes entitled *The omes of Our Forefathers*, the first volume published in 1879. On a final ip to England he began a similar series on old houses in England and cotland, which unfortunately was never published.

[1] His diary is owned by his descendants Miss Flora M. Ramsay and Mrs. Frances C. Bond.
ef: *M.&M. Karolik Collection of Watercolors and Drawings*, Vol. I, p. 304.

318.

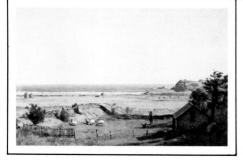

319.

Whitaker, William

LOG RAFTING

Fig. 316

H. 14½"; w. 22" 1871
oil on canvas
signed, on verso: "Painted by Wm. Whitaker/1871"
(cat. #27.1.2-28)

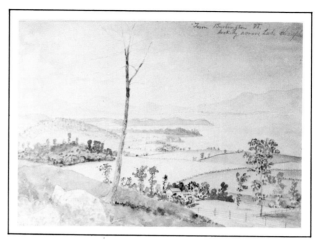

317.

Whittredge, Thomas Worthington (1820 – 1910)

MOUNT STORM PARK, CINCINNATI Fig. 318

H. 11"; w. 14¾" 1840
oil on academy board
on verso: "The City of Cincinniati (sic) for M. George Schoenbingers Deer/Park, painted on the ground in 1840/by W. Whittredge, N. A./(July 24, 1905)."
Exhibited: "The Best of Shelburne" IBM Gallery November-December, 1964.
(cat. #27.1.2-75)

This is a study for a larger painting in the Worcester Museum of Art, Worcester, Massachusetts and came from the collection of Miss Olive Whittredge, the artist's daughter, who wrote the inscription on the back of the canvas.

VIEW NEAR NEWPORT, RHODE ISLAND Fig. 319

H. 15"; w. 22½"
oil on canvas
signed, l.r.: "W. Whittredge"
(cat. #27.1.2-74)

Thomas Worthington Whittredge was born in 1820 near Spring- field, Ohio and by 1837 was in Cincinnati where he painted houses, signs, and began painting a few portraits. In Indianapolis in 1842, his brief endeavor as a photographer ended in failure, as did his attempts at portraiture in West Virginia the following year. Turning to landscape painting, Whittredge met greater success and began exhibiting at the National Academy by 1846. With the financial backing of some supporters, Whittredge went to Europe in 1849 where he remained ten years. From London, Belgium, and Paris he went to Germany where he spent three years study- ing under Karl Lessing. During this period he and several other Americans posed for Emanuel Leutze's second version of WASHINGTON CROSSING THE DELAWARE. In 1854 Whit- tredge travelled with Albert Bierstadt on a sketching trip to Westphalia (see p. 29) and spent the next five years in Rome where he was associated with George Loring Brown, Frederic Edwin Church, and Sanford R. Gifford. Returning to America in 1859 Whittredge visited Newport and Cincinnati and then estab- lished a studio in the Tenth Street Building in New York City which he maintained until 1880. He again exhibited at the National Academy in 1861, serving as its President between 1874-1877. In 1865-1866 he, along with Sanford Gifford and John F. Kensett, accompanied Major General Pope from Kansas to the Rockies, the first of three western trips he was to make. Marrying a Miss Foote of Geneva, New York in 1867, Whittredge afterwards painted landscapes in Newport, the north shore of Mas- sachusetts, Lake George, and the Catskills. In the 1880's he built a house in Summit, New Jersey where he spent his last years.

320.

320.

Photograph of Dr. William Seward
Webb with James Watson Webb

Wolcott, H. (?) C.

THE GAINSBOROUGH HAT

Fig. 320

H. 10″; w. 7¾″ 1955
oil on canvas
signed, l.r.: "H. (?) C. Wolcott"
(cat. #27.1.1-183)

This portrait of J. Watson Webb, Sr. was done from a photograph taken when he was about four years old.

Attributed to

Wollaston, John (active 1736 – 1767)

MRS. WILLIAM (CLARA WALKER) ALLEN (1737 – ?)

Fig. 321

H. 36″; w. 30½″ c. 1767
oil on canvas
Gift of: Edmund Ashley Prentis, 1956
(cat. #27.1.1-42)

John Wollaston was born in England, possibly the son of J. or T. Wollaston, and "had some instruction from a noted drapery painter in London."[1] In New York in 1749 Wollaston produced about 300 paintings before departing for London where he spent the years 1752 and 1753 and married the daughter of an official of the British East India Company. Back in the United States, Wollaston painted portraits in and around Annapolis in 1753 and 1754, in Virginia in 1755 and 1757, and in Philadelphia in 1758. In March, 1759, he was on his way to India as a writer for the British East Indian Company and between 1760 and 1765 served as a magistrate in Calcutta. Probably by 1766 Wollaston was in Philadelphia, Maryland, and Virginia and painted twenty portraits in Charleston, South Carolina in 1767, after which he returned to England. Wollaston's portraits are easily recognized. As Jules David Prown has remarked, his sitters "appear as if they were all relatives too closely inbred by the artist's brush."

Two other portraits of Mrs. Clara Allen, both by John Hesseilus, are in existence.[2] The daughter of John and Catherine Yates, Clara Walker Allen was born September 7, 1737. She was the first wife of William Allen whose home, Claremont, was on the James River in Virginia.

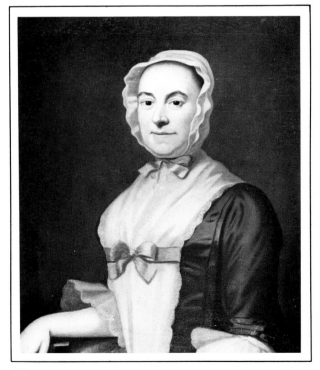

321.

[1] Letter of Charles Willson Peale to Rembrandt Peale, 1812, quoted in Virgil Barker, *American Painting* (Bonanza Books, 1960), p. 113.

[2] One is owned by the Detroit Institute of Arts and the other by the Brooklyn Museum. Both are illustrated in Waldron P. Belknap, *op. cit.*, Plate XXII, 18D and 18E.

Wood, Thomas Waterman (1823 – 1903)

SISTERS NELLIE A. AND ANNA MARIE SMITH

H. 36"; w. 29" October, 1864
oil on canvas
signed, l.c.: "T. W. Wood/1864"
On verso (note): "Nellie A. ? Smith./Born Nov. 16 1857.? Died Jan. 21,
 1864./Anna Maria Smith./Born Oct. 15 1859./Died April
 30 1863./Painted Oct. 1864."
(cat. #27.1.1-164)

These portraits, as is obvious from the inscription, were
painted after the girls' deaths. The artist, Thomas Water-
man Wood, was born in Montpelier on November 12, 1823,
the son of a cabinet maker. Wood began his career in his
father's shop, designing and constructing furniture and
began studying painting with Chester Harding in Boston
between 1846 and 1847. Three years later he married
Minerva Robinson of Waterbury, Vermont and began build-
ing "Athenwood", his home on a southern hill overlooking
Montpelier where he was to summer for the rest of his life.
In the spring of 1852 the Woods moved to New York City
where for the next three years Thomas was to paint por-
traits. He was persuaded to go to Quebec City in 1853 for a
short time and later to Kingston and Toronto, where he re-
ceived commissions for portraits. In 1855 the Woods
moved to Washington, D.C., the following year to Balti-
more, and in August, 1858 headed for Europe where
Thomas spent most of his time in Paris, copying old mas-
ters in the Louvre and Luxembourg Museums. Returning to
the United States and settling in Nashville, Tennessee in
the fall of 1859, Wood moved to Louisville, Kentucky in
1862 where he remained for four years, gradually turning
more and more to genre painting. In the fall of 1866 he
moved to New York City where he became President of the
American Water Color Society in 1878, Vice President of
the National Academy in 1879, and ultimately President of
the National Academy in 1891. As a final and permanent
gesture, Wood established the Wood Gallery in Montpelier
in 1895, displaying his copies of old masters, the paintings
of his contemporaries, and his own work.

322.
Cover of *American Artist* magazine, September, 1942.
Courtesy of the publication.

Wyeth, Andrew (1917 –)

SOARING Figs. 240 and 322

H. 48"; w. 87" 1950
tempera on masonite
signed, l.r.: "Andrew Wyeth"
(cat. #27.2.5-3)

The painter Andrew Wyeth hardly needs introduction. Born in Chadds Ford, Pennsylvania where he continues to paint, Wyeth is the son of
the noted painter and illustrator Newell Convers Wyeth under whom he began study as a child. He later studied at the Pennsylvania
Academy of Fine Arts. The Wyeths' summer home is in Cushing, Maine where some of Andrew's most well-known paintings have been
done. In commenting on his father's influence on and criticism of his work, Wyeth mentioned SOARING:

"One painting I did — which he didn't like — was a pair of turkey vultures. I was looking down on them from above with the fields of a
farm far below. As a kid I used to lie on my back in the fields in March and April, when you get those turkey vultures here, and find
myself looking up and wondering how it would look looking down. I did the painting long before I went up in a plane. But my father
disliked it." [1]

In the cover illustrated here, Wyeth is shown with a drawing for this work. "With a wingspread of nearly five feet, it is the exact size of
the live bird, — native in the Brandywine Valley — which was kept in his studio for a week or more during his process of study." [2] In
commenting about his favorite medium, egg tempera, Wyeth remarked:

"I learned that medium from Peter Hurd, my brother-in-law. He taught me everything about the medium: mixing the emulsion and
adding the dry pigments. . . I paint on masonite panels — pressed wood — which have been coated with four or five coats of gesso, a
mixture of Permalba and gelatin glue, and then sanded. It's the same surface the Florentines used, except they used live boards,
which aren't really as good as what we have, since they dry out eventually and crack. The tempera itself, the pigment, takes about six
months to dry, so that its adhesion to the coated panel, as you can imagine, is really tough. You know the way egg sticks on a plate if
you leave it for a while? Well, that's why we use it, except that the egg color disappears. It's a remarkable medium. Not for everyone,
of course. . . Tempera's more the quality of . . . a hornet's nest, or a beehive — almost a dusty beauty." [3]

[1] George Plimpton and Donald Stewart, "An Interview With Andrew Wyeth," *Horizon*, The Magazine of the Arts (September, 1961) © Copyright 1961 by American Heritage Pub-
lishing Co., Inc.
[2] "Andrew Wyeth, One of America's Youngest and Most Talented Painters," *American Artist*, September, 1942, Volume 6, No. 7, p. 24.
[3] Plimpton and Stewart, *op. cit.*

323. TINKLE

ANONYMOUS PAINTINGS

YOUNG BLAKE

Fig. 324

H. 29¾"; w. 23⅞" c. 1830
oil on canvas
Exhibited: California Palace of the Legion of Honor, San Francisco
Santa Barbara Museum of Art, Santa Barbara, California
"Painting Today and Yesterday in the U.S.A."
(cat. #27.1.1-5)

This portrait was found in Massachusetts.

324.

25. 326.

BURBRIDGE, WILLIAM (– 1837)

Fig. 325

H. 25¾"; w. 21"
oil on canvas
(cat. #27.1.1-53)

BURBRIDGE, SUSAN (– 1836)

Fig. 326

H. 25¾"; w. 21"
oil on canvas
(cat. #27.1.1-54)

These two portraits, found in Bardstown, Kentucky, depict both of the sitters in mourning attire. Little is known of either of them except that William died on May 9, 1837 and Susan on December 9, 1836. Both portraits show a strong relationship with the work of the Kentucky painter Patrick Henry Davenport, a native of Danville.[1]

[1] See the portraits of Mrs. Isaac Shelley and Dr. Ephraim McDowell, illustrated in William Barrow Floyd's "Portraits of Ante-bellum Kentuckians", The Magazine Antiques, April, 1974, pp. 811 and 816; and Edna Talbott Whitley, Kentucky Ante-Bellum Portraiture (National Society of Colonial Dames in America in the Commonwealth of Kentucky, 1956) pp. 162 and 519.

King Charles I of England (1600 – 1649)

Fig. 327

H. 14¼"; w. 10½" c. 1649
reverse oil painting on glass
(cat. #27.11-4)

Depicted in the hat with a jeweled headband which he wore at his trial in 1649, King Charles I in this reverse painting on glass assumes a dignified pose. The portrait, based on an oil painting by Edward Bowers, was undoubtedly copied from a mezzotint after Bowers published by Robert Preece. This print, widely distributed among Loyalist homes, was apparently copied many times. A needlepoint version entitled "The Royal Martyr King Charles I of Blessed Memory" is on exhibit in the American Wing of New York's Metropolitan Museum.[1]

[1] Metropolitan Museum, New York, New York (catalogue #38.95).

327.

CHURCH, ALFRED

Fig. 329

H. 3"; w. 2½" 1839
watercolor and pencil on paper
Inscribed, bottom: "Alfred Church, taken 1839. Age, 27"
Gift of: Mrs. Ruth Lanphear, 1956
(cat. #27.2.1-34)

HOAG, SARAH ANN

Fig. 328

H. 3"; w. 2½"; c. 1839
watercolor and pencil on paper
Inscribed, center top: "Sarah Ann Hoag, Age 25."
Gift of: Mrs. Ruth Lanphear, 1956
(cat. #27.2.1-33)

These two carefully painted portraits tell a poignant story. Sarah Ann Hoag, a nurse at her Uncle Sam's sanitarium, was engaged in 1839 to Alfred Church. A week before the wedding Alfred died. Sarah later married Thomas Marshall and lived in a large brick house in Victory Mills, New York. Another pair of portraits, painted by the same artist in the same year, is in the Abby Aldrich Rockefeller Folk Art Collection in Williamsburg, Virginia,[1] while a second pair is part of the M. & M. Karolik Collection of the Museum of Fine Arts, Boston.[2]

<hr>

[1] See "Harry A. Morehouse and Helene Ann Park", in Nina Fletcher Little's *The Abby Aldrich Rockefeller Folk Art Collection, A Descriptive Catalogue* (Boston: Little Brown & Co., 1957), #71 and #245.
[2] "Mr. and Mrs. Miles Reed", in *M. & M. Karolik Collection of American Watercolors and Drawings, 1800-1875* (Boston: Museum of Fine Arts, 1962), V. II, p. 120, #1091.

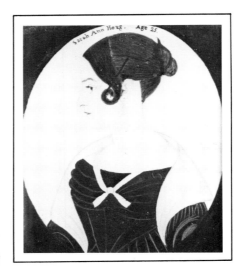

328.

329.

330.
Jonas Clark's
Inventory

CLARK, GENERAL JONAS, JR. (1774 – 1854)

Fig. 330

H. 27"; w. 25¾" c. 1826
oil on canvas
(cat. #27.1.1-70)

330.

330. Home of Jonas and Betsey Clark, Middletown Springs, Vermont. Photograph by Herbert Wheaton Congdon, courtesy of Special Collections, University of Vermont

CLARK, MRS. BETSEY STODDARD (1783 – 1872)

Fig. 331

H. 28½"; w. 26" c. 1826
oil on canvas
(cat. #27.1.1-71)

From the Clark family register, now in Shelburne's collection, one learns that Jonas Clark, Jr. was born to Jonas Clark and Avis Dodge Clark on December 30, 1774. Moving from Canterbury, New Hampshire to Middletown Springs, Vermont with his father at age sixteen, young Jonas learned the mason's trade while studying law at night. With his wife Betsey Stoddard whom he married September 30, 1799, Jonas raised three sons: Merritt, born in 1803; Horace, born in 1807; and Charles, born in 1817. Jonas served Middletown with distinction — as State's Attorney for Rutland County for sixteen years; Representative of Middletown for eighteen years; Brigande Major and Inspector of the Second Brigade, Second Division, of the Vermont State Militia in 1814; Justice of the Peace for forty years; and Democratic candidate for Governor of Vermont in 1849.[1]

The Clark home in Middletown Springs, built in 1814, appears in Herbert Wheaton Congdon's *Old Vermont Houses*. Betsey "refused to have her portrait painted unless she was shown holding the good book, otherwise folks would have thought her too vain."[2] Her Bible is in the Museum collection, along with an inventory of the Clark estate which lists, among other things, "1 large invalid's cradle" such as can be seen in the attic of the Museum's Dutton House.

<hr>

[1] Abby Maria Hemenway, *Vermont Historical Gazeteer* (Claremont, New Hampshire: The Claremont Manufacturing Co., 1877), III, pp. 824-825.
[2] Information from Mrs. Florence Dale Clark, wife of the Clark's great grandson, Shelburne Museum MSS.

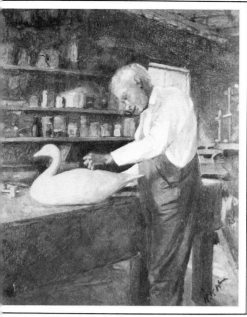

2.

K (?), H.

A. ELMER CROWELL CARVING

Fig. 332

H. 13¾"; w. 11"
oil on academy board
signed, l.r.: "H. K _____(?)"
Gift of: Mrs. Stuart Crocker, 1966
(cat. #27.1.5-49)

This painting of the famous decoy and miniature bird carver A. (Anthony) Elmer Crowell was done by an artist whose signature cannot be deciphered. A large collection of Mr. Crowell's carvings is in the Museum's Dorset House.

DAVIS, JAMES OF YARMOUTHPORT, MASSACHUSETTS

H. 7¹/₁₆"; w. 4⅝"
ink, wash, and pencil on paper
on verso (label): "James Davis, Sen./Yarmouthport, Mass."
(cat. #27.9-58)

This rather clumsily drawn portrait depicts a man of firm resolve and strong character.

FIFTEEN GIRLS AND SCHOOLMARM (MISS DONOVAN'S FIFTH GRADE)

Fig. 333

H. 10¾"; w. 15⅝"
watercolor cut-outs pasted on posterboard
on verso: "Margaret Donovan/Helen Keller/Miss Kimball/?/Ella Burlingame/Nora Broderick/Helen Brown/Laura Goodwin/Mary Chesley/Nellie Sullivan/May Morrill/Corine Hale/Margaret Weld/Jessie Burpee/Annie Marston/Miss Baker"
(cat. #27.2.1-27)

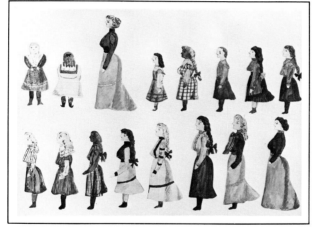

333.

OTY, CAPTAIN SAMUEL

Fig. 334

H. 47¼"; w. 35¼" c. 1735
oil on canvas
(cat. #27.1.1-134)

ccording to the book *Doten-Doty Family in America,*
en Captain Doty's house in Saybrook, Connecticut was
n down "all the old papers and documents were de-
oyed but oil paintings of Capt. Doty and his daughter-in-
w which, in a very dissipated state, were preserved. The
rtraits, renovated and renewed are now [1897] in the
ssession of Reverend William D'Orville Doty of Roches-
r, New York. The one represents a fine portly gentleman
the costume of the time, holding in his hand a letter
ich is directed to 'Philip Thomas, merchant, Barbados'.
open window shows a bark under full sail. The other
inting is that of Mrs. Margeria Parker Doty, the wife of his
n Samuel."[1]
While the former is undoubtedly the portrait now at Shel-
rne, the location of the daughter's portrait is unknown.
ptain Doty's pose, with one hand holding a glove, first
peared in portraits by Titian during the Renaissance and
s popularized by English and Flemish portraitists in the
venteenth century. This anonymous artist probably
opted the pose from an English mezzotint, a practice in
nerican portraiture used by even such competent
inters as John Singleton Copley and Robert Feke.

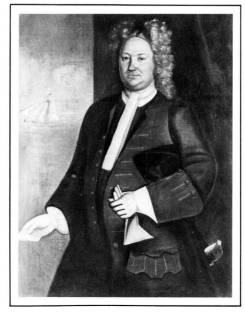

Letter from Roswell B. Whidden, Old Saybrook Historical Society, Old
ybrook, Connecticut, April 5, 1969, Shelburne Museum MSS, from a book
blished by Ethan Allen Doty in 1897. The inscription on the letter in the
ptain's hand is no longer legible.

334.

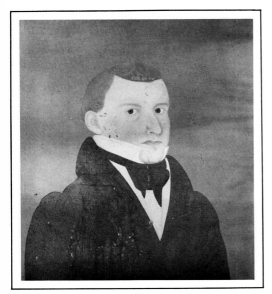

335.

DURKEE, WILLIAM H. HARRISON OF TUNBRIDGE, VERMONT

Fig. 335

H. 26″; w. 24″ c. 1840
oil on canvas
(cat. #27.1.1-41)

William Durkee of Tunbridge, Vermont was made Second Lieutenant of the First Company of Riflemen, Sixth Regiment, First Brigade, Fourth Division of Vermont in June of 1834 and elected Captain in October of the following year. His documents of appointment, signed by Governor William A. Palmer (see p. 73) are in Shelburne's collection, as is his regimental flag which hangs in the Charlotte Meeting House. This portrait, wrapped in newspapers marked "Grandfather Durkee", was found among the belongings of Durkee's granddaughter, Josie Heath, of Royalton, Vermont.

335.
Military appointment of
William Durkee, Shelburne
Museum Collection

335. Regimental flag of William Durkee, Shelburne Museum Collection

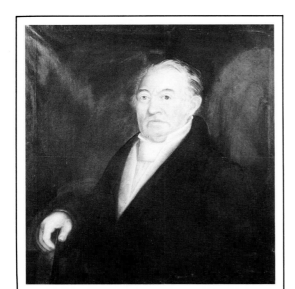

336.

HARRINGTON, JOSEPH, OF SHELBURNE, VERMONT (1772 – 1846)

Fig. 336

H. 38¼″; w. 36½″
oil on canvas
Gift of the estate of Emily Hough
(cat. #27.1.1-43)

The son of Jeremiah Harrington and his second wife, Mary Randall McReay, Joseph Harrington was born in Providence, Rhode Island on June 24, 1772. In 1790 at the age of eighteen, he journeyed to the newly settled land of northern Vermont, joining his father and half-brothers, William and Benjamin, on Shelburne (then Pottiere's) Point where they had built a "block house" in 1784. In 1794 Joseph married Edatha Blish and five years later began clearing land for a farm two miles south of the village of Shelburne. After Edatha's death, Joseph married Elinore Wooster of Charlotte, Vermont on January 20, 1821. Joseph had nine children by his first wife and two by his second. He is buried in Burlington's Elmwood Cemetery, having died in December of 1846.

HENRY, PATRICK (1736 – 1799)

Fig. 454

H. 33½″; w. 23¼″
oil on canvas
(cat. #27.1.1-24)

This portrait and its companion, PENNSYLVANIA DUTCH LADY,[1] were once in the collection of the Polish sculptor Elie Nadelman. Coming to America in 1914, Nadelman and Mrs. Joseph A. Flannery (whom he married in 1919) amassed a most significant collection of American Folk Art and were among the first to exhibit this work, in their home at Riverside-on-Hudson. While extremely flatly done, this portrait is unusually strong and decorative.

[1] Now in the Karolik Collection of the Museum of Fine Arts, Boston. Henry married twice — Sarah Shelton in 1754, and after her death, Dorothea Dandridge in 1777. This portrait is probably meant to depict the latter.

337.

HOGEBOOM, (?)

Fig. 337

H. 36½"; w. 27½" 1797
oil on canvas
on verso (label in brown script): "Mrs. (?) De Wimple Vroman, afterwards Mrs. Gen.[1] David Thomas, daughter of Judge Stephen Hogeboom. This portrait was painted January 1797 — in Claverack, Columbia Co., New York."

(cat. # 27.1.1-8)

While long believed to be Catherine Hogeboom Webb, second wife of Samuel Blachley Webb, the old label on the new stretcher of this portrait suggests that it may be one of her sisters. The daughter of Judge Stephen Hogeboom, the portrait's subject is undoubtedly Mary Hogeboom Thomas, who with her husband David, cared for the orphaned James Watson Webb (see pp. 41, 101, 152) after his parents' deaths (Catherine's in 1805 and Samuel's in 1807).

OWARD, SALLY OF GRANTHAM, EW HAMPSHIRE

Fig. 338

H. 30½"; w. 26"
oil on canvas
(cat. # 27.1.1-35)

OWARD, SAMUEL OF GRANTHAM, EW HAMPSHIRE

Fig. 339

H. 36"; w. 32"
oil on canvas
(cat. # 27.1.1-36)

espite the discrepancies in sizes, these two por-
aits appear to be a pair. They were acquired from a
reat niece of the sitters.

338.

339.

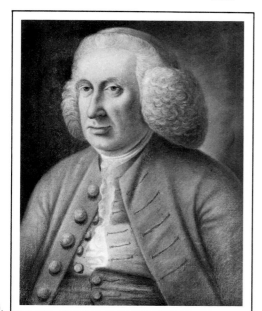

340.

DR. SAMUEL JOHNSON (1696 – 1772)

Fig. 340

H. 22⅛"; w. 17½"
pastel on paper
(cat. # 27.3.1-37)

An American clergyman, educator and philosopher, Samuel Johnson was born in Guilford, Connecticut and attended Yale (then called Collegiate School) beginning in 1714. First a Congregational minister, he joined the Anglican Church in 1724, serving as Minister of the first Anglican Church in Connecticut until 1756. That year he became the first President of the Anglican Institution, King's College, New York City (Columbia University). He resigned in 1763 and thereafter retired to Stratford, Connecticut.

341.

LACY, MISS MARY H. (1819 –)

Fig. 341

H. 30″; w. 25″ c. 1837
oil on canvas
on verso: (label on stretcher) "J. Eastman Chase/Paintings,
 Etchings and . . ."
 (stencil): "Sold by W. W. MESSER/208
 WASHINGTON ST./BOSTON/FANCY GOODS,
 CUTLERY/& ARTIST'S COLOUR STORE"
 (on stretcher) "Mary H. Lacy/Born April 14, 1819/18
 years"
(cat. #27.1.1-145)

This painting bears resemblance to the works of William Matthew Prior and his brothers-in-law, the Hamblens. If it was painted in Boston, however, where the canvas was sold, it would have been done before Prior or the Hamblens' arrival there in 1840.

LEEDS, DEMARIS OF MYSTIC, CONNECTICUT

Fig. 342

H. 15⁹/₁₆″; w. 11⁹/₁₆″ c. 1820-30
pastel on paper, mounted on canvas
(cat. #27.3.1-17)

LEEDS, DAVID OF MYSTIC, CONNECTICUT

Fig. 343

H. 15⁹/₁₆″; 11⁹/₁₆″ c. 1820-1830
pastel, on paper, mounted on canvas
(cat. #27.3.1-16)

342.

343.

LOVEJOY, RINGO SMITH

Fig. 344

H. 23″; w. 19″ c. 1813
oil on canvas
(cat. #27.1.1-138)

MAXWELL, JAMES

Fig. 345

H. 24½″; w. 19¼″ 18th c.
pastel on paper
(cat. #27.3.1-11)

While long known as the "Maxwell" portrait, this painting is now known to be James Maxwell of Warren, Rhode Island.

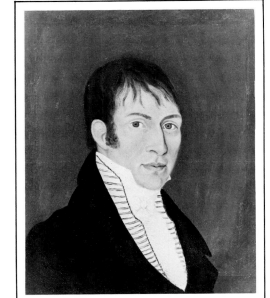

344.

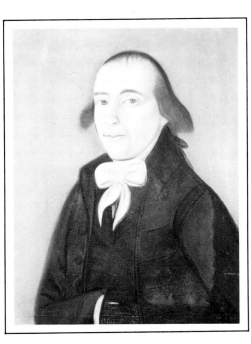

345.

MUNSON, CLARISSA ANNA

Fig. 346

H. 2"; w. 1½" 1830
Miniature oil on ivory
on verso
(note in brown script): "Miniature of/Clarissa Anna Munson./born Jan
21ˢᵗ 1814 — painted/when she was sixteen years
of/age — 93 years ago — married/Col. Lemuel
Bostwick Platt (Sen.) of Milton, Vt."

(cat. #27.1.1-159)

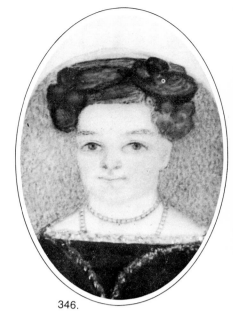

346.

JHO. PARSONS (BOY WITH SEVEN BRASS BUTTONS)

Fig. 347

H. 13¾"; w. 9¼" c. 1810-1815
oil on paper
on verso of wooden panel in back of frame (now removed): "Jho.
 Parsons"

(cat. #27.1.1-44)

THOS. HALE (BOY WITH THREE BRASS BUTTONS)

Fig. 348

H. 13¼"; w. 9⅛" c. 1810-1815
oil on paper
on verso of wooden panel in back of frame (now
removed): "Thos Hale"
(cat. #27.1.1-45)

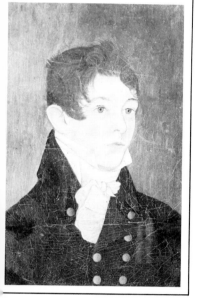

47.

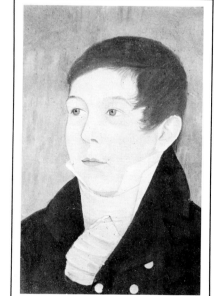

348.

CAPTAIN SIDNEY PATCH

Fig. 349

H. 13"; w. 10" (oval) c. 1800
pastel on paper
(cat. #27.3.1-13)

This well-drawn pastel portrait of Captain
Patch of Salem, Massachusetts, is sur-
rounded by a gold and black oval painted in
reverse on the glass.

349.

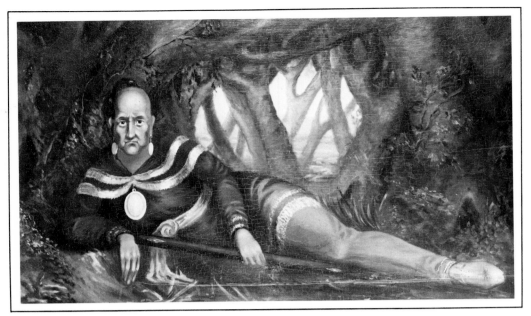

350.

350. Joseph Wright of Derby, SIR BROOKE BOOTHBY, courtesy of The Tate Gallery, London, England.

RED JACKET, CHIEF OF THE SENECA INDIANS (1758 – 1830)

Fig. 350

H. 27"; w. 44¼" c. 1830
oil on wood
(cat. #27.1.1-17)

Born in 1758 in "Old Castle" (Seneca) New York, Red Jacket was also known as "Sa-go-ye-wat-ha" (he-who-keeps-them-awake, or the Great Orator). Nicknamed because of the military tunic given him by the British during the Revolution, Red Jacket was presented with a silver peace medal in 1792 by George Washington, (now exhibited at the Buffalo Historical Society). During the War of 1812 Red Jacket initially urged neutrality, but later joined the American side. He was painted, often in the costume of his tribe, by many artists, among them J. L. D. Mathies in Rochester in 1820, Robert W. Weir, Charles Bird King in 1828 (in a blue jacket, as here) and twice by George Catlin. The extremely unusual pose in the portrait relates very closely to that in an English painting of SIR BROOKE BOOTHBY (1744-1824) by Joseph Wright, dated about 1781. Now on exhibit in London's Tate Gallery, this portrait was shown at the Royal Academy in 1781, but no engraving after the painting is known to exist. Red Jacket's portraitist must, therefore, have seen the canvas in England or a copy of the original in America. Significantly Sir Brooke Boothby, a member of the Litchfield Literary Society and a friend of Erasmus Darwin, Thomas Day, and Jean-Jacques Rousseau, was completely in tune with the romantic concept of "The Noble Savage" and the importance of communing with nature. In his portrait he holds a copy of Rousseau's "Juge de Jean-Jacques", the manuscript of which he received from the author in 1776 and published in Litchfield in 1780.[1]

[1] Letter to the author from Elizabeth Einberg, Assistant Keeper, Tate Gallery, London, August 15, 1974, Shelburne Museum MSS.

351.

GENERAL WINFIELD SCOTT

Fig. 351

H. 24"; w. 16½"
oil on canvas
(cat. #27.1.1-99)

Purchased originally from Norman M. Dort of E. Putney, Vermont, this portrait was painted by Mr. Dort's grandfather. It was undoubtedly done from a print or newspaper reproduction and probably dates either from 1846 when Scott was the hero of the Mexican War or from 1852 when he ran for President against Franklin Pierce. Scott, born in 1786 near Petersburg, Virginia, was a graduate of William and Mary College. He gave up studying law to join the Army in 1808 and entered the War of 1812 as a Lieutenant Colonel, emerging as a Major General. In 1825 he prepared the first manual of military tactics for the Army, in 1841 was General in Chief of the U.S. Army, and by 1842 was a Lt. General. After the Mexican War and his bid for the Presidency, Scott helped recruit forces to protect the Capital in 1861. Retiring that year, he spent his later years writing his autobiography. In a lithoplane (a process by which porcelain is incised and lit from behind) another artist has used the identical pose that Scott assumes here.[1]

[1] Louise Bruner, "Lithoplanes", The Magazine Antiques, July, 1974, p. 117.

STURTEVANT, HARRIET MOREY (1807 – 1874)

Fig. 352

H. 15¼"; w. 11¼" c. 1833
pastel on paper
(cat. #27.3.1-9)

STURTEVANT, CULLEN FRIEND (1795 – 1889)

Fig. 353

H. 15⅜"; w. 11¼" c. 1833
pastel on paper
(cat. #27.3.1-8)

Among Hartland, Vermont's early settlers were the Sturtevant family. The son of Dr. Friend and Sarah Porter Sturtevant, Cullen Friend Sturtevant was born April 21, 1795 in Pittsfield, Massachusetts, moved to Woodstock, Vermont in 1804, and to Hartland in 1807 where he died February 2, 1889. His wife, Harriet Morey Sturtevant, was born December 11, 1807 at Strafford, Vermont to Reuben and Martha Frizzell Morey and married Cullen on November 27, 1833. She died June 20, 1874 at Hartland and is buried in the village cemetery.

In 1822 Cullen and his brother, Thomas Foster Sturtevant, began the factory production of cloth in Hartland from locally grown wool. In 1826 they were joined by their brother, George. An accomplished musician, Cullen enjoyed fishing, reading, and writing poetry and was active in both the church and social life of the community.[1]

[1] Information from Warner B. Sturtevant, Wilbraham, Massachusetts in a letter dated March 17, 1961, Shelburne Museum MSS.

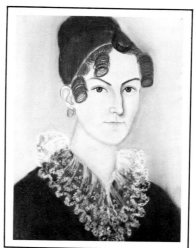

352.

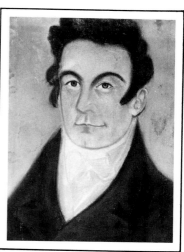

353.

STURTEVANT, MRS. ROBERT (REBECCA SHERMAN)

Fig. 354

H. 27"; w. 19¾" c. 1825
oil on wood
(cat. #27.1.1-52)

STURTEVANT, ROBERT 1768 – 1863)

Fig. 355

H. 27"; w. 20" c. 1825
oil on wood
(cat. #27.1.1-51)

These two portraits were found in an attic in Southport, Connecticut. Born in Carver or Middleboro, Massachusetts in 1768, Robert Sturtevant was the son of Robert, Sr. and Deborah Murdock Sturtevant. He married Rebecca Sherman who bore him eight children. After moving from Middleboro to Savoy, Massachusetts, Robert became a farmer, sheep raiser and trader in lands and timer. He operated a sawmill and general store, and served as a town selectman for twenty years and representative to the Massachusetts legislature for three terms.[1]

[1] Letter from Warner B. Sturtevant, Wilbraham, Massachusetts, dated January 27, 1962, Shelburne Museum MSS. Mr. Sturtevant suggests that the paintings may be early works by Cephas Thompson, Sr., a painter from Middleboro (see p. 132).

354. 355.

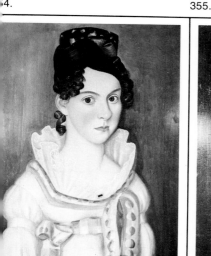
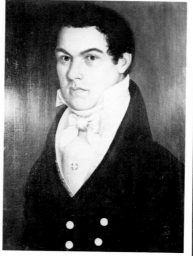

356.

357.

358.

THURSTON, DOLLY COTTRELL
(MRS. GEORGE) (– 1789)

Fig. 356

H. 3½"; w. 2½" (oval) 5⅛" × 4⅛" overall
c 1786
watercolor on paper
Inscribed on verso: "Mrs. George Thurston
(Dolly Cottrell) married
February 22, died October
21, 1789. Known as
Madam Thurston."

(cat. #27.2.1-17)

THURSTON, JEREMIAH
(1768 –)

Fig. 357

H. 3¾"; w. 2¾" (oval) 5 x 3⅞" overall c.1786
watercolor on paper
Inscribed, on verso: "Jeremiah Thurston/son
of: George Thurston &
Dolly/Born May 29 —
1768/Lt. Gov. R.I.
1816-1817"

(cat. #27.2.1-15)

THURSTON, GEORGE
(1746 – 1827)

Fig. 358

H. 3¾"; w. 2¾" (oval) 5 x 3⅞" overall c. 1786
watercolor on paper
inscribed, on verso: "George Thurston/Born
1746/died 1827/George
Thurston/married Dolly
Cottrell/February 22d
1766."

(cat. #27.2.1-16)

VITCH, MARIA (?) JOSEPHINE

H. 3⅛"; w. 3⅞"
watercolor and pinprick on paper
Inscribed in center of wreath: "Maria (?) Josephine Vitch"
(cat. #27.2.1-44)

This small, charming portrait depicts a little girl in
checked dress with a pinpricked bodice holding a
wreath with her name inscribed within it. The pin-
prick technique probably originated in seventeent
century France and was used to give pattern and
texture to paintings.

359.

TORRES, C. L., BOGOTA

Fig. 359

H. 2¼"; w. 2½" 1800-1860
watercolor on paper
(cat. #27.2.1-32)

The origin of this delicately done miniature
portrait, labeled "C. L. Torres, Bogota", is un-
known. There is some evidence that it is a self-
portrait.

GEORGE WASHINGTON Fig. 462

H. 26¾"; w. 22½" c. 1870's
oil on canvas
(cat. #27.1.1-87)

Found in the attic of a 200-year-old house in Pawlet, Vermont, this po
trait of George Washington appears to have been painted with house
paint. Undoubtedly it was inspired by one of the many portraits of
Washington adorning the homes and buildings of America; they becam
almost symbols of victory and national patriotism. This version would
have been done from one of Washington's later portraits when his mos
predominant facial characteristic became the forward thrust of his lowe
jaw.

WEBB, JAMES WATSON (1802 – 1884) Fig. 360

H. 24"; w. 20¼" c. 1827
oil on canvas with cradled back
(cat. #27.1.1-172)

Dating between his miniature portrait (on p. 101) and his portrait by Wil
liam Merritt Chase (p. 41) is this painting of James Watson Webb whic
depicts his energy and zest vividly. Joining the army at the age of seve
teen, Mr. Webb in 1819 was a Second Lieutenant in the Artillery Corp
In 1821 he was assigned to Fort Dearborn (Chicago) where in 1822 h
carried word of a contemplated Indian attack on Fort Snelling through
the wilderness to Fort Armstrong and thus averted a possible disaste
His courage won him considerable recognition. Returning to New Yo
he became the editor of the *Morning Courier* in 1827, a newspaper
which two years later became, as the *Courier and Enquirer*, one of th
foremost newspapers in the country. This portrait was probably paint
shortly before he resigned his commission.

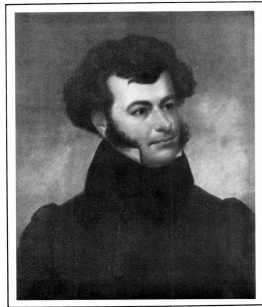

360.

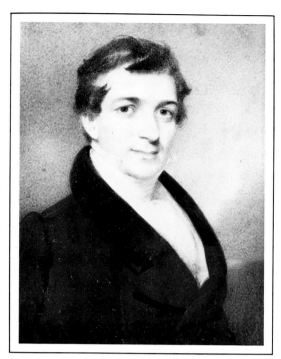

361.

WEBB, ?

Fig. 361

H. 2½"; w. 2⅔"
watercolor on ivory
(cat. #27.2.1-30)

The technique in this miniature is very similar to that in the portrait of Henry Livingston Webb painted by Henry Inman (see p. 83). The two portraits came to the Museum from the Webb estate and are similarly framed.

DANIEL WEBSTER (1762 – 1852)

Fig. 362

H. 36"; w. 29" c. 1835-1840
oil on canvas
Exhibited: Karolik Collection of early 19th century American
 Paintings to Six Midwestern Museums, 1953
(cat. #27.1.1-123)

This portrait was acquired from the now defunct Mercantile Library Association of Roxbury, Massachusetts, formed in 1820 to resemble the Boston Athaeneum wih its members donating portraits of themselves and prominent friends. It is not known whether Webster was a member, however the portrait is listed in a pamphlet of the library's portrait collection in 1860.[1] It was possibly painted by the Boston artist Chester Harding (1792-1866). Webster, a graduate of Dartmouth College, was a lawyer in Portsmouth, New Hampshire. Between 1823-1827 he was a member of the United States House of Representatives from Massachusetts, and beginning in 1827 was United States Senator from that state. He served as Secretary of State under William Henry Harrison, John Tyler, and Millard Fillmore.

[1] Information from Charles Childs, Childs Gallery, Boston, 1952.

362.

LADY WITH GREYHOUND

Fig. 363

H. 13″; w. 9¾″
reverse oil painting on glass
(cat. #27.11-2)

LADY IN HEAVY SHAWL

Fig. 364

H. 14″; w. 10¼″
reverse oil painting on glass
(cat. #27.11-5)

363.

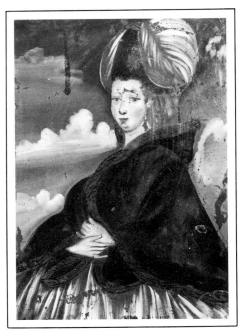

364.

While these two portraits are probably English, reverse painting on glass was practiced in the American colonies during their early years.

LITTLE GIRL FROM THE HUDSON RIVER VALLEY

Fig. 365

H. 31⅜″; w. 2⅝″
oil on canvas
(cat. #27.1.1-177)

While this portrait has been entitled LITTLE GIRL FROM THE HUDSON RIVER VALLEY, it may as easily be English or Dutch.

365.

366.

LITTLE GIRL WITH RED ROSE IN HAIR

Fig. 366

H. 29½″; w. 24⅛″
oil on canvas
(cat. #27.1.1-182)

For several years this portrait of a little girl in a red dress has delighted visitors to the Museum's Prentis House. Flatly painted with great attention to detail, the portrait relates in many respects to the work of the anonymous "Gansevoort Limner".[1] Active along the Hudson River between 1730 and 1745, this Dutch artist painted many of his young girls holding roses, as here, and often included a landscape background. In appearance, this little girl most resembles the Gansevoort limner's portrait of CORNELIUS WYNKOOP.[2]

[1] Mary Black, "The Gansevoort Limner", The Magazine *Antiques*, November, 1969, pp. 738-744.
[2] *Ibid.*, Figure 17, p. 744.

367.

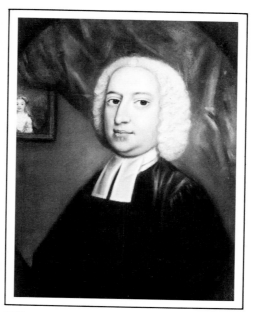

368.

WOMAN IN BLUE

Fig. 367

H. 12½"; w. 10½" 18th c.
pastel on paper
(cat. #27.3.1-43)

CLERGYMAN WITH LADY'S PORTRAIT IN BACKGROUND

Fig. 368

H. 12¾"; w. 10½"
pastel on paper
(cat. #27.3.1-44)

The pose and organization of this portrait were probably inspired by a mezzotint, imported to this country from England or Holland. It is believed to be American.

GIRL WITH HAT UNDER ARM

Fig. 369

H. 13"; w. 10⅝"
pastel on paper
Gift of: Katharine Prentis Murphy, 1958
(cat. #27.3.1-42b)

BOY WITH HAT UNDER ARM

Fig. 370

H. 12⅞"; w. 10⅜"
pastel on paper
Gift of: Katharine Prentis Murphy, 1958
(cat. #27.3.1-42a)

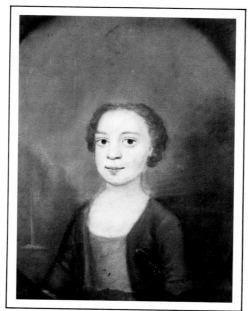

369.

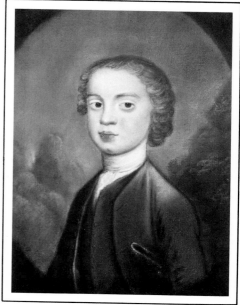

370.

This pair of portraits was probably done in the late seventeenth or early eighteenth century. Nothing is known of their origin.

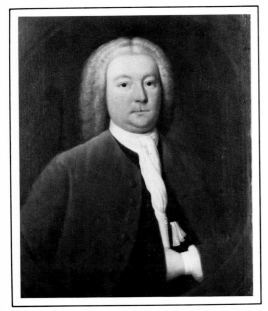

371.

GENTLEMAN WITH A STEINKIRCK

Fig. 371

H. 30½"; w. 25¼" c. 1725
oil on canvas
Gift of: Katharine Prentis Murphy, 1957
(cat. #27.1.1-181)

The fashion of pulling one's scarf ends through a waistcoat buttonhole resulted from an episode in the Battle of Steinkirck of August, 1692, during an era of very formal military action. On this occasion the British had the extreme discourtesy to attack the French lines by surprise in the early morning. The French officers, not having time to get properly and formally clothed, hastily drew their scarves through their buttonholes to keep them from flowing about. The fashion of the "steinkirck" caught on and continued until the first quarter of the eighteenth century. This portrait could be American, English or possibly from Continental Europe.

WOMAN IN BLUE SASH

Fig. 372

H. 23¼"; w. 17⅜"
pastel on paper
(cat. #27.3.1-22)

MAN IN GREEN WAISTCOAT

Fig. 373

H. 23⅜"; w. 17⅜" late 18th c.
pastel on paper
(cat. #27.3.1-21)

These two portraits, found in New England, resemble the works of Benjamin Blyth (see p. 32) very closely. Unfortunately, nothing is known of their origin.

372.

373.

OFFICER OF THE AMERICAN REVOLUTION

Fig. 374

H. 8¹/₁₆"; w. 3¼" 1775-1780
watercolor on paper
(cat. #27.2.1-4)

374.

375.

376.

FORTY-NINE FASHION PRINTS

Figs. 375 and 376

H. 7½"; w. 4¾" each
water color on paper
Gift of the Webb Estate, 1963
(cat. #27.2.6-8)

These carefully done fashion plates date between 1784 and 1802. Number twenty-five of the original series of fifty is missing.

BOY IN BROWN STRIPED SUIT

Fig. 377

H. 12¼"; w. 8⅜" c. 1785
pastel and pencil on brown paper
(cat. #27.3.1-20)

This a profile view of a boy with shoulder length light brown hair, wearing a brown and white striped coat, white organdy collar with ruffled edge, and tan waistcoat.

377.

DEMOISELLE WITH ROSE TRIMMED HAT

Fig. 378

H. 14⅝"; w. 10³/₁₆" 18th c.
pastel on parchment
on verso: "E.B./S.S.B."
(cat. #27.3.1-18a)

DEMOISELLE WITH BLUE FLOWERS ON HER BONNET

Fig. 379

H. 14⁹/₁₆"; w. 10⅜" 18th c.
pastel on parchment
on verso (on stretcher): S.S.B.
(cat. #27.3.1-18b)

Because both of these pastels have been backed with paper printed with French text, these portraits probably originated in France or Canada.

378.

379.

157

PROVIDENCE BELLE

Fig. 380

H. 20¼"; w. 25" c. 1800
pastel on paper
Exhibited: The Downtown Gallery "American
 Ancestors" November, 1938
 University of Pittsburgh, Pa., October, 1939
 Dallas Museum of Art, October 1946
 Wichita Art Museum, October 1947
 Downtown Gallery Exchange, December,
 1948
 Grand Rapids, Michigan, December, 1948
 Currier Gallery of Art, Manchester, New
 Hampshire, February, 1949
 cat. #27.3.1-3)

Found in Providence, Rhode Island, this early
and unusually large pastel is very compe-
tently painted.

380.

PORTRAIT OF A YOUNG MAN

Fig. 381

H. 6¼"; w. 6⅞" (oval) c. 1801
watercolor on Whatman paper
(cat. #27.2.1-5)

This carefully done watercolor
depicts a man in a shaggy
Brutus haircut, popular by the
late eighteenth century in
France.

381.

YOUNG MAN WITH
HALF-MOON HAIRCUT

Fig. 463

H. 31"; w. 24¾" c. 1810
oil on canvas
(cat. #27.1.1-107)

This well-painted portrait is un-
doubtedly American.

SPRINGFIELD FAMILY Fig. 382

H. 30"; w. 48½" c. 1820
oil on wood
Exhibited: Downtown Gallery, August, 1947
 Downtown Gallery, "The American Family", September, 1948
 Currier Gallery, March, 1949
 Akron Art Gallery, January, 1951
(cat. #27.1.1;21)

This rather large portrait was found in Springfield, Massachusetts and
has been done on two panels of wood, somewhat awkwardly joined.

382.

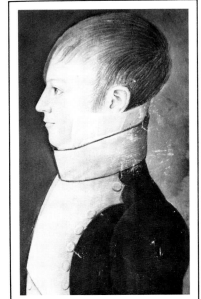

383.

YOUNG SOLDIER Fig. 383

H. 14"; w. 8¹³/₁₆" c. 1825
pastel on paper
(cat. #27.3.1-12)

This anonymous soldier wears a type of blue uniform, faced with scarlet,
which was worn around 1825.[1]

[1] See Elizabeth McClellan, *Historic Dress in America 1800-1870* (Philadelphia: George W.
Jacobs and Co., 1910), p. 400, figure 339.

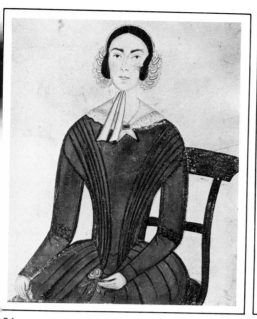

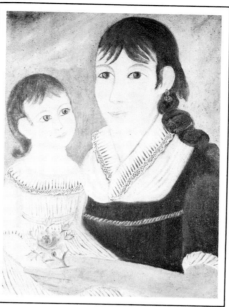

WOMAN IN GREEN WITH RED ROSE

Fig. 384

H. 5¼″; w. 4⅝″ c. 1827
watercolor on paper
(cat. #27.2.1-6)

MOTHER AND DAUGHTER WITH ALMOND-SHAPED EYES

Fig. 385

H. 15″; w. 9″ c. 1828
Oil on canvas, mounted on masonite
Exhibited: Montreal, September, 1963, exhibit of the
 Vermont Development Department
(cat. #27.1.1-33)

This portrait was done by an amateur whose technique, though crude and direct, lends a certain charm. The blue arm of the mother remains a puzzle: possibly some underpainting has bled through.

84. 385.

RAMED GROUP OF FIFTEEN MINIATURES

Fig. 386

oils and watercolors on ivory and paper, 18th c.
Directoire to about 1830
(cat. #27.1.1-135)

is large grouping of miniatures, mostly European, con-
sts of the following:

top row:
man in red vest holding miniature of his wife (2¼″ × 1¼″)
 on verso: "fait en Mai 1794, mariage 1er Avril 1754"
Profile of a woman in white cap and shawl (2¼″ × 2¼″) Mme. Campan
 (Mme. Jeanne Louise Henrietta Campan) 1752-1822; companion to
 the princesses (aunts of Louis XVI) and later to Marie Antoinette.
 Served after the Revolution as Governess and opened a school
 for young ladies.
Two women and a man (1¾″ × 1¾″)

second row:
young woman with pink ribbon (2″ × 1⅝″)
young woman in green (2½″ × 2½″)
woman in corkscrew curls (2⅛″ × 1¾″)

third row:
middle-aged man (2½″ × 2¹/₁₆″)
child in pink holding pink rose (3½″ × 2¾″)
 on verso: "Anne Tracy Creswold, born June 17, 1798, aged 12 yrs."
older woman in frilly bonnet (2¼″ × 1¾″)

fourth row:
woman in orange cap (2″ × 1½″)
woman with black crossed scarf at neck (2⅝″ × 2¼″)
young officer (2⅜″ × 1¾″)

fifth row:
man in ruffle-fronted shirt (2½″ × 2½″)
man (1½″ × 1⅛″)
woman in empire dress with lace hat (2½″ × 2½″)

386.

159

MINIATURE IN FUR NECK PIECE

Fig. 387

H. 3¼"; w. 2½"
oil on ivory
Gift of: Mrs. Helen Bruce, 1959
(cat. #27.1.1-39)

This rather austere woman is believed to be French.

387.

MOTHER AND CHILD

Fig. 388

H. 2⅜"; w. 2⅜"
miniature oil on ivory
(cat. #27.1.1-160)

This small miniature is delicately painted and very attractive. The baby holds a pear.

WOMAN IN LIGHT BROWN DRESS

Fig. 389

H. 3¼"; w. 2⅞"
pencil and watercolor on paper
(cat. #27.2.1-18)

WOMAN IN EMERALD GREEN DRESS

H. 3½"; w. 2⅞"
pencil and watercolor on paper
(cat. #27.2.1-19)

WOMAN IN PROFILE

H. 1¾"; w. 1½"
watercolor on paper
(cat. #27.2.1-35)

WOMAN WITH CORKSCREW CURLS

Fig. 390

H. 17"; w. 13¾" c. 1830
oil on wood
Gift of: Mrs. Brooks Shepard, 1958
(cat. #27.1.1-30)

While the handwoven canvas used for this portrait would indicate a date between 1820 and 1830, the hairstyle of the sitter was not popular until the 1840's, making this the more likely date for this portrait.

PAIR OF MINIATURE PORTRAITS

H. 3⅛"; w. 2⅛"
watercolor on ivory
Gift of: Mr. J. Watson Webb, Jr., 1974
(cat. #27.2.1-45)

These two miniature watercolor portraits probably depict members of the Webb Family. Judging from their clothing and hairstyles, they appear to date about 1830.

388.

389.

390.

391.

CHILD WITH WHIP

Fig. 391

H. 20⅛"; w. 15¾" c. 1830
watercolor on paper
(cat. #27.2.1-20)

This portrait, an especially large watercolor, was found in New Jersey. Because of the whip, a usual prop, one assumes the child is a boy.

GIRL WITH APPLE Fig. 392

H. 40¾"; w 27½" c. 1835
oil on curved, wooden panel
(cat. #27.1.1-47)

This painting bears a strong resemblance to other portraits by
Sheldon Peck. Born in Cornwall, Vermont in 1797, Peck painted
single and family portraits in Vermont; in Jordan, New York; and
Lombard, Illinois where he settled in 1838 to farm and paint. His
earlier portraits were on wood, while later he preferred canvas.
Peck died in Illinois on March 9, 1868.[1]

[1] Marianne E. Balazs, "Sheldon Peck", The Magazine *Antiques*, August, 1975, pp.
273-284.

GIRL IN GREEN Fig. 455

H. 54"; w. 36" c. 1835
oil on canvas
(cat. #27.1.1-88)

While the artist of this portrait is unknown, he is far from
incompetent. He appears to have also painted a portrait of
Mary Louisa Bird, "taken in 1837 when she was nine years
old".[1]

[1] Illustrated in "Plain and Fancy, A Survey of American Folk Art", a
catalogue of an exhibit at the Hirschi and Adler Galleries, New York City,
April 30 through May 23, 1970.

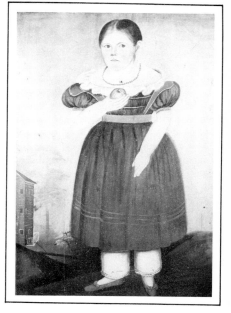

392.

394.

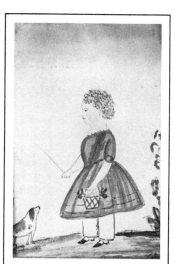

395.

SATAN'S CHILD

Fig. 394

15" diameter; stretcher 18" × 18"
oil on canvas
(cat. #27.1.1-81)

In many ways this portrait resembles
Horace Bundy's PORTRAIT OF A
CHILD (see p. 38). In this painting the
child faces frontally, and his features
are sharply defined.

TEACHING HER DOG TRICKS

Fig. 395

H. 5¾"; w. 4¼"
ink and watercolor on paper
(cat. #27.9-32)

FAMILY PORTRAIT WITH GREEN VELVET DRAPERY

Fig. 396

H. 35½"; w. 53" c. 1835
oil on canvas over pressboard, counter-mounted with linen
(cat. #27.1.1-68)

In this large, unusual portrait, the three pairs of eyes have
a disconcerting habit of watching one with mild disap-
proval. Its origin is unknown.

MOTHER AND CHILD WEARING CORAL BEADS

Fig. 393

H. 30¼"; w. 24¼" c. 1835
oil on canvas
(cat. #27.1.1-67)

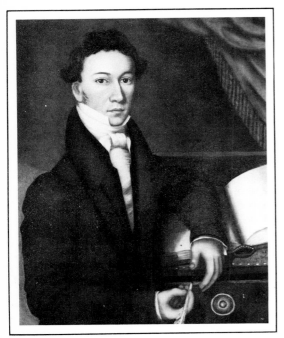

397.

MERCHANT FROM SYRACUSE

Fig. 397

H. 29⅝"; w. 24" c. 1847
oil on canvas
(cat. #27.1.1-106)

The ledger in this portrait has the name L. John_?_ on it and the date 184(7?).

THE PET LAMB

H. 16¾"; w. 14"
pastel on brown paper
Inscribed, l.l.: "The Pet Lamb"
(cat. #27.3.1-27)

LADY IN BROWN DRESS

Fig. 398

H. 2¹³/₁₆"; w. 2⁵/₁₆"
miniature oil on ivory
(cat. #27.1.1-161)

398.

399.

LITTLE GIRL WITH CURLS IN ROCKING CHAIR

Fig. 399

H. 33¼"; w. 26¼"
oil on canvas
(cat. #27.1.1-143)

NEW RED SHOES

Fig. 400

H. 26½"; w. 32¼" c. 1845
oil on canvas
(cat. #27.1.1-144)

400.

401.

MY PUPPY (Boy in Red Dress)

Fig. 401

H. 36"; w. 29¼" c. 1845
oil on canvas
(cat. #27.1.1-140)

Trousers of cambric muslin and dres[ses] were frequently worn by young bo[ys] as well as girls during the first half o[f] the nineteenth century. This solemn child is undoubtedly a boy.

INDIAN TRANSPARENCIES

KING PHILIP Fig. 461

H. 24¼"; w. 16½" c. 1850
watercolor on oil-treated window shade
(cat. #27.2.1-8)

CAPTAIN JOSEPH BRANT

H. 26½"; w. 17"
watercolor on oil-treated window shade
(cat. #27.2.1-9)

404.

02.

403.

TECUMSEH Fig. 404

H. 24½"; w. 16¼"
watercolor on oil-treated window shade
(cat. #27.2.1-10)

POWHATEN Fig. 402

H. 24¼"; w. 16½"
watercolor on oil-treated window shade
(cat. #27.2.1-11)

OCEOLA

H. 24½"; w. 16½"
watercolor on oil-treated window shade
(cat. #27.2.1-12)

POCAHONTAS

H. 24½"; w. 15¾"
watercolor on oil-treated window shade
(cat. #27.2.1-13)

RED JACKET Fig. 403

H. 24½"; w. 18½"
watercolor on oil-treated window shade
(cat. #27.2.1-14)

Because of the oil treatment on their surfaces, it has been assumed that these seven portraits of American Indians were displayed in a nineteenth century traveling show, illuminated from behind by whale oil lamps or candles. When they were acquired by Mrs. Webb the faces were so begrimed that they were unrecognizable. Duncan Ross Munro, in charge of the Museum's Paint Shop and Landscape department, miraculously restored them. Now mounted between opaque glass and non-reflective glass, the transparencies are lit from behind by flourescent lights. After examining them, John C. Ewers, Assistant Director of History and Technology at the Smithsonian Institution wrote:

> I am unable to identify the name of the artist. The fact that the Indians portrayed lived during a period of three centuries (Powhaten, Pocahontas and King Philip in the 17th century — Brant in the 18th — the Tecumseh, Osceola and Red Jacket in the 19th) suggests to me the probability that the paintings were executed no earlier than the 1840's and that none of them were painted from life. The rough resemblance of some of these poses (Brandt, Osceola, King Philip and Red Jacket) to known portraits of these individuals suggests to me that the artist probably attempted to copy the works of other artists who portrayed American Indians. However, the portraits labeled Powhatan, Pocahontas and Tecumseh may be imaginary creations of the artist.[1]

[1] Letter, undated, Shelburne Museum MSS.

GIRL WITH CORKSCREW CURLS Fig. 405

H. 17½"; w. 12½" c. 1850
watercolor on paper
Exhibited: "American Primitive Watercolors" Smithsonian Institution Traveling Exhibition Service
 in cooperation with the Abby Aldrich Rockefeller Collection of Folk Art, Williamsburg,
 Virginia, July, 1964
(cat. #27.2.1-7)

Found in Wells, Maine, this watercolor portrays a young girl with corkscrew curls, done by the same artist who painted MISS MARY FURBER in the Karolik Collection of the Museum of Fine Arts, Boston.[1] Mary is described as having been born in Portsmouth, New Hampshire in 1795 and having later resided in Eliot, Maine. Eliot and Wells are both located on the southern tip of Maine. The artist may be the Mr. Willson who painted a portrait of Barnard Stratton of Amherst, Massachusetts in September, 1822.[2]

405.

[1] Illustrated in *M. & M. Karolik Collection of American Watercolors and Drawings, 1800-1875* (Boston: Museum of Fine Arts, 1962), V. I, p. 42, #1074.
[2] Nina Fletcher Little, "Indigenous Painting in New Hampshire", The Magazine *Antiques*, July, 1964, p. 64.

406.

LITTLE BOY WITH FLOWERS

Fig. 406

H. 4"; w. 3" (oval) H. 4⁹/₁₆"; w. 3⅞" overall
silhouette profile and watercolor on paper;
mounted under oval border painted on glass
(cat. #27.14-2)

This charming picture utilizes three popular nineteenth century techniques — silhouetting, watercoloring, and reverse painting on glass.

LITTLE GIRL IN BLACK WITH DOLL IN WHITE

H. 6¼"; w. 3⅞"
watercolor on paper
(cat. #27.2.1-36)

LITTLE GIRL IN WHITE WITH DOLL IN YELLOW

H. 7½"; w. 4½"
watercolor on paper
(cat. #27.2.1-37)

These two mid-nineteenth century watercolors, undoubtedly by the same artist, both depict little girls in empire style dresses, playing with their dolls.

LITTLE GIRL IN BLUE HOLDING RABBIT

H. 7⅝"; w. 5¾"
watercolor on paper
Inscribed in pencil below: "Taken at 4¼ years of age"

(cat. #27.2.1-40)

407.

CHILD IN WHITE DRESS HOLDING TOY SPANIEL

Fig. 407

H. 16¹³/₁₆"; w. 13" c. 1845
pastel on paper
Gift of: Mrs. J. C. Rathborne, 1958
(cat. #27.3.1-23)

This very charming pastel was found in New Jersey.

LITTLE GIRL WITH SNOWBERRY

Fig. 408

H. 24"; w. 20¼" c. 1840-50
oil on canvas, mounted on paperboard
Exhibited: Karolik Exhibition shown in Six Midwestern Museums, 1953
(cat. #27.1.1-137)

The painter of this delightful child has yet to be discovered. The same artist probably painted a portrait of a child playing with blocks, formerly in the Karolik Collection.[1]

[1] CHILD PLAYING WITH BLOCKS, c. 1850, illustrated in Parke-Bernet Galleries catalogue, *Art Property of the Estate of the Late Maxim Karolik*, June 17 and 18, 1964, No. 253. The painting was owned by E. M. Strauss in 1970 (see Katharine McClinton, *Antiques of American Childhood*, New York, 1970, p. 244.)

408.

YOUNG GIRL SEATED

H. 28"; w. 24"
pastel on paper
(cat. #27.3.1-24)

This picture came from Ware, Massachusetts and is believed to have originated in that area. The solemn child wears braided ribbons around her head.

CHILD IN BLUE CHECKED DRESS

H. 23¼"; w. 17½"
watercolor on paper
(cat. #27.2.1-42)

This is one of the few primitives in which the little girl looks like a real child rather than a miniature adult.

BOY WITH SPECKLED VEST

Fig. 409

H. 37"; w. 33"
oil on canvas
(cat. #27.1.1-34)

While the artist of this portrait is unknown, he appears to have also painted a portrait of a young boy now at Old Sturbridge Village, Sturbridge, Massachusetts.[1]

[1] See YOUNG BOY, illustrated in Nina Fletcher Little's *Country Art in New England, 1790-1840* (Sturbridge, Massachusetts, n.d.), Figure 13.

FIVE CHILDREN'S PROFILES

BOY FACING RIGHT (black suit)

H. 3"; w. 2½"
watercolor on paper
(cat. #27.2.1-41a)

GIRL FACING RIGHT (hair in bun with blue ribbon)

H. 3"; w. 2½"
watercolor on paper
(cat. #27.2.1-41b)

EDWIN H (BOY FACING LEFT) (black suit)

H. 3"; w. 2½"
watercolor on paper
Inscribed at top (in pencil): "Edwin H"
(cat. #27.2.1-41c)

GIRL FACING LEFT (hair in bun, blue ribbon)

H. 3"; w. 2½"
watercolor on paper
(cat. #27.2.1-41d)

YOUNG BOY WITH BOOK, FACING LEFT (in plaid suit)

H. 3"; w. 2½"
watercolor on paper
(cat. #27.2.1-41e)

These five portraits, all with a red curtain framing them, undoubtedly represent members of one family. Four portraits in the Museum of Fine Arts, Boston, of John and Eliza Munsell and their two sons, Washington Wingate and William Henry, were done by the same artist.[1]

[1] See *M. & M. Karolik Collection of American Water Colors & Drawings* (Boston: Museum of Fine Arts, 1962), pp. 116 and 119.

WOMAN IN STRIPED DRESS

Fig. 410

H. 30¼"; w. 24¼"
oil on canvas
(cat. #27.1.1-142)

410.

411.

LADY WITH APOLLO KNOT

Fig. 411

H. 29¾"; w. 24¾" c. 1835
oil on canvas
(cat. #27.1.1-132)

The Apollo knot, an elaborate hair fashion consisting of upstanding, lacquered loops, originated in France and was popular in America in the mid-1830's.

BLUE BEADS-BLUE SASH

Fig. 412

H. 17¾"; w. 13½"
oil on canvas
(cat. #27.1.1-32)

This pleasant portrait was found in Salem, Massachusetts.

LADY AND CHILD

H. 25½"; w. 21"
pastel on paper
Gift of: Redfield Proctor, 1954
(cat. #27.3.1-39)

412.

PORTRAIT OF A GIRL WITH BRAIDS

Fig. 413

H. 17"; w. 13½"
pastel on paper
Gift of: Redfield Proctor, 1954
(cat. #27.3.1-38)

GIRL WITH SHELL AND DOVE

H. 25½"; w. 20¾"
pastel on paper
(cat. #27.3.1-47)

GIRL WITH A DOVE

H. 22½"; w. 19⁵⁄₁₆"
pastel on paper
Gift of: Redfield Proctor, 1954
(cat. #27.3.1-46)

413.

414.

SISTER IN BLUE DRESS

Fig. 414

H. 5⅝"; w. 4⅛"
watercolor on paper
(cat. #27.2.1-23)

This pair of portraits bear a strong relationship to the work of the Ithaca, New York painter, Henry Walton (see p. 135). They are somewhat softer than most of Walton's work, and the features are less sharply defined.

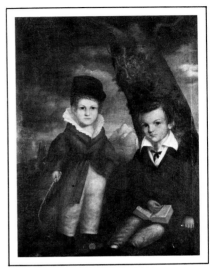

415.

BROTHER IN BLACK COAT

Fig. 415

H. 5¾"; w. 4¼"
watercolor on paper
(cat. #27.2.1-24)

416.

TWO BROTHERS FROM RUTLAND, VERMONT

Fig. 416

H. 36"; w. 27½"
oil on mattress ticking
Gift of: Dr. and Mrs. E. William Davis, 1959
(cat. #27.1.1-83)

Done on mattress ticking, this portrait, while somewhat more awkward, is reminiscent of a portrait of Rufus and Gardner Wainwright, done by the Vermont painter Benjamin F. Mason about 1840.[1] Mason is known to have been painting in Rutland in the summer of 1834.

[1] See Alfred Frankenstein and Arthur K. D. Healy, *Two Journeymen Painters* (Middlebury: The Sheldon Museum, 1952), Figure 17.

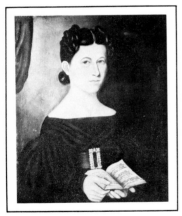

LADY HOLDING "LADIES' BOOK"

Fig. 417

H. 26"; w. 21½"
oil on canvas
(cat. #27.1.1-74)

417.

WE SISTERS THREE

Fig 418

H. 43"; w. 55" c. 1840
oil on canvas
(cat. #27.1.1-85)

Found in New York state, the title of this portrait might read SISTERS TWO WITH THEIR BROTHER ONE, since all young children of this era wore dresses. The same artist undoubtedly painted FOUR CHILDREN, formerly in the Edith Gregor Halpert collection[1] and probably painted JOSEPH AND ANNA RAYMOND in the Edgar and Bernice Garbisch Collection in the National Gallery.[2] Two other portraits, of THE THREE HUIDEKOPER CHILDREN in the Corcoran Gallery[3] and BOY WITH A TOY DRUM (attributed to William Thompson Bartoll) in the New-York Historical Society[4], bear a less striking but nonetheless noteworthy similarity to Shelburne's portrait.

[1] See Edith G. Halpert Folk Art catalogue of Sotheby Parke Bernet, Inc., November 14 and 15, 1973, Sale 3572, #35.
[2] *American Primitive Paintings from the Collection of Edgar and Bernice Chrysler Garbisch*, Part II (National Gallery of Art, Smithsonian Institute, 1957), p. 68.
[3] *A Catalogue of the Collection of American Paintings in the Corcoran Gallery of Art* (Washington, D.C.: The Corcoran Gallery of Art, 1966), p. 67.
[4] Illustrated in Jean Lipman and Alice Winchester, *The Flowering of American Folk Art* (New York: The Viking Press, 1974), p. 49.

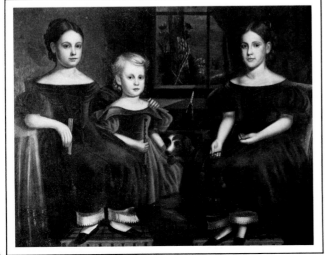

418.

Landscapes — Known Sites

CALIFORNIA

CALIFORNIA

Fig. 419

H. 26"; w. 36" c. 1855
oil on canvas
(cat. #27.1.2-61)

This painting, dubiously entitled CALIFORNIA, was undoubtedly copied from an engraving of Asher B. Durand's oil painting PROGRESS, done for Mr. Charles Gould and exhibited at the National Academy of Design in 1853. The engraving, called ADVANCE OF CIVILIZATION, was published in *Ballou's Pictorial Drawing-Room Companion* in 1855.[1]

[1] *Ballou's Drawing Room Companion*, VIII (April 7, 1855), 221. Another painting copied from the print is illustrated in Hirschl & Adler Galleries catalogue "Quality, An Experience in Collecting." November 12-December 7, 1974, #11.

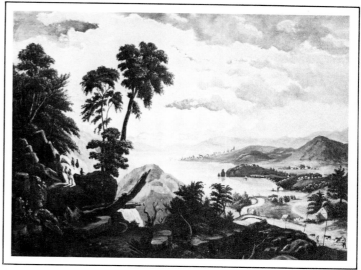

419.

YOSEMITE, CALIFORNIA

Fig. 420

H. 17½"; w. 18¾"
oil on canvas, mounted on pressboard
Gift of: Mrs. Brooks Shepard, 1958
(cat. #27.1.2-22)

This brightly colored painting was undoubtedly inspired by a small folio Currier and Ives lithograph entitled CALIFORNIA YO-SEMITE FALLS.[1] The print does not place the deer in the same location or include the hunter, seen on the left of this painting.

[1] Harry T. Peters, *Currier and Ives, Printmakers to the American People* (Garden City and New York: Doubleday, Doran and Co., Inc., 1929), No. 3884, p. 317.

CONNECTICUT

STONINGTON, CONNECTICUT TOWNSCAPE

Fig. 421

H. 18"; w. 22" c. 1800-1825
watercolor on paper
Exhibited: Abby Aldrich Rockefeller Collection of Folk Art,
 Williamsburg, Virginia, July, 1964
(cat. #27.2.2-8)

420.

NEW YORK

AUSABLE CHASM (TABLE ROCK) NEW YORK

Fig. 460

H. 29¼"; w. 36"
oil on canvas
on verso (label): "HUDDICK'S/BUFFALO, N.Y."
(cat. #27.1.2-17)

Sometime between 5,000 and 20,000 years ago the Ausable River, created by the melting of the last glacial ice cap, found a fault in the Potsdam sandstone underlying it and slowly carved out this chasm. One of America's "scenic wonders," the one and a half mile long gorge was first discovered by Major John Hope and was a popular tourist attraction by 1870. Today trails, walkways and bridges, or a scenic boat ride from the Table Rock through the Grand Plume make this attraction much more accessible to visitors.

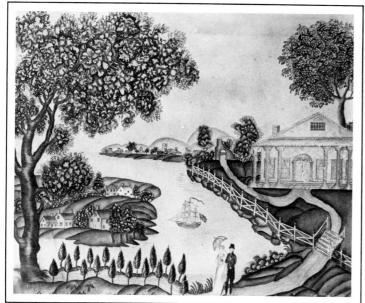

421.

422.

GLENEYRE FALLS ON ESOPUS RIVER, NEW YORK

Fig. 422

H. 27¼"; w. 34¼" 1800-1825
oil on wood
On verso (tag): "Gleneyre Falls/on Esopus River/New
York from a house in Saugerties, New
York circa 1800-1825"
(cat. #27.1.2-10)

Esopus Creek, on both sides of the Astrokan Reservoir, is located a few miles west of Kingston, New York.

423.

SCENE — HUDSON RIVER

Fig. 423

H. 24"; w. 32" c. 1880
oil on canvas
(cat. #27.1.2-8)

HAYMAKING ON THE HUDSON

Fig. 424

H. 26"; w. 36" c. 1851-1860
oil on canvas
on verso (label): "J N ORCOTT & BRO./DEALERS
IN/CHROMES, COLORED PICTURES,
FRAMES/AND FANCY GOODS./NO. 55
MARKET STREET,/LYNN, MASS."
(cat. #27.1.2-70)

Painted from the same vantage point as Horace Bundy's BLUE MOUNTAINS (see p. 38) this landscape was also undoubtedly done from a print — either James Smillie's AMERICAN HARVESTING, engraved in 1851 or Currier and Ives' A SUMMER LANDSCAPE — HAYING. Both prints were based upon Jasper Cropsey's painting AMERICAN HARVESTING SCENERY, done in 1849.

424.

HOUSE ON THE HUDSON RIVER

Fig. 425

H. 11½"; w. 15½" c. 1850
oil on canvas
(cat. #27.1.2-103)

HUDSON RIVER SCENE

H. 16¼"; w. 20⅜"
black and white chalk on sandpaper
Gift of the Webb estate, 1961
(cat. #27.3.2-2)

While this chalk drawing is supposed to represent the Hudson, the body of water more resembles a lake. The scene is quite picturesque, with boaters and fishermen, cows and birds.

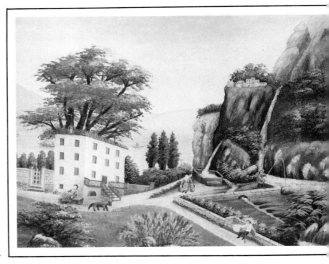

425.

SCENE ON THE HUDSON

Fig. 426

H. 29½"; w. 38¾"
oil on canvas
Inscribed, l.r.: "SCENE ON THE HUDSON"
(cat. #27.1.4-66)

VIEW OF THE HUDSON RIVER

H. 13⅜"; w. 11⅞"
charcoal and white chalk on sandpaper
(cat. #27.3.2-1)

Another Hudson River view, this landscape includes sailboats and a steamer. In the foreground is a gentleman in a tall hat with two ladies and a dog.

426.

427.

NEWBURGH, NEW YORK STEAM ENGINE WORKS

H. 8½"; w. 6¾" 1867
oil on wood
Inscribed, on verso: "Newburgh Nov. 25, 1867 in City of Newburgh/forming a Company called/Whitehall guards in/Company went to West Newburgh/to fire upon this target/Captain/Alex J. Withers/Foreman of Company/James Mosier/57 years 1864/

(cat. #27.1.2-113)

his foundry, with "Whitehall, Smith & Co., Newburgh Steam Engine Works" over its door, was the source of many of the Museum's foundry patterns, now on display in the Diamond Barn.

WASHINGTON'S HEADQUARTERS, NEWBURGH, NEW YORK Fig. 428

H. 14"; w. 20¼" 1835
oil on canvas
Inscribed, l.r.: "1835"
On verso: "Washington's Head Quarters, Newburgh, New York"
(stencil): "Prepared by ? & PAINE ? Brush Mat _____/No. 523 S. Broad Street/New York"
(cat. #27.1.2-11)

uilt by Jonathan Hasbrouk in 1750 and enlarged in 1770, is house in Newburgh, New York served as George Washington's headquarters from April 1, 1782 to August, 783. It had previously been used in 1778 by Baron Von iedesel, Commander of a Hessian force in General Burbyne's Army. Three major events transpired in the house uring Washington's tenure; he rejected the concept of becoming "King"; formulated the idea of an indissolvable nion of states under one federal head, and established e Order of the Purple Heart.

This particular view of the house, done by an anonymous rtist after an engraving by James Smillie, was based on n original painting by Robert Walter Weir. The artist pos-

CROW'S NEST FROM BULL HILL LOOKING TOWARD WEST POINT Fig. 427

H. 25"; w. 36" c. 1840
oil on canvas
(cat. #27.1.2-64)

This painting, taken from an engraving by William Henry Bartlett done in 1837, depicts a view looking southwest across the Hudson River toward West Point. Bartlett (1809-1854), an English topographical artist, visited the United States four times between 1836 and 1852 to paint North American landscapes. Translated into steel engravings, the views were published in *American Scenery,* a book printed in London in 1842 accompanied with a text by the American writer Nathaniel Parker Willis. Bartlett's engravings served as a source for both amateur and professional painters countless times.

In some respects, particularly the handling of the foliage in the foreground, this painting resembles the work of Thomas Chambers (see p. 40). Chambers not only painted Hudson River scenes often, but was frequently inspired by Bartlett's engravings.

428.

sibly saw a reproduction of the engraving appearing in the *New York Mirror* in 1834 or a small folio Currier and Ives print of unknown date. Fourteen years later the house was purchased by the state of New York to become the nation's first historic house to be opened to the public. On April 19, 1933 the United States Post Office Department issued a three cent peace commemorative stamp based on the Smillie engraving. The stamp was reissued the following March in full sheets of 400.[1]

[1] Max G. Johl, *United States Postage Stamps of the Twentieth Century, 1933-1937* (New York: H. L. Lindquist, 1933), pp. 61-63.

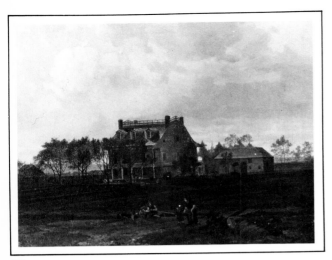

429.

429. Havemeyer Mansion, 1861. Lithograph for D.T. Valentine's Manual, Shelburne Museum Collection

430.

431.

POUGHKEEPSIE RIVER FRONT 1817 Fig. 431

H. 9½"; w. 13½" 1817
watercolor on paper
Inscribed, l.r.: "Poughkeepsie River Front 1817" cut from three different type faces and
 pasted on the bottom
(cat. #27.2.2-15)

Interesting and unusual because of title cut out of type set and pasted below, this is quite a delightful watercolor.

THE ALBERT AND WILLIAM HAVEMEYER FARM, FAR WEST 59th STREET, NEW YORK CITY Fig. 429

H. 14¼"; w. 19¾"
oil on canvas
Gift of: Mrs. Noel Haskins Murphy, 1967
(cat. #27.1.2-120)

William Frederick and Albert Havemeyer were the sons of William Havemeyer, an immigrant to America in 1799 from Germany, who began a sugar refining business in New York with his brother, Frederick C. Havemeyer. In 1828 William Frederick and his cousin, Frederick C. Havemeyer, Jr. took over the business under the firm name of W. F. & F. C. Havemeyer, Jr. They in turn were succeeded in 1841 by their brothers, Albert and Dietrich Michae Havemeyer under the name A. & D. Havemeyer. William Frederick assumed a role of prominence in New York City as President of the Bank of North America and the New York Savings Bank, Vice President of the Pennsylvania Coal Company and the Long Island Railroad, and as Mayor of New York for three terms elected in 1845, 1849, and 1892.[1]

Whether William and Albert shared the ownership of the house in this painting, or, as is more likely, Albert succeeded William in living here is unknown. Two prints exist of the house. One illustrated here, is entitled HAVEMEYER MANSION, NEW YORK, 1861[2], while the second is inscribed THE LAST OF THE HAVEMEYER ESTATE, UNION HOME & SCHOOL FOR SOLDIER'S CHILDREN.[3]

[1] Henry O. Havemeyer, _Biographical Record of the Havemeyer Family_ (New York 1944), pp. 25-44. The author, the son of Frederick Christian Havemeyer, Jr., was Electra Havemeyer Webb's father.
[2] The print was lithographed for D. T. Valentine's Manual for 1861 by George Hayward, 171 Pearl Street, New York.
[3] Lithograph by Major & Knapp, 449 Broadway, New York for D. T. Valentine's Manual, 1864. In this version the house lacks one story.

NIAGARA FALLS Fig. 430

H. 18¼"; w. 25" c. 1840
pastel on sandpaper
Inscribed, l.l.: "NIAGARA"
(cat. #27.3.2-13)

INDIAN AT NIAGARA FALLS

H. 17½"; w. 23"
oil on academy board
(cat. #27.1.2-43)

According to the past owner, this painting was found in Hartlan Vermont.

VIEW OF THROG'S NECK

H. 13⅜''; w. 17½'' December 24, 1795
watercolor on paper
Inscribed below: "View of Throg's Neck"
l.r.: "New York, December 24, '75"
(cat. #27.2.2-21)

This very competently painted scene depicts Throg's Neck, where the East River enters Long Island Sound between the Bronx and Queens. The artist, possibly Adriana Vethake, may have been one of the pupils of Archibald Robertson at the Columbian Academy in New York, founded the same year that this watercolor was done. Robertson came to America from Scotland in 1792, followed shortly by his brother, Alexander. The brothers are particularly remembered for their drawings of the New York area, many of which were the sources for fine aquatints.[1]

[1] See Old Print Shop *Portfolio*, August-September, 1950, pp. 2-7.

432.

FORT TOMKINS, SACKETS HARBOR Fig. 433

H. 11¾''; w. 17''
oil on wood (was a checkerboard with breadboard ends)
Inscribed, below: "FORT TOMKINS, SACKETS HARBOR"
On verso (tag): "Fort Tompkins/Sackets Harbor, on Lake Ontario, N.Y. was settled in
 1801. During the War of 1812 it served as a U.S. Naval station and was the
 scene of several engagements."
(cat. #27.1.4-21)

Despite the item on which this was painted, it is extremely well done.

LAKE CHAMPLAIN FROM WHITEHALL, NEW YORK Fig. 434

H. 3 13/16''; w. 8⅛'' 1837
pencil on paper
inscribed, l.l.: "Lake Champlain from Whitehall, N. York. 1837"
(cat. #27.8-3)

433.

VERMONT

BARNET AND McINDOES FALLS, VERMONT Fig. 435

H. 24''; w. 38¼'' c. 1875-80
oil on canvas
on verso: "Dawson/Vermont"
(cat. #27.1.2-100)

Erroneously once entitled "DAWSON, VERMONT", a town which does not exist, this scene really depicts Barnet and McIndoes Falls, Vermont, two towns southeast of St. Johnsbury. With McIndoes Falls village church on the left and the Barnet village church in the middle, the scene also includes Harvey Mountain in the center and Roy Mountain on the right. The painting must have been done after 1850, as the first trains ran through this area in October of that year. Possibly Peter Dawson, a resident of Barnet during this period, did this landscape.

434.

NEWBURY, VERMONT Fig. 436

H. 21½''; w. 25¾'' c. 1875-1880
oil on canvas
(cat. #27.1.2-98

This scene depicts another town on the Connecticut River, painted in a somewhat similar but not identical manner to BARNET AND McINDOES FALLS.

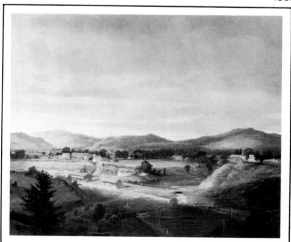

436.

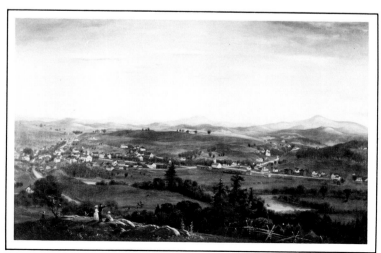

435.

171

EARLY STEAM LOCOMOTIVE CROSSING TRUSS BRIDGE AT BELLOWS FALLS, VERMONT Fig. 437

H. 18¼"; w. 24"
oil on academy board
(cat. #27.1.2-116)

Bellows Falls, in southeastern Vermont, is on the Connecticut River.

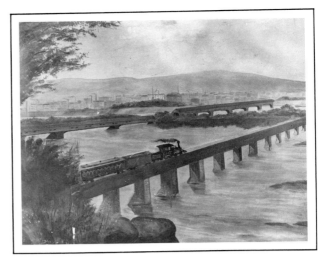

437.

VIEW OF BURLINGTON, VERMONT Fig. 457

H. 19"; w. 28"
pastel on paper
(cat. #27.3.2-8)

There are many similarities between this pastel and the drawing by Louisa M. Holt (see p. 80). It, too, was undoubtedly copied from an engraving entitled VIEW OF BURLINGTON, VERMONT although the artist has taken more liberty with the engraving by incorporating more of his own ideas. The reliance on the print fo inspiration explains why the artist has colored the Unitarian Church (on the right) white, rather than the red which the Churc Street brick building has always remained.

CASTLETON, VERMONT Fig. 438

H. 23"; w. 17" after 1841
oil on sheepskin parchment
(cat. #27.1.2-45)

This painting of Castleton, Vermont was done on the back of a diploma from the College of Medicine, Castleton, Vermont. By ar act of the General Assembly of Vermont on October 20, 1818, a charter was granted to a medical school to be called the Castle ton Medical Academy. The name of the institution changed twic — to the "Vermont Academy of Medicine" in 1822 and on Oc tober 22, 1841 to "Castleton Medical College". It prospered unt the 1850's when one of its foremost teachers, Dr. Joseph Per kins, moved to Burlington. Internal troubles and subsequent los of faculty caused its closing in 1854.[1] This painting was done aft 1841, depicting the village of Castleton, with the Castleton Rive in the foreground and Bird Mountain in the distance.

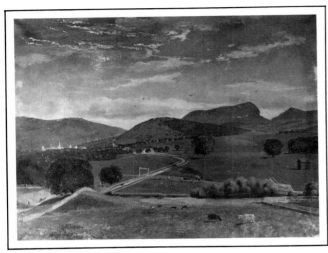

438.

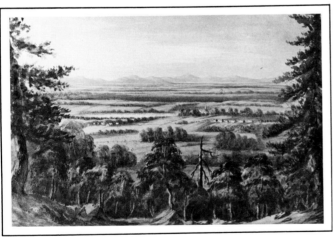

439.

[1] Abby Maria Hemenway, *Vermont Historical Gazeteer* (Claremont, New Hampshire: The Claremont Manufacturing Co., 1877), V. III, pp. 519-522.

VIEW ON LAKE CHAMPLAIN Fig. 439

H. 13"; w. 8¼"
watercolor on paper
(cat. #27.2.2-17)

Two sites have been suggested as the locale of this watercolor — Mount Philo and Mallett's Bay. The former appears the more likely.

LAKE CHAMPLAIN, TWIN BAYS Fig. 440

H. 20"; w. 32"
oil on canvas
Inscribed, l.l.: "LAKE CHAMPLAIN. TWIN BAYS"
Die impressed on stretcher: "PAT OCT 7 84/35 INCH
 PAT OCT 7 84/26 INCH"

(cat. #27.1.2-21)

The canvas on which this painting is done is very coarsely woven. The scene is nearly identical to that done by W. C. Addison, described on p. 23.

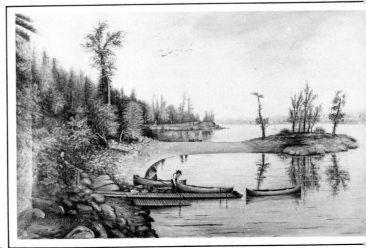

440.

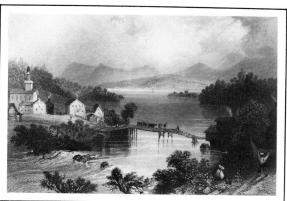

441.

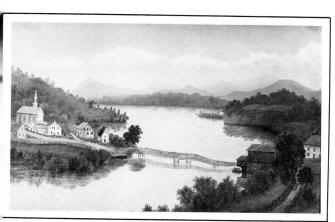

441.

OUTLET OF LAKE MEMPHREMAGOG Fig. 441

H. 12¼"; w. 20"
oil on academy board
(cat. #27.1.2-27)

Based on an engraving, this painting depicts a scene which
is now the site of Magog, Quebec, close to the Vermont
border. From an original drawing of the Outlet by William
Henry Bartlett, the scene was engraved by H. Alard and
published in London and also appeared in N. P. Willis'
Canadian Scenery Illustrated (London, 1842). An almost
identical version was published by Currier and Ives. A
painting similar to Shelburne's but encircled by an elabo-
rate ribbon and scrolls is in the collection of Old Sturbridge
Village.[1] Attributed to Joseph Miller, a coach painter from
Boscawen, New Hampshire, it is probably by a different ar-
tist than Shelburne's painting.

[1] Illustrated in Nina Fletcher Little's *Country Art in New England, 1790-
1840* (Old Sturbridge Village, Sturbridge, Massachusetts, 1960), p. 21.

MONTPELIER RAILROAD STATION Fig. 442

H. 8¾"; w. 13¾" after 1873
oil on canvas
on verso (in pencil): "Montpelier, Vt."
(cat. #27.1.6-2)

The Wells River Depot on Main Street in Montpelier, Vermont, com-
pleted in November, 1873, still exists, now occupied by State offices. A
locomotive and car alongside the station in this painting are marked "M.
& W. R." for the Montpelier and Wells River Railroad which ran its first
mail and passenger train on November 30, 1873. Behind the locomotive
in the foreground of the painting is a car owned by the Central Vermont
Railroad, a company which succeeded the Vermont Central Company
after it went bankrupt in 1873. Built by M. W. Baldwin in 1851, the
locomotive MIDDLESEX was originally No. 27, THE SAGUENAY of
twenty tons. The telegraph wires visible in the painting were first in-
stalled in 1849 by Cheney & Co. Express for the telegraph office in the
depot and were later taken over by Western Union and American Ex-
press.[1]

[1] Information from John Malvern of the Vermont Historical Society.

SHELBURNE TOWN HALL

H. 18½"; w. 23" c. 1926-27
pencil on paper
Inscribed, below: "Shelburne Town Hall/Shelburne, Vermont"
(cat. #27.8-63)

This drawing of the Shelburne Town Hall was probably done between
1926 and 1927 by the building's architect, James W. O'Connor of New
York City.

WINOOSKI RIVER ON A CLEAR DAY Fig. 443

H. 13"; w. 19¼"
oil on canvas
signed, l.r.: "L. H. H./Dec. 1871"
(cat. #27.1.2-118)

This competently painted landscape of Vermont's Winooski River was
done by an anonymous artist with the initials L. H. H. A covered bridge
and village appear in the distance.

442.

443.

Landscapes — Anonymous Sites

AMERICAN DREAM Fig. 444

H. 7⅜″; w. 9⅜″ c. 1827
watercolor and cutouts on paper
(cat. #27.2.2-6)

Some of the figures in this painting — a carriage, horses, a man, and an Indian — have been cut from a wood engraving and pasted on paper. The remainder of the work has been done in watercolor. Despite the unnatural proportions, the effect is charming.

RIVER TOWN

H. 8″; w. 10″
white chalk and charcoal on sandpaper
(cat. #27.3.2-6)

WHITE CHURCH WITH GOTHIC SPIRE AND SEVEN SHEEP

H. 16″; w. 20″
oil on canvas
Gift of Julian Hatch, 1960
(cat. #27.1.2-47)

444.

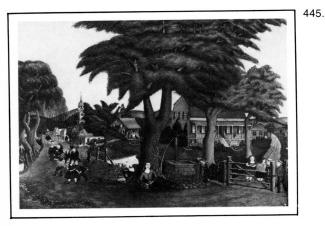

A DAY IN THE COUNTRY SUMMER Fig. 445

H. 19″; w. 27″ c. 1870
oil on canvas
on verso (label): "A Day in the Country Summer"
Given in memory of Mrs. P. H. B. Frelinghuysen by Mr. and Mrs. Peter F. Carleton, 1964
(cat. #27.1.7-24)

Here is a scene in which a print was used by an amateur painter to create this oil painting — a far from dry copy.[1] The interpretation reveals the artist's own imagination. The recalcitrant, demure girl placidly reclining against the tree in the lithograph has been transformed in this oil version into a buxom and sensuous woman. The artist painting by the bridge in the lithograph, in the painting looks toward the alluring girl. There are other obvious differences — a lack of perspective and brighter colors in the oil perhaps being the most noticeable. Each is special in its own way.

[1] The lithograph, entitled HOME IN THE COUNTRY, was published by Haskell and Allen, 15 Hanover Street, Boston, between 1871-1875. (Shelburne Museum cat. #27.6.2-34). Two Currier and Ives lithographs drawn by Fannie Palmer, THE OLD OAKEN BUCKET and THE VILLAGE BLACKSMITH, incorporate elements of the same design.

MY HOME Fig. 446

H. 22½″; w. 21½″ c. 1810
oil on wood
Inscribed, l.c.: "My Home"
(cat. #27.1.2-5)

This naive but charmingly painted scene has been sentimentally inscribed "My Home."

445.

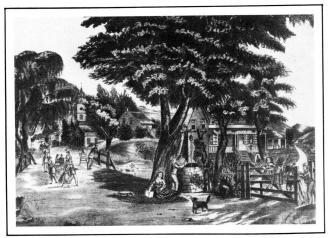

445. HOME IN THE COUNTRY, lithograph by Haskell & Allen, Shelburne Museum Collection

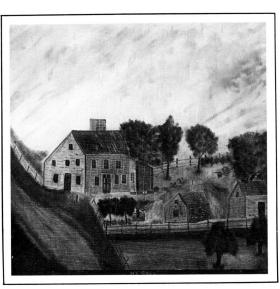

446.

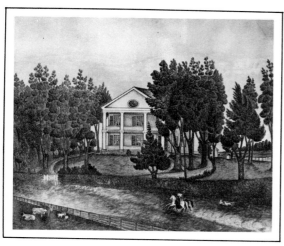

447.

Fig. 447

H. 10¼″; w. 12¾″ c. 1837
watercolor on paperboard
(cat. #27.2.2-11)

FANTASTIC LANDSCAPE

H. 18″; w. 28″
oil on canvas
Gift of: Redfield Proctor, 1959
(cat. #27.1.2-129)

CHATEAU

H. 16″; w. 20″
oil on canvas
on verso (label): "17″ × 18″ Nassau Street/Mortimer W."
(cat. #27.1.2-146)

This painting of a chateau with many leveled roofs and chimneys was painted by an anonymous artist quite recently.

C _____ Y, M. L.

FISHERMAN'S HOME

H. 9″; w. 12″
oil on academy board
on verso: "#16 Fisherman's Home"
(cat. #27.1.2-124)

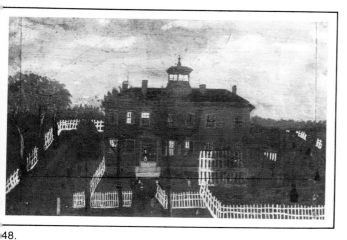

48.

449.

RED MANSION Fig. 448

H. 18¾″; w. 30″
oil on wooden breadboard
(cat. #27.1.6-3)

Painted on two boards fastened together at the back and with breadboard ends, this scene is of a charmingly detailed red mansion with a lighted tower. A man in a top hat stands at the door.

LAKE TOWN IN THE MOUNTAINS Fig. 449

H. 25″; w. 32″
oil on canvas
(cat. #27.1.2-102)

It has been suggested that the scene depicted in this painting is in Canada. It could as easily be a site in any of the American states bordering on Canada.

WINTER SCENE Fig. 450

H. 8⅞″; w. 10″ c. 1830
oil on academy board
(cat. #27.1.2-1)

Found in Connecticut, this painting is thought to be the work of a young person.

450.

TWO COVERED BRIDGES OVER CANAL WITH BARGES Fig. 451

H. 6"; w. 7½" c. 1840
watercolor on paper
(cat. #27.2.2-4)

While found in Connecticut, the location of this scene is unknown.

HORSES ON A COUNTRY ROAD

H. 12½"; w. 14"
oil on canvas
on verso (stencil): "FROM/M. J. WHIPPLES/Artist's Supply Store,/35 CORNHILL/BOSTON"
Gift of: Redfield Proctor, 1954
(cat. #27.1.2-123)

THE GOOD SAMARITAN

H. 13⅝"; w. 17 5/16" c. 1815
watercolor on paper parchment
Inscribed, l.c.: "St. Luke/10th Chap./33 verse"
(cat. #27.2.6-3)

Found in South Wales, New York, this watercolor transposes a Biblical scene to a contemporary site.

451.

452.

453.

M., E.

LAKESIDE RESORT HOTEL AND SIDEWHEELER S.S. THE BELL Fig. 452

H. 19"; w. 24"
oil on canvas
signed, l.r.: "E. M."
(cat. #27.1.2-97)

This painting, by the unknown "E. M." was once called RESORT HOTEL ON LAKE CHAMPLAIN, but probably depicts a scene on Lake George.

SEATED INDIAN WATCHING SAILBOATS

H. 8⅞"; w. 11¼"
white chalk and charcoal on tan paper
(cat. #27.3.2-11)

An Indian on a fallen tree trunk looks down from a high hillside to a lake with four sailboats in the distance in this very romanticized chalk drawing.

LAKE SCENE WITH INDIANS #1 Fig. 456

H. 26¾"; w. 31¾" c. 1880
oil on canvas
(cat. #27.1.2-36)

LAKE SCENE WITH INDIANS #2 Fig. 453

H. 28¾"; w. 36¼" c. 1880
oil on canvas
(cat. #27.1.5-25)

These paintings of the same scene were undoubtedly copied from a print by two different artists. A third version is said to be located in Arlington, Vermont. Number One has been painted with such meticulous detail that it bears a resemblance to embroidery. The stylized rhythm and bright colors of this painting make the muted tones and indistinct drawing of Number Two dull by comparison.

454. PATRICK HENRY

455. GIRL IN GREEN

456. LANDSCAPE WITH INDIANS #1

457. VIEW OF BURLINGTON, VERMONT

458. SUFFRAGETTES TAKING A SLEIGH RIDE ON THE CONSTITUTION

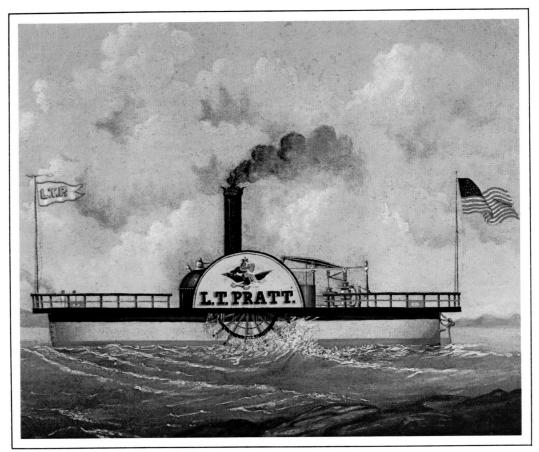

459. THE "L.T. PRATT"

460. AUSABLE CHASM

461.
KING PHILIP

462. GEORGE WASHINGTON

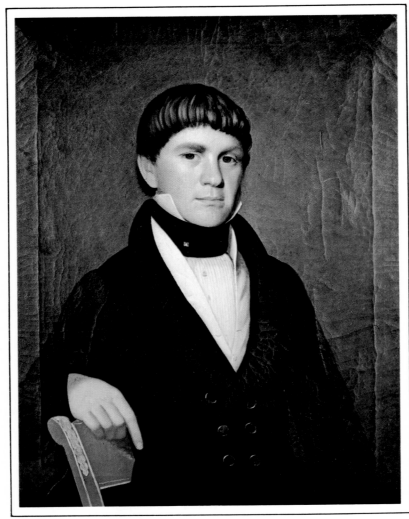

463. YOUNG MAN WITH HALF-MOON HAIR CUT

Miscellaneous Subjects

464.

SUFFRAGETTES TAKING A SLEIGH RIDE ON THE CONSTITUTION Fig. 458

H. 20"; w. 36" c. 1870 – 1890
oil on canvas
(cat. #27.1.5-25)

After the revolution the Constitution gave states the right to grant suffrage to women. New Jersey did so until 1807, after which no state allowed the practice until the Wyoming Territory gave women the vote in 1869. In that year Susan B. Anthony and Elizabeth Cady Stanton founded the National Woman Suffrage Association which in 1890 united the American Woman Suffrage Association. In 1890 several states granted women their voting rights. This painting appears to date from this early period in the movement, long before the Nineteenth Amendment was passed August 26, 1920. The suffragettes were subjected to ridicule and humility, harangued by their husbands and lampooned by cartoonists. Illustrations of their unruly behavior often appeared in print, and this painting may have been done after one of these magazine or newspaper illustrations. An 1856 engraving shows a sleigh that is similar to the one depicted here.[1] The painting has great charm, showing the gallantry and determination of the women in their campaign for the right to vote. Undoubtedly the artist was untutored, but with a sense of humor and an excellent concept of design. One interesting detail is that the only by-stander who gives them any notice is a black man.

[1] See *American Heritage* (December, 1958), Vol. X, No. 1, pp. 110-111.

BEHOLD WITH BOLDNESS HERE I STAND

H. 11⅜"; w. 13⅜"
watercolor and ink on paper
(cat. #27.9-4)

In feeling somewhat reminiscent of the Pennsylvania German frakturs, this watercolor includes a female figure with a parasol in one hand and a laurel branch in the other, standing between two tulip trees. The inscription, carefully lettered beneath her reads:

Behold with boldness here I stand,
My cause is right, though some may judge,
Go not abroad to tattle much,
If I am wrong, let me alone.
And hold the laurel in my hand,
And many at my honor grudge
Nor in your dwellings welcome such
And mind the business of your own.
Keep within compass
To avoid many evils,
If others do evil
There's nothing can hurt you
And your will be sure
Which others endure
Pray let them alone
But sins of your own.

BOSTON MASSACRE Fig. 464

H. 8"; w. 9¼" c. 1775
watercolor and ink on paper
(cat. #27.2.6-8)

This watercolor of the Boston Massacre was copied from an engraving by Paul Revere inscribed "The Bloody Massacre perpetrated in King St., Boston, March 5, 1770 by a party of the 29th Reg." Originally colored by hand, Revere published the engraving almost immediately after the event. His engraving, however, was undoubtedly done from an original drawing by Henry Pelham. Several other engravings of the event exist, including a smaller version probably also by Revere, another published in London, one by Jonathan Milliken (Mulliken) of Newburyport, Massachusetts, and a woodcut printed in 1772 for a Massachusetts calendar or Almanac. To further complicate the matter, later reprints exist.[1]

[1] See George H. Sargent, "Paul Revere's 'Boston Massacre' ", The Magazine *Antiques*, March, 1927, pp. 214-216.

OUR FLAG IS THERE Fig. 465

H. 15"; w. 19½"
oil on canvas
(cat. #27.1.4-68)

Assigning a date to this puzzling painting is extremely difficult. The flag has twenty stars and thirteen stripes, indicating a date of 1818. In April of that year President Monroe signed a bill giving the official United States' flag thirteen stripes with a star for each state in the Union. On December 3, 1818, Illinois became America's twenty-first state. The uniforms worn by the soldiers in the painting appear to be of the Civil War period except for the officer in the tall hat who wears a style popular during the Mexican War. The cannon is a type invented by Admiral John Adolphus Bernard Dahlgren before the Civil War, while the title suggests the Star Spangled Banner which was written in 1814!

465.

185

466.

VICTORY — CUTWORK EAGLE Fig. 466

H. 13″; w. 16⅛″
paper cutout with ink and watercolor
Exhibited: Abby Aldrich Rockefeller Exhibition, July, 1964
(cat. #27.15-1)

An elaborate relation of the silhouette technique, this intricate art is called papyrotania or "scherenschnitte", meaning to cut stiff paper into ornamental designs. Done by the Chinese centuries ago, the art was revived in Europe in the seventeenth century to portray religious subjects primarily. This example is undoubtedly American.

A GAME OF DICE Fig. 470

H. 6⅝″; w. 8⅜″ 18th c.
oil on canvas
Gift of: Miss Helen Shahda, 1959
(cat. #27.1.7-5)

PRIZE BIRD Fig. 467

H. 6⅝″; w. 8⅜″ 18th c.
Gift of: Miss Helen Shahda, 1959
(cat. #27.1.7-4)

The frames of these two early paintings are probably from Continental Europe and appear to be original. In both works the fixed expressions on the boys' faces remind one of the paintings of the early Italian Renaissance.

ROOSTER

H. 4″; w. 3¹/₁₆″
watercolor on paper
(cat. #27.2.5-9)

DOGS

H. 25½″; w. 32¼″
oil on canvas
signed, l.r.: "Alfred D. Drewy (?) '98"
(cat. #27.1.5-52)

DUCK HUNTING Fig. 468

H. 19⅜″; w. 25″
oil on canvas
(cat. #27.1.5-2)

SHEPHERD AND SHEPHERDESS IN ARCADIA

H. 8⅜″; w. 12″
pencil on paper
(cat. #27.8-10)

Before a classical building a shepherd and shepherdess tend their flock of sheep.

JAMES HERVEY CARTER, PEDDLER (1831 – ?)

H. 16″; w. 26″
oil on canvas
Gift of: Mrs. Paul Moore, 1959
(cat. #27.1.7-6)

This brightly painted peddler's cart has been decorated with several scenes, including a landscape of a lake. The owner, James Hervey Carter, has his name proudly displayed on the cart's side as well as on the storage trunk in the rear. Carter and his brother, Henry Wood Carter, were the sons of William and Persis (Wood) Carter. Henry, the older of the two, was a Lebanon, New Hampshire merchant who was known for his brightly colored wagons, made by the Abbot, Downing and Co., carriage manufacturers in Concord, New Hampshire. James apparently worked for his brother. In 1855 Henry ordered a carriage with instructions to have a large picture of "Carter's three teams" going up Mount Washington painted on one side — his own team with bay horses, R. W. Holmes' team with black horses, and J. H. Carter's "roane (sic) colored horses" pulling a carriage with a red body and straw running gear.[1] In Shelburne's painting the carriage body is straw and wheels are red. Henry Carter later operated H. W. Carter and Sons' Clothing Factory, still in operation in Lebanon today.

[1] Order for H. W. Carter's Carriage, 1855, in the Abbot-Downing Collection, New Hampshire Historical Society.

BURLINGTON 1, STEAM LOCOMOTIVE

H. 8¼″; w. 11″
colored pencil on paper
Inscribed (bottom): "This engine runs a wood train on the southern end of R.R."
(cat. #27.8-11)

Built by the Taunton Locomotive Works in Massachusetts in 1849, this locomotive was one of the original engines of the Rutland Railroad. Rebuilt at Rutland in October, 1865, it was leased to the Vermont Central Railroad in 1870 and scrapped in 1887.

467.

468.

ENGINE "44"

H. 6½"; w. 17¾"
colored pencil on paper
(cat. #27.8-66)

This very detailed and beautifully drawn engine of the New York, New Haven and Hartford Railroad must have been done after 1873 when the Hartford and New Haven, and New York and New Haven Railways, merged. With rails covering over 2,000 miles of land in New York, Rhode Island, Connecticut and Massachusetts, the New York, New Haven and Hartford includes the first three miles of rails laid in the United States.

EARLY RAILROAD STEAM ENGINE

H. 18⁹/₁₀"; w. 29½"
watercolor on paper
(cat. #27.2.6-19)

This intricately done watercolor in pastel tones is technically very accurate.

RAILROAD ENGINE AND TENDER "CENTRAL VERMONT 40"

H. 17"; w. 29" 1870 – 1875
watercolor on paper
(cat. #27.2.6-20)

Done in very bright colors, this watercolor of an engine has "Gov. Smith" painted on the cab and "Central Vermont 40" on the tender. The train, built in 1852, was originally named IRON HORSE and renamed GOV. SMITH in 1869. John Gregory Smith, whose family had controlled the Central Vermont Railroad from its inception, was the President of the Railroad from the 1860's to 1891 and Governor of Vermont from 1863 to 1865. The GOV. SMITH was a 4-4-0 type of engine with sixty-six inch driving wheels. She no doubt covered most of the 900 miles of track operated by the Central Vermont, extending from New London, Connecticut; through Vermont; west to Ogdensburg, New York; and north to Canada.

470.

471.

469.

EAGLE WITH SNAKE Fig. 469

H. 28"; w. 41" c. 1830's
oil on canvas
Exhibited: Loan Exhibition of the Karolik Private Collection of Early 19th Century Paintings
 to Six Midwestern Museums, 1953
(cat. #27.1.5-28)

When the eagle was proclaimed the official emblem of the United States in 1782 his popularity soared. Never has a bird been translated into so many idioms. Adorning the Great Seal of the United States, the President's flag, currency, and innumerable official documents, the majestic bald eagle has been fashioned by hand and machinery out of and into almost every imaginable material. Shelburne's collection abounds with the eagle motif, depicted on textiles, glass, ceramics, wood, and canvas. In this example, the eagle seems transfixed in space, protecting America, its land and people. The painting may have been inspired by a print entitled A VIEW OF NEW ORLEANS FROM THE PLANTATION OF MARIGNY which depicts an eagle holding a banner inscribed, "Under My Wings Everything Prospers."[1]

[1] Illustrated in Kennedy Galleries publication, *Notable American Prints from the Collection of Henry Graves, Jr.*, May 7-31, 1959, p. 8, illustration #14. Dated 1803, the print was done by Bouqueta de Woiseri.

TWO OWLS ON A LIMB

H. 25"; w. 31" late 19th c.
oil on canvas
(cat. #27.1.5-45)

WOMAN STANDING IN A GAZEBO

H. 12¾"; w. 8½" (size of arch-shaped opening)
watercolor on paper
(cat. #27.2.2-22)

TINKLE Fig. 323

H. 23¾"; w. 18" 1883
oil on academy board
Inscribed on verso: "April 1883
 (label) "F. W. Devoe & Co. Academy Board/F. W. Devoe &
 Co./Manufacturers of Artists' Tube Colors/Canvas, Oil-sketching
 paper, Millboards,/Fine Bristle and Sable Brushes,/Paints, Varnishes,
 & c./Cor. Fulton and William Sts., New York."
 (Pencilled on label): "Tinkle Born Febr 1881"
(cat. #27.1.5-26)

The affection and sentiment which pets engender seem to emerge with regularity as visitors pass by this painting of a sleek, white cat. Born in February of 1881, Tinkle was two years and two months when she "sat" for her portrait.

COURSED HARE DOUBLING Fig. 471

H. 23⅛"; w. 28 1/16"
oil on canvas
(cat. #27.1.5-4)

This hunting scene is probably English. While primitive, it is painted with a good deal of spirit and vivacity. It was no doubt inspired either by the English engraving IN FULL CHACE after James Seymour which also served as a model for two mantle paintings in Massachusetts — one in Franklin and the other in East Douglas[1] — or a painting by the English painter John Nott Sartorius entitled A LANDSCAPE WITH HUNTING SCENE, dated 1798.[2]

[1] Illustrated in Nina Fletcher Little's "English Engravings as Sources of New England Decoration," *Old-Time New England*, Spring, 1964, pp. 103-104.
[2] Sotheby Parke Barnet catalogue "Important Old Master Paintings", Sale Number 3734, March 6 and 7, 1975, #23.

472.

DANIEL BOONE'S SISTER AND FRIENDS CHASED BY INDIANS

H. 11¼″; w. 17¾″ c. 1830
oil on canvas
on verso: "Daniel Boone's sister and friends chased by Indians"
Gift of: Mrs. Brooks Shepard, 1958
(cat. #27.1.1-28)

This painting was copied from an illustration entitled
YOUNG GIRLS FLEEING FROM INDIANS done by Jean
Francois Millet and Karl Bodmer for James Fenimore
Cooper's *The Last of the Mohicans* in 1826.[1] In the book
there is also an illustration called DELIVERANCE FROM
INDIANS OF THE DAUGHTERS OF DANIEL BOONE by
the same artists.[2] At some point in this painting's history
the two titles were apparently confused.

[1] Illustrated in Benjamin Poff Draper, "American Indians — Barbizon
Style," *The Magazine Antiques*, September, 1943, p. 109.
[2] *Ibid.*, p. 110.

474.

475.

H. 14¾″; w. 11½″
pen and ink on Bristolboard.
marking, u.l.: stamped with crown and "Reynolds Bristolboard"
(cat. #27.9-44)

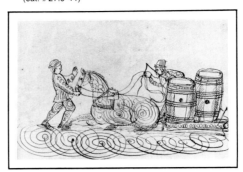

473.

RABBIT CROUCHED BEFORE SINGLE FLOWER

H. 2⅞″; w. 7⅜″
brown ink on paper
on verso: "G. J. Beetdenyder" (?)
Gift of: George Frelinghuysen, 1974
(cat. #27.9-62 a)

MAN WITH WALKING STICK AND COW

H. 2¼″; w. 7⁵/₁₆″
brown ink on paper
Gift of: George Frelinghuysen, 1974
(cat. #27.9-62 b)

HORSE PULLING TWO BARRELS ON A SLED Fig. 473

H. 6⅜″; w. 8¼″
brown ink on paper
Gift of: George Frelinghuysen, 1974
(cat. #27.9-62 c)

SHOOTING DUCKS

H. 4¾″; w. 7¼″
brown ink on paper
Gift of: George Frelinghuysen, 1974
(cat. #27.9-62 d)

PEACOCK AND DOG BEFORE A FOUNTAIN

H. 6⅝″; w. 8¼″
brown ink on paper
Gift of: George Frelinghuysen, 1974
(Cat. #27.9-62 e)

These five pen and ink drawings have been drawn care-
fully, very much like calligraphy work.

ACROBATIC CIRCUS RIDERS Fig. 474

H. 14½″; w. 17¼″
watercolor on paper
(cat. #27.2.6-31)

This very sprightly and gay watercolor is very flatly
done with bold outlines and considerable verve.

HIAWATHA'S WOOING Fig. 475

H. 14⅛″; w. 17⅛″ c. 1875
pastel on sandpaper
Gift of: Mrs. Emmie Chambers
(cat. #27.3.1-26)

From the white man's first contact with the North American continent th
Indian evoked a sense of romance and adventure, curiosity, respect,
and fear. In this painting, based on Henry Longfellow's poem *Hiawath*
of 1855, an appealing tale of Indian romance has been portrayed. Un-
doubtedly based upon a print, the painting depicts the moment when th
Ojibway hero, Hiawatha, with a freshly killed deer over his shoulder, firs
encounters Minnehaha (Laughing Water), seated with her father "The
Ancient Arrow-maker" before their tepee.

Mourning Pictures, Acrostics, and Family Genealogies

76.

477.

M., J. P. (active 1832)

IRA BLANCHARD ACROSTIC Fig. 476

H. 8½"; w. 6½" 1832
pen, ink and watercolor on paper
signed, l.r.: "J. P. M. 1832"
(cat. #27.2.6-12)

LINCOLN BLANCHARD
ACROSTIC Fig. 477

H. 8½"; w. 6½" 1832
pen, ink, and watercolor on paper
signed l.c.: "Mr. L. Blanchard, died Feb.ʸ 17, 1815. AE
 19 years and 23 days, J. M. P. 1832"
(cat. #27.2.6-11)

Lincoln and Ira Blanchard were the sons of James and Mary (Shute) Blanchard, and were natives of Searsport, Maine. Lincoln died at age nine, not nineteen, and never left Searsport.[1]

[1] Information from Mr. and Mrs. J. Crawford Hartman, letter of August 27, 1961, Shelburne Museum, MSS

CHURCH FAMILY REGISTER

H. 22"; w. 17¾" after 1851
watercolor and ink on paper
(cat. #27.2.6-15)

Two grey pillars frame this picture, and blue grapes, green leaves and tendrils grow from them, forming an arch at the top of this family register. The names and dates of birth of members of the Church family are contained within wreaths between the pillars, while their death dates are entered beneath each wreath. The top wreaths contain the names of the parents of the family, Asa Church and Juliette Humphrey, married October 29, 1789. Asa was born in Mansfield, Connecticut on May 16, 1766 and died September 11, 1847. The entries include fourteen members of the family, most of whom were born in Chelsea or Jericho, Vermont.

MEMORIAL TO SALLY FARNHAM (1765 – 1816)

Fig. 478

H. 5⅜"; w. 7" 1816
ink and cutout, printed material on paper
inscribed on the memorial: "In/MEMORY OF/SALLY
 FARNHAM/who died June 15, A.D.
 1816, Aged 51."

(cat. #27.9-48)

The inscription on the tomb of this mourning picture has been commercially printed, cut out, and pasted on paper. The urn above it, while also cut from separate paper, is hand done in brown ink as is the remainder of the drawing. On the reverse, six generations of Sally's descendants are listed in pencil. Sally, who married Avery Farnham, was born in 1765 and died June 15, 1816.

MOURNING PICTURE OF LEWIS GEORGE

H. 12¼"; w. 15" c. 1814
watercolor on paper
Inscribed: "Sacred to the/Memory of/Lewis George/who Died
 April 16th/1814. Aged 59 years."
(cat. #27.2.6-2)

478.

MOURNING PICTURE TO RUFUS B. HOVEY AND HIS WIFE POLLY KENDALL

H. 19¾"; w. 20¼" c. 1885
pastel and pencil on sandpaper
Inscribed: "To the Memory of Rufus B. Hovey/Born November 10, 1794/Died
 January 9, 1844/and/Polly Kendall, his wife, Born July 7, 1797/Died
 September 20/1885"
Gift of: Judge Clarence P. Cowles, 1949
(cat. #27.3.2-12)

Rufus B. Hovey was a son of Rufus C. Hovey of Brookfield, Vermont, who with his wife Polly Kendall and several of his siblings, settled in Albany, Vermont in 1827. Rufus served as town selectman in 1829, 1830, 1833, 1834, and 1838, and as town representative to the Assembly in 1835 and 1837.[1]

[1] See Abby Maria Hemenway, *The Vermont Historical Gazeteer* (Claremont, New Hampshire, 1877) V. III, pp. 64 and 67.

MOURNING PICTURE FOR DAVID NICHOLS, JR.

Fig. 479

H. 15"; w. 19" c. 1833
watercolor on paper
Inscribed on tomb: "In Memory of David Nichols, Jr. who died
December 25, 1833. Aged 12 years 10
months. Though brief thy course on earth
below, Thy days were marked with every
grace,/And Kindred tears for thee shall
flow,/While angels guard thy resting place."

(cat. #27.2.6-13)

MOURNING PICTURE FOR OBADIAH NICHOLS

Fig. 480

H. 18½"; w. 24" 1812
watercolor on paper
Inscribed on urn: "Sacred to/the Memory of/Obadiah
Nichols/lost at sea Dec 1812/Aged 31 years"
on pedestal below: "Remember/that we are
mortal"

(cat. #27.2.6-14)

479.

480.

Both of these memorial pictures were found in Providence, Rhode Island. The palms and ship in the distance in Obadiah's painting probably indicate that he died at sea in a tropical climate.

481.

482.

MOURNING PICTURE TO MRS. MARY THOMAS

H. 13"; w. 15"
watercolor on paper
Inscribed on tomb
(cut from printed text): "In memory of a beloved Mother, Mrs.
Mary Thomas. Died May 27th, 1808, age
67. The sweet remembrance of the just
shall flourish while they sleep in dust."
Gift of: Mr. Sargent Bradlee, 1974 (Mrs. Thomas'
great-grandson)
(cat. #27.2.6-30)

WASHINGTON FAMILY TOMB Fig. 481

H. 31½"; w. 30" c. 1831-37
oil on canvas
(cat. #27.1.6-9)

This is the "New Tomb" of General George Washington as it appeared be-
tween 1831 and 1837. The bodies of General and Mrs. Washington were
placed in the "Old Tomb" until 1831 when Washington's surviving executors
compiled with a provision in his will directing the building of this vault at the foo
of a vineyard enclosure. In 1837 a marble sarcophagus was provided for
Washington's casket which proved too large for the vault depicted here. An
outer, open vault in which the bodies now rest was added and the entire struc-
ture enclosed by a brick wall.[1] The tablet above the doorway is still in place
inscribed, "I am the resurrection and the Life."

[1] Information from a letter of May 25, 1947 from the Mount Vernon Ladies' Association of the Unio
Mount Vernon, Virginia, Shelburne Museum MSS.

MOURNING PICTURE IN MEMORY OF THE LATE LAMENTED GEORGE WASHINGTON Fig. 482

H. 13½"; w. 12½" c. 1800
watercolor on paper
Exhibited: "American Folk Art," Downtown Gallery, May, 1954
(cat. #27.2.6-7)

This mourning picture, found near Kingston, Massachusetts, depicts a monu
ment inscribed:
Born 1732 — Died 1799
First in War — First in Peace
First in Fame — First in Virtue

Sacred to the Memory of the Late great & good George Washington, Firs
President of the Thirteen United States of America. Respectively Adresse
(sic) to the people of Massachusetts, Connecticut, New York,
Pennsylvania, Delaware, Maryland, Virginia, North Carolina, South
Carolina, New Jersey, Georgia, Kentucky, New Hampshire.
Since the artist has omitted Rhode Island and Vermont but has included Ken
tucky in this carefully done memorial, it must date after 1792 when Kentucky
joined the Union.

Still Life Paintings

FRUIT ON MARBLE

Fig. 483

H. 24"; w. 30" c. 1865
oil on canvas
(cat. #27.1.3-1)

This marvelous still life was found in
Maine where it probably originated.

FLOWERS IN A TUMBLER

Fig. 484

H. 8⅞"; w. 9⅜" c. 1820
watercolor and pencil on paper
Exhibited: "Amateur Art of the 19th Century"
 Downtown Gallery, September,
 1952
(cat. #27.2.3-1)

Found in Connecticut, this painting
contains a daisy, carnation, sweetpea,
butterfly, and ladybug which were first
drawn in pencil and then filled in with
watercolor.

STENCILED ROSE DESIGN

H. 10¼"; w. 13¾"
oil stencil on linen
(cat. #27.1.3-4)

In this stenciled design a rose "tree" is
surrounded by other rose motifs.

STILL LIFE WITH PEACHES

H. 9¼"; w. 11½" c. 1860
pastel on paper
Gift of: W. C. Atkins in memory of his sister Miss Flora Atkins,
 1950
(cat. #27.3.3-4)

This painting was found in the Atkins'
home in Cabot, Vermont and was done by
the donor's father, mother or aunt.

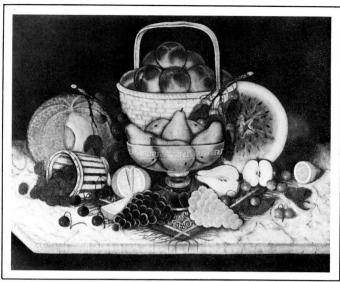

483.

484.

485.

BOWL OF FRUIT

Fig. 485

H. 7⁷⁄₁₆"; w. 9⁷⁄₁₆" c. 1785
watercolor, ink, pin prick and material on paper
(cat. #27.15-6)

This still life is probably English. Swatches of mate-
rial have been pasted on the paper to imitate flower
petals, while the fruit and bowl have been painted.
This kind of work forms a bridge between the nee-
dlework and drawing frequently taught at young
ladies' seminaries. Pinpricking, used to outline the
design here, was a popular technique used in late
nineteenth century valentines.

486.

STILL LIFE WITH BASKET OF FRUIT

Fig. 486

H. 18″; w. 30″
oil on canvas
(cat. #27.1.3-17)

VASE OF FLOWERS WITH BIRD NEST

H. 21¾″; w. 13¼″
reverse painting on glass with silver foil,
backed by canvas
Gift of: Julia Sargeant Estate, 1962
(cat. #27.11-1)

In this unusual reverse painting on glass, areas have been unpainted to expose silver foil placed between the glass and a canvas backing, creating a glittery effect.

COLUMBINES

H. 11½″; w. 9″
watercolor on paper
(cat. #27.2.6-25)

FULL BLOWN ROSE

Fig. 487

H. 8½″; w. 7″
oil stencil on paper
(cat. #27.10-1)

ALABASTER VASE OF FLOWERS AND A BAR OF MUSIC

Fig. 488

14¾″; 11⅜″ c. 1840
Imprint on paper of three Prince of Wales Feathers surmounted with the words ''Bristol Board''
(cat. #27.2.3-4)

WILD GAME, OYSTERS, LOBSTER WITH TWO LIVE CANINES

H. 26″; w. 22″
oil on canvas
Gift of: Mrs. Brooks Shepard, 1958
(cat. #27.1.3-3)

Because the canvas used for this painting is handwoven, it probably dates between 1820 and 1830. While fairly primitive, the painting, by an anonymous artist, portrays several still-life objects realistically.

FRUIT IN A BASKET

Fig. 489

H. 18″; w. 23″ c. 1845-50
watercolor on paper
(cat. #27.2.3-3)

This watercolor was found in New Jersey.

487.

488.

489.

Marine Scenes

CLIPPER SHIP "ISAAC WEBB," NEW YORK

Fig. 490

H. 16"; w. 21½" 1851
watercolor on paper
Inscribed, below: "Clipper Ship 'ISAAC WEBB' New York, 1851"
(cat. #27.2.4-8)

The ISAAC WEBB was one of the last packets of the Black Ball Line, the first Yankee company to establish a regular schedule between England and America. Beginning in 1818 and consisting of four ships owned by five associated merchants, the line eventually kept thirty-nine packets in regular operation. Normally a ship left Liverpool, England on the first of every month, while another left New York on the tenth. William H. Webb, builder of the last ten packets on the line, named the ISAAC WEBB after his father whose ship building business he took over in 1840. The Black Ball Line ceased operation in 1878.

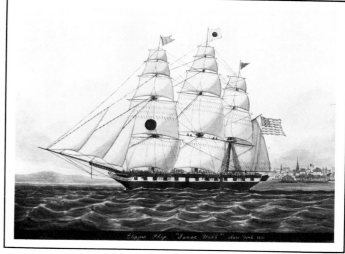

490.

BRITISH-AMERICAN NAVAL BATTLE

Fig. 491

H. 20"; w. 24"
oil on canvas
(cat. #27.1.4-44)

This competently painted naval scene depicts two British and two American vessels engaged in battle.

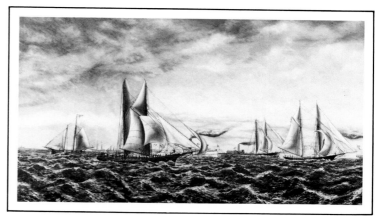

492.

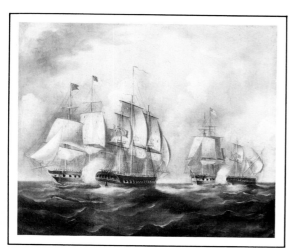

491.

SAILS AND STEAM

Fig. 492

H. 27"; w. 48"
oil on canvas
(cat. #27.1.4-78)

In this well done painting, four large sailboats and three steamboats, one of which is the RIVER QUEEN, ply the rough blue water.

S.S. ARROW

Fig. 493

H. 9½"; w. 23⅛" c. 1840
oil on wood
(cat. #27.1.4-16)

The ARROW, running between Haverstraw and Nyack, New Jersey and New York City, was originally built by Lawrence and Sneden in New York City in 1837. Commanded by Captain Isaac Smith, she originally weighed 290 tons. Enlarged to 363 tons, the ARROW became known as BROADWAY, later GEORGE WASHINGTON, and in 1865 again became the ARROW. In that year her boiler exploded on August 5 off Haverstraw, New York, halfway between Peekskill and Tarrytown, killing five persons. Her machinery was recovered from the sunken wreck and later installed in the new CHRYSTENAH.

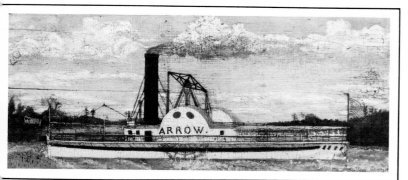

93.

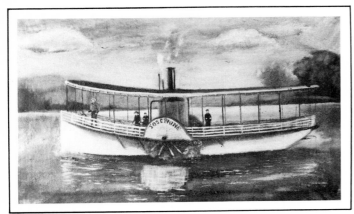

494.

STEAM PACKET ROYAL TAR Fig. 495

H. 30⅜"; w. 21¾" overall; painting is 11 × 17⅜"
Oil painting on black, metal tray
(cat. #27.1.4-84)

This painting of the ROYAL TAR has been done in the center of a large, metal tray. The ROYAL TAR, named for King William III of Great Britain, was built by William and Isaac Olive of Carleton, New Brunswick, Canada, and was launched November 9, 1835. Operating first between St. John, New Brunswick and Boston, she was 164 feet long, 24 feet across the beam, weighed 400 tons, and cost $40,000 to build. Her first trip was made in May of 1836. On October 21 of that year she was on the St. John to Portland, Maine run, carrying a crew of twenty-one, seventy-two passengers, the Burgess collection of serpents and birds, Dexter's locomotive museum, a brass band, and many animals including an elephant, two camels, a gnu, two lions, a Siberian tiger, horses, a leopard, and a pair of pelicans. Forced by a high northwest wind to seek shelter near Fox Island, the boat was soon discovered to be on fire, caused by an overheated boiler. The smoke was so intense that within five minutes the crew could not work the fire pump. Slipping anchor, they tried to head for shore under jib and fore-sail, both of which promptly caught fire causing the packet to be blown toward the sea. Sixteen of the passengers and crew took the larger life boat but because of the wind could not get close enough to save the others. The Captain, Thomas Reed, took command of the other boat and with a crew of two saved some of the other passengers. Fortunately a distress signal was seen by the crew of the U.S. Revenue cutter VETO, who managed to rescue some of the others. Thirty-two lives were lost, including four members of the crew; the elephant jumped overboard with some of the passengers clinging to his back and was swept out to sea, as were some of the horses. All of the other animals perished. Captain Reed was presented with a purse of $750 in gold for gallantry and was made harbor master of St. John where he remained for many years.

Chap, E. T. or E. J.

SIDEWHEELER S.S. JOSEPHINE Fig. 494

H. 15⅜"; w. 26¾"
oil on canvas
signed, l.r.: "E. T. or E. J. Chap. . . ."
Gift of: Mrs. J. C. Rathbone, 1959
(cat. #27.1.4-34)

"The story is the JOSEPHINE plied between North Hampton and New Haven and when business was slack, she spent her summers on the lake as an excursion boat. When trains and motors killed the boat rides — she was docked — but no "Electra" salvaged her — I am sure it is no masterpiece and feel it was painted by a little passenger on her farewell ride."[1] There were at least seven JOSEPHINES with side paddles, and another is depicted on p. 127.

[1] Letter from donor, July 29, 1959, Shelburne Museum MSS.

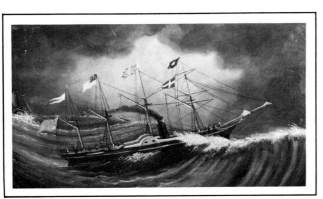

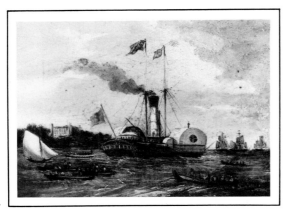
495.

496.

STORM AT SEA Fig. 496

H. 15"; w. 25"
oil on heavy cardboard
(cat. #27.1.4-18)

A ship on storm tossed waters flies both British and American flags. Three sailing vessels appear in the distance.

EARLY STEAMER Fig. 497

H. 10"; w. 14¼" c. 1830
oil on canvas
(cat. #27.1.4-25)

An early steamboat flying a British flag with large paddlewheels glides by a low hill with a Greek Revival building on it. Several other boats — six with oarsmen — are around it. This painting was found in Rochester, New York.

497.

EARLY AMERICAN STEAMBOAT Fig. 498

H. 26¼″; w. 34″ c. 1820
oil on wood
(cat. #27.1.4-31)

HUDSON RIVER FERRYBOAT "L. T. PRATT"

Fig. 459

H. 20″; w. 24⅛″
oil on canvas
(cat. #27.1.4-24)

There was once a Philadelphia canvas maker's mark on the back of the canvas (no longer visible because of the wax relining). No information on the L. T. PRATT has been uncovered, and the painting appears to be of fairly recent date.

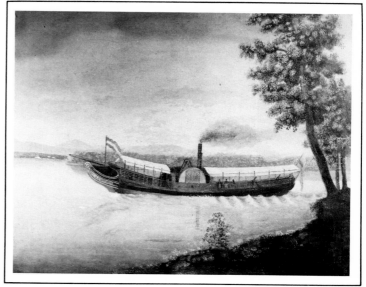

498.

LADY OF THE LAKE Fig. 499

H. 14″; w. 18¼″
oil on wood
(cat. #27.1.4-17)

The LADY OF THE LAKE of 422 tons was built in Oswego, New York by George S. Weeks in 1842 for service from Niagara Falls to Ogdensburg, via Lewiston, Oswego, and Kingston. 197 feet long and twenty-four feet wide, she was the first steamer on Lake Ontario to have an upper cabin. By July of 1848 she was under the management of the Ontario and St. Lawrence Steamboat Company. A previous owner of this painting wrote that her grandfather was the LADY's Captain.

I have somewhere some contemporaneous accounts of an accident when the LADY broke her rudder, I think, in a storm. My grandfather wrote a message of distress on the bottom of a pail and set it adrift. It was picked up on the shore and relayed to her sister ship which came to her rescue.[1]

In 1852 the LADY was put on the ferry run between Cape Vincent and Kingston and the following year was purchased by M. W. Brown of Toronto, Ontario. Renamed QUEEN CITY, she plied Lake Ontario between Hamilton and Toronto until she caught fire on January 22, 1855, while moored at Queen's wharf in Toronto.[2]

[1] The original owner wishes to remain anonymous. Information from the Vose Gallery, Boston, 1954.
[2] Erik Heyl, *Early American Steamers* (Erik Heyl: Buffalo, New York, 1967), Vol V, pp. 161-162.

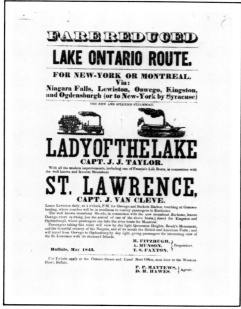

499. Broadside courtesy of The New-York Historical Society.

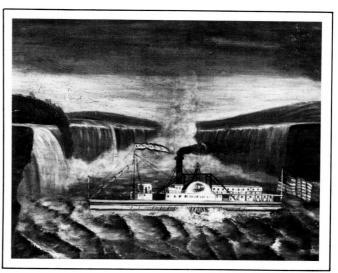

499.

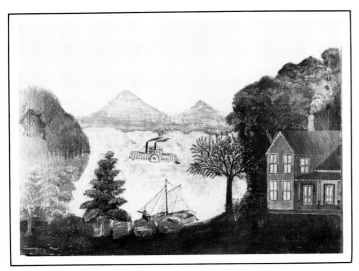

500.

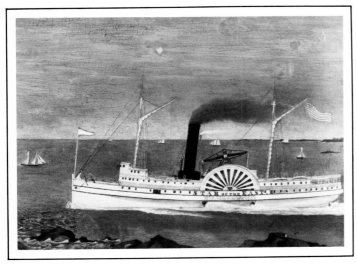

501.

STAR OF THE EAST

Fig. 501

H. 16⅜"; w. 23¼" c. 1870
oil on canvas
(cat. #27.1.4-1)

The Kennebec Steamboat Company, organized following the Civil War, commissioned John Englis and son of Brooklyn, New York to build the 1,413 ton STAR OF THE EAST in 1866. 244 feet long and thirty-five feet across the beam, she had a vertical beam engine. Originally scheduled to run between Bath and Hallowell, Maine, the low drawbridge at Gardiner prevented its reaching Hallowell, and hence the run ended at Gardiner. Rebuilt in 1899, the STAR OF THE EAST was renamed SAGADAHOC and in 1903 was based in Troy where she piled the Hudson as the GREENPORT until 1917.

THE TALLAHASSEE

Fig. 502

H. 24"; w. 33½"
oil on canvas
Gift of: J. Watson Webb, Jr., 1970
(cat. #27.1.4-80)

Built in 1847 in New Albany, Indiana, the TALLAHASSEE of 163 tons was based in Louisville, Kentucky until she was abandoned about 1853.

GOTHIC HOUSE AND STEAMBOAT

Fig. 500

H. 26"; w. 35" c. 1850-1860
oil on canvas
(cat. #27.1.4-33)

Painted on very thin canvas, (now relined) the artist of this landscape has thinned his paint with turpentine, causing it to run.

STEAMSHIP NEW WORLD

H. 25"; w. 38" c. 1855
oil on canvas
(cat. #27.1.4-81)

The NEW WORLD, weighing 1,418 tons and built by William H. Brown of New York, began service as a day boat in 1848. 371 feet in length with a thirty-six foot beam, her engine was built by T. F. Secor and Company with a cylinder seventy-six inches in diameter and a fifteen foot stroke. Rebuilt as a night liner by John Englis in 1855, her length was increased to 385 feet and her weight to 1,675 tons. The first inland steamer to have a double tier of staterooms above the main deck, the NEW WORLD was lit by gas lamps and richly furnished. On October 25, 1848, opposite Fort Washington, a schooner crossed her bow. The engineer stopped her engines so quickly that the strain on the gallows' frame caused the walking beam to drop and the connecting rod to snap and fall through the boat's bottom. The NEW WORLD sank in thirty minutes, but all of her passengers were rescued. Raised and rebuilt, she again sank off Stuyvesant shore on July 4, 1861 with no loss of life. Once more raised, her engines were installed in the ST. JOHN, and the NEW WORLD herself was taken to Fortress Monroe to serve as a hospital ship during the Civil War.

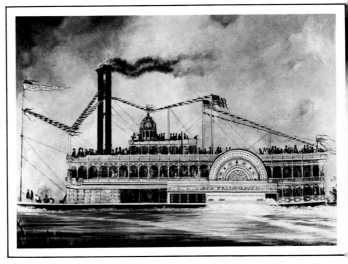

502.

196

PADDLE STEAMBOAT MISSISSIPPI

Fig. 503

H. 7⅝″; w. 12½″
oil on canvas
on verso (label): #2655 Paddle Steamboat "Mississippi"
(cat. #27.1.4-82)

There were several, large paddle steamboats named MIS-
SISSIPPI, and it is not known which one appears in this
small oil painting. The same boat is the subject of an en-
graving, illustrated in the *Pictorial History of American
Ships*.[1]

[1] John and Alice Durant, *Pictorial History of American Ships* (New York: A.
S. Barnes & Co., 1953), p. 134.

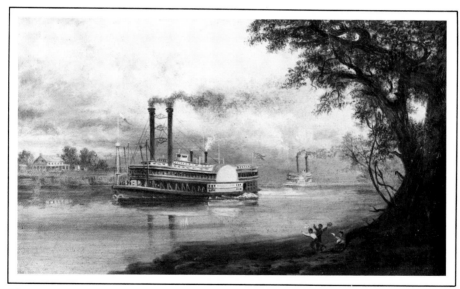

503.

INDEX